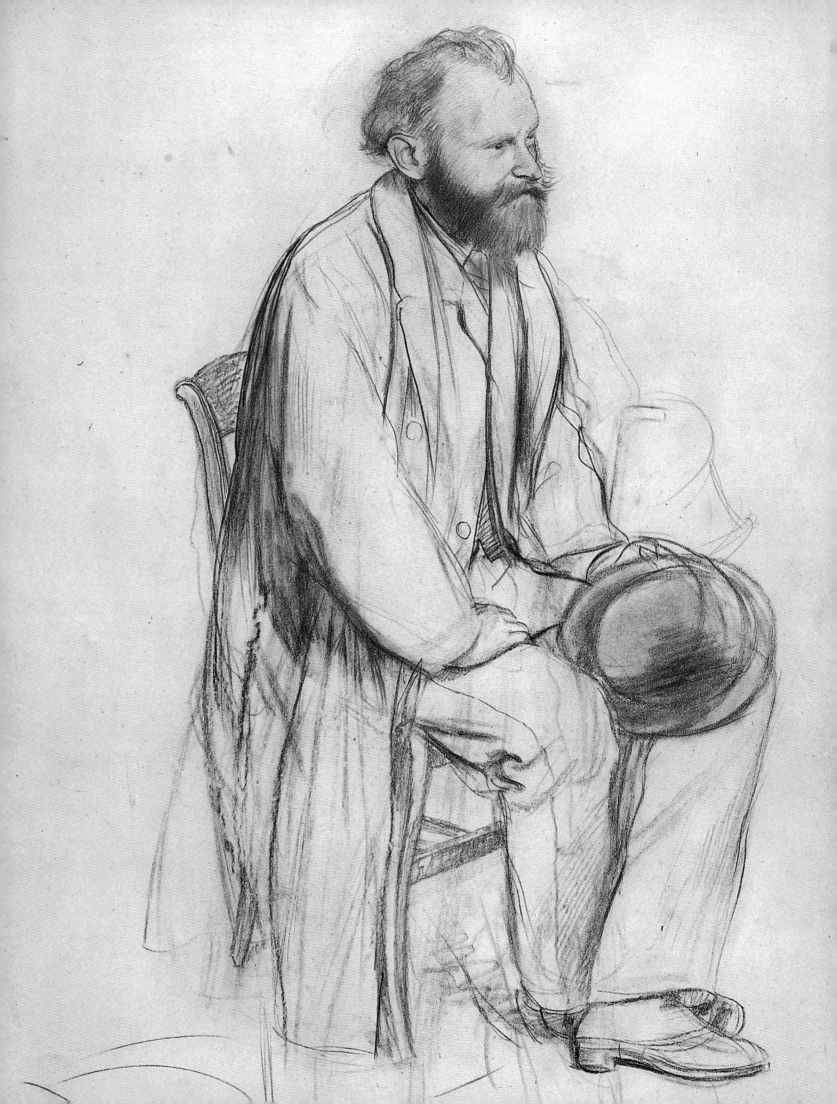

MANET
—
DEGAS

Stephan Wolohojian and Ashley E. Dunn

with contributions by

Stéphane Guégan, Denise Murrell, Haley S. Pierce,
Isolde Pludermacher, and Samuel Rodary

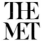

The Metropolitan Museum of Art, New York
Distributed by Yale University Press, New Haven and London

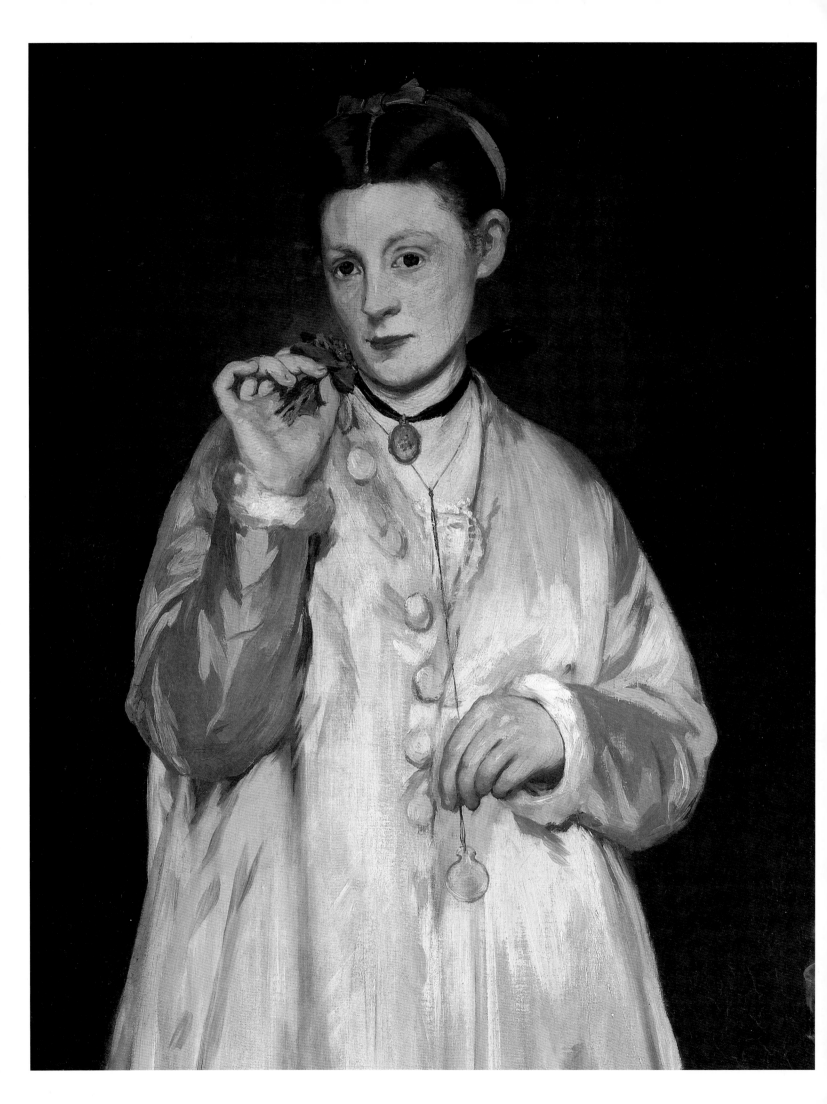

CONTENTS

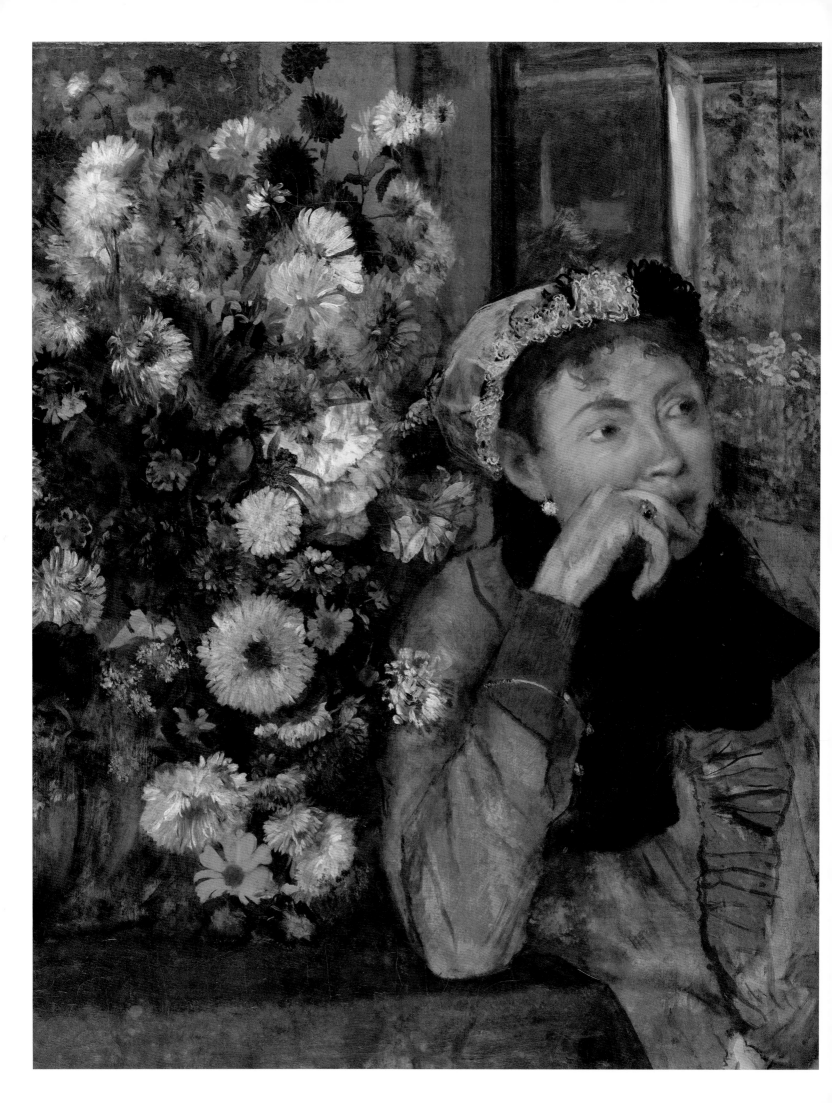

DIRECTOR'S FOREWORD

To consider the legacies of Édouard Manet and Edgar Degas, two giants of art history who reimagined the visual language of modern life, it is only fitting to reunite them in museum galleries, a setting reminiscent of their legendary first encounter at the Louvre. At that moment, neither had attained the stature of modern master for which they are known today, more than 160 years later. Each was extraordinarily ambitious, and their sustained, thoughtful, at times competitive observation of one another and their milieu would become vital to their enterprise. Their rivalry in paint and on paper over the course of two decades produced some of the most provocative and admired images in Western art.

Pairing these artists in an exhibition requires a similar spirit of collaboration, drive, and resourcefulness. Not long after I became Director of The Metropolitan Museum of Art, Laurence des Cars, then President of the Musée d'Orsay and now of the Musée du Louvre, and I had a conversation about potential joint projects and ways to foster a fruitful partnership between our institutions. *Manet/Degas* represents one such endeavor. Over half of the more than 160 works in the exhibition are drawn from the unparalleled collections of The Met and the Musée d'Orsay, and the rest are loans from nearly fifty other institutions and individual collectors whose exceptional generosity has helped make this bold exhibition possible. While each artwork plays a critical role in bringing to life the dialogue between Manet and Degas, there is one that stands apart, Manet's masterpiece *Olympia*. For the truly unprecedented opportunity to share this painting with American audiences at The Met, I especially thank Christophe Leribault, President of the Musée d'Orsay, who has supported the exhibition since his appointment in 2021 and has been an extraordinary friend and partner in making it a reality.

For more than four years, curators Stephan Wolohojian, John Pope-Hennessy Curator in Charge of the Department of European Paintings, and Ashley E. Dunn, Associate Curator in the Department of Drawings and Prints, at The Met have worked closely with their counterparts at the Musée d'Orsay, Isolde Pludermacher and Stéphane Guégan, to shape the content of this exhibition and its accompanying catalogue. Building upon the foundational scholarship of monographic exhibitions devoted to Manet (1983) and Degas (1988) organized by The Met and the Réunion des Musées Nationaux, they, along with Denise Murrell, Merryl H. and James S. Tisch Curator at Large at The Met, offer new perspectives on the relationship between this storied pair of artists in the pages that follow.

We have wonderfully generous donors to thank for helping The Met to bring this singular presentation to fruition. Our heartfelt gratitude is owed to Alice Cary Brown and W. L. Lyons Brown, the Sherman Fairchild Foundation, and Harry and Linda Fath. For their significant support, we send our profound thanks to the Janice H. Levin Fund, the Gail and Parker Gilbert Fund, The Sam and Janet Salz Trust, Rosalind and Kenneth Landis, and Elizabeth and Dean Kehler. This publication captures the extraordinary dialogue between these two artists and is made possible thanks to a lead grant from Gregory Annenberg Weingarten, GRoW @ Annenberg. We extend sincere appreciation to Anonymous, in memory of Nanette Kelekian, Robert M. Buxton, Elizabeth Marsteller Gordon, Claude Wasserstein, the Mellon Foundation, and Hubert and Mireille Goldschmidt, whose investments in this project are deeply meaningful.

Max Hollein

Marina Kellen French Director and CEO
The Metropolitan Museum of Art

ACKNOWLEDGMENTS

A project of this scale would never come to frui-tion without the contributions of many individ-uals. First and foremost, we thank Max Hollein, Marina Kellen French Director and CEO, for recognizing the potential of this major collabora-tion between two institutions with unparalleled collections of works by Édouard Manet and Edgar Degas. Max championed the project from the start, and we are grateful for his enthusiastic and steadfast support throughout its organization. Keith Christiansen, Curator Emeritus, Depart-ment of European Paintings, likewise embraced and encouraged this institutional partnership. We want to thank as well Andrea Bayer, Deputy Director for Collections and Administration, for helping us in myriad ways.

We greatly appreciate the vision of Laurence des Cars, formerly President of the Musées d'Orsay et de l'Orangerie and now President-Director of the Louvre, whose longtime ambi-tion was to bring these two giants of nineteenth-century French painting together in an exhibi-tion. We subsequently received essential support from her successor, Christophe Leribault, who ensured that many exceptional loans were able to travel from Paris to New York.

A project of this scope cannot be achieved without the generosity of exceptional donors. Our sincere thanks go to Alice Cary Brown and W. L. Lyons Brown, the Sherman Fairchild Foundation, and Harry and Linda Fath for their lead support. For their own generous gifts to the exhibition, we send our appreciation to the Janice H. Levin Fund, the Gail and Parker Gilbert Fund, The Sam and Janet Salz Trust, and Rosalind and Kenneth Landis. Thank you to Elizabeth and Dean Kehler for their kind gift. We gratefully acknowledge Gregory Annenberg Weingarten, GRoW @ Annenberg, which makes this publi-cation possible. Further appreciation is due to Anonymous, in memory of Nanette Kelekian, Robert M. Buxton, Elizabeth Marsteller Gordon, Claude Wasserstein, the Mellon Foundation, and Hubert and Mireille Goldschmidt.

This singular project is indebted to the foun-dational research of many great scholars who have worked on these two artists and to the projects that many of them presented at this museum, espe-cially the 1983 exhibition organized for the cen-tennial of Manet's death, the equally important Degas exhibition that followed in 1988, and the exhibition on Degas's personal collection in 1997. Much of our work rests on the exceptional con-tributions of Jean Sutherland Boggs, Françoise Cachin, Douglas W. Druick, Ann Dumas, Colta Ives, Henri Loyrette, Charles Moffett, Michael Pantazzi, Theodore Reff, Susan Alyson Stein, Engelhard Curator, Department of European Paintings, Gary Tinterow, Juliet Wilson-Bareau, and others who contributed to those projects.

Our co-curators at the Musée d'Orsay, Stéphane Guégan and Isolde Pludermacher, with whom we worked closely to develop the project begin-ning in 2019, and who made vital contributions to this catalogue, deserve special thanks. We also extend our gratitude to the core team in Paris, past and present: Elise Bauduin, Pauline Dujardin, Hélène Flon, Caroline Gaillard, Clémence Maillard, Pierre Malachin, Odile Michel, and Jean-Benoît Ormal-Grenon.

Although the foundation of this exhibition draws from the remarkable holdings of our institutions, such a project could not have been realized without the support of friends and col-leagues and the generous loans from public and private collections; a full list of lenders appears on page 11. For their trust and collegial assistance in facilitating loans, we warmly thank: L. Lynn Addison, Cassandra Albinson, Sébastien Allard, Scott Allen, Malene Anthon, Naoko Asano, Jacqui Austin, Maria Balshaw, Katrin Bäsig, Christoph Becker, Emily Beeny, Candace K. and Frederick W. Beinecke, Paula Binari, Debra and Leon Black, Sarah Ganz Blythe, Jonathan Bober, Armelle Bonneau-Alix, Katalin Borbély-Roberts, Jo Briggs, Melissa Buron, Ana Caldeira, Alice Calloway, Caroline Campbell, Thomas P. Campbell, Laura Cartolaro, Éric de Chassey, Cyanne Chutkow, Jay Clarke, Mary Cochran, Paula Coelho, Caroline Corbeau-Parsons, Isabelle Corriveau, Nina Del Rio, Vincent Delieuvin, Thomas Denenberg, Martine Depagniat, Érik Desmazières, Judith F. Dolkart, Benjamin Doller, Duncan Dornan, Julian Drake, Katherine Drake, Ann Dumas, Tara Emsley, Laurence Engel, Cser Enikö, Côme Fabre, Kaywin Feldman, Gabriele Finaldi, Elisa Flynn, Anne-Brigitte Fonsmark, Frances Fowle, Judit Geskó, Gloria Groom, Kazusa Haii, Tracy Hamilton, Katie Hanson, Jodi Hauptman, Joachim Homann,

Patrick Hotung, Ashley Houston, Diana Howard, Hélène Jagot, Leila Jarbouai, Robert Flynn Johnson, Kimberly Jones, Leslie Jones, Louisa Joseph, Hannah Kauffman, Liz Kelsey, Richard Kendall, Yukie Kiyota, Alexander Klar, Martin Kline, Koons Collection, Elizabeth Largi, Baán László, Audrey Leboida, Leah Lehmbeck, John Leighton, Adam Levine, Nicole Linderman, Grace Liptak, Bernhard Maaz, Julia Marciari-Alexander, Karin Marti, Stephen Mazoh, Fiona McKellar, Aurore Méchain, Sarah Mohrman, Janet Moore, Mary Morton, Nathalie Muller, Nancy T. Nichols, Isaharu Nishimura, David Norman, Alexander Nyerges, Maureen O'Brien, Tomoko Ochiai, Magnus Olausson, Roberta J. M. Olson and Alexander B. V. Johnson, Paul G. Oxholm, Anne Pasternak, Sylvie Patry, Adriano Pedrosa, Susanna Pettersson, Catherine Pimbert, António Filipe Pimentel, Mark Ramirez, Sylvie Ramond, Barbara Rathburn, Jeff Rausch, Verena Rayer, Katharine Richardson, Christopher Riopelle, Anne Robbins, Clare Rogan, James Rondeau, Carol Rossi, Kevin Salatino, Salvador Salort-Pons, Karen Serres, George Shackelford, Jill Shaw, Lisa Small, Michelle Smith, James C. Steward, Sasha Suda, Kate Swisher, Bahij Tamer, Martha Tedeschi, Matthew Teitelbaum, Jennifer Thompson, Richard Thomson, Trine Vanderwall, Dominique Vazquez, Ernst Vegelin van Claerbergen, Hannah Wagner, Hilke Wagner, Morgan Webb, Guy Wildenstein, and Stephanie Wiles.

Quincy Houghton, Deputy Director for Exhibitions at The Met, was instrumental in navigating the complexities of this ambitious undertaking, as was Gillian Fruh, who ably guided the exhibition through every phase. Our research assistant, Haley S. Pierce, managed countless aspects of the project with patience and tremendous focus. We are forever indebted to her for ensuring its realization. We extend special thanks to Denise Murrell, Merryl H. and James S. Tisch Curator at Large, Director's Office, for her generous engagement, especially her important contribution to this catalogue and the exhibition programming. We likewise thank Samuel Rodary for his work on the extensive comparative chronology in this volume.

For shaping this catalogue, we acknowledge the Publications and Editorial Department under the thoughtful leadership of Mark Polizzotti and his colleagues Peter Antony and Michael Sittenfeld. Thanks to Chris Zichello for overseeing the production of this book, Mark Nelson of McCall Associates for its design, Jenn Sherman for securing the images and reproduction rights, John Goodman for his translations of the French texts, and Margaret Aspinwall for carefully editing the notes and bibliography. Above all, we are indebted to our editor, Elisa Urbanelli, for her close reading of the essays and her invaluable suggestions and patience throughout the editing process.

Executing an exhibition of this scope required heroic efforts from many Met staff members. Aislinn Hyde expertly oversaw the logistics of all the loans and Meryl Cohen offered us key guidance at various stages. Joachim Hackl, who conceived the exhibition design, was an ideal collaborator. Frank Mondragon created the striking graphics, and Jennifer Bantz adeptly edited the wall text. We relied upon the expertise of Rebecca Capua, Rachel Mustalish, Sherman Fairchild Conservator in Charge, and Marjorie Shelley in the Department of Paper Conservation and Charlotte Hale, Walter Burke Conservator, in the Department of Paintings Conservation. Richard Carino, David del Gaizo, Ricky Luna, John McKanna, Rachel Robinson, and Garth Swanson installed the exhibition, which was beautifully lit by Amy Nelson and her team.

Additionally, we depended upon the essential fundraising undertaken by Whitney Donhauser, Jason Herrick, and the Development team, including Jennifer Brown, Elizabeth Burke, Evie Chabot, Julie Hamon, Kimberly McCarthy, Jane Parisi, Kate Thompson, and John L. Wielk. For promoting the exhibition, we thank Jennifer Isakowitz, Claire Lanier, Jonathan Lee, Gretchen Scott, and Ken Weine in External Affairs. For planning and executing related content and programs online and in person, we gratefully acknowledge Christopher Alessandrini, Melissa Bell, Kate Farrell, Isabella Garces, and Rachel Smith in Digital, as well as their colleagues Skyla Choi, Nina Diamond, and Douglas Hegley; and Chelsea Kelly and Heidi Holder, Frederick P. and Sandra P. Rose Chair of Education. Other key Met contributors, past and present, include Taylor Miller and his team in Buildings; Amy Lamberti and Emily Balter in the Counsel's Office; Alicia Cheng, Chelsea Garunay, Maru Perez Benavides, Alexandre Viault, and Margaret Zyro in Design; Kate Dobie in Development; Laura D. Corey in the Director's Office; Marissa Acey, Mary Creed, Casey Davignon, Clara Goldman, Sarah Jane Kim, Arielle Llupa, and Elizabeth Zanis in the Department of Drawings and Prints; Lisa Cain, Gillian Carver, Gretchen Walter, and especially Jill Wickenheisser in the Department of European Paintings; Marci King and Melissa Klein in Exhibitions; Nesta Alexander in the Registrar's Office; and the vital staff of the Thomas J. Watson Library and Visitor Experience.

For their support and counsel we are grateful to curatorial colleagues across the Museum: Nadine Orenstein, Drue Heinz Curator in Charge, Department of Drawings and Prints; Jane Becker, Alison Hokanson, Jennifer Meagher, and Asher E. Miller, Department of European Paintings; Pierre Terjanian, Arthur Ochs Sulzberger Curator in Charge, Department of Arms and Armor; and Sarah E. Lawrence, Iris and B. Gerald Cantor Curator in Charge, Department of European Sculpture and Decorative Arts.

Finally, we thank our families, who have lived through this project alongside us, especially William and Isla Dunn and Marina van Zuylen.

Stephan Wolohojian

John Pope-Hennessy Curator in Charge, European Paintings

Ashley E. Dunn

Associate Curator, Drawings and Prints

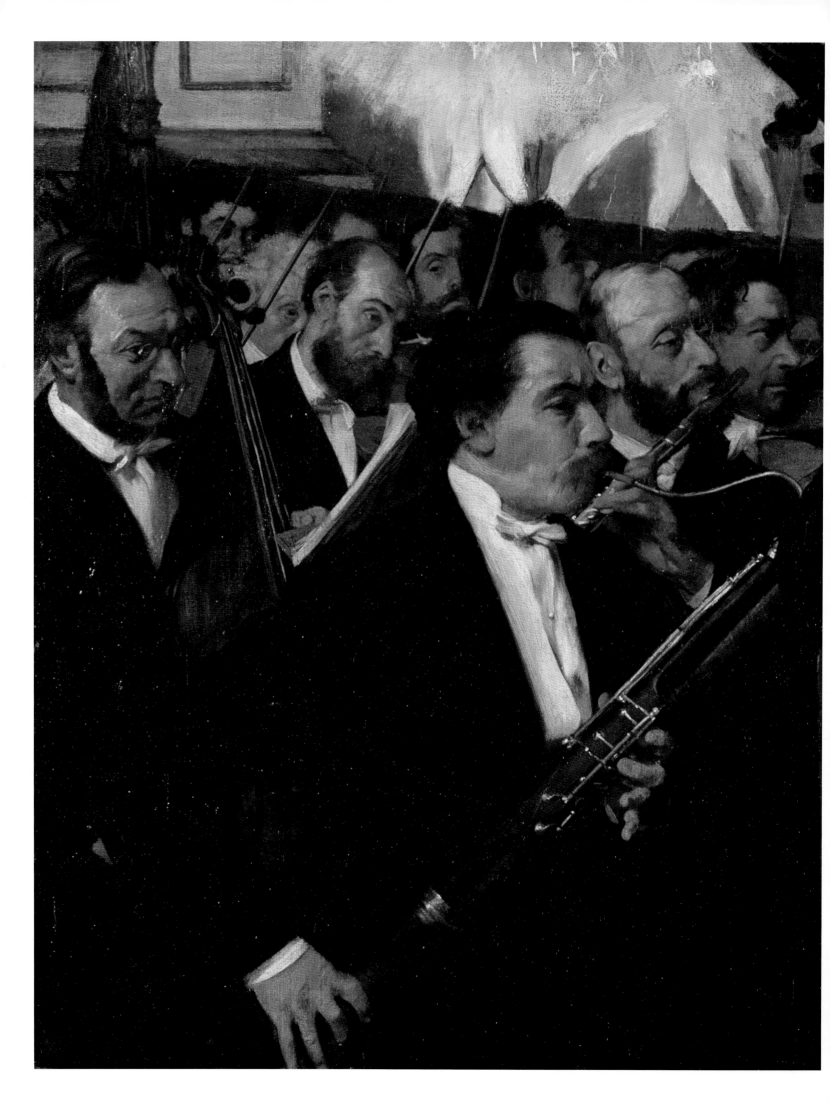

LENDERS TO THE EXHIBITION

Brazil
Museu de Arte de São Paulo Assis Chateaubriand

Denmark
Ordrupgaard, Copenhagen

France
Bibliothèque de l'Institut National d'Histoire de l'Art, Paris
Bibliothèque Nationale de France, Paris
Musée des Beaux-Arts, Lyon
Musée des Beaux-Arts, Pau
Musée des Beaux-Arts, Tours
Musée d'Orsay, Paris
Musée du Louvre, Paris

Germany
Albertium I Galerie Neue Meister, Staatliche Kunstsammlungen
 Dresden
Bayerische Staatsgemäldesammlungen–Neue Pinakothek,
 Munich
Hamburger Kunsthalle, Hamburg

Hungary
Szépművészeti Múzeum / Museum of Fine Arts, Budapest

Japan
Kitakyushu Municipal Museum of Art

Portugal
Calouste Gulbenkian Foundation, Lisbon–Calouste
 Gulbenkian Museum

Sweden
Nationalmuseum, Stockholm

Switzerland
Kunsthaus Zürich

United Kingdom
The Courtauld, London
Glasgow Life (Glasgow Museums) on behalf of Glasgow City
 Council: from the Burrell Collection with the approval of the
 Burrell Trustees
National Galleries of Scotland, Edinburgh
The National Gallery, London
Tate

United States
The Art Institute of Chicago
Brooklyn Museum
Detroit Institute of Arts
Fine Arts Museums of San Francisco
Harvard Art Museums/Fogg Museum, Cambridge
The Metropolitan Museum of Art, New York
Museum of Art, Rhode Island School of Design, Providence
Museum of Fine Arts, Boston
National Gallery of Art, Washington, D.C.
Philadelphia Museum of Art
Princeton University Art Museum
Reading Public Museum, Pennsylvania
Shelburne Museum, Vermont
Toledo Museum of Art
Virginia Museum of Fine Arts, Richmond
The Walters Art Museum, Baltimore
Yale University Art Gallery, New Haven

Private Collections
Anonymous lenders
Candace K. and Frederick W. Beinecke
Patrick Hotung
Robert Flynn Johnson
Koons Collection
Roberta J. M. Olson and Alexander B. V. Johnson

INTRODUCTION

Stephan Wolohojian and
Ashley E. Dunn

This project explores one of the most significant artistic dialogues in the genesis of modern art: that of Édouard Manet (1832–1883, fig. 1) and Edgar Degas (1834–1917, fig. 2). Friends, rivals, and, at times, antagonists, these two artists worked in conversation throughout their careers, from the time of their meeting in the early 1860s. Born just two years apart, they shared similar backgrounds as the eldest sons of Parisian upper-middle-class families, yet comparison between the two puts in relief their distinctive temperaments, styles, politics, approaches to different media, and career strategies. Examining the intersections of their work and practice highlights the contrasts and heterogeneity, even conflict, present in modernist painting from the outset.

The relationship between Manet and Degas is not straightforward, and attempts to assess it are complicated by the paucity of primary evidence of their exchanges. No letters survive from Degas to Manet, but a striking group of portraits—drawings, etchings, and a painting—offers a glimpse of Degas's regard and interest in his close colleague, as does the important collection of works by Manet that Degas assembled in the decades after the former's death.[1] In contrast, there are four known letters addressed from Manet to Degas, all written between May 1868 and July 1869.[2] Although Manet never portrayed Degas, he kept a photograph of him, inscribed "Degas" by a later, unknown hand, in an album alongside those of his wife and his only student, Eva Gonzalès.[3] Unlike Degas, who amassed a considerable holding of his friend's work, Manet had nothing by Degas in his collection when he died.

A fuller picture can be gleaned from the remarks they made about one another—equally admiring and critical—in their correspondence with mutual friends and in the commentaries of third parties who observed aspects of their relationship firsthand.[4] Two distinct figures emerge from these accounts: Manet, elegant and social, as quick and confident as his brush, who continued to seek official recognition through his devotion to the Salon; and Degas, reserved and fiercely independent, who struck out on a fresh path that required the collective participation of other new realist painters under the umbrella of the group now known as the Impressionists.

Both artists circumvented the established training ground of the École des Beaux-Arts to learn their craft. Degas seems to have dropped out in his first semester at that prestigious school, while Manet studied with Thomas Couture, who had set up his own studio as a challenge to the institution. To deepen their artistic education, each traveled to Italy with his own itinerary, overlapping there in 1857. The two painters shared a profound respect for the work of the old masters, which they honed through their copying practices. They absorbed these models as source material in the development of their own visual languages throughout their careers.

Key to this development for both artists was the role of the museum. It is significant that the oft-repeated story of their first meeting took place in a grand gallery of the Louvre.[5] The setting was not a Parisian salon, a school, or an artist's studio, but France's great repository of art at the center of Paris—a vibrant, new public space for discovery and pedagogy, outside the normative structures of the academy. In this charged and transitional moment, the museum as a site, studio, and stage provided a new model for artistic training and engagement with history and its reception.

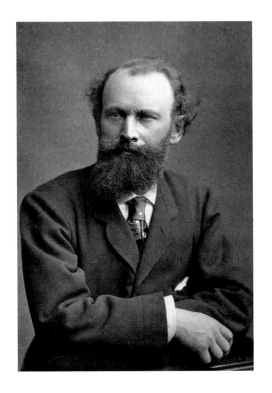

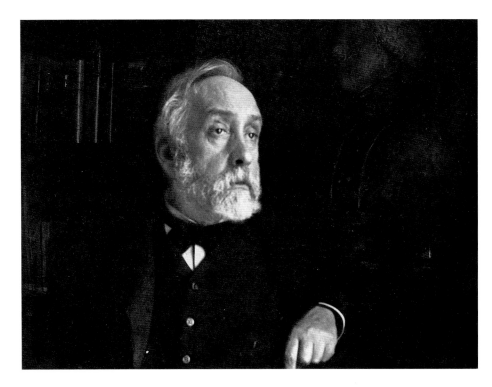

Refurbished in 1851, with new galleries to exhibit more art, the Louvre offered a text-book of models. Degas drew studies of sculpture by Michelangelo and painted small copies of works by French, Dutch, and other Italian Renaissance artists such as Mantegna (pl. 23), while Manet made copies in oil after Titian and even the more recent work of Eugène Delacroix, on view in the galleries for contemporary art at the Musée du Luxembourg (pls. 22, 15). Later in life, Degas would turn the museum into his subject, showing fellow artist Mary Cassatt as a visitor, confidently inspecting the collections at the Louvre while her sister focused intently on her guidebook (pls. 70–72). The public, modern, urban spaces of the museum served as a middle ground between the past and present, the artist and the critic. The avant-garde artists working in this privileged space generated a range of responses, from appropriation to interpretation, grounded in a common and familiar set of references.[6] What previously was seen on distant travel was now housed in the heart of the cosmopolitan city. This great museum along with the Cabinet des Estampes and myriad private collections, formed by discerning connoisseurs who made them accessible, afforded artists close contact with artworks from the past, in three dimensions and vivid color. Some have even argued that this public theater of objects and collections laid the foundations for both a new canon of art history and modern art itself.[7]

Manet and Degas were at the forefront of the burgeoning modern movement. From his public debut in 1861, when he received an honorable mention at the annual Salon for *The Spanish Singer* (pl. 73), Manet rapidly established himself as a major figure of the Paris art world. His repeated *succès de scandale*—his audacious *Déjeuner sur l'herbe* at the Salon

Fig. 1 Anonymous, *Édouard Manet*, ca. 1876. Photomechanical proof (Woodburytype), 4 3⁄4 × 3 1⁄4 in. (12 × 8.2 cm). Musée d'Orsay, Paris (PHO 1983 165 514 11)

Fig. 2 Edgar Degas, *Self-Portrait*, 1895. Gelatin silver print, 7 1⁄4 × 9 5⁄8 in. (18.3 × 24.3 cm). Musée d'Orsay, Paris (PHO 1994-44)

des Refusés of 1863 and his daring *Olympia* at the Salon of 1865 (pl. 81)—are well-known landmarks in art history. Degas finally joined him on the public stage in 1865, exhibiting his bizarre attempt at history painting, *Scene of War in the Middle Ages* (pl. 83), a complex, modestly scaled work in an experimental medium whose narrative was difficult to decipher. Unsurprisingly, it went unnoticed. However, another work from that year, *A Woman Seated beside a Vase of Flowers (Madame Paul Valpinçon?)* (pl. 84), marked a new direction, straining the category of portraiture by placing a still life of a large floral bouquet at the center of the composition and pushing the sitter to the periphery. Portraiture was a major genre for each artist, and through a rich pictorial dialogue they expanded its formal conventions and iconographic complexity.[8]

The portraits that Manet and Degas made in the first decade of their relationship reveal the animated Parisian milieu in which they lived and worked. They captured the likenesses of artists, politicians, literary figures, and members of the avant-garde who gathered at the Café Guerbois, the Nouvelle-Athènes, and other spots at the foot of Montmartre. They also met frequently at salons hosted by sophisticated women within their circle. Manet's mother regularly received a remarkable group on Thursdays. Writers and critics such as Charles Baudelaire, Edmond Duranty, Stéphane Mallarmé, and Émile Zola; artists including Félix Bracquemond, Henri Fantin-Latour, Berthe and Edma Morisot, and Pierre Puvis de Chavannes; and composers and musicians, among them, Manet's wife, Suzanne, who had been the Manet brothers' piano teacher, participated in these soirées.

Degas attempted to capture the relaxed sociability of such evenings in a double portrait of his friend distracted in thought, comfortably slumped on a sofa, as Suzanne plays the piano (pl. 3); Manet made his own portrayal of her in the same setting and pose at around the same time (pl. 5). Degas seems to have presented his canvas as a gift to the Manets, but what ensued is unclear. Years later, writers familiar with both artists recorded that Manet slashed the painting because he was displeased with his wife's features.[9] Degas claims to have been so shocked that he grabbed the canvas and took it home, then showed his outrage by returning a small still life that Manet had given him.

The events of the Franco-Prussian War (1870–71) and its aftermath drew the two men closer together. While many painters fled Paris—Claude Monet and Camille Pissarro to London, Paul Cézanne to Provence—Manet and Degas, both committed patriots, stayed to defend their city during the Siege, serving as National Guardsmen and volunteering as gunners in the artillery.[10] Both were impacted deeply by their experiences; however, the visual trace of these conflicts in their work is more subtle in the case of Degas, whereas Manet produced some of his most poignant, critical, and graphically bold prints in response to the conditions of war and the violent suppression of the Commune that followed.[11]

During the 1870s they continued artistic conversations from the previous decade, such as their dual series of horse-racing pictures, while also expanding their repertoire of subjects drawn from modern life.[12] The rivalry between Manet and Degas is apparent in their treatments of Parisian women in the urban contexts of cafés, brasseries, cafés-concerts, and millinery shops, and in their reinvention of the traditional female nude.[13] Their approaches appear closely related in their pastels of bathers yet highly divergent when it comes to Degas's

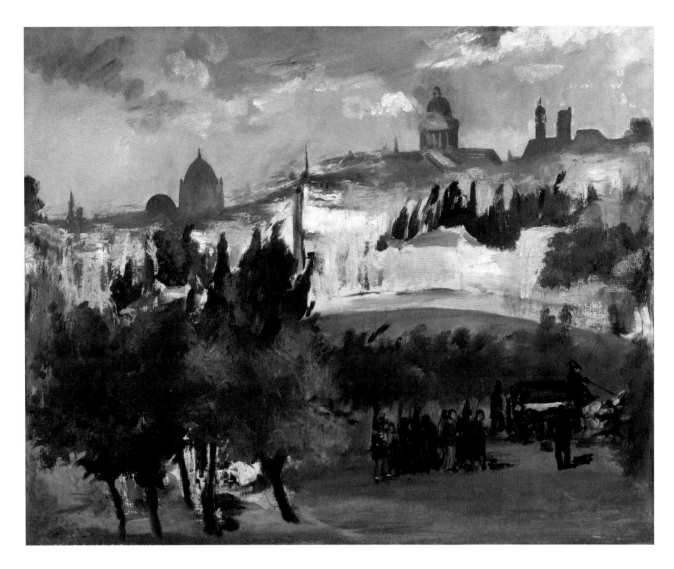

Fig. 3 Édouard Manet, *The Funeral*, ca. 1867. Oil on canvas, 28 5/8 × 35 5/8 in. (72.7 × 90.5 cm). The Metropolitan Museum of Art, New York, Catharine Lorillard Wolfe Collection, Wolfe Fund, 1909 (10.36)

monotypes of brothel scenes.[14] These visual exchanges surely would have continued were it not for Manet's premature death in 1883.

Degas lived to see his work enter museum collections. In 1878 the Musée des Beaux-Arts in Pau was the first public gallery to acquire a painting by him, *A Cotton Office in New Orleans*, of 1873 (pl. 141). A decade later, in 1889, The Metropolitan Museum of Art became the first museum to acquire work by Manet when it accepted *Boy with a Sword* and *Young Lady in 1866* as gifts from the intrepid American collector Erwin Davis (pls. 44, 93).[15] For many years, the two paintings hung in its galleries as the only representatives of modern French art. The Museum's catalogue conveyed ambivalence in describing the artist as "an eccentric realist of disputed merit; founder of the school of '*Impressionnistes*.'"[16] Nevertheless, the fact that they were accessioned and on display spoke volumes.

Mary Cassatt, who played a principal role in shaping the earliest collections of Impressionist art in America, believed so strongly that Manet's work belonged in this country that she refused to support Monet's 1890 campaign to purchase *Olympia* for the French state.[17] In 1909 Louisine Havemeyer, who had been assembling an impressive collection of the artist's work with Cassatt's encouragement and guidance, offered *The Dead Christ with Angels* for long-term loan to The Met (pl. 75). Undoubtedly influenced by Cassatt's attitude, she had purchased the painting from dealer Paul Durand-Ruel in 1903 expressly to keep it in America. Referring to it as a "museum Manet," she never displayed it in her home, finding that it "crushed everything beside it."[18] That same year, The Met made its first purchase of a work by Manet, *The Funeral* (fig. 3), from Ambroise Vollard.[19]

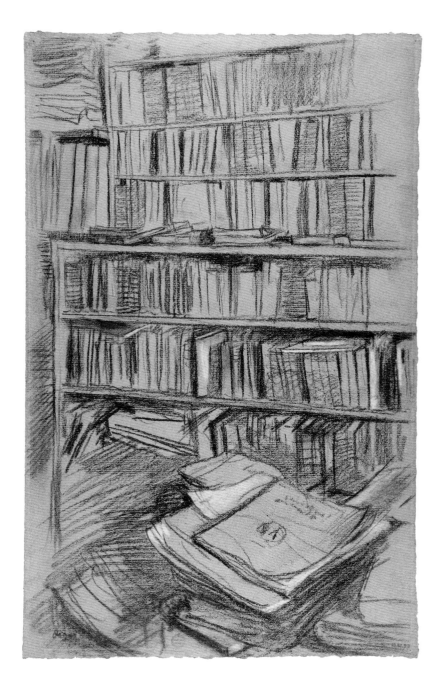

Fig. 4 Edgar Degas, *Bookshelves, Study for "Edmond Duranty,"* 1879. Dark brown chalk, heightened with white chalk, 18 7/16 × 12 in. (46.9 × 30.5 cm). The Metropolitan Museum of Art, New York, Rogers Fund, 1918 (19.51.9b)

There was a considerable delay on the part of the Museum in acquiring paintings by Degas, but it was not for lack of trying. In September 1909, its curator Bryson Burroughs visited Degas at his studio in an attempt to broker the sale of an "important" painting, but the asking price was ultimately deemed too high.[20] Following Degas's death, The Met was the only American museum to purchase directly from his studio sales. The ten drawings won at those auctions included three portraits of Manet (pls. 6, 11, 106), two preparatory drawings for the portrait of Edmond Duranty (fig. 4; pl. 67; see fig. 56), and five pastel drawings. Burroughs, nevertheless, lamented that the Museum still had no paintings by the artist. Pleading his case, he wrote in the *Bulletin*: "His pictures . . . have a reality that equals Manet."[21] Finally, with the Havemeyer Bequest in 1929, the Museum received 112 works by Degas in all media, as well as six paintings and three pastels by Manet, making it the leading repository of works by these artists outside of France.[22]

The Museum has continued to build on these exceptional foundations, which have motivated the institution's ambitious exhibition program. The anniversary of Manet's death in 1983 occasioned a major retrospective organized jointly by The Met and the Réunion des Musées

Nationaux, which led in turn to further collaboration—along with the National Gallery of Canada—on the Degas retrospective of 1988–89.[23] These landmark exhibitions generated robust scholarship, and their catalogues remain essential resources on the works of these artists. Today, thirty-five and forty years later, we have an opportunity to present Manet and Degas to the next generation, this time in relation to each other.

These two giants of French painting have been the subjects of innumerable monographic studies, and their relationship has been explored in the pages of essays and books.[24] This current project is the first to attempt to realize their artistic conversation in three dimensions. It adopts the "dialogical" model executed successfully in recent years with pairings such as *Degas Cassatt* and *Pissarro and Cézanne*.[25] It is through such juxtapositions that we can assess how these major artists defined themselves with and against each other. Whereas Monet had close relationships with Pierre-Auguste Renoir and Alfred Sisley, and Cézanne and Pissarro often painted together, Manet and Degas worked less side by side than at a critical angle to one another. Each took stock of the other's work, distilling it until it became foundational for his own project or, perhaps puzzling for historians, totally irrelevant to it. In the case of Manet and Degas, the scarcity of other evidence of their friendship makes direct comparison between the works of art even more crucial. This exhibition offers the rare opportunity to make this appraisal.

MANET AND DEGAS MEET:
ENCOUNTERS IN ETCHING

Ashley E. Dunn

"How audacious of you to etch that way, without any preliminary drawing, I would not dare do the same!"[1] With this declaration, in late 1861 or early 1862, Édouard Manet purportedly greeted Edgar Degas for the first time.[2] According to early twentieth-century accounts, the two artists met in a gallery of the Musée du Louvre in front of the *Portrait of the Infanta Margarita Teresa* (fig. 5), a painting attributed at the time to the seventeenth-century Spanish painter Diego Velázquez and now understood to be the product of his workshop. As Degas stood with a copperplate in hand, "attacking" it with an etching needle, Manet stopped to comment on this boldness as compared to his own approach to the technique.[3] Degas later recalled that this exchange marked the beginning of their enduring friendship.[4]

The circumstances of this meeting and the related prints made by each artist (pls. 18, 19, fig. 6) clearly indicate two of the interests that Manet and Degas shared early in their careers: the work of Velázquez and the intaglio printmaking technique of etching. This inter-section of pursuits firmly locates them as ambitious young painters of their day. In France, admiration for the Spanish school grew throughout the 1840s and 1850s, and the practice of etching—in which an artist draws with a needle on an acid-resistant ground, exposing the copperplate beneath, and then incises the lines by submerging the plate in acid—burgeoned among painters in the 1860s. Although Degas's attention to Spanish art was ultimately less sustained than Manet's, both artists remained engaged with printmaking and reproductive processes throughout their careers.

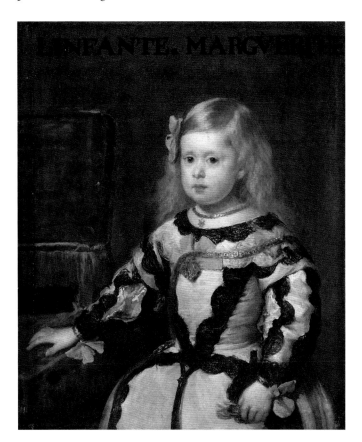

Fig. 5 Diego Velázquez (Spanish, 1599–1660) and Workshop, *Portrait of the Infanta Margarita Teresa (1651–1673)*, 1654. Oil on canvas, 27½ × 22⅞ in. (70 × 58 cm). Musée du Louvre, Paris (941; MR 537)

This essay considers closely the questions that still linger about their first encounter over an etching plate and assesses the series of portraits that Degas made of Manet during the height of their friendship in the late 1860s, when they reconvened around the medium. Placing these projects in the context of the artists' early printmaking practices and examining them in relation to each other cast light on some of the wider topics of debate at that time— and since—about the role and status of graphic techniques. These issues include the relationship among drawing, sketching, and etching; definitions of originality and reproduction; and the impact of a work's intended audience, whether public or private, on artistic choices. This examination also points toward what might have mutually attracted the two artists to printmaking, propelling each of them to generate highly original and distinctive printed oeuvres. In their ongoing graphic experimentation over the course of their careers, the act of translating from one medium into another helped both Manet and Degas to see and think differently, and to imagine new possibilities out of past efforts.

The etchings that the artists created after the *Portrait of the Infanta Margarita Teresa* differ strikingly from one another. Each took license in his interpretation of the source. Unlike, for instance, the etching by Ephraïm Conquy commissioned by the Chalcographie du Louvre (the museum's engraving department and print shop) (fig. 7), their objective was not to provide a faithful reproduction. Manet's print maintains the orientation of the painting; Degas's reverses it. Manet employed pure etching, whereas Degas combined this technique with drypoint (incising with a needle directly into the plate without the use of acid). The dark, fuzzy drypoint lines emphasize the lace in the infanta's dress, which Manet, in contrast, almost eliminated, evoking it only sparsely with linear hatching. Manet etched his plate more evenly and deeply compared to Degas, whose delicate, lively strokes convey his attention to the painterly surface and the shimmering textures of the child's hair and silk dress. Manet's bold handling of line reveals his study of Francisco Goya's etchings after Velázquez, especially in the zigzag shading of the background, which is distinct from the more regular hatching that Degas used to surround the figure.[5]

Manet's reported reaction to Degas's method raises the question of the role of drawing in each artist's approach to printmaking. What shocked Manet was that Degas worked on

the copperplate in front of the motif as opposed to basing his print on a preparatory drawing. In rhetorical terms, this process aligned with how promoters of etching associated the medium with drawing and with the personal and spontaneous aesthetic of the sketch.[6] Yet, from a practical perspective, it would have been quite unusual at the time to work with etching materials outside the studio.[7] Some scholars have speculated that Degas more likely etched the composition lightly in his atelier using a reproduction for his source and then added some or all of the drypoint lines while in front of the painting as he sought to emulate its tonalities.[8] However, Degas was known for disregarding standard practices and challenging himself when it came to his materials, so it is entirely possible that he treated his plate like the page of a sketchbook while standing in the gallery at the Louvre, drawing into the waxy ground before returning to the studio to bite the lines with acid.[9]

When Manet executed his own etching after the painting, he first made a drawing of the composition in graphite with watercolor or wash (fig. 8). As his remark to Degas implies and surviving watercolors attest, this was his habitual process.[10] Although the drawing of the *Infanta* is now lost, it is known through a photograph taken in Manet's studio after his death.[11] In addition, Manet may have used a tracing to aid in the reversal of the image on the plate, thereby rendering his print in the same orientation as the painting. His liberal approach in the translation from watercolor to etching is particularly evident in the simplification of the infanta's dress and the redirection of her focus. In the watercolor, her outward gaze from the painting is maintained, but in the print, it becomes vague and further removed from the source.

Precisely when Manet etched his version relative to meeting Degas is still unknown, and whether he made it before or after colors the potential dynamic of their exchange. It would be a remarkable coincidence and art-historical kismet if he happened to be working on it at the exact moment that he stumbled upon the slightly younger artist. When he came across Degas in the gallery, did he immediately identify a rival whose daring approach spurred him to try his hand at the subject? Or had he recently attempted the same project and, therefore, felt entitled to comment on Degas's efforts?

At the time of their encounter, each artist had begun to experiment with etching relatively recently. Degas had started slightly earlier; the amateur printmaker and collector Prince

Grégoire Soutzo, a friend of his father's, likely motivated his first attempt with the medium in 1856.[12] The following year, while studying in Italy, Degas continued his trials with the guidance of the French engraver Joseph Gabriel Tourny, who cultivated his appreciation for the work of the seventeenth-century Dutch master Rembrandt van Rijn. Degas made his *Young Man, Seated, in a Velvet Beret, after Rembrandt* (pl. 29) as part of his process of study and absorption. As with the *Infanta*, Degas etched his plate in the same orientation as the source, resulting in a print that reverses the original. In this careful copy of Rembrandt's etching, Degas attended to the specificity of the line for instruction in the technique, whereas the Velázquez portrait, as a painted source, encouraged a freer, more expressive interpretation.

When Degas returned to Paris, he intermittently continued etching small-scale portraits, among which *Marguerite De Gas, the Artist's Sister* is his most accomplished (pl. 42). This sensitive and frank bust-length depiction of his younger sister displays Degas's increasing sophistication with the etching medium, striking a tonal balance between the delicacy of her face and the richness of the background and the fur muff. It integrates influences from many sources, including Rembrandt, Jean Auguste Dominique Ingres, and Eugène Delacroix, as well as Degas's peers Alphonse Legros and James Tissot.[13] Degas painted two portraits of his sister around this time, one full-length and one bust-length, but the etching is neither preparatory to nor a repetition of either painting.[14] The absence of any known related drawing may support the idea that Degas sketched on the surface of his plate.

By the time he crossed paths with Manet, Degas had made about fifteen etchings, but these early attempts remained private studies that were never meant to be published. In contrast, Manet took an almost immediate interest in employing etching for the public dissemination of his work. Most of his etchings, therefore, derive from his paintings and were intended for publication.[15] *Monsieur Manet (The Artist's Father) I*, based on the double portrait of his parents that he exhibited at the Salon of 1861, is an exception among his early efforts, in that it was never published, but demonstrates Manet's reconsideration of a composition in etching (pls. 37, 38). His father's health was in severe decline at the time, and Manet wrestled with how to portray him in a dignified manner.[16] The artist's struggle is particularly borne out in the shifting representation of his father's gaze. Although the elder Manet's eyes are downcast in the painting, an X-ray shows that he originally looked outward. Manet returned to the frontal gaze when he made a drawing in red chalk to prepare his etching, and he maintained it in the print.[17] Dissatisfied with his first effort, whether due to technical troubles or expressive ones, he created a second version of the etching, of which only a few impressions survive.[18]

In 1861 Manet initiated a period of concentrated engagement with the etching technique, working in the milieu of art dealer and publisher Alfred Cadart's print enterprise with encouragement and guidance from his friends Félix Bracquemond and Legros.[19] Alongside these and other artists, Manet was a founding member of the Société des Aquafortistes (Society of Etchers), established by Cadart in collaboration with the printer Auguste Delâtre in 1862 to further interest in etching among artists, critics, collectors, and the general public.[20] Even before the official launch of the society, critics made positive note of Manet's etching *The Spanish Singer* hanging in Cadart's shop window (pl. 153).[21] In producing this print, based on the painting that made his reputation at the Salon of 1861 (pl. 73), the artist did not

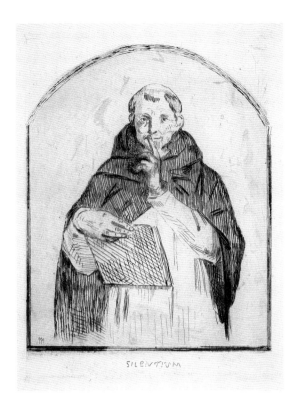

SILENTIVM

Fig. 9 Édouard Manet, *Silentium*, 1862–64, published 1905. Etching on blue laid paper; third state of three, plate 8 × 5 15⁄16 in. (20.3 × 15.1 cm), sheet 14 1⁄2 × 9 3⁄8 in. (36.8 × 23.8 cm). The Metropolitan Museum of Art, New York, Rogers Fund, 1921 (21.76.13)

endeavor to reverse the composition on the plate, despite making the customary intermediary drawings—a watercolor and a tracing—that would have enabled such a maneuver. By comparison, for *Dead Christ with Angels*, his largest and most ambitious etching, he created the watercolor in reverse so that the subsequent print maintains the orientation of the painting (pls. 76–79).[22] Across his etched oeuvre, Manet was inconsistent with respect to the orientation of his prints, which, as a consequence, calls attention to the mechanics of their making.[23]

In September 1862 Cadart announced the publication of a portfolio of eight of Manet's etchings, *Huit gravures à l'eau-forte*.[24] The suite included two etchings after works attributed to Velázquez; four "autographic reproductions" after Manet's own paintings, including *The Spanish Singer*; and two original compositions more loosely affiliated with painted works.[25] Among these, Manet chose the two Velázquez-related etchings, along with his etching after *Lola de Valence* published in the Société des Aquafortistes' series *Eaux-fortes modernes* (pl. 96), for submission to the Salon of 1863. Rejected by the jury, they were ultimately displayed in the Salon des Refusés, along with his paintings.

In general, the chronology of Manet's prolific early period of etching has been difficult to pin down precisely. Comparison of the *Infanta* print with his other two copies related to Velázquez, *The Little Cavaliers* and *Philip IV*, shows the extent to which it differs in approach. In the sparseness of its style and the abstraction of its source, it has more in common with *Silentium*, a copy after a fresco by Fra Angelico, another print that has proved challenging to date (fig. 9).[26] The emptiness of the lower part of the *Infanta* composition suggests that the work may be unfinished.[27] Perhaps, compelled by his encounter with Degas, Manet took up the subject but then abandoned it in favor of the other two etchings after works attributed to Velázquez. If he did leave it incomplete, it resonates with Degas's version in this way. The unique impression of the second state of Degas's print shows that he burnished the plate, likely with the intention of reworking it, although it seems he never did.

Manet provided the direct inspiration and motivation for Degas's next series of prints, a group of etched portraits of his by-then close friend (pls. 7, 8, 12).[28] Perhaps Manet's initial words still rang in his ears, as Degas prepared the portrait etchings with a thorough drawing campaign. Nevertheless, Degas's method of working from drawing to etching was less direct

than Manet's, and over the course of making the three portrait prints the two processes became even more loosely allied.

In his drawing *Édouard Manet, Seated, Holding His Hat* (pl. 6), Degas took an Ingresque approach, rendering Manet's face in fine detail while more freely sketching his body and the drapery of his overcoat in long, brisk strokes. The contrast between the face and body is evened out by the more regular hatching of the etching, which is the most faithful to its preparatory drawing among the group of portrait prints (pl. 7). The plate is considerably smaller than the drawing; therefore, it appears Degas executed the transfer of the design freehand, instead of using a tracing procedure like Manet often did.

For *Édouard Manet, Seated, Turned to the Right*, Degas synthesized different aspects of the preparatory drawing to compose the etching (pls. 8, 9). To Manet's body, casually seated sideways in the chair, he appended the larger version of his head from the sheet, replicating it in the etching down to each strand of hair. In the second state of the print, he added the top hat, adjusting its position to the foot of the chair.[29] To the etched composition he also added a background; in the print, the rectilinear back of a stretcher both serves as a framing device and denotes a studio setting. The considerable number of surviving impressions of this print implies that Degas was reasonably pleased with it. However, in the fourth and final state he largely burnished out the head and background.[30] An unlocated study of Manet's head that does not directly relate to any of the existing prints may give some indication of Degas's unrealized intention to rework the plate (fig. 10).[31]

For *Édouard Manet, Bust-Length Portrait* (pl. 12), there are no equivalent preparatory drawings. It has been compared to another sketch of Manet seated with legs crossed, *Édouard Manet, Seated, Right Profile* (pl. 11), but the angle and perspective do not align. Among the three etchings, it is the most resolved in the sense that the plate was not burnished in later states. However, despite its level of finish, not many impressions were printed, so the audience for the print was limited. In the fourth state, Degas incorporated aquatint for the first time in his oeuvre, darkening Manet's coat and the background.[32] He likely learned this tonal technique from Bracquemond, who surely also taught it to Manet.[33] Around this time, Manet revisited a number of his early etchings and applied aquatint to the plates, darkening them overall—too much in certain cases.

A drawing of Manet covered in ink wash suggests that Degas may have been thinking about the more tonal approach of aquatint for yet another printed portrait of his friend (pl. 10). The connection of this sheet to the other preparatory drawings for the series of etchings is confirmed by the similarity of the head to the one that appears faintly at the top of the sheet in *Édouard Manet* (pl. 9). Three other extant drawings show Manet in a similar posture, leaning against a table or desk. In one version, Manet's pose is almost identical, but he wears an artist's smock (fig. 11). Two other, more slight drawings depict him from the opposite side with his right leg crossed over his knee rather than at the ankles.[34] The drawing with ink stands out among the group as distinct in its medium. Could it be a rough value study (comparing darkness and lightness of tones) for yet another print? The slapdash application of a diluted wash over Manet's head obscures more than it clarifies. The use of ink wash is rare within Degas's drawing practice, especially in this period. In fact, it is a technique

more readily associated with Manet. It seems that Degas may have adopted the medium as an ode to his friend. That the drawing remained a lasting tribute is attested by the fact that he eventually gave it and a few others to Manet's niece Julie on the occasion of her marriage.[35]

With regard to etching, the two artists' paths diverged after the 1860s. Manet virtually abandoned the technique, with only a few exceptions, in favor of lithography.[36] He did, however, continue to distribute and display his early etchings later in his career; Cadart issued a second edition in 1874 and Manet showed a selection of them in the 1876 *Noir et blanc* exhibition at Galerie Durand-Ruel. Degas became interested in sharing his prints with a wider audience, too. He collaborated with colleagues to prepare a print publication, and when that project failed to launch he included "trials and [multiple] states" of his etchings in the fifth Impressionist exhibition, in 1880.[37] For Degas, etching and its related techniques, especially monotype, continued to provide a vital field of experimentation into the 1890s, but, like Manet, he was also keen to explore the era's plethora of ever-evolving print media such as *gillotage* and other transfer-relief techniques, including photomechanical processes.[38] In fact, what unites the two artists is precisely their omnivorous appetite for reproductive techniques developed in the 1870s and beyond. They were both painter-printmakers who embraced the industrial and commercial methods of reproduction as well.

Printmaking provided both artists with an invitation to revisit and revise. Beyond the small changes between states in the early works examined briefly here, the two artists explored the iterative nature of graphic techniques in profound ways. To cite just two examples: Manet made three interpretations after his *Berthe Morisot with a Bouquet of Violets*, one in etching and two in lithography (pls. 56–59); and Degas developed *Mary Cassatt at the Louvre: The Paintings Gallery* over twenty states (pl. 71). It was the open-endedness, the enticement to rethink and rework, offered by printmaking that ultimately appealed to both artists.

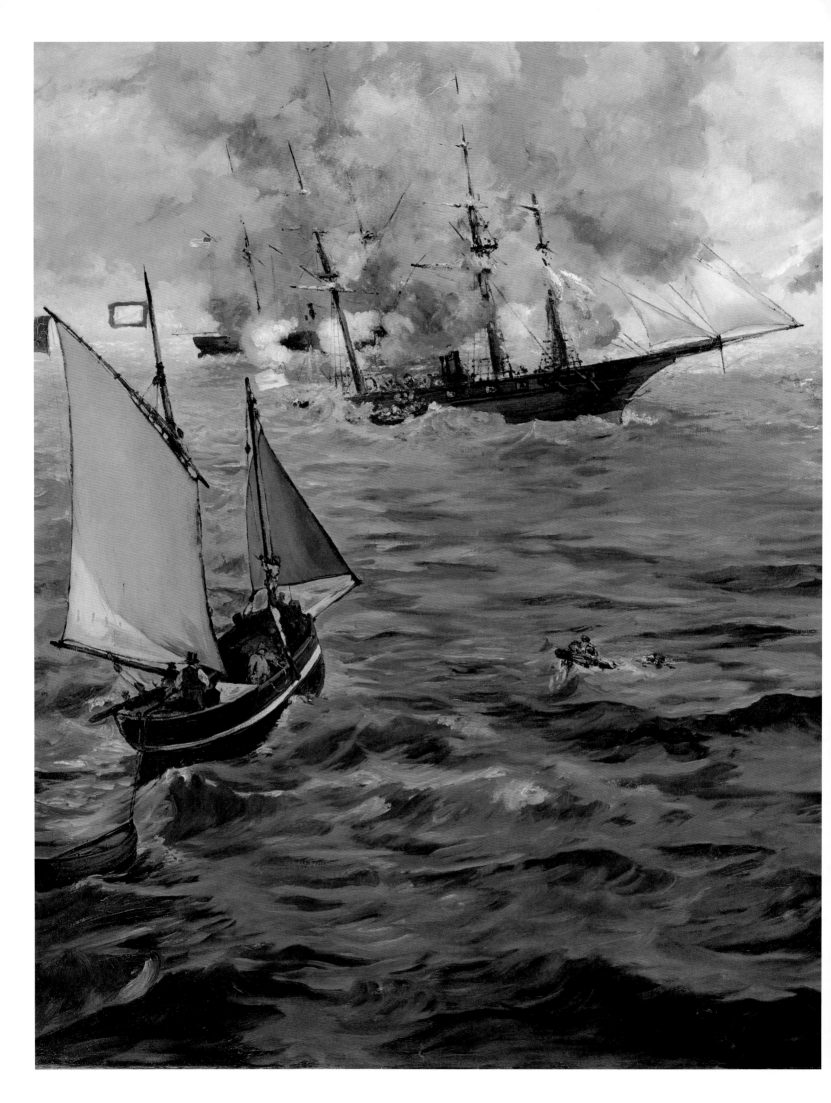

POLITICAL SENSIBILITIES: MANET AND DEGAS ON BOTH SIDES OF THE ATLANTIC

Isolde Pludermacher

The political convictions of both Manet and Degas, though inseparable from their personalities, occupy very different places within their respective artistic productions. Throughout his career, Manet, a committed republican, conceived and exhibited works linked to events that affected or incensed him as a citizen. With strong compositions based on press descriptions, firsthand testimony, and photographs, he sought to make a forceful impression on the public, the likely motive behind his decision to never abandon exhibiting at the Salon. In this way he profoundly revitalized the genre of history painting. Degas, whose opinions can be described as "conservative . . . in everything except his art,"[1] explored this genre early in his career, but he always left current events out of his public work, even when they directly affected his family. Thus, if "politics *à la Degas* were inevitably as high-minded, violent, and impossible as he was,"[2] he never acted "like a sectarian or a pamphleteer *through his work*."[3] In their complexity and intensity, the artists' divergent connections to politics shed light on their own relationship.

DISTINCT LEGACIES

The familial histories of both artists were marked by the French Revolution, a period in which their paternal grandfathers played very different roles. Whereas Clément Manet was "linked with the men of the Revolution" who could have managed to obtain for him a "high position,"[4] Hilaire Degas had to flee France in great haste during the Reign of Terror because he was a businessman who had "been a speculator in grain."[5] He settled in Naples, where he founded a bank in his name. Following a somewhat similar trajectory, Germain Musson, Degas's maternal grandfather, left his birthplace, the French colony of Saint-Domingue, which became the independent state of Haiti in 1804, after an insurrection by the enslaved population. Around 1810 he arrived in New Orleans, where he married a Creole woman, Marie Céleste Désirée Rillieux, and became a cotton exporter. Degas's family history was thus closely linked to revolutionary upheavals and probably helped to shape the artist's penchant for social order. While in contact with his Italian family, several of whose members were connected to the revolution of 1848,[6] Degas first manifested his interest in politics. He "often [had] strong but amicable disagreements"[7] about the subject with Gennaro Bellelli, his Neapolitan uncle, who had difficulty dealing with his imposed exile to Florence. Degas depicted him in his *Family Portrait (The Bellelli Family)* (pl. 49) with his back partly turned to the viewer, an odd posture perhaps meant to signify his status as an outcast.

Manet's political consciousness, in contrast, was formed in the crucible of events that he himself witnessed in Paris: the labor uprising known as the June Days in 1848[8] and the coup d'état of Louis-Napoléon Bonaparte on December 2, 1851.[9] Also, as a young apprentice in the Merchant Marine, during a stopover in Rio de Janeiro, he encountered the violence of a society built on slavery: "In this country all the negroes are slaves; they all look downtrodden; it's extraordinary what power the whites have over them; I saw a slave market, quite a revolting spectacle for us."[10] The "us" here encompasses his own family, the intended recipients of his words, who were seemingly already committed to the republican cause.[11] These sympathies might well explain Manet's choice to study in the atelier of Thomas Couture,

who was well-known for his grand republican allegories. Nonetheless, such subjects seem to have held little appeal for the young artist, who during his apprenticeship considered "history painter" to be the "harshest" insult one might pronounce.[12] From the start of his career, however, he tackled the *grand genre*, whether in religious scenes, which reveal a sensibility close to that of the scholar Ernest Renan, or in subjects connected to current events that particularly interested him. In this respect he clearly differed from Degas, who at this same moment was working on historical compositions whose subjects were as temporally distant as they were obscure.

THE AMERICAS

Incontestably, one of the most significant historical events unfolding when Manet and Degas first came into contact was the American Civil War (1861–65). The French press followed the hostilities closely, for political reasons as well as economic ones.[13] The so-called cotton famine, occasioned by an embargo on cotton exports from the South, caused a serious crisis in the European textile industry, prompting artists to express their support for the laborers who lost their jobs. The Société des Aquafortistes, established in September 1862 by Alfred Cadart and whose earliest members included Manet, organized a sale to benefit unemployed textile workers in March and April 1863.[14]

A year later, in July 1864, Cadart displayed in the window of his shop a large-scale canvas by Manet whose spectacular composition was directly inspired by an episode in the Civil War that took place on June 19, 1864, off the coast of Normandy: *The Battle of the USS "Kearsarge" and the CSS "Alabama"* (pl. 138). Widely anticipated and subsequently described in the French press, the battle unfolded before a large audience of curious onlookers.[15] Manet was not a direct witness, but he consulted illustrated articles to render as accurately as possible the victory of the Union ship, the *Kearsarge*, over the Confederate *Alabama*, which he represented sinking amid a cloud of smoke so thick as to largely obscure the victorious vessel. In the foreground, a French pilot boat heads to the rescue of some of the crew, while in the background an English steamer approaches to transport others to England. After completing his picture, Manet visited the *Kearsarge* at anchor in Boulogne and noted with satisfaction that he had "surmised [it] rather well." He had also sought to capture its "appearance at sea,"[16] drawing on his experience as a young sailor. In this first painting by him inspired by a contemporary event, Manet rendered living history by combining verbal accounts and press images with his personal maritime experience. Only one month after the actual events, he publicly celebrated the victory of the Northerners, whose antislavery stance he shared.

It seems unlikely that these convictions were shared by Degas, whose maternal family lived off the cotton industry in Louisiana and thus profited from slavery. His mother's dowry came in part from the sale of an enslaved person,[17] and Michel Musson, his uncle, enslaved seven people prior to the Civil War.[18] When New Orleans was about to fall into Union hands, Eugène Musson, Degas's uncle, tried to convince France to support the Confederate cause by publishing, in 1862, a long open letter to Napoleon III in which he proclaimed: "That in imposing work upon the black race, which has hitherto remained in total idleness, the white

Fig. 12 Goya (Francisco de Goya y Lucientes) (Spanish, 1746–1828), "One Can't Look," plate 26 from *The Disasters of War*, 1810 (published 1863). Etching, burnished lavis, drypoint, and burin, plate 5 11/16 × 8 1/4 in. (14.5 × 21 cm), sheet 9 15/16 × 13 1/2 in. (25.2 × 34.3 cm). The Metropolitan Museum of Art, New York, Purchase, Jacob H. Schiff Bequest, 1922 (22.60.25[26])

race only accomplishes its right and duty," further evoking "the moral and intellectual superiority of our planters to whom God has more especially confided the education of the infant peoples of Africa."[19] Moreover, the Degas family was related to Jefferson Davis, president of the Confederacy, through the marriage of Davis's nephew, Joseph Davis Balfour, to Estelle Musson, the artist's cousin. As a young infantry lieutenant, Balfour was killed in the battle of Corinth in October 1863, and the following year Estelle, the mother of a young baby at the time, took refuge in France, accompanied by her mother and one of her sisters. Degas visited them in Bourg-en-Bresse and seems to have been quite touched by his cousin's situation: "Poor little woman, one cannot look at her without thinking that this head has fluttered before the eyes of a dying man."[20] Stories told by his family may lie behind the mysterious *Scene of War in the Middle Ages* (pl. 83), which the artist exhibited at the Salon of 1865. Hélène Adhémar has suggested that this work might be an oblique depiction of cruel acts endured by the women of Confederate families during the war.[21] As in Francisco Goya's *Disasters of War* (fig. 12), of which Degas owned the 1863 edition,[22] the violence is shown in all its senselessness. Neither the vague title of Degas's painting nor its desolate landscape, in which a town burns in the distance, offers any explanation of this massacre, perpetrated by men on horseback against women whose clothing has been torn away.

While Degas went all but unnoticed at the 1865 Salon, Manet obtained a resounding *succès de scandale* with *Olympia* (pl. 81), a painting whose Black servant is perhaps a signifier of the Civil War.[23] The victory of the Union on April 9, 1865, and the abolition of slavery

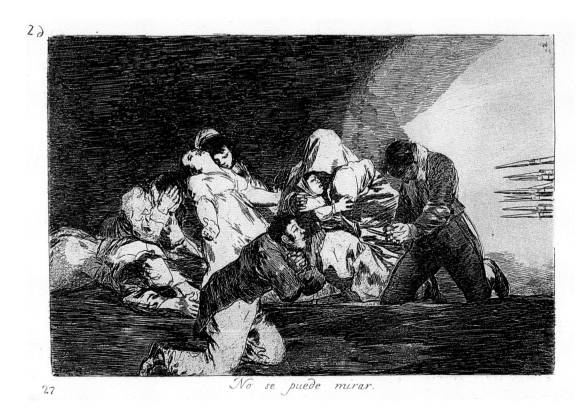

No se puede mirar.

on December 6 were not without political consequences for Napoleon III, whose position, while officially neutral during the conflict, was subsequently revealed to be more ambiguous due to France's economic ties to the South. Hoping to establish an imperial foothold on the American continent that would serve as a counterweight to the United States, Napoleon III had unleashed a military operation in Mexico in 1861, on the pretext of compelling the government in place to repay its European debts, and then promoted the reestablishment of a Mexican empire and the installation on its throne, in April 1864, of Archduke Maximilian, brother of the emperor of Austria. However, the French troops soon incurred heavy losses from rebellious Mexican republican forces led by Benito Juárez and backed by the United States. In February 1867 Napoleon III decided to recall his army, thereby depriving Emperor Maximilian of French military support. Refusing to abdicate, the latter was soon surrounded by Juárez's army in the town of Querétaro, where he had taken refuge with a small cohort of loyal troops. Brought before a military tribunal, Maximilian and two of his generals, Tomás Mejía and Miguel Miramón, were condemned to death and, despite European pleas on their behalf, were executed on June 19, 1867. It took two weeks for the news to reach France, where the Exposition Universelle was in full swing. The tragic outcome caused considerable indignation toward Napoleon III, who was held largely responsible for it, prompting several European leaders to depart Paris at the height of the festivities.

Struck by this drama, Manet immediately took up the subject, which inspired the most ambitious of all his artistic projects linked to contemporary events, *The Execution of Maximilian* (pls. 142–44, 160). He threw himself into a large composition intended for the Salon of 1868, working on it for several months and realizing four paintings in succession, three of them monumental, as well as a lithograph to ensure its dissemination to the public.[24] Anxious to render the event accurately, he guided his project through several versions, adapting it in accordance with details provided by accounts that steadily appeared in the press and by photographic documents available to him. The final version, which bears his signature and the date of Maximilian's execution (fig. 13), combines expressive force with concern for objectivity. Its composition, which recalls Goya's *The Third of May* of 1814 (Museo Nacional del Prado), underscores the dignity of the emperor and his generals, whose hands he grasps, in the face of their executioners. Maximilian is presented as a modern martyr with an almost Christ-like aura: wearing a Mexican hat like a halo, mysteriously resistant to the force of the bullets shot at point-blank range, his face and those of his companions in misfortune encircled by a cloud of smoke released by the rifle barrels. The squad seems to consist of the same repeated, faceless soldier gesturing mechanically. At right the sergeant calmly loads his own rifle, ready to deliver the *coup de grâce*. With his mustache and beard, he resembles Napoleon III, a tactic previously adopted by Gustave Courbet for the figure of the *braconnier* (poacher) who is also holding a rifle in *The Artist's Studio* of 1855 (Musée d'Orsay).[25] The currency and violence of Manet's subject combined with the effect of proximity achieved through the picture's dimensions and framing forcefully denounce the emperor of the French as the guilty party responsible for the tragic event. This message is underscored by the fact that the soldier-executioners wear uniforms that resemble those of the French army, consistent with a description of the event reported in the French press.[26] Although the painter

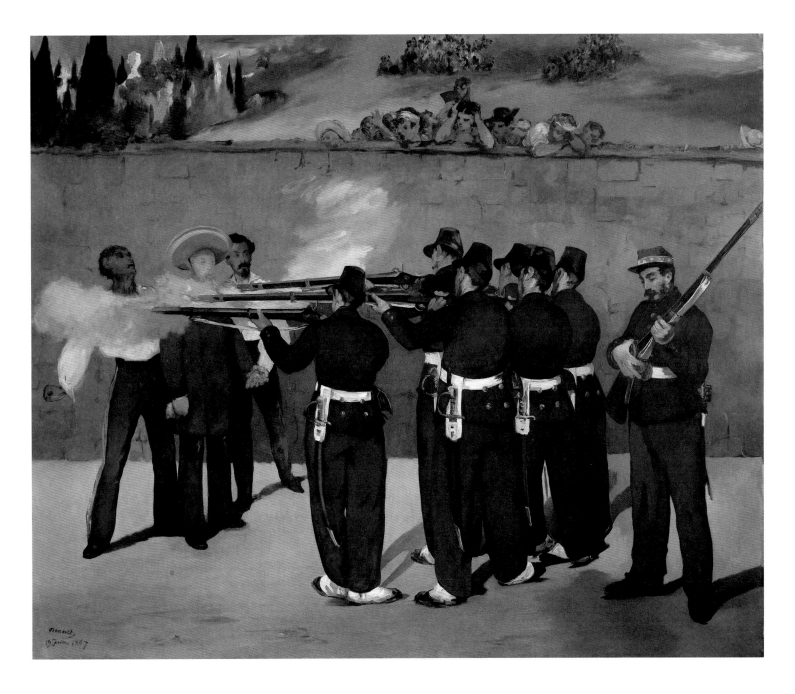

Fig. 13 Édouard Manet, *The Execution of Maximilian*, 1868–69. Oil on canvas, 99 ¼ in. × 9 ft. 10 ⅞ in. (252 × 302 cm). Städtische Kunsthalle, Mannheim

affirmed publicly that he had treated his subject "from a purely artistic point of view," the work prompted feelings of "horror and anger" in the censors. Manet was informed that his canvas would be refused by the Salon of 1869, while his lithograph was banned and the stone threatened with destruction.[27] Émile Zola observed in *La Tribune*: "On examining a proof of the condemned lithograph, I noticed that the soldiers shooting Maximilian were wearing a uniform almost identical to that of our own troops. . . . [A]n artist dared . . . to put before their eyes such a cruel irony: France shooting Maximilian!"[28]

In addition to its denunciation of Napoleon III's political opportunism, of which Maximilian was a sacrificial victim, Manet's painting lends itself to other, equally subversive readings. Its subject is, in effect, the fragility of the power of an emperor overthrown by republican forces. The resistance of Juárez to European attempts at domination was hailed by Victor Hugo, who published, from his place of exile in Guernsey, an open letter to the

Mexican president in which he asked him to spare Maximilian "by the grace of the Republic," after having declared: "The America of today has two heroes. . . . John Brown, through whom slavery died. You, through whom freedom has lived."[29] Juárez was not only a victorious republican but also, as a Zapotec, the first Indigenous head of state in the Americas. The issue of race was apparently not lost on Manet, who emphasized the contrast between the very pale skin of Maximilian and the brown skin tones of the face of General Mejía, who was of Indigenous origin, like the spectators straining to watch the execution from beyond the wall. None of the versions of Manet's *Execution of Maximilian* would be exhibited during the artist's lifetime, no doubt because they were deemed too radical.[30] Remaining in his studio, they were seen only by a few close friends, perhaps including Degas, who acquired fragments of the second version after Manet's death.[31]

THE WAR OF 1870 AND THE COMMUNE

It was a France weakened by the Mexican campaign that entered war with Prussia in July 1870. Drafted into the National Guard, Manet and Degas remained in Paris to defend the city, thereby distinguishing themselves from several artists who preferred to flee the country. Both men endured the long weeks of siege marked by waiting, cold, and privation. Manet wrote movingly about the experience in many letters to his wife,[32] in which he revealed himself to be "a mixture of patriot, witness, soldier, political man, and painter."[33] These letters, like those of the Morisot family, who remained in Passy, testify to the close relationship at the time between Manet and Degas. Both sincere patriots,[34] they shared a deep respect for the army and the military uniform.[35] They attended public meetings together, such as the one held by General Gustave Cluseret at the Folies-Bergère, where the views of "true republicans"[36] were expressed. They later joined the artillery as volunteer gunners. This gave them firsthand experience of the realities of combat, which were revealed to them with even greater brutality by the death of some of their friends, including the sculptor Joseph Cuvelier and the painters Frédéric Bazille and Henri Regnault.[37] Both of them were greatly tested; according to Mme Morisot, they had heated arguments "over the methods of defence and the use of the National Guard, although each of them was ready to die to save the country."[38] Having left Paris after the armistice on January 26, 1871, they did not witness the events of the Commune (March 18–May 28, 1871)—Suzanne Manet wrote at the time about having taken "all the pains in the world" to restrain her husband, who was "quite annoyed about being so far away at such a time"[39]—but once back in the capital they both inveighed, with a virulence worthy of "two Communards," against the "drastic measures used to repress them" mobilized by the Versailles forces.[40]

This period, lived intensely by both artists, did not leave either of them unscathed. Manet emerged from it quite stricken, thinner, unable to paint for a time. Greatly affected by the death in combat of several of his friends, Degas also suffered the first signs of his vision problems. He later claimed that his eyes had been "injured by the severe cold during the nights spent keeping watch during the siege of Paris."[41] Nonetheless, this experience left hardly any immediate traces in either of their productions. In the case of Degas, only a few caricatures of

Fig. 14 Edgar Degas, *Caricatures of Napoleon III and Otto von Bismarck*, from Notebook no. 21, 1868–72. Sheet 4 ³⁄₁₆ × 2 ⁹⁄₁₆ in. (10.6 × 6.5 cm). Bibliothèque Nationale de France, Département des Estampes et de la Photographie, Paris

Napoleon III, Otto von Bismarck, and Adolphe Thiers in his notebooks and a sheet of portrait drawings of Napoleon III and some of his marshals bear witness to current events (fig. 14).[42] As for Manet, despite his desire to "do some studies after nature,"[43] he undertook no significant work during the time he served in the National Guard. It was only after the fact that he executed a series of prints evoking the period of the Siege of Paris and the Commune. *Line in front of the Butcher Shop* (pl. 146) is an almost abstract etching, manifesting the influence of Japanese prints, in which only the title and the tip of a bayonet rising above a mass of umbrellas indicate the context of the scene, one that had already entered the "collective memory."[44] On several occasions, Manet described in his letters the paucity of meat in Paris, where the inhabitants "delighted in horse" while donkey was "beyond price," and which saw the establishment of "butcher shops of dogs, of cats and rats."[45] The two other episodes that he depicted, with dramatic intensity, are actual scenes of civil war with barricades visible in the background: one shows the execution of three communards, the other a dead soldier lying on the ground. Each of these lithographs derived from an earlier composition. *The Barricade* (pl. 144) was preceded by a large wash drawing (pl. 143), perhaps a study for a projected painting that was never realized; outline drawings of the execution of Maximilian and his generals traced from the banned lithograph figure on the verso.[46] This reversed composition served as the basis for the group of communards whose bodies are obscured by rifle smoke, as in *The Execution of Maximilian*. The lifeless soldier in the lithograph *Civil War* (pl. 145) is reminiscent of *The Dead Toreador* (pl. 85), itself a fragment, subsequently reworked, of a larger composition, a process that eliminated its anecdotal elements and underscored its universal import. In this print, Manet replaced the neutral background of the

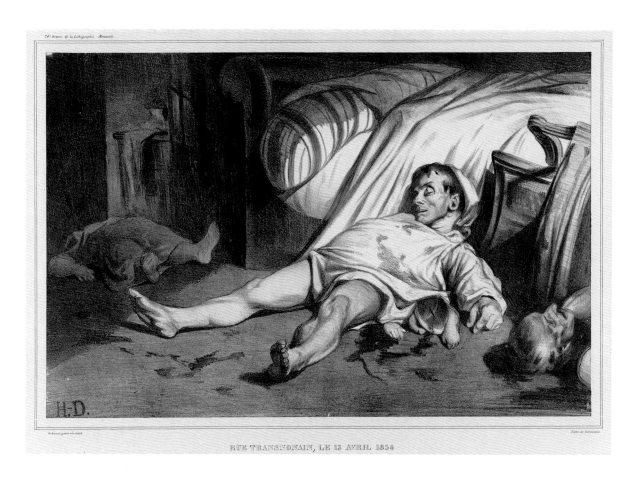

RUE TRANSNONAIN, LE 15 AVRIL 1834

painting with an urban landscape suggestive of a barricade-ridden Paris. The dead soldier is accompanied by parts of other recumbent figures cropped by the framing, a compositional device much like the one used by Honoré Daumier in his lithograph *Rue Transnonain, April 15, 1834* (fig. 15), which also memorializes bloody reprisals against a popular uprising in Paris. These decisions to rework earlier compositions are less signs that Manet had imagined, rather than witnessed, similar scenes than they are indications of his desire to influence public opinion with strong and effective images.[47]

DEGAS IN NEW ORLEANS

Under the leadership of Thiers, whom Manet despised,[48] the beginnings of the Third Republic were a difficult and uncertain time. The Salon again opened its doors in May 1872; while Degas henceforth refused to take part in it, Manet sent the canvas that he had exhibited in Cadart's shop window eight years earlier, *The Battle of the USS "Kearsarge" and the CSS "Alabama."* This episode from the Civil War accrued a new meaning in France after the Commune, even as it evoked wounds that remained painful in the United States, as Degas would soon witness directly. In October 1872 he embarked on his first visit to his mother's country, which he considered to be "a bit his own."[49] He was accompanied by his brother René, who had resided in New Orleans since 1866 but had just visited him in Paris, where together they had gone "to revisit the memorable sites of the Siege."[50]

Fig. 15 Honoré Daumier (French, 1808–1879), *Rue Transnonain, April 15, 1834*, Plate 24 from *L'Association Mensuelle*, July 1834. Lithograph, image 11 ¼ × 17 ⅜ in. (28.6 × 44.1 cm), sheet 14 ⁵⁄₁₆ × 21 ¹¹⁄₁₆ in. (36.4 × 55.1 cm). The Metropolitan Museum of Art, New York, Rogers Fund, 1920 (20.23)

Degas spent four months in New Orleans, where he produced, at their request, portraits of his family members.[51] In his correspondence, he mentions Manet several times and notably confided to Henri Rouart: "Manet would see here more beautiful things than I," among them "the beautiful and thin negresses, dressed in their cotton clothes, opening their green shutters, and the old ones with their large madras tignons going to the market,"[52] descriptions that resonate with works by the elder artist: for example, *Olympia* (pl. 81), *The Balcony* (pl. 98), and *La négresse* (*Portrait of Laure*) of 1862–63 (Pinacoteca Giovanni e Marella Agnelli, Turin). Racial observations are frequent in Degas's letters, where he mentions in turn "a good negro" polishing his boots while he slept and the "negresses in all their varying shades" who looked after his nephews and nieces, insistently emphasizing on several occasions physical contact and the juxtaposition of skin colors.[53] His experience in Louisiana apparently prompted him to examine his own Creole origins and generated a form of anxiety no doubt exacerbated by the post–Civil War context.[54] His way of distinguishing between "beautiful women of pure blood," "stunning quadroons," and "negresses so well grown"[55] in his letters reveals the well-established though fluid categories integral to the society in which he moved there and within which he struggled to define himself, declaring: "Louisiana must be respected by all her children, and I am more or less one of them."[56] This uneasiness may explain the absence of Black people in his New Orleans paintings. Mixing aesthetic considerations with his own perceptions, he wrote: "As for the black community, I don't have enough time to tackle the subject. These ebony forests are rich in colors and in sketching ideas. It will be odd to go back to Paris and live solely among the whites. Besides, I love silhouettes so much, and these are walking silhouettes!"[57] It is in the form of a discreet "silhouette," significantly situated outside a domestic threshold, that a Black nursemaid whose face is largely illegible constitutes the only evidence of a Black presence in Degas's work from New Orleans (pl. 117). The circuitous argument he formulated to justify this absence is a rejection of the picturesque in favor of the depiction of a familiar universe: "One must not nonchalantly make art of Paris or Louisiana, or else that would turn into the *Monde Illustré*. And then really only one very long stay would give you the habits of a race."[58] The reassuring image that he subsequently evokes to describe this world is that of a "fine linen laundress [*blanchisseuse*], with bare arms,"[59] significantly establishing whiteness—of the arms, of the linens—as a refuge.

As Degas discovered, it was always a question of whiteness in New Orleans, given the ubiquity of cotton: "You have to either be born here or be in the omnipresent business of cotton, otherwise you're in trouble."[60] He took delight in the apparent success and esteem enjoyed by his brothers Achille and René, associates in the De Gas Brothers firm, whose letter-head stationery he enjoyed using for his correspondence.[61] He shared in their entrepreneurial spirit by conceiving "a rather hard painting" that he thought might be sold to "a wealthy cotton spinner in Manchester" because of its subject: "Inside a cotton buyers' office in New Orleans" (pl. 141).[62] The painting includes portraits of several members of the Degas family. Michel Musson, the artist's uncle, whose office is represented,[63] is seated in the foreground, his back turned to the rest of the scene. While he assesses the quality of some cotton with his hands, the artist's two brothers have only a distant relationship to the "precious material," René being absorbed in his newspaper and Achille idly leaning against an interior window. *Cotton*

Merchants in New Orleans (pl. 140) is a painting "less complicated and more unexpected . . . in which there are people in summer suits, white walls, sea of cotton on tables."[64] The colorful marine painting partially visible on the wall at right evokes the transatlantic commerce of the cotton trade and also, probably coincidentally, Manet's *The "Kearsarge" at Boulogne* (pl. 139). Upon his arrival in Louisiana, before embarking on these ambitious, marketable works, Degas had been struck by "the contrast of the active and positively arranged offices with this immense black animal force."[65] These comments reveal not only his full awareness of the mode of production that grounded the profitable family enterprise but also his anxious and distanced way of understanding the Black population that was all around him but which he did not depict.[66] We must remember that the financial interests of the artist's family were based on the economy of slavery in the Southern states. During the Civil War, Degas's uncle, father, and brother René had acquired significant quantities of Confederate bonds that turned out to be poor investments, causing substantial debts that led to first the liquidation (1874) and then the bankruptcy (1876) of the De Gas bank in Paris. Although it represents a world on the brink of collapse, *A Cotton Office in New Orleans* offers no indications of the family tragedy to come.[67]

No doubt the political views of his relatives contributed to another blindness to which Degas fell victim during his stay in New Orleans: shortly after his departure, members of his family, including Michel Musson, joined the White League, a paramilitary supremacist organization opposed to Reconstruction.[68] Although his painting did not find a buyer in England, as Degas had hoped, it was shown as *Portraits in an Office (New Orleans)* at the second Impressionist exhibition, organized at Galerie Durand-Ruel in 1876; Zola compared it to a "reproductive engraving in an illustrated newspaper,"[69] a pitfall that Degas specifically sought to avoid. The artist nonetheless had the satisfaction of seeing his canvas purchased two years later by the museum in Pau, which thereby became the first French institution to acquire one of his works.

MANET AND THE REPUBLICAN BIAS

While Degas invested considerable energy in organizing the Impressionist exhibitions, Manet continued to favor official channels for exhibiting his works, whether through submissions to the Salon or his 1879 proposal to decorate the meeting hall in the Hôtel de Ville, a scheme that was rejected. In January of the same year, President Patrice de MacMahon, who had ordered the bloody suppression of the communards, and whom Manet had caricatured in his lithograph *Polichinelle* (pl. 150),[70] submitted his resignation. With Léon Gambetta, whose family was on friendly terms with Manet,[71] heading the Chamber of Deputies, a new era of the Third Republic commenced, one marked by the establishment of powerful symbols that reclaimed the legacy of the French Revolution: the selection of the "Marseillaise" as the national anthem and July 14 as the national holiday. When the communards were granted amnesty on July 11, 1880, Manet celebrated the initiative in a note to his friend Isabelle Lemonnier that he decorated with two crossed tricolor flags (fig. 16). In tune with the radical republican government, Manet undertook several works that bear witness to his political sympathies.

He completed two portraits of Deputy Georges Clemenceau,[72] depicting him with assertively crossed arms and a determined gaze (Musée d'Orsay, Paris, and Kimbell Art Museum, Fort Worth), and another portrait, in a similar pose, of the extreme-left polemicist Henri Rochefort, exhibited at the Salon of 1881 (Kunsthalle, Hamburg). A virulent opponent of the regime of Napoleon III, which he denounced in the satirical newspaper *La Lanterne*, Rochefort had been deported to a penal colony in New Caledonia after the Commune.[73] Having escaped in 1874, he returned to Paris after the amnesty and resumed his activity as a republican, radical, and patriotic essayist in the newspaper *L'Intransigeant*. The heavily romanticized account of his escape (*L'évadé, roman canaque* [The man who escaped, a Kanak novel]) inspired Manet to paint a "sensationalist" canvas, *The Escape of Rochefort* (pl. 147), intended for the Salon.[74] As he had done some fifteen years earlier with his *"Kearsarge,"* the artist devised a composition dramatized by the infinite horizon of a phosphorescent sea, the setting for the escape of the fragile craft delivering Rochefort and his companions to an Australian schooner just visible in the distance. The moonlight, the water extending as far as the eye can see, the isolation and vulnerability of the escapees—all give the event a romantic allure that was far from reality.[75] At the Salon of 1881, Manet was awarded a second-class medal, soon followed by conferral of the Légion d'Honneur, which was presented to him by his friend and future biographer Antonin Proust, who had become minister of fine arts in Gambetta's cabinet. These official honors, disdained and ridiculed by Degas, were valued by Manet as endorsements by a government whose values he shared, and as definitive confirmation of the connection between his art and his republican convictions.[76]

Although the political dimension of Manet's work had no equivalent in Degas's production, it nonetheless fascinated the latter, who eloquently compared his elder's celebrity to that of Garibaldi.[77] His collection testifies to this; at Manet's estate sale, Degas acquired, through his intermediary Paul Durand-Ruel, an impression of *Civil War*, then, several years later, more of Manet's lithographs with political subject matter: *Maximilian*, *The Barricade*, and *Polichinelle*. In a troubling historical concurrence, while the political scandal of the Dreyfus affair was spurring Degas to embrace fiercely reactionary, nationalist, and anti-Semitic positions, stances that prompted him to sever relations with his oldest friend, Ludovic Halévy, he continued his unsparing efforts to reunite the dispersed remnants of the second version of *The Execution of Maximilian*.[78] Indignant over the mutilation of a painting that he especially admired, he managed to reassemble four fragments on a single canvas, his final and patiently realized homage to a friend who had died too young.

Fig. 16 Édouard Manet, *Letter to Isabelle Lemonnier decorated with two French flags*, July 14, 1880. Watercolor, 7 1/8 × 4 3/8 in. (18 × 11.2 cm). Musée du Louvre, Paris, Département des Arts Graphiques (RF 11183 recto)

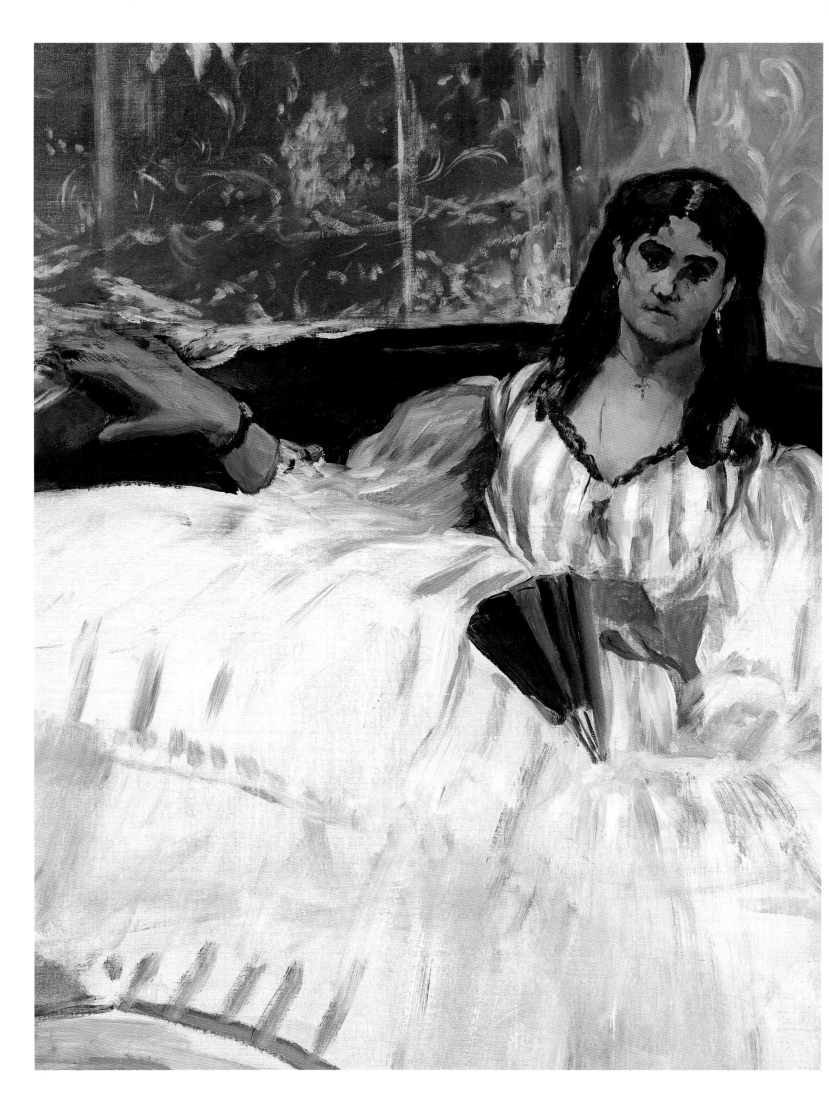

MANET, DEGAS, AND THE DEMIMONDE OF ALEXANDRE DUMAS FILS

Denise Murrell

The novelist and playwright Alexandre Dumas fils coined the term *demimonde*, or half-world, to describe a liminal space that existed at the intersection of respectability and disrepute within the social and artistic milieu of late nineteenth-century Paris. His literary portrayals of the demimonde inscribed the glamorous, opulent, and often turbulent lifestyle of its invariably female protagonists into the art, music, and literature that became emblematic of modern life during the period. In their depictions of women of color, Édouard Manet and Edgar Degas not only manifested the racial anxiety of Parisian bourgeois society but also visualized the duality and ambiguity implicit in Dumas's characterization of the demimonde. The difference in the artists' approaches to these portrayals is a result of their distinct political and cultural perspectives.

The demimonde was a world that Dumas fils knew intimately. As the illegitimate son of one of the era's most famous novelists, Alexandre Dumas père, who wrote *The Three Musketeers* and *The Count of Monte Cristo*, Dumas fils inherited a mixed-race paternal ancestry that traced back three generations to a French aristocrat and an enslaved Haitian woman.[1] The younger Dumas moved freely in elite social circles sustained by the financial security from his aristocratic paternal lineage and his own highly successful career. But his racial heritage was well-known and openly commented on by his peers, and he was frequently depicted in caricatures published in the popular press that intensified the Blackness of his features well beyond observed reality (fig. 17). He was subjected throughout his life to societal censure.

Fig. 17 André Gill (French, 1840–1885), *Alexandre Dumas fils*, from *Vingt portraits contemporains* (Paris: M. Magnieret, 1886)

Dumas's close friend George Sand, having been born to an aristocratic father and a working-class mother, shared his profound sense of outsider status based on the duality of her social position. She wrote that her family circumstances had "sometimes caused [her] to reflect on the racial question,"[2] echoing the painful memories of the young Dumas, whom fellow aristocrat Horace de Viel-Castel derisively described as "this Black man poorly white-washed by three generations of an adulterous lineage, this great grandson of a marquis de la Pailleterie and a Black woman from Saint-Domingue [modern-day Haiti]."[3] Claude Schopp suggests that Dumas, in *Affaire Clémenceau* (1866), "evokes, beneath the mask of fiction, the hell of his middle school student years, during which some reproached him 'for not having a father because he had perhaps two' which made the child 'suspicious, restless, prone to hatred.'"[4] In a letter to Sand, Dumas used a commonplace racial slur to describe himself as "'working like a Black man [slave],' from whom I am descended in my paternal line."[5]

Dumas's articulation of the demimondaine was embodied by the female characters in his widely acclaimed novel *La dame aux camélias* (1848) and its successful adaptation for the stage (1852), which was inspired by his affair with the courtesan Marie Duplessis. Giuseppe Verdi composed his 1853 opera *La traviata* (The Fallen Woman) with a libretto by Francesco Maria Piave based on Dumas's play. Scholars have asserted that the female figure in Manet's *Olympia* (pl. 81) was named for Olympe, a rival of the play's tragic protagonist, Marguerite Gautier.[6]

Olympe was positioned opposite Marguerite, who makes a failed attempt to leave behind her life as a courtesan and gain the respectability of a love-based relationship. Manet's visualization of Olympia places the glamorous but unsentimental courtesan, as represented by Olympe, in a clearly delineated binary with the woman who attains social acceptance through marriage to a prominent man.

Dumas posited, however, that this binary oversimplifies the fluidity of the boundaries between disrepute and respectability. He explored this liminality in the character of Marguerite, asserting that both conditions can be present in the life of an individual woman, whose social status vacillates as circumstances change. He explicitly articulated his views in an 1868 preface to his aptly titled play *Le demi monde* (1855), in which he addressed how the meaning of *demimonde* had changed in the intervening decade:

> The designation "Demi-Monde" should be given a meaning different from the one that it now has, and this neologism that I was proud to introduce into the French language, so hospitable in the nineteenth century, serves to designate, due to error or carelessness on the part of those who employ it, the class of women from which I wanted to distinguish them, or at least conflates into a single category two different ones that are quite distinct and even hostile to one another.
>
> Let us establish here, then, for the dictionaries to come, that "Demi-Monde" does not represent, as is thought, as is printed, the throng of courtesans but rather the class of déclassé women. Not just anyone can belong to the Demi-Monde. You must pay your dues before gaining admittance. As Madame d'Ange says in the second act [of the play]: "This world is a degradation for those who came from above, but it is a pinnacle for those who came from below."[7]

In late 1862 Manet prepared a watercolor study for a planned portrait of Jeanne Duval (fig. 18), a young actress who was the longtime companion of the artist's friend Charles Baudelaire and had occasionally visited Manet's studio.[8] The study captures aspects of Duval's presence as described by a Baudelaire biographer: "She was a young woman of color, very tall, who carried well her brown head . . . ingenuous and superb, crowned by a mass of extremely frizzy black hair, and whose queenly gait, full of a fierce grace, had something about it that was divine and bestial."[9]

Duval is rendered semi-reclining on a deep green sofa, one leg stiffly extended before her as her right hand grips the curved sofa back. Her slender torso is almost completely submerged beneath the billowing crinolines of her fashionable day dress. With this pose and attire, the artist ostensibly situated Duval within the well-established lineage of portrayals of the socially respectable bourgeois women of late nineteenth-century Paris. Yet, by bestowing his sitter with the light brown skin tones that betray Duval's biracial heritage, he simultaneously denoted the liminality, and ultimate impossibility, of this placement. As a woman of color, a professional actress, and Baudelaire's mistress, Duval was in reality immutably positioned within a coexisting milieu that overlapped with some aspects of the social establishment but existed primarily outside it.

Fig. 18 Édouard Manet, *Study for the Portrait of Jeanne Duval*, ca. 1862. Watercolor, 6 ⅝ × 9 ⅜ in. (16.7 × 23.8 cm). Kunsthalle Bremen

Manet's *Study for the Portrait of Jeanne Duval* conveys a direct visualization of the duality inherent in Dumas's intended meaning of *demimonde*. Though a demimondaine, Duval was not a courtesan. She was an actress who had earned a modest living before becoming Baudelaire's muse and confidante, and their long-term emotional and intellectual engagement was based on shared artistic and social pursuits.[10] During one of her frequent breakups with Baudelaire, he wrote to a friend that whenever he saw a fine-art object, he wanted Duval to be there to admire it with him.[11] She was therefore a figure who, according to Dumas, could blend "into a single category two different ones that are quite distinct and even hostile to one another."[12] This portrayal stood in stark contrast to that of the courtesan, who, as in Manet's *Olympia* of the following year, represented a fixity seen only in a secondary character, Dumas's Olympe, and whose identification with the term *demimonde* was based on a connotation that had evolved away from Dumas's originally intended meaning.

The intentionality with which Manet captured Dumas's concept of the demimondaine in the Duval portrait is hard to ascertain. Dumas and Manet moved in the same social circles and periodically spent significant time together. That Manet made no known images of Dumas is not unusual, considering that several other notable friends, including Degas, never sat for him.

More remarkable is that there is no known direct correspondence between them. Still, the circumstances of their documented encounters spanning several decades suggest that Manet and Dumas had opportunities to speak with each other at length, and that Manet was well aware of Dumas's literary characterizations prior to 1862, when he made Duval's portrait.

Antonin Proust, who was among Manet's well-known sitters (pl. 69), recounted one of the earliest gatherings that included the artist and Dumas: "We took a long walk along the Normandy coast with Alexandre Dumas fils. Dumas was relaxing, or so it seemed, in the aftermath of the success of *La dame aux camélias*."[13] Proust was a childhood friend of Manet's; they visited the Louvre together and had been students in the atelier of the painter Thomas Couture, who was also present for this seaside excursion. While this anecdote implies a close friendship among the four men, as well as an opportunity to discuss *Camélias* directly with Dumas, there is no other known mention of this trip that might shed light on Manet's intentions with the Duval portrait or, for that matter, *Olympia*.

There is also no record of Manet himself having referred to the title of his painting as *Olympia*, and it is generally assumed that the artist Zacharie Astruc, who was friends with both Dumas and Manet, came up with it, inspired by the name of the protagonist's rival in Dumas's *Camélias*, which Astruc used in an excerpted poem published with *Olympia*'s Salon catalogue listing.[14] Manet's 1866 portrait of Astruc (fig. 19), made three years after the painting, appears to reference certain interior details, including the turned-away stance of the maids, of Titian's *Venus of Urbino* (1538), a major precedent for *Olympia*. Manet and Dumas made at least one joint visit to Astruc's studio.[15]

Given Dumas's omnipresence within the elite circles of Parisian salons, it is striking that there is so little evidence of direct personal contact between him and his peers. He often gave readings at literary salons, where his attendance combined social and professional commitments, as depicted by Henri Adolphe Laissement and Émile-Antoine Bayard (figs. 20, 21). Recalling accounts of Dumas's childhood, during which he was tormented or simply ignored and relegated to loneliness and despair, it is worth considering the extent to which race- and class-based censure existed even for the affluent and successful Dumas, who circulated at the apex of Parisian society. Alexandre Dumas père was also racially caricatured in popular periodicals, and he described episodes of racism that he encountered in social settings.[16]

Manet's revision from the study to his final 1862 painting, *Woman with a Fan (Jeanne Duval)* (pl. 91), can be considered in this context of class and racial anxiety. Like Dumas, Duval was of mixed-race heritage, the illegitimate offspring of an interracial liaison. Manet modified his representation of Duval in the final painting, perhaps in reaction to the censorious response to Duval as a woman of color and her involvement in an interracial relationship with Baudelaire.

One significant revision from the watercolor study, which clearly renders Duval as a woman of color, to the final portrait is the lightening of her skin tone, making the physiognomy of her racial heritage all but indiscernible. This effacement followed a pattern of erasure that had developed in the previous decade. Manet was an admirer of Gustave Courbet, who was said to have completely painted Duval out of a position hovering over Baudelaire in *The Artist's Studio*, his monumental 1855 group portrait.[17] Baudelaire's now-classic poetry volume, *Les fleurs du mal*, had been banned by a French court within two months of its 1857

Fig. 20 Henri Adolphe Laissement (French, ca. 1854–1921), *A Reading to the Committee in 1886*, 1886. Oil on canvas, 37¾ × 55⅞ in. (96 × 142 cm). Comédie-Française, Paris

Fig. 21 Émile-Antoine Bayard (French, 1837–1891), *Alexandre Dumas fils Reading One of His Plays in a Salon*, n.d. Ink, gouache, and graphite, 5 5/16 × 9 5/8 in. (13.5 × 24.5 cm). Musée Alexandre Dumas, Villers-Cotterêts (91.2.13)

Fig. 22 Charles Baudelaire (French, 1821–1867), *Portrait of Jeanne Duval*, 1865. Pen and ink, 8⅛ × 5¾ in. (20.5 × 14.5 cm). Musée d'Orsay, Paris (RF 41644 recto)

publication; the book was widely understood to be a tribute to Duval, albeit one fraught with the poet's own eroticized fetishization of Duval's ethnicity.[18]

Still, the intentionality of Manet's portrayal of Duval as a woman of African ancestry, even as he lightened her skin, arguably, to racial illegibility, is confirmed by added sartorial and formal details. In the final portrait, Duval wears red coral earrings, a signification of Blackness that is absent from the study but rendered with clarity in the painting. Red coral earrings are a long-established ethnic marker of Black femininity that situates Duval within the same visual lineage as the Black maid in *Olympia*, posed by the model Laure, who wears two-tiered coral earrings. Moreover, they echo Baudelaire's own sketches of Duval, in which she is seen with other unambiguous ethnic signifiers, including large hoop earrings and a madras plaid headscarf typical of the Antilles (fig. 22).

Manet's portrayal uses other emphatic sartorial signals of the demimondaine's social ambiguity, as described by Dumas. Duval does not wear the revealing silks and glittering jewels of the courtesan. Instead, she is attired in the same type of stylish white day dress, embellished with a demure pastel stripe and a modest ruffled neckline, worn by the upper-bourgeois family and friends depicted in other portraits by Manet, including his own wife, who is also seen in the same semi-reclining pose as Duval (fig. 35).[19] This equivalence of respectability is underscored by Duval's necklace in the shape of a Christian cross.

The social placement implied by her dress suggests the material reality of Duval's comfortable and independent bourgeois lifestyle, which she maintained with Baudelaire's financial support as well as her own resources. In his 1911 memoir of Baudelaire, Nadar described Duval's home on the rue Saint-Georges, in an upscale area just blocks from the palatial

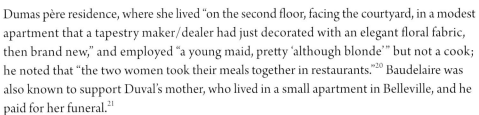

Dumas père residence, where she lived "on the second floor, facing the courtyard, in a modest apartment that a tapestry maker/dealer had just decorated with an elegant floral fabric, then brand new," and employed "a young maid, pretty 'although blonde'" but not a cook; he noted that "the two women took their meals together in restaurants."[20] Baudelaire was also known to support Duval's mother, who lived in a small apartment in Belleville, and he paid for her funeral.[21]

This description of Duval's maid as her sometime dining companion provides a factual context for Dumas's depiction of his protagonist's maid in *Camélias*. Three generations removed from his enslaved Haitian great-grandmother, Dumas seems to have expressed an awareness of and empathy for the humanity and individualized specificity of women from her social stratum. The maid's role exceeds servitude; she is portrayed as a source of wisdom, pragmatism, and loyalty. The Black maid in Manet's *Olympia* conveys these same qualities with a facial affect that is animated, not blank, her lips parted as if in conversation with her employer. Notably, Manet made a portrait study of the model Laure that was significantly larger than his study depicting Victorine Meurent, the artist who modeled the prostitute.[22]

Even as Manet evoked Duval's stature in Baudelaire's life and her relatively elevated level of material comfort, he also alluded to the societal backlash that ultimately ended her nineteen-year relationship with the poet. Her right hand seems relaxed in the study, but in the painting, it is oversize, with flexed fingers clutching the sofa back. Her large, dark eyes, invariably noted in descriptions of Duval, were softened enough in the study to be legible; in the painting they are gaping black voids, with irregular lower edges evocative of tears. These details comprise an unsettling representation of trauma, anguish, and despair. The asymmetrical billow

of her vast crinoline, intensified by the addition of sheer, fluttering lace curtains, conveys a striking sense of turbulence that is in stark contrast to the sense of calm, settled stability seen in Manet's portrayals of his wife and the artist Berthe Morisot, his friend and sister-in-law. With these mixed signals Manet presents a self-assured young woman whose access to a bourgeois lifestyle is repeatedly challenged and disrupted by the controversy surrounding her ethnicity.[23] Ultimately, his portrayal of Duval signifies the unlikeliness that she would ever experience, in any sustained way, the settled stability of bourgeois social status.

The figure of the demimondaine of color at the interstices of respectability and scandal captures a reality that was integral to modern Parisian life. It is a subject that seemed to interest Manet across the decades, as he later made efforts to paint a portrait of Adah Menken, a high-profile, mixed-race American actress from New Orleans, who was a mistress of Alexandre Dumas père. While correspondence documents Manet's request to meet with Menken after one of her performances at the Théâtre de la Gaîté, there is no known evidence that a portrait was ever made.[24]

Degas, like Manet, portrayed women of color, both as they appeared in reality and in ways that made them most presentable, according to the period's taste, in a finished painting. He likewise represented the duality and ambiguity of the demimonde as conceived by Dumas, but from a wholly different perspective. And, like Manet, Degas attended the same salons and social gatherings as Dumas, though he, too, made no images of the writer and left no documented correspondence with him.[25]

"We are both Creoles," Degas proclaimed, referencing the mixed-race Haitian painter Théodore Chassériau and thereby acknowledging his family's maternal lineage, which could be traced from pre-revolution Haiti to New Orleans.[26] Degas, therefore, like Duval and Dumas, lived and worked at the crux of the period's anxiety around mixed-racial heritage and illegitimate origins. During a four-month visit to New Orleans in 1872–73, about a decade after Manet depicted Jeanne Duval as a Parisian demimondaine, Degas made his earliest and most extended commentary about Black women of comparable and higher social stature. Key to understanding the remarkably different approaches Manet and Degas took to the subject is an awareness of their disparate political perspectives.

Manet was an avowed republican, which by default meant that he supported abolition on an intellectual basis, though there are no indications that he was an antislavery activist.[27] His youthful trip to Brazil in 1848, the year France abolished territorial enslavement, predated the 1850 abolition there. Manet at times used the racially derogatory language of the period but also wrote of being appalled when he witnessed an auction of enslaved individuals. He closely observed the Black women forced onto the sale block: "[they] are generally naked to the waist, some with a scarf . . . falling over their breasts. . . . They dress with a great deal of care. . . . Some . . . arrange their frizzy hair in very artistic styles and almost all wear petticoats adorned with monstrous flounces."[28] Manet's depictions of Laure and Jeanne Duval fifteen years later veer away from the imagery of enslavement that he witnessed in Brazil—no bared breasts, no exotic locales—in favor of a visual representation of the free Black presence that, while fraught with the racial complexities of the time, was nevertheless integral to the modernity of the post-abolition period.

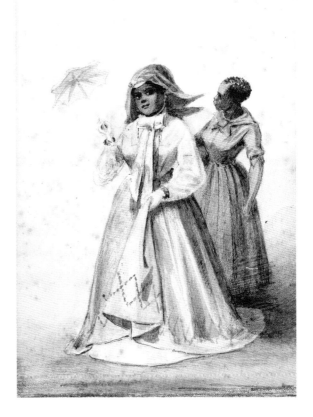

In contrast, Degas visited New Orleans as a guest of his matrilineal family, the Mussons, who situated him as a direct beneficiary of the accumulated wealth that they derived from their role as enslavers, first in Haiti and then in the United States. His uncle fought for the South during the Civil War and joined white supremacist groups during Reconstruction. The dowry of Degas's New Orleans–born Creole mother had been created by the sale of an enslaved woman who had been transferred to her by her father.[29] The family continued to prosper from the ownership of a cotton manufacturing business that was dependent on Black labor.

This background provides context for the mix of admiration and distancing in Degas's descriptions of the Black women he encountered in New Orleans. In his letters, he seemed bemused and almost disbelieving that they appeared relatively prosperous, well-dressed, and sophisticated in their bearing, as he noted, "the beautiful and thin negresses, dressed in their cotton clothes, opening their green shutters, and the old ones with their large madras tignons going to the market."[30] The women that Degas vividly described, but never painted, were likely from New Orleans's significant population of affluent Black families, many of whom had attained freedom before the Civil War; others could have emerged from a New Orleans version of the demimonde that resonated with that in Paris, as defined by Dumas. Édouard Marquis portrayed these free women of color in an 1867 series of watercolors (figs. 23, 24). This storied social structure, sometimes described as *plaçage*, was a system in which wealthy white Creole men entered civil unions with women of color whom they allegedly met at so-called quadroon balls. Recent scholarship has challenged the broad basis of this system as being in large part undocumented myth. These studies document, however, that such long-term liaisons were commonplace, if more individually organized.[31] This New Orleans arrangement, so like Dumas's powerful characterization of the Parisian demimonde as a blend of respectability and disrepute, supports the author's theory on the lack of racial and social fixity. Whether in Paris, New Orleans, or innumerable other societies worldwide, Dumas's half-world was a universally recognizable space.

Fig. 23 Édouard Marquis (born France, 1812–1894), *Creole Women of Color Out Taking the Air*, 1867. Watercolor, 6 3⁄8 × 3 15⁄16 in. (16.2 × 10 cm). Louisiana State Museum Collection, New Orleans (1982.001.10.4)

Fig. 24 Édouard Marquis, *Creole Woman of Color with Maid*, 1867. Watercolor, 7 1⁄8 × 4 1⁄2 in. (18.1 × 11.4 cm). Louisiana State Museum Collection, New Orleans (1982.001.10.2)

The Musson family was almost certainly aware of these interracial relationships, as Degas's mother had cousins who were prominent free men of color, including Norbert Rillieux.[32] Rillieux was a leading chemical engineer and the son of Constance Vivant, a free woman of color, and Degas's maternal great-uncle, who openly acknowledged and supported the five children they had together. Degas never mentioned his African American cousins, but this racial and social liminality within his own family, as well as the political stance of his hosts, was likely central to the fact that he never painted the elegant New Orleans women that he wrote about. His only portrayal of a Black New Orleans woman, in *Courtyard of a House (New Orleans, sketch)* (pl. 117), was a slight rendering of a unidentifiable servant in profile. Reflecting values that were aligned with his family history, he embraced Black servitude as the seemingly natural order of things: "Nothing pleases me like the negresses in all their varying shades, holding in their arms such white little white children, against a background of such white houses."[33]

It is instructive to compare Degas's portrayal with that of the nannies in Manet's *Children in the Tuileries Gardens* (pl. 116), his first depiction of the model Laure. Both paintings render the figures as blank-faced types, not as individuals. But Manet's Black nanny is more attentively portrayed: her pose is frontal, her attire is fully visible, and she is an active participant in the scene, tending the hair of one of the children; Degas's nanny, by comparison, is passive. Manet seems to have thoughtfully composed the figures in *Children*, preparing at least one study that appears in his 1862 carnet.[34] Degas's nanny is manifestly an almost casual sketch.

A few weeks before his return to Paris, Degas made one final comment on Black New Orleans women: "As for the black community, I don't have enough time to tackle the subject. These ebony forests are rich in colors and in sketching ideas. It will be odd to go back to Paris and live solely among the whites. Besides, I love silhouettes so much, and these are moving silhouettes!"[35] To the extent that Degas portrayed the Parisian demimonde, it was generally not in private spaces like Jeanne Duval's bourgeois interior or the luxe boudoir of Olympia as a high-end courtesan. Instead, he focused on the more public face of the middle-to-lower echelons of this half-world—represented by performers and by cocottes seated alone in the cafés, thus advertising their availability—as in *In a Café (The Absinthe Drinker)* and *The Singer in Green* (pls. 118, 122).[36]

Fig. 25 Edgar Degas, Study for *Miss La La at the Cirque Fernando*, 1879. Pastel on paper, 24 × 18 ¾ in. (61 × 47.6 cm). Tate, Presented by Samuel Courtauld, 1933 (No4710)

In January 1879, at an ocean's remove from his family in New Orleans, Degas returned to the seemingly unfinished business of observing the Black female figure with an identity autonomous of servitude. He visited the intimately scaled Cirque Fernando, a short walk from his Montmartre home, to attend several performances of the celebrated biracial aerialist Olga Albertine Brown, whose stage name was Miss La La.[37] He later invited her to his studio and made seven pastel studies and a final oil painting that capture one of her signature acts, in which she was suspended from the ornate domed ceiling of the prestigious venue's single ring by a dental device clenched between her teeth and attached to a rope (figs. 25, 26).

The studies and painting of Miss La La constitute Degas's only portraitlike treatment of a single Black subject with a known identity. They are also one of his most extensive series of pastel studies made in preparation for any single painting. Perusal of the series reveals that, as with Manet's Jeanne Duval, Degas initially depicted Miss La La's skin in the deep brown tones of her actual appearance. In the final painting, save for her lush tufts of curly hair, her racial heritage is, like Duval's, ambiguous to indiscernible, depending on the viewer's perception. The graceful placement of the aerialist's arms and feet reveals the choreographed artistry of her act, in stark contrast to the focus on the display of extreme strength in the racist caricatures of Brown's act in popular culture.[38] With her facial features obscured in profile view, like those of many of Degas's ballerinas, she perhaps finally embodies the "moving silhouettes" of the Black women that had caught his attention in New Orleans.

These visualizations by Manet and Degas of racial fluidity, emanating from Dumas's critique of the complex tangle of social, economic, and emotional responses to an insistence on an unsustainable racial fixity, were emblematic of the modernizing societies of late nineteenth-century Paris and New Orleans. They are a window onto the era's nascent efforts to reckon with the legacy of racism, colonialism, and the consequences of enslavement.

Fig. 26 Edgar Degas, *Miss La La at the Cirque Fernando*, 1879. Oil on canvas, 46⅛ × 30½ in. (117.2 × 77.5 cm). The National Gallery, London, Bought, Courtauld Fund, 1925 (NG4121)

PRESENCE OF ABSENCE:
DEGAS, MANET, VALÉRY

Stéphane Guégan

But how can painting be put into words?[1]

Paul Valéry's *Degas Dance Drawing* is a rather haunted book, owing to both its difficult birth and its revival of an entire artistic past. Time is one of its protagonists, in several respects. The distinct relief felt by the author (fig. 27) when the essay appeared in 1936, in a luxurious illustrated edition, is understandable given the forty years that had elapsed since the first mention of Degas in his *Carnets*.[2] In fact, 1896 was the year they met. Valéry, at age twenty-five, recorded the sixty-two-year-old Degas as one of the six living personalities whom he most admired and who were objects of reflection for him. No other painter figured among them.[3] But his painter of choice was not the only ghost Valéry wanted to bring to light, for *Degas Dance Drawing* combines the gravity of a new discourse on method with the cheerful tone of a souvenir album. The reader is enjoined from the opening lines not to scrutinize it continuously, from beginning to end; there is no false modesty in this recommendation. Valéry, as a proper heir of Charles Baudelaire and of Symbolism, allowed himself to be guided by the law of correspondences and analogies. In its construction and enunciation, the text leaves visible the effects of the montage procedure from which it issued, allows its digressions to

Fig. 27 Pierre Auradon (French, 1900–1988), *Paul Valéry*, n.d. 4 ¾ × 3 ⅜ in. (12 × 8.7 cm). Bibliothèque Littéraire Jacques Doucet, Paris

expand beyond reasonable bounds, and ends up speaking about anything but its subject, as if this deliberate heterogeneity were the best way to access a personality and an art practice of extreme complexity. Among the revenants encountered by the reader in these pages, two major figures stand out: the poet Stéphane Mallarmé, Valéry's preeminent literary model, and Édouard Manet, Degas's indispensable contemporary, the one without whom, suggests the essay, it would be impossible to comprehend the evolution of the singular painter of dancers, racetracks, and some of the most beautiful nudes of the period—one whose prudishness, a quality that had seemingly vanished forever, here returned under new cover. If *Degas Dance Drawing* had not made possible a deep exploration and comparison of the two painters, would Valéry have devoted so much space to politics, to Eros, to poetry? Would he have so emphasized Degas's double debt to Jean Auguste Dominique Ingres and Eugène Delacroix? Finally, would he have spent so much time summoning up the lively voices of Berthe Morisot and Ernest Rouart, the husband of Julie Manet, who was Morisot's daughter and the niece of "uncle Édouard"? From start to finish, Manet's painting shapes Valéry's text. And it does so by way of the "presence of absence" that the writer cherished in Manet's portrait of Morisot with a bouquet of violets (pl. 56).[4]

Degas Dance Drawing demands, then, to be read from the proper perspective: its own vantage point of the 1930s, based on the memory of a distant era. Since the book is rich with nearly a half-century's worth of conception and writing, we should examine, up front, its temporal sequence, which begins at the end of the nineteenth century, amid the first stirrings of the Dreyfus affair, a notorious political scandal that divided France; the last of Mallarmé's Tuesday evening salons; the run of the art and literary journal *La Revue Blanche*; and the bequest to the French state of Gustave Caillebotte's renowned art collection. Thanks to this bequest, in 1897 Manet's painting *The Balcony* (pl. 98) entered the Musée d'Art Moderne, then situated in the Orangerie of the Palais du Luxembourg and its extension, where it joined his *Olympia* (pl. 81), which had arrived in 1890. Seven works by Degas, moreover, enriched France's official galleries, a milieu that the artist himself had shunned, in essence, since the end of the Second Empire by his decision to no longer exhibit at the Salon. The man was anything but ready to become a public personality, as Manet had been from 1863 when *Déjeuner sur l'herbe* shocked visitors to the Salon des Refusés. If Manet had built his career on the conquest of an ever-expanding audience, Degas confined himself to toying with a few collectors and even fewer dealers. Scarcity is profitable, and Degas's prices crept up over the course of the 1890s; nonetheless, his fame remained largely clandestine. As soon as he could, the reticent artist discouraged anyone who might be tempted to write about him. He granted no studio visits or interviews to journalists—the opposite of what Manet stirred up prior to his death in 1883.

This kind of deliberate withdrawal, of artistic sacralization, can only have encouraged Valéry to penetrate Degas's entourage. The young provincial who settled in Paris in March 1894 was already well equipped to gain access to those he admired. The novelist Joris-Karl Huysmans and Mallarmé, two of Valéry's early chosen mentors, were introduced to him. Huysmans sang the praises of Manet's modernity and, even more, of Degas's art, finding it more responsive to contemporary life: speedy, bizarre, disconcerting, passionate. If Valéry was

soon confronted with the Manets in Mallarmé's rue de Rome apartment, he was also sensitive to the fact that the poet was, like Degas, a habitué of the Morisot circle. The strange marriage of theoretical reflections and intimate confidences that lends *Degas Dance Drawing* its charm would have been impossible without these network connections. To wit, Valéry's friendship with the writer André Gide enabled him to establish contact with Julie Manet and her husband, Ernest Rouart, and in 1896 it was Rouart, Degas's only student, who provided Valéry access to the master he admired.[5] Four years later Valéry married Jeannie Gobillard, one of Julie Manet's cousins (figs. 28, 29). We can begin to see how Valéry's account of Degas was connected to Manet's posthumous destiny.

A REVERSAL OF VALUES

Between 1889 and 1932 Valéry witnessed what he called the "triumph of Manet."[6] At the Exposition Universelle commemorating the French Revolution of 1789, fourteen paintings by the great deceased artist were deemed worthy of its *Centennale de l'Art Français*. This was just the start of a growing recognition that would culminate in 1932 with the retrospective exhibition marking the centenary of Manet's birth. Having become the poet of the Third Republic, Valéry wrote the preface to the catalogue as a way of making symbolic reparations. The French nation—which had never purchased any of Manet's paintings, had been

Fig. 28 *Julie Manet, Paul Valéry, Jeannie Gobillard, Ernest Rouart, and Paule Gobillard*, March 23, 1900. Private collection

Fig. 29 *Ernest Rouart, Julie Manet, Paul Valéry, and Jeannie Gobillard on the day of their double wedding*, May 31, 1900. Archives du Mesnil, on permanent loan at the Musée Marmottan Monet

reluctant to exhibit *Olympia* at the Musée du Luxembourg, and had waited until 1907 to admit that important art-historical touchstone into the Louvre—was making a public apology. But strangely, the belated consecration of Manet engendered a contrary phenomenon, one whose ultimate effects would become apparent toward the end of the 1970s, when foundations were laid for a national museum of the nineteenth century, the future Musée d'Orsay. Rather than Manet, would not Paul Gauguin, Georges Seurat, and above all Paul Cézanne better personify the revolutions that had given birth to so-called modern art?

Jacques-Émile Blanche's *Manet*, published in 1924, allows us to assess the vagary of history that continued to impact Manet's reputation through the twentieth century. Although now forgotten, it is among the richest books ever written about the painter, and it had more than a little to do with Valéry's future analyses. The son and grandson of famous psychiatrists, the young Blanche had known Manet in the early 1880s, when he was just entering the career from which the older painter was about to exit. Intelligence, perception, verbal expression: Blanche lacked for nothing at the age of twenty. He witnessed, from a prime box seat, the astonishing spectacle that was the final phase of Manet's career, when the painter was surrounded by new collectors, several of them members of the Parisian Jewish elite, and happy with his fate despite his illness. What, then, had happened to change Manet's reputation? Blanche's appraisal of 1924 distills a certain bitterness about the new hierarchies of the art world. A time of "intellectual research and of theoreticians,"[7] in his words, the postwar period had reshuffled the deck to such an extent that the mimetic experimentations of Seurat and the physical seductions of Pierre-Auguste Renoir were deemed preferable to the more complete genius of Manet: "Albeit he holds a considerable, though undetermined, place among painters of the nineteenth-century, men will be found to affirm that his influence acted on mediocre minds only, and had no development and no future. In a word that he was no more than an amateur, a *dilettante*."[8] This moment, which also saw an uptick in Cézanne's reputation, judged realism, including that of Manet, to be obsolete: "An unprecedented reversal of values, in my opinion."[9] And Degas, who died in 1917? Blanche, who had frequented his company, gotten him to talk, and studied him, could only face the facts: Degas's art, *a priori* more constructed, seemed to have escaped the demotion that had struck Manet.

The context of World War I had proven favorable to the valorization of Degas, to his accelerated elevation into the French patrimony.[10] Rapid and lively as well, in a bombed-out Paris, was the sale of the atelier in which the blind patriarch had stockpiled the works of his youth, as un-Impressionist as they were saturated with the whole of a French tradition whose extremes were finally reconciled: in them, Nicolas Poussin, the Le Nain brothers, Ingres, Delacroix, and Théodore Chassériau seemed never to have been at odds. The Degas of *Family Portrait (The Bellelli Family)* (pl. 49), *Semiramis Building Babylon* (pl. 74), and *Scene of War in the Middle Ages* (pl. 83), after more than fifty years of oblivion, was received as a shock. The French state rushed to acquire these pearls, now miraculously available. These paintings reinforced the position of critics who, beginning with Camille Mauclair, saw Degas as heir to the French classics, a category sufficiently vague to encompass all the abovementioned artists.

This "Impressionist of line,"[11] in the words of Louis Hourticq, was, at his roots, less Impressionist than he was "Ingres-ish" (*l'Ingrolâtre*), to cite Blanche,[12] who was very much

aware of the many imitators and artists who laid claim to the master of Montauban. Blanche knew, moreover, that Manet too was among Ingres's followers, as Antonin Proust had reminded readers of *Le Studio* at the beginning of the century.[13] He also understood that the art of Manet could not help but strike the younger generations as overly dependent on an eroticism inherited from Antoine Watteau and Jean-Honoré Fragonard. But he warned his readers against exaggerating an antithesis between Manet and Degas, sensing that it could do harm to both artists, who are comparable in more than one respect:

> The one helps us to understand the other. In the case of Manet and Degas, the result would be to bring up endless debate on certain problems of modern aesthetics which gained so much importance after they passed away: for instance, whether intellect does not pass for being the mysterious gift of *painting*; and how far the one does deceive us in respect of the innate, fatalistic essence of the other. How is one to be distinguished from the other? In view of the avowed state of mind of thousands of young artists the solution of the problem— made more involved by critical analysis with its pretensions to science and philosophy—must be sought in the minds of Manet and Degas. . . . Now it must be carefully borne in mind that Degas' speculative and inductive intellect is much closer than that of Manet to the ideal of those painters to whose futures we look confidently.[14]

In short, although the scales tilted a bit in Edgar's favor, the case of Édouard, Blanche suggested, was far from settled. The centenary exhibition, together with the publication of the catalogue raisonné of Manet's paintings by Georges Wildenstein and Paul Jamot, revived the controversy around the warring "brothers" and their respective modernity. Valéry took the floor, then, on Manet in 1932 and Degas in 1936, with the conviction that he had to situate himself and the two artists within an overall landscape marked by new realisms and by Surrealism: art with a subject.

POETRY IN ACTION

Valéry's preface to the 1932 catalogue, "Triomphe de Manet," brushes aside the banal and the circumstantial. If one must speak of Manet's victory over time, he claimed, it is not solely borne of the artist's greatness, at first delayed, then sovereign. What he saw at work here was the aptitude of poets to unite behind the best of their time. His imaginary allegory presented, like a painting by Henri Fantin-Latour, a group of writers on some modern Parnassus, forming a cortege around Manet: "Here we would doubtless see Champfleury, [Théophile] Gautier, [Edmond] Duranty, Huysmans. . . . But first of all: Charles Baudelaire, Émile Zola, Stéphane Mallarmé."[15] Valéry was well aware that the poet of *Les fleurs du mal* had said very little about his friend's painting, and he observed that Mallarmé and Zola, two of the writers who supported the controversial artist, had not taken very far the parallel that he considered the essential key:

One need only leaf through the short collection of [Baudelaire's] *Fleurs du mal* to observe the significative diversity of the subjects of these poems, to connect this with the diversity of motifs encountered in the catalogue of the works of Manet, in order to confirm, without much difficulty, a real affinity between the concerns of the poet and those of the painter. The man who wrote "Bénédiction," "Tableaux Parisiens," "Les bijoux," and "Le vin des chiffonniers," and the man who painted, by turns, *Christ with Angels* [pl. 75] and *Olympia* [pl. 81], *Lola* [pl. 97], and *The Absinthe Drinker* [fig. 40]: there must be some profound correspondence between them.[16]

These subject analogies do not exhaust Valéry's argument; Manet and Baudelaire propel lived experience and thought toward formal expression through a deliberate awareness of the particularities of their respective languages. According to Valéry: "It is not their intention to speculate about 'feeling' or introduce 'ideas' without having skillfully and subtly organized the 'sensation.' They pursue, in sum, and attain the supreme end of art: *charm*, a term that I use here in all its force."[17] Two paintings, in this respect, dominate: *Olympia* and *Berthe Morisot with a Bouquet of Violets* (pl. 56). The former defies prohibitions in its bodily reality, insolent gaze, and refusal of moral self-condemnation: "She is scandal, idol; public power and presence of a wretched arcanum of Society."[18] The latter work quietly takes us even closer to Manet:

> This face with large eyes, whose vague fixity is deeply distracting and presents, somehow, a *presence of absence*—all this contrives and imposes upon me a singular sensation . . . of *Poetry*—a word that I must immediately explain. . . . Manet . . . composes from the mystery to the firmness of his art. He combines a physical resemblance to the model with a unique accord well-suited to a singular person, and forcefully fixes the distinct and abstract charm of *Berthe Morisot*.[19]

The fact that the painter was far from indifferent to his sitter: Zola stifled it, and Mallarmé scarcely conceded it.

The Parnassus on which Valéry situated Manet welcomed other painters as well. Before Claude Monet, Frédéric Bazille, Renoir, and Morisot, the writer named Degas, a significant precedence. More than Manet, he was Valéry's chosen artist, for he satisfied quite precisely the definition of great art for which *Degas Dance Drawing* constitutes a manifesto. The ambition of the *pictor doctus*, the learned painter, whom Valéry defined in 1895 through Leonardo da Vinci, was here reimbodied, perhaps for the last time. Degas, he wrote, "was always ready to talk about the *science* of art: he would say a picture was the result of a *series of operations*. . . . Degas rejected *facility* as he rejected all but the precise object of his researches."[20] There was another reason for him to mention his painter of choice among Manet's admirers. Without the one, how to make sense of the other? asked Valéry, echoing Blanche. *Degas Dance Drawing* resonates endlessly with this paradoxical coupling, all the more decisive for being conflictual. Valéry, at odds with then-current opinion, knew how much internal resistance

the artist had to overcome, in the early 1860s, before allowing his brushes, trained in view of very different subject matter, to fully accept "contemporary life." Degas's youthful sketchbooks might have contained glimpses of the modern world, but scribbling was one thing, painting another. Manet had preceded him down this path and even precipitated his advance along it; this was obvious, especially as Valéry compensated for Degas's silences with the convergent confidences that issued from Morisot's circle by way of Berthe's notebooks and Ernest Rouart's notes.[21]

The shadow of Manet also becomes discernible as soon as Valéry, finally getting to what was essential, deals with the nude. But the essayist's admission of a common penchant for suspending the limits of decency—Manet by way of open intrusion, Degas through a subtle and self-conscious voyeurism—takes us down a path of denial: "[Degas] turned his back on softly reclining beauties, on Venuses and odalisques; nor did he try to create his own supreme, obscene, and brutally factual Olympia on her bed."[22] Neither Ingres nor Manet, in short, he rendered neither the blissful voluptuousness of impure divinities nor the social inscription of real bodies. Degas captured his models more than he flattered them; he privileged the mechanics of living, just as he exaggerated the facial expressions, insisted Valéry, who cast all shadow of malignancy onto Manet. And yet, he knew. He knew that Degas was no stranger to the world of the *maison close* (brothel) and that he had acquired, from the artist himself, Gauguin's copy of *Olympia*. Many of Degas's toilette scenes, with all due respect to Valéry, were realized while thinking about his old comrade's transgressive idol.[23] Moreover, according to Valéry, didn't Manet flaunt this "decisive power" through his execution, and thus through signifying effects of a kind that impressed even Degas? Hostile to Impressionism, which seemed to him the beginning of the retinal drifts of a twentieth century cut off from the poetry of the image, Valéry finished by concluding, albeit obliquely, that Manet and Degas were spiritual twins, brothers in *la cosa mentale*.

DEGAS, AFTER MANET

Stephan Wolohojian

No visitor could enter the vestibule of Degas's apartment on the rue Victor-Massé without confronting the gaze of Manet's *Olympia*. Degas acquired Paul Gauguin's large-scale copy of this painting at an auction of that artist's work in 1895 (fig. 30). He pursued many Gauguins at this sale. As one witness recalled, he bid so enthusiastically on works of his younger contemporary that he even bought this painting sight unseen.[1] Even if Degas raised his hand to secure Gauguin's copy without having first inspected it, *Olympia* was deeply embedded in his psyche, stamped in his memory since its sensational appearance at the Salon of 1865, thirty years earlier. In 1890, Degas had been one of the subscribers who helped purchase the painting from Manet's widow on behalf of the French nation, giving artists such as the younger Gauguin the opportunity to copy it in the public galleries of the Musée du Luxembourg.[2] Degas already had a tracing and precious proofs of Manet's two etched versions of *Olympia* (pl. 81).[3] But one can easily imagine that owning this resonant reminder of his rich exchanges with Manet in the 1860s, a time of shared pursuit and interest, was something the artist would impulsively pursue for his collection.

Degas's world in the 1890s was becoming increasingly inward looking; the rooms of his large apartment were filled with collected works by artists he admired—old masters, Jean Auguste Dominique Ingres and Eugène Delacroix from the recent past, and contemporaries such as Gauguin and Paul Cézanne—but also with gifts from and exchanges with other artists.[4] The critic Roger Fry identified two motives in Degas's collecting: "one, friendly, personal feeling towards artists whom Degas knew … and two, Degas's insatiable and pure love of the highest quality."[5] As he became a curator of his collection, even as his eyesight gradually weakened, this world became his theater, staging what one contemporary critic, Gustave Geffroy, called the life "of a recluse, shut away with his models and his sketches."[6]

The extent to which this assessment holds is debatable. Degas regularly visited and dined with friends, traveled in the company of other artists, attended the opera, and kept an attentive ear to the world beyond the walls of his private domain. Descriptions of a frail and reclusive figure are difficult to align with Sacha Guitry's seconds-long film clip of the eighty-one-year-old artist confidently strolling along the boulevard de Clichy, the main artery of the neighborhood he called home and whose cafés, theaters, and urban life had been his inspiration for more than half a century (fig. 31). Geffroy's portrait of a faltering and cloistered artist was more likely a response to the unease that Degas felt toward the ever-invasive presence of an art world seeking to commodify its artists, turning them into cult figures framed by their artistic personalities.

The Degas whom Geffroy observed was indeed looking inward, engaged in carefully curating his private domain, his *maison d'artiste,* the "anarchistic refuge" that has been described as "more metaphorical than literal: almost a performance."[7] The audience of this performance straddled a taut duality between private and public. While solitarily building his collection, Degas was envisioning a public museum in which to show it. That project took myriad forms; at one time he even imagined joining forces with fellow artist-collector Étienne Moreau-Nélaton, who owned Manet's *Déjeuner sur l'herbe,* a fantasy that never materialized. By the start of the twentieth century, Degas seems to have abandoned the idea of these galleries. Skeptical about the French government's involvement and oversight in managing

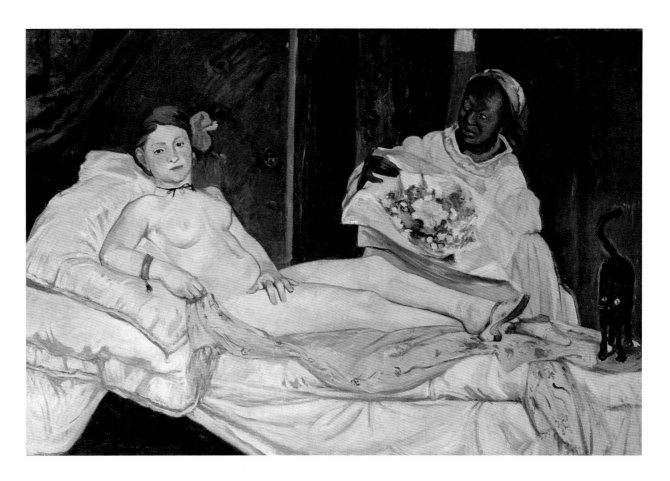

such an aspiration, the artist withdrew to the singular contemplation of his layered world of memories set within an assemblage of his own production. Works dating from the earliest moment of his career to the present, many of which he was loath to sell or give away for reasons still unclear, were interwoven into the densely packed spaces of his sprawling complex of home, studio, and personal gallery. It was certainly a considered decision to place the copy of Manet's most recognized and most public painting at the threshold of his private world, and its presence undoubtedly had an effect on the many visitors—artists, friends, models—who came and went.

Degas was not yet forty-nine years old when Manet died, at fifty-one, at the end of April 1883. Although their dialogue, often fraught but always generative, was silenced, Degas continued to engage with Manet, pondering their longtime association well after Manet's death and piecing together his friend's artistic legacy through his idiosyncratic collecting practice and in the expansive directions of his own work. Degas's far-from-systematic acquisition of works by Manet—eight paintings, a good dozen works on paper, and an almost complete group of prints—obtained through artistic exchange, gift, auction, or purchase from Manet's heirs, offers insights into not only his interest in Manet's art but also his own artistic investigations.[8]

Degas's career was multilayered in the decades following Manet's death, as he broke away from the Impressionists and took his practice in new directions. His public face and engagement with a large critical audience began to dwindle only three years afterward. The last large, group-organized show in which he participated was the eighth and final Impressionist exhibition of 1886. His keen interest in presenting his work, a commitment that at times even led him to mastermind the Impressionist exhibitions and oversee their installation, lighting,

promotion, and publicity, had vanished. Although he continued to show discrete bodies of new work, he did so only at private galleries. In the 1890s, as he pulled back from the public eye, he expanded his practice into new and uncharted areas: making hybrid pastel-monotypes, staging photographs, and modeling figures in wax around metal armatures. This Degas would have been unknown to Manet, as well as to most people outside his immediate circle.

While Degas's art became increasingly out of step with the new generation of Post-Impressionists, his earlier work began to be diffused through publication and printed reproduction, which introduced it to younger artists and the broader public.[9] For the first time Degas witnessed his contemporaries critically reframing his work, along with Manet's. Myriad quips from Degas register his irritation at the opinions of others and his desire to set the record straight. On the occasion of his friend Daniel Halévy's reading of Antonin Proust's newly published *Édouard Manet: Souvenirs* (1897), Degas expressed his annoyance with Proust's assessment of Manet's *Déjeuner sur l'herbe* as a proto-Impressionist painting made the day after he and the author had been "lying on the banks of the river on a Sunday in Argenteuil." As Halévy later recalled, Degas stopped him and blurted out: "It's wrong. He confuses everything. Manet was not thinking of painting *en plein air* when he made *Le déjeuner sur l'herbe*. He only thought of it after seeing the first paintings by Monet."[10] Degas took exception to the fact that Proust, a longtime friend of Manet's and the subject of a grand portrait by him (pl. 69), had retrospectively situated the artist's work in the context of the Impressionists, even though Manet had kept a fraught distance from that circle through his long commitment to exhibiting in the official Salon.[11] As Halévy's anecdote

Fig. 31 Sacha Guitry (French, born Russia, 1885–1957), *Degas on Boulevard de Clichy*, ca. 1914. Film still. Yale University Library, New Haven, Visual Resources Collection (109089)

demonstrates, a jealous rivalry between the two artists was still alive at the close of the century, with Degas further asserting that Manet could do little more than imitate others and made few artistic strides of his own.[12]

Ever uneasy about critics throughout his career, in the 1880s and 1890s especially, Degas mistrusted the written appraisals of his work. The Degas introduced in print inevitably presented an artist from decades earlier, thus exposing a chasm between what circulated about him and his current artistic pursuits. Owing to both Degas's own reticence and the disinterest of dealers, the seminal work he was producing at the time was often unknown, or worse, overlooked. His intimately observed figure drawings, large and small, and his astonishing pastels of bathers were almost forgotten by the critics as quickly as they were made (pls. 129, 135, 136). So were his fragile sculptures capturing movement through built-up layers of beeswax applied to carefully twisted wires. His uncategorizable monotypes of abstract landscapes (fig. 62), which critics struggled to assess as either Symbolist or simply "curious," were also not circulated.[13] In both text and reproduction, his oeuvre was represented by the more popularly entrenched paintings of ballet dancers and horses, as well as psychologically haunting portraits. His focused gaze on the working class, his depictions of Parisian milliners and laboring laundresses, found no place in the public eye. To many observers Degas's practice seemed somehow historic, still caught in the 1870s and 1880s, as if it existed within Manet's chronological parameters and not fully in its present moment.

Toward the end of the 1890s Degas took over the two floors below the fourth-floor artist's studio in which he had settled earlier in the decade. His domain expanded to include living quarters on the floor below the studio and, one level below, a large, uninhabited space for his art collection. In his 1918 biography of the artist, Paul Lafond evocatively described the top-floor studio, with its tubs, screens, studio props, and benches, and the apartment, which was appointed with old family furniture and piled with books, plaster casts of body parts, boxes of artworks, Neapolitan crèche figures, and even a papier-mâché elephant, all crowding rooms hung with pictures.[14]

The floor below his living quarters was more public and dominated by an art gallery, a large room filled with paintings on easels or leaning against walls, which Gary Tinterow characterized as Degas's "unofficial and very private museum."[15] It was here that one found his paintings by El Greco, Ingres, Delacroix, Gustave Courbet, Jean-Baptiste-Camille Corot, Cézanne, Vincent van Gogh, Gauguin, and others. It is interesting to think that the artist who shied away from painting large, full-length portraits presented two in this grand room. The first, Eugène Delacroix's confident portrait of Louis-Auguste Schwiter, presents its sitter on the edge of a terrace, revealing an English sensibility of placing portrait subjects in outdoor settings. Joining Schwiter was Manet's equally large, full-length portrait of Armand Brun who, with his hands in his pockets, pauses on a garden path as he gazes beyond the picture plane (fig. 32). Without a doubt, the largest and most prominent Manet in Degas's collection was *The Execution of Maximilian,* one of Manet's three depictions of the moment in 1867 when the Austrian archduke, who had taken the Mexican throne with the backing of Napoleon III of France, was executed by firing squad (pl. 160).[16] This canvas was part of the artist's largest and most ambitiously scaled series of history paintings, which curiously were never exhibited

in France during his lifetime. Manet's final painting of the subject was shown in New York and Boston in 1878–79, but this monumental canvas, still stored in the artist's studio at his death, had been considerably damaged and was sold off in pieces by Suzanne Manet's son, Léon Leenhoff. Manet's curious placement of this historic event in an open and atemporal land- scape had affinities with Degas's *Young Spartans Exercising* of about 1860 (The National Gallery, London) and other early history paintings such as his large and ambitious *Scene of War in the Middle Ages* (pl. 83), a canvas exhibited in 1865, in the same Salon as *Olympia*; these were

paintings Degas held on to and, in some instances, even reworked over the course of decades.[17] Most scholars consider that Salon pivotal in Degas's own reevaluation of his work, especially his abandonment of history painting for subjects of modern life. Having moved away from this genre, Degas must have been interested to see Manet take it on in his large *Maximilian*.

In his first effort toward reassembling the canvas, Degas seems to have come upon the section of the sergeant loading his rifle in the collection of Alphonse Portier—through whom he had acquired the extraordinary pastel *Madame Manet on a Blue Sofa* (fig. 35). The soldier's intense focus on his gun, with eyes down, has parallels in Degas's ballet dancers' attention to their slippers and his milliners' concentration on their hats. Although this fragment, which contains Manet's signature discreetly written under the officer's vial of powder, could have been framed independently, Julie Manet, the painter's niece, recorded in 1894 that Degas had by then acquired two fragments and intended to "try to put the painting back as it was."[18] Degas secured the large center fragment by trading a group of his own works with the dealer Ambroise Vollard, who reported the artist's urgent intent to assemble the remaining pieces.[19] When he tracked down all the fragments, he affixed them to a large canvas approximating the original size and installed the extraordinary painting, arguably his most important Manet, at the center of his picture gallery, in the company of his other prized paintings. This ambitious project of reassembly resonates ironically with an incident involving a cut canvas that had taken place decades earlier.

When Degas began collecting Manet in earnest after the artist's death, he possessed no paintings by his friend. In a huff, he had returned the one painting Manet had offered him, sometime around 1867. It was a small still life of a modest bowl of nuts that Manet supposedly gave him after a dinner when he had broken a similar salad bowl (fig. 33).[20] In this

golden moment of their friendship, when both men would have seen each other regularly, Degas painted a portrait of Manet lounging on a sofa and listening to his wife, Suzanne, at the piano.[21] As recounted by Vollard years later, Degas, who had given the portrait to Manet as a gift, was shocked to find it slashed, with a sizable strip along its right side missing (pl. 3).[22] He apparently grabbed it and took it home where, in a grand gesture, he removed Manet's still life from his wall and returned it. "Monsieur," he wrote, "I am returning your *Plums*."[23] In Degas's *Self-Portrait with Paul-Albert Bartholomé* (pl. 148), one sees the painting of Manet and his wife in a simple frame, hanging on the wall of the sitting room in one of his earlier apartments, where other works by Manet also hung—his *Ham* and the lithograph *Polichinelle* below it (pls. 149, 150). Degas's photographs are most often staged; here, he and his artist friend Bartholomé are seated rigidly in poses that seem especially keen to trace their profiles. Degas's features extend beyond the picture hanging behind him, its sharp edge cutting through his face like the straight edge Manet used to slice the painting above it. Degas imagined that he would someday restore his canvas, but the artist, who compulsively reworked and modified so many of his paintings over decades, seems to have left this one as it was for more than thirty years.[24]

It is difficult to get a sense of Degas's interest in Manet through the paintings in his collection. At Manet's posthumous sale in 1884, where works such as *Olympia* and *Bar at the Folies-Bergère* could be had, Degas bought only two drawings—an early ink study of a woman at her bath (pl. 32) and a portrait of the writer Henri Vigneau—and a lithograph, *Civil War* (pl. 145).[25] The very first Manet painting that Degas acquired was *The Departure of the Folkestone Boat*, a gift from Berthe Morisot and her husband, Manet's brother Eugène (fig. 34). Morisot must have been especially attached to it. She had bought the quickly executed canvas of the modest ship, which made regular crossings of the English Channel,

Fig. 33 Édouard Manet, *Nuts in a Salad Bowl*, 1866. Oil on canvas, 10 ⁷⁄₁₆ × 17 ¹¹⁄₁₆ in. (26.5 × 45 cm). Private collection

Fig. 34 Édouard Manet, *The Departure of the Folkestone Boat*, 1868. Oil on canvas, 24 ⁷⁄₁₆ × 39 ⁹⁄₁₆ in. (62 × 100.5 cm). Sammlung Oskar Reinhart "Am Römerholz," Winterthur (1923.17)

for her sister Edma; however, Edma's husband, a naval officer, rejected it on account of the dubious way the captain was placed on the bridge while maneuvering the boat.[26] This inaccuracy certainly would not have concerned Degas, who must have been drawn to its energetic, sketchlike handling and to the way it captured the hurried activity around the boat's departure, both on and off the shore.[27] But one can easily imagine that this painting also reminded Degas of Manet's appeals to join him on a trip to London in the summer of 1868.[28] As Mari Kálmán Meller and Juliet Wilson-Bareau have asserted, "each of the Manets in his household was a participant in a dialogue that, in Degas's mind, never came to an end."[29] One of the last paintings by Manet that Degas acquired depicts the figure of a woman with a cigarette dangling from her mouth (pl. 159). This quickly rendered portrait, as easily drawn from life as from an imaginary theatrical character, brings together what one writer described as bold brushstrokes reminiscent of a painter like Frans Hals and the insightful gaze of an artist who had studied the great portraits of seventeenth-century Spain.[30]

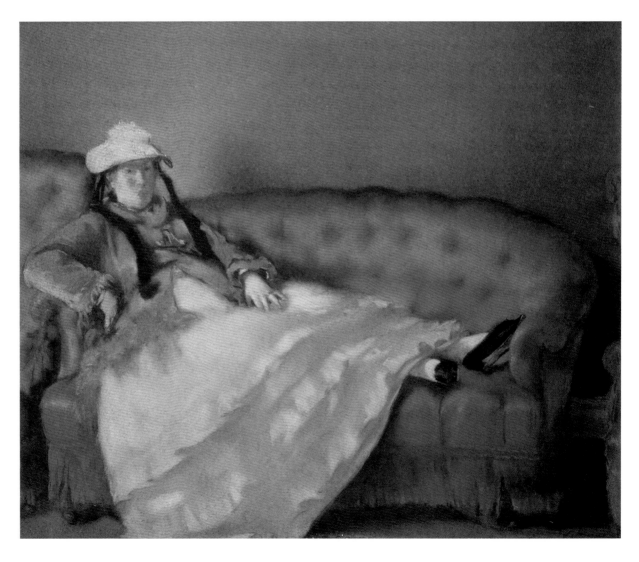

Henri Loyrette characterized the way Degas hung his collection as "at once autobiographical and polemical."[31] In the quiet of his bedroom, the echo of musical evenings with Lorenzo Pagans could be heard in the portrait of his father with the Spanish tenor, one of a select group of paintings he chose to hang above his small iron bed (pl. 39). Painted about ten years after *The Spanish Singer* (pl. 73), Manet's first popular and critical success and his debut entry at the Salon of 1861, this and other works that filled Degas's apartment would have rekindled memories of Manet's presence at these and other soirées. They would have conjured up conversations at the Nouvelle-Athènes or the Café Guerbois where the Manet-Morisot circle would gather and where the two painters' early acquaintance deepened into friendship. These were more than paint on a canvas or aesthetic touchstones; they were poignant souvenirs of people and a time past.

Paul Poujaud, one of Degas's regular dinner companions later in life, observed that Manet's extraordinary pastel of his wife reclining on a blue sofa, in the same pose as his subject in *Olympia,* was one of Degas's most beloved possessions (fig. 35).[32] Degas, who made some of the most astonishing pastels of all time and, according to some scholars, provoked Manet to work in pastel, must have marveled at Manet's handling of this complex medium.[33] Its rich application, creating a velvety surface on which the pigment appears to melt into the diffused light, is very different from the energetic strokes of his later portrait of Suzanne with a cat (pl. 158). *Madame Manet on a Blue Sofa* hung in one of Degas's sitting rooms next to Mary Cassatt's *Girl Arranging Her Hair* of 1886 (National Gallery of Art, Washington, D.C.), which he acquired from her that year by trading one of his own pastels.

Cassatt was among a group of female artists in Manet and Degas's circle. Among the closest to Manet was Morisot, whom he first painted in *The Balcony,* in 1868–69 (pl. 98). Manet was fascinated by his sister-in-law and depicted her in a variety of poses and at a scale large and small. His final portrayal of her, *Berthe Morisot in Mourning,* was painted after the death of her father, in 1874 (pl. 157).[34] In a letter written only a few hours before her final breath, in March 1895, Morisot instructed her daughter Julie Manet: "Tell M. Degas that if he founds a museum he should select a Manet."[35] Although his dream of a museum never came to fruition, two years after her death Degas purchased from Vollard this haunting painting, his very last Manet.

Fig. 35 Édouard Manet, *Madame Manet on a Blue Sofa*, 1874. Pastel on brown paper, mounted on canvas, 19¼ × 23⅝ in. (49 × 60 cm). Musée d'Orsay, Paris (RF 4507 recto)

PLATES

AN ENIGMATIC RELATIONSHIP

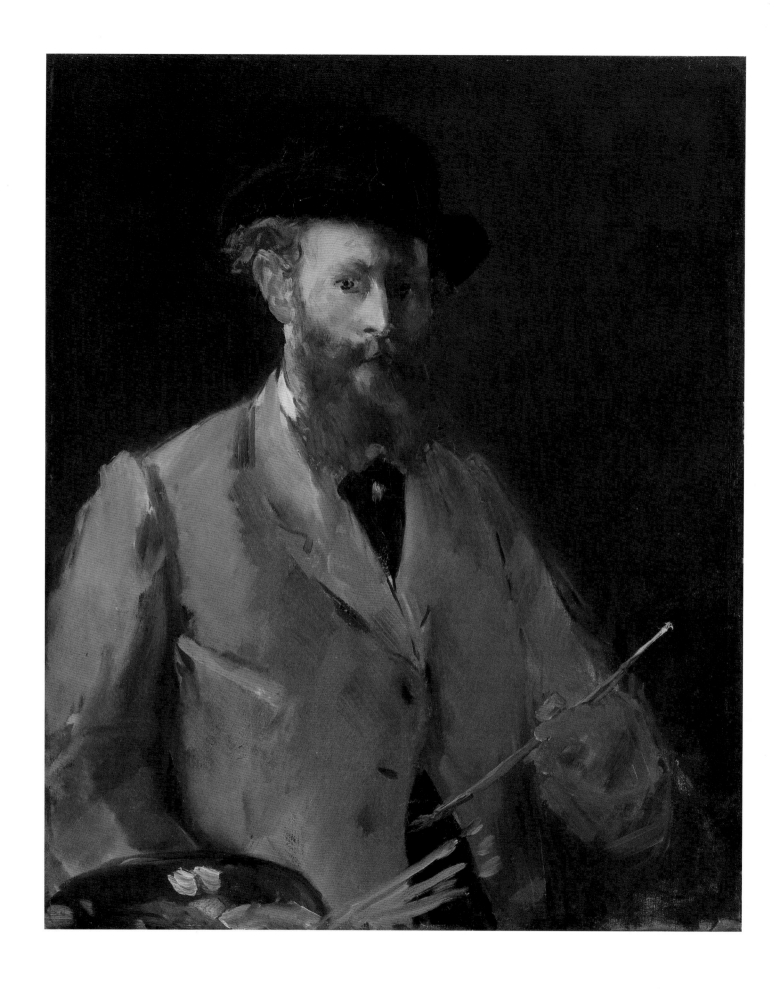

1. Édouard Manet, *Portrait of the Artist (Manet with a Palette)*, ca. 1878–79. Oil on canvas

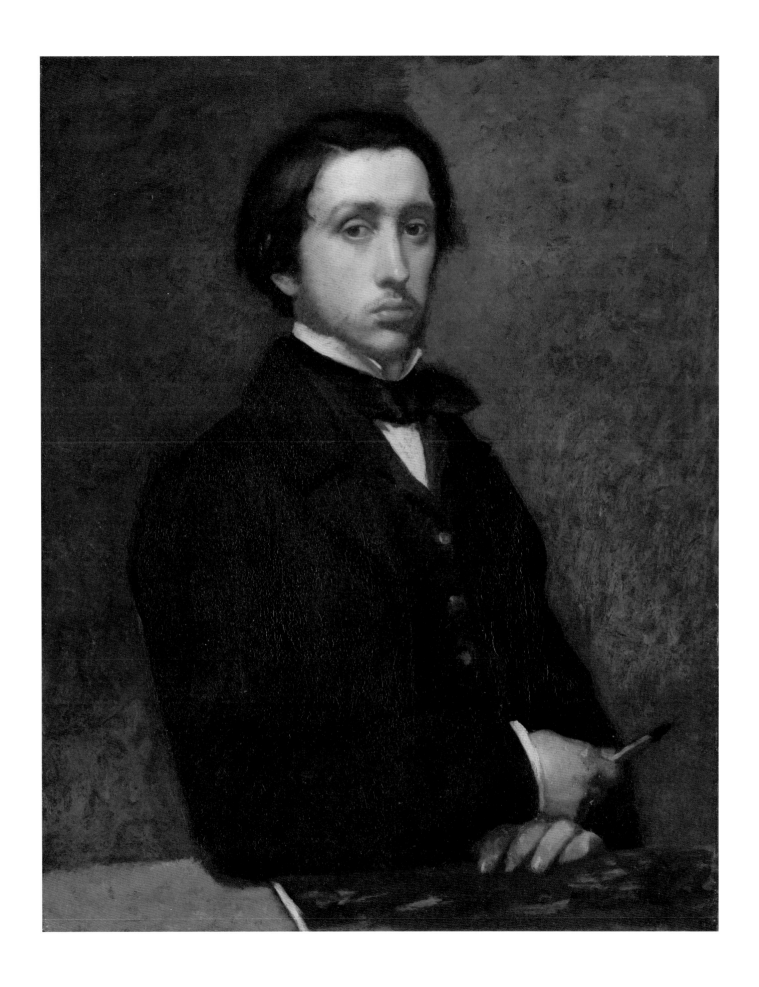

2. Edgar Degas, *Portrait of the Artist*, 1855. Oil on paper mounted on canvas

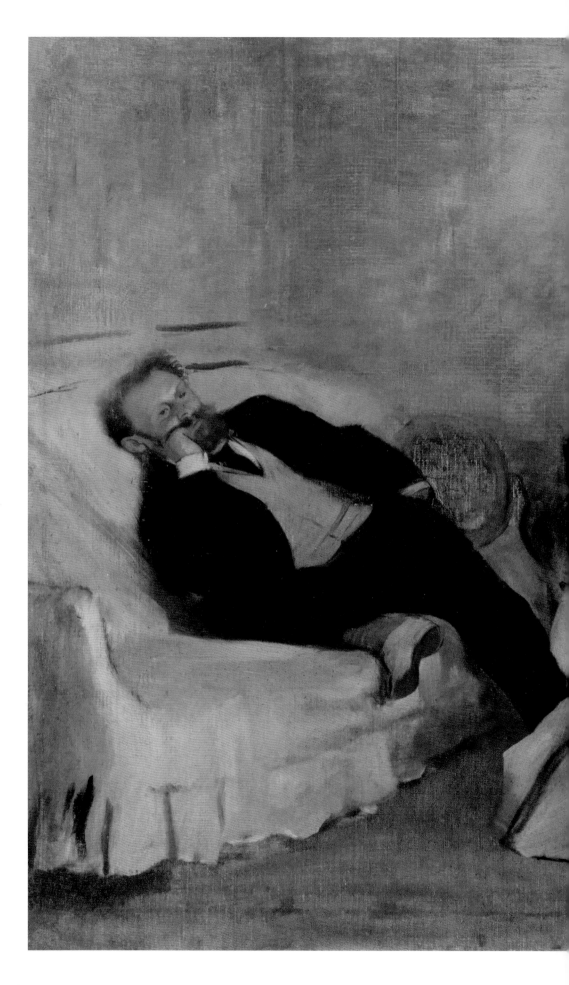

3. Edgar Degas, *Monsieur and Madame Édouard Manet*, 1868–69. Oil on canvas

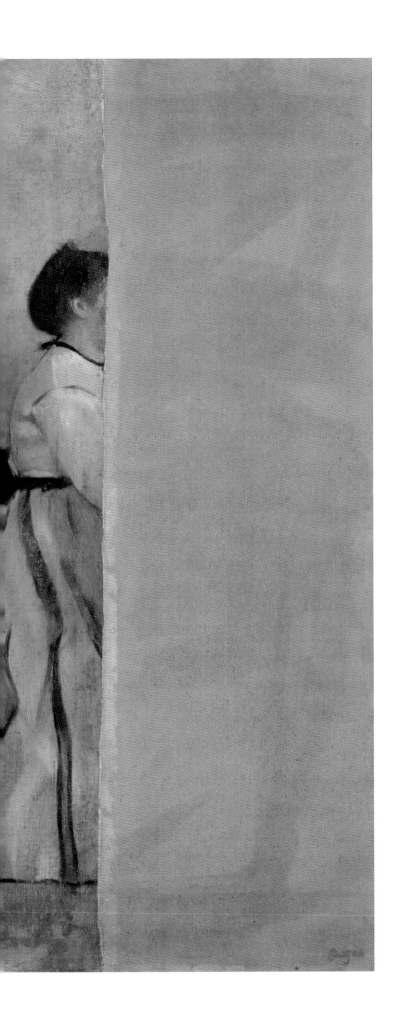

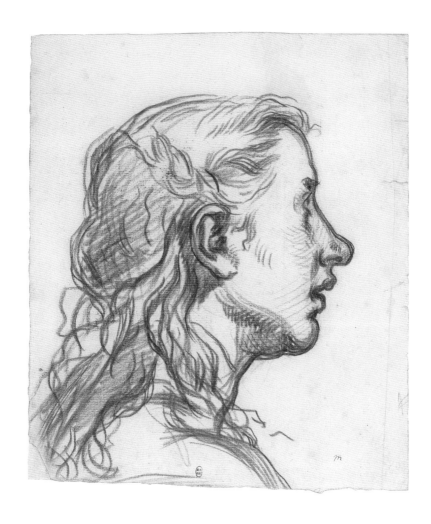

4. Édouard Manet, *Head of a Young Woman (Suzanne Manet)*, 1859–61. Red chalk with traces of black chalk

5. Édouard Manet, *Madame Manet at the Piano*, ca. 1868–69. Oil on canvas

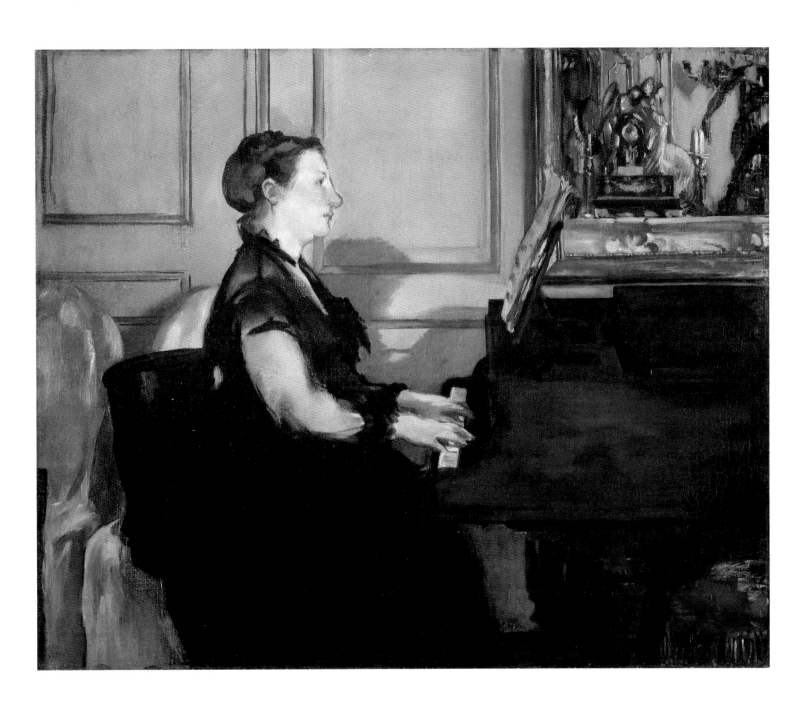

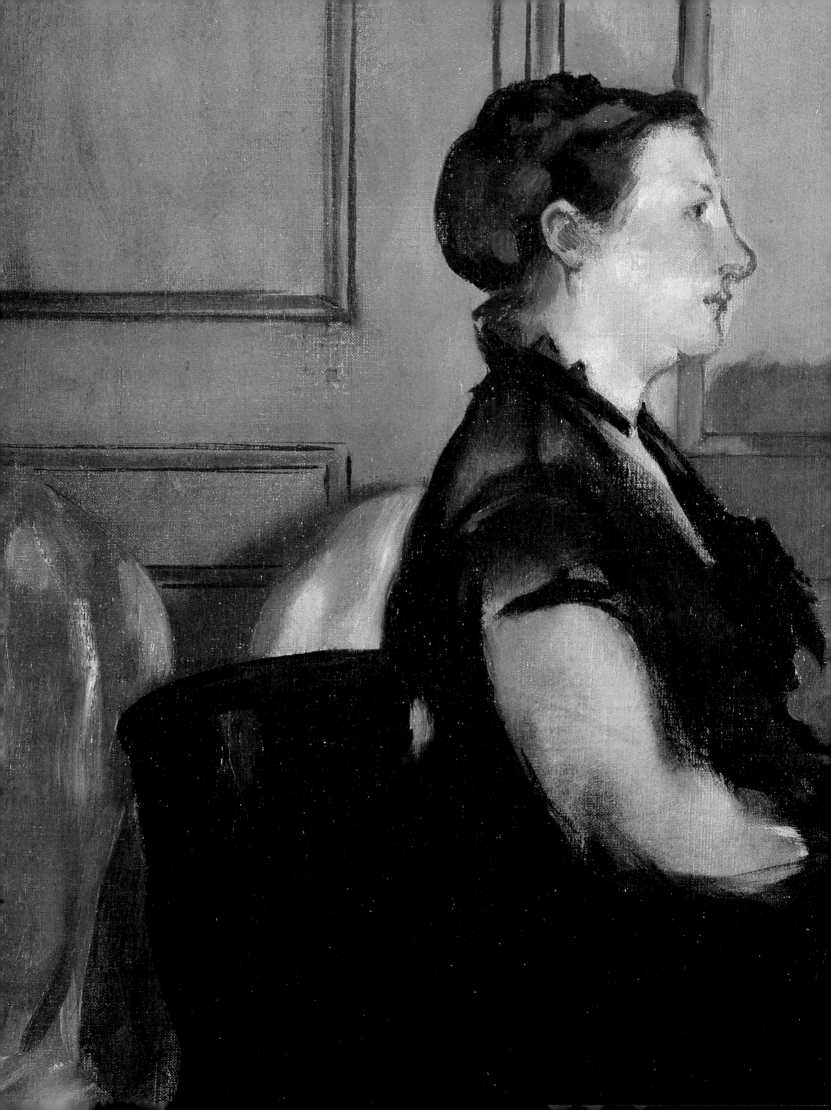

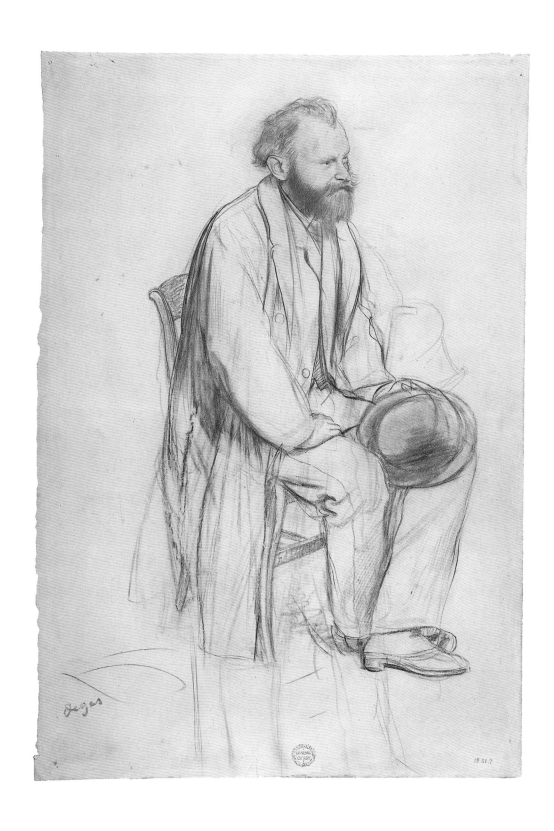

6. Edgar Degas, *Édouard Manet, Seated, Holding His Hat*, ca. 1868. Graphite and black chalk

7. Edgar Degas, *Édouard Manet, Seated, Turned to the Left*, ca. 1868. Etching

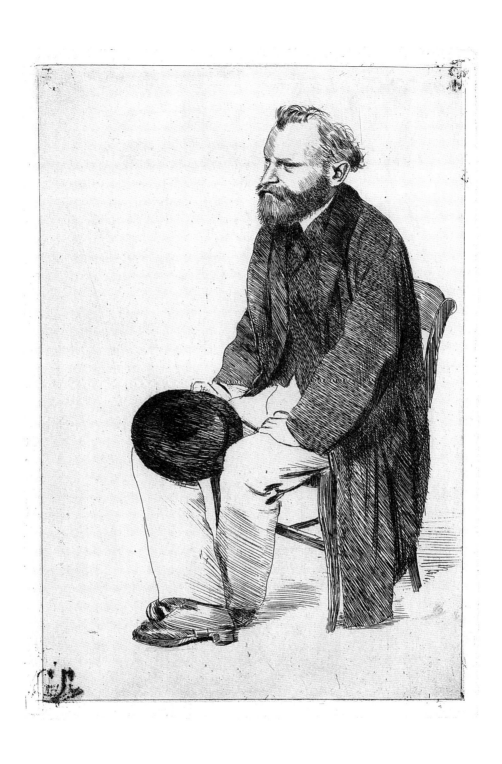

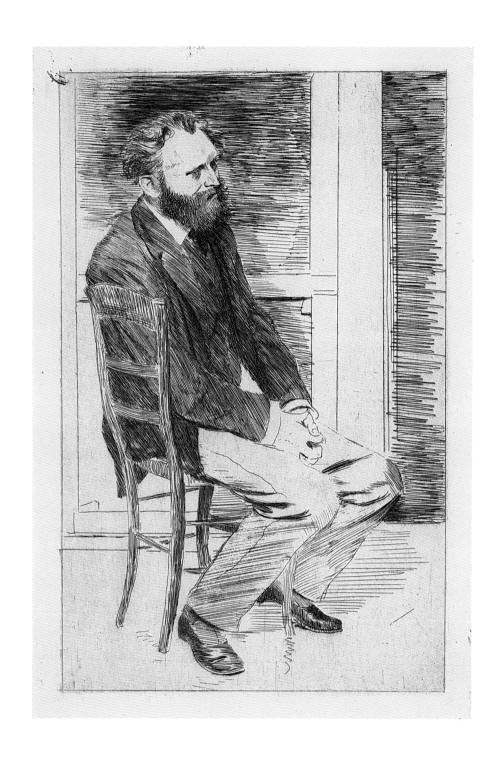

8. Edgar Degas, *Édouard Manet, Seated, Turned to the Right*, ca. 1868. Etching and drypoint

9. Edgar Degas, *Édouard Manet*, ca. 1868. Graphite with white highlights on pink wove paper

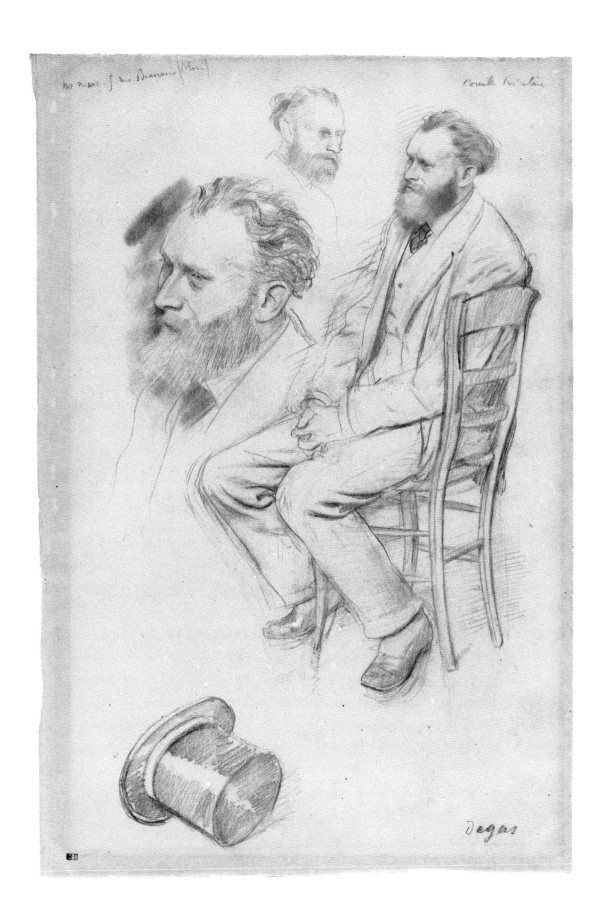

10. Edgar Degas, *Édouard Manet Standing*, ca. 1868. Graphite and ink wash

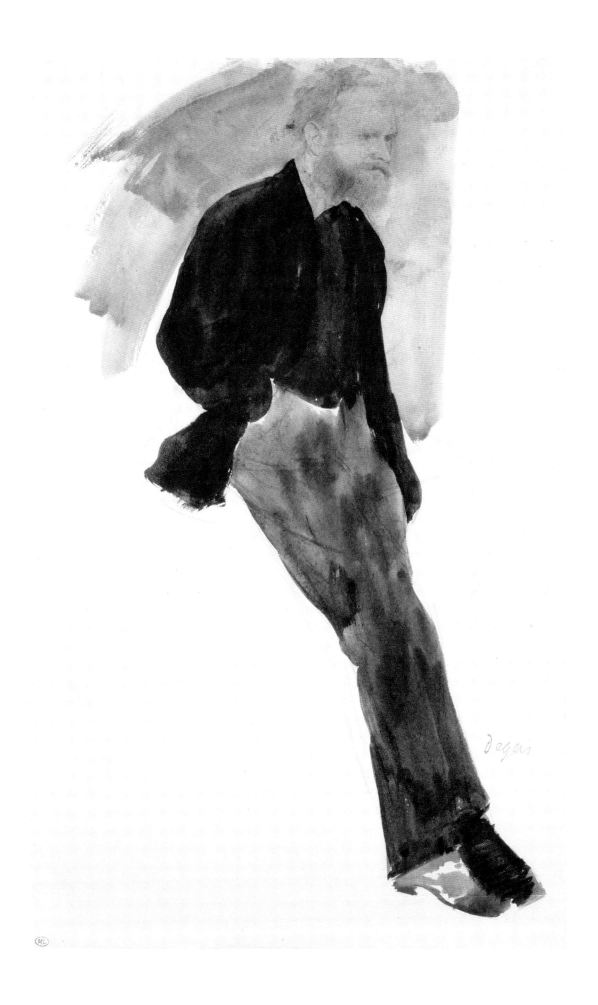

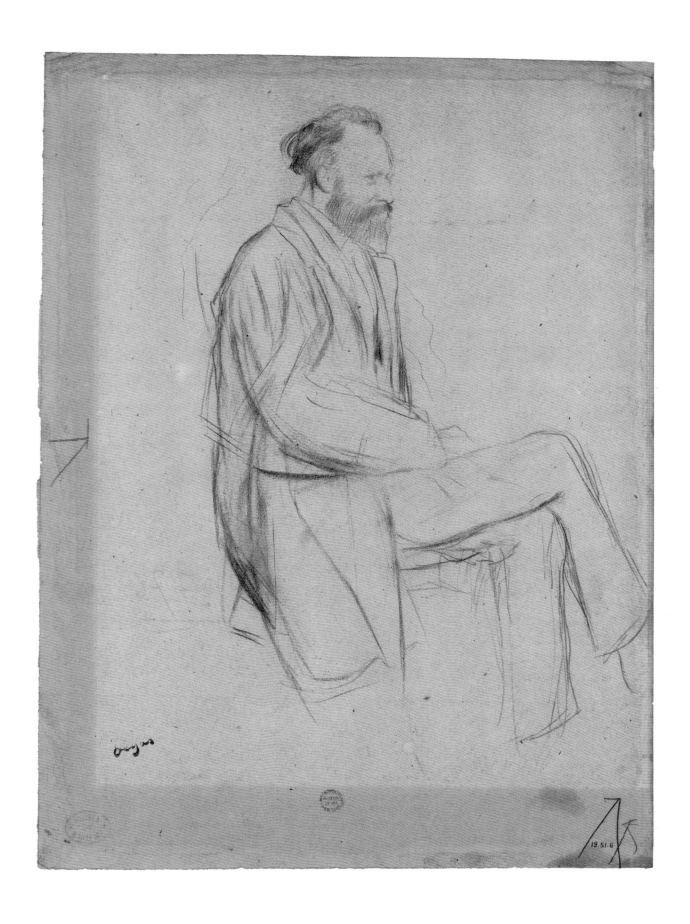

11. Edgar Degas, *Édouard Manet, Seated, Right Profile*, ca. 1868. Black chalk on faded pink wove paper

12. Edgar Degas, *Édouard Manet, Bust-Length Portrait*, ca. 1868. Etching, drypoint, and aquatint

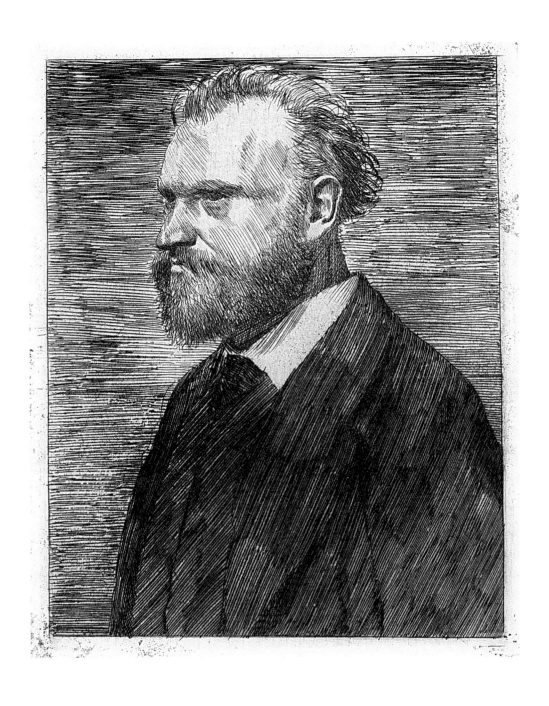

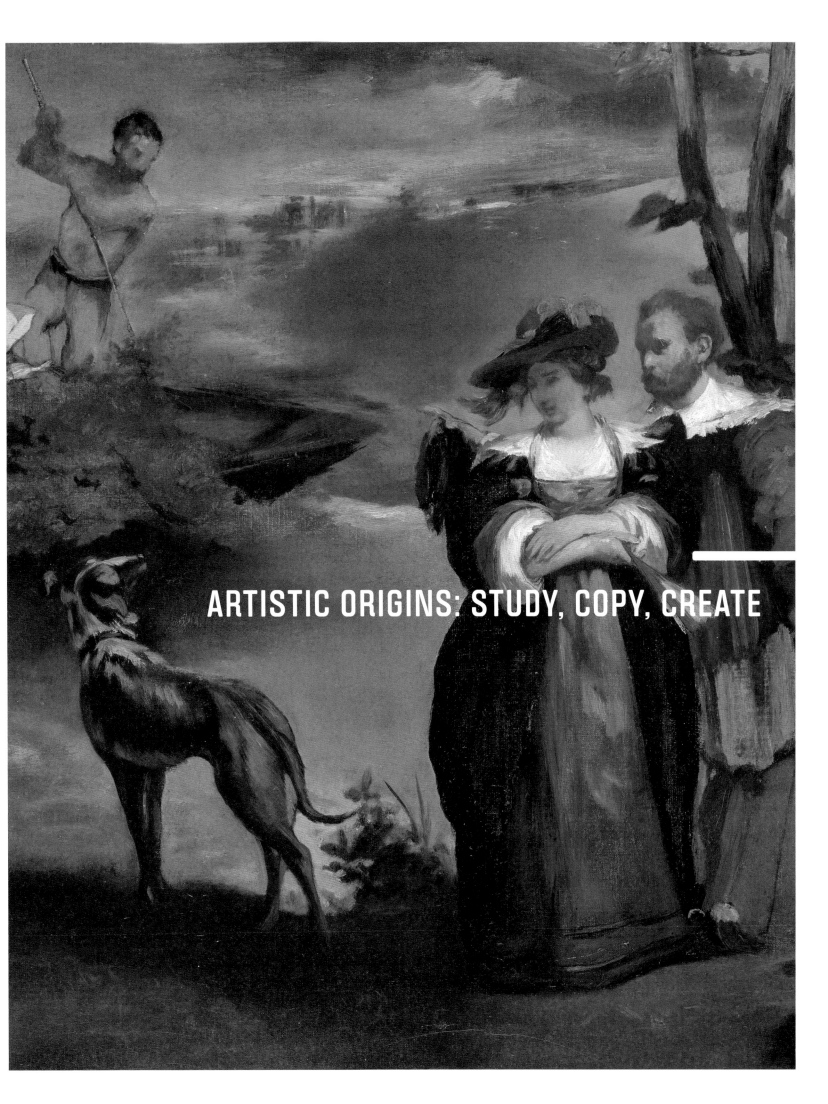

ARTISTIC ORIGINS: STUDY, COPY, CREATE

13. Édouard Manet, *Portrait of a Young Man*, ca. 1856. Pastel

14. Edgar Degas, *René De Gas*, 1855. Graphite

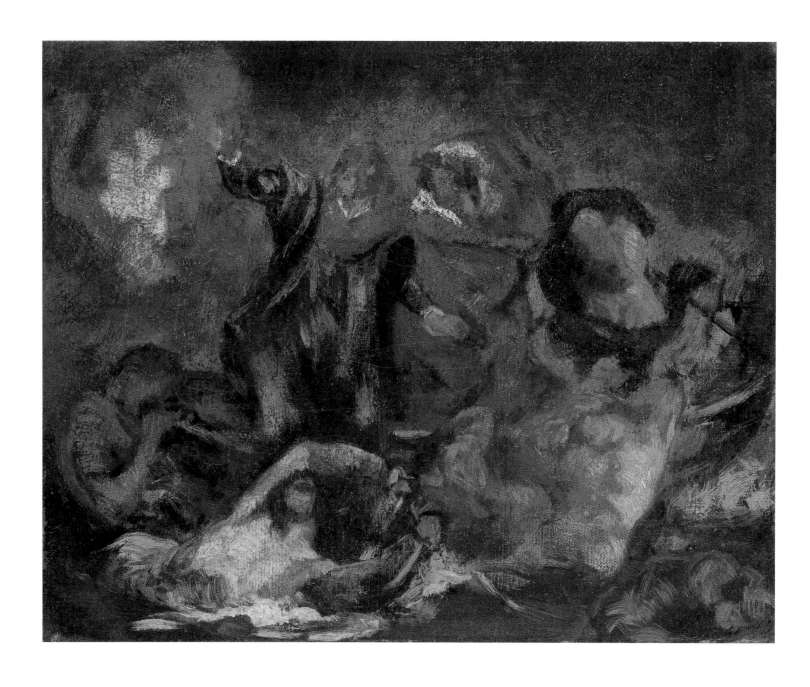

15. Édouard Manet, *Copy after Delacroix's "Barque of Dante,"* ca. 1859. Oil on canvas

16. Edgar Degas, *The Entry of the Crusaders into Constantinople, after Delacroix*, ca. 1860. Oil on cardboard

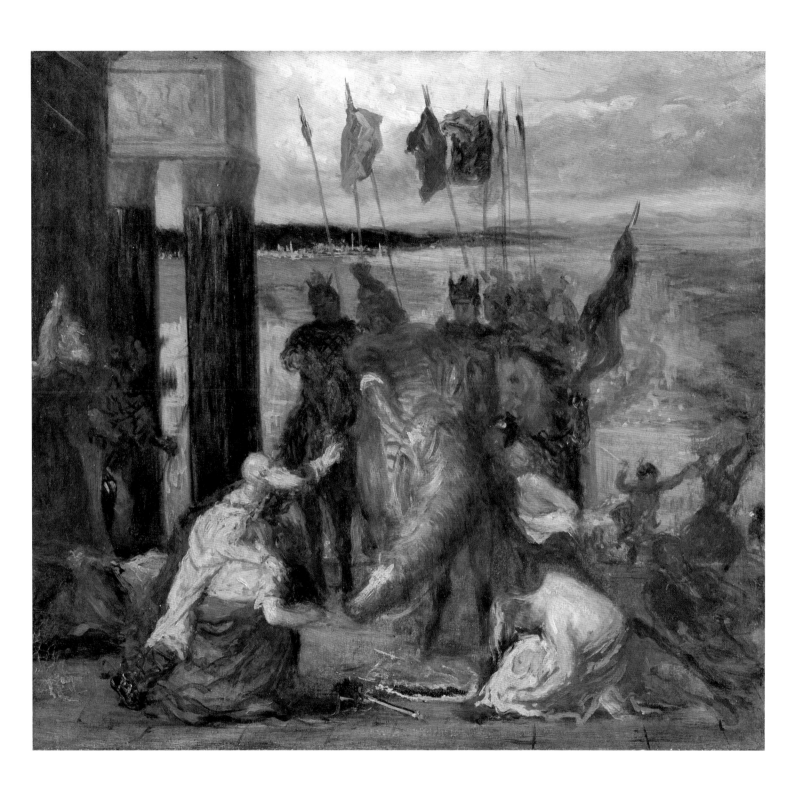

17. Édouard Manet, *The Infanta Margarita, after Velázquez*, 1861–62. Etched copperplate

18. Édouard Manet, *The Infanta Margarita, after Velázquez*, 1861–62. Etching

19. Edgar Degas, *The Infanta Margarita, after Velázquez*, ca. 1861–62. Etching and drypoint

20. Edgar Degas, *Memory of Velázquez*, ca. 1858. Oil on canvas

21. Édouard Manet, *Spanish Cavaliers*, 1859. Oil on canvas

22. Édouard Manet, *The Madonna of the Rabbit, after Titian*, ca. 1850–60. Oil on canvas

23. Edgar Degas, *The Crucifixion, after Mantegna*, ca. 1861. Oil on canvas

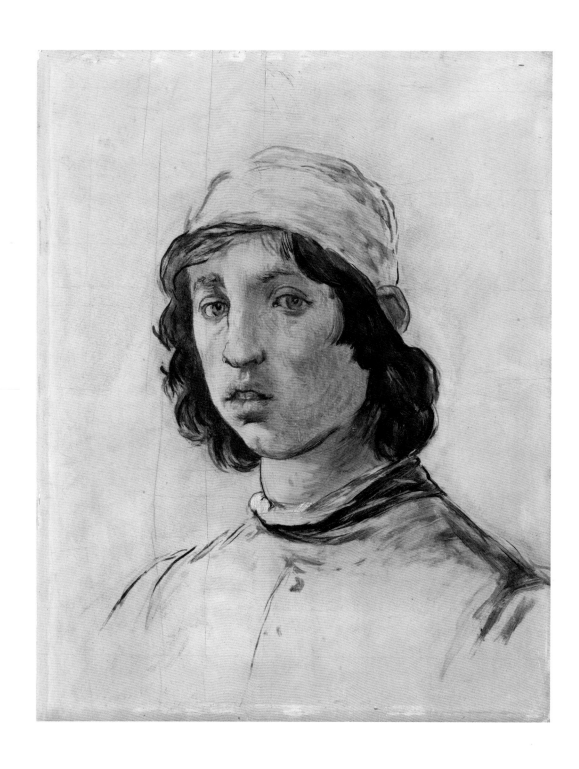

24. Édouard Manet, *Portrait of the Artist, after Filippino Lippi*, ca. 1857. Oil on cradled panel

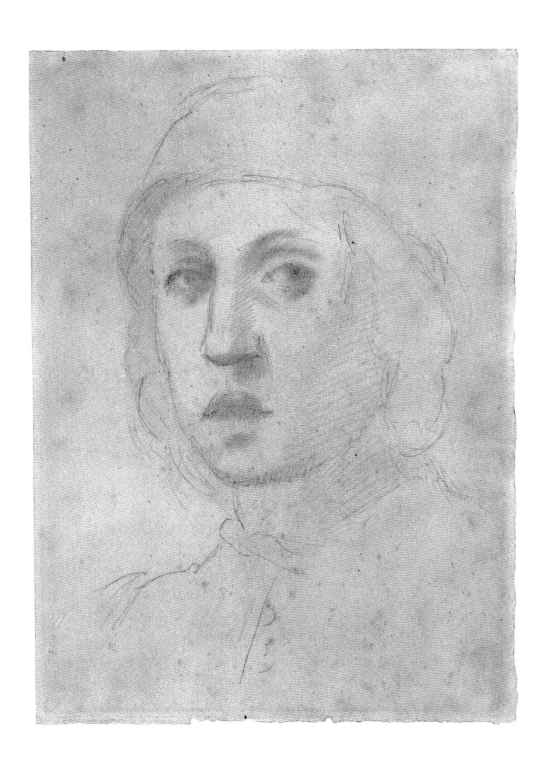

25. Edgar Degas, *Self-Portrait in the Manner of Filippino Lippi*, ca. 1858. Graphite

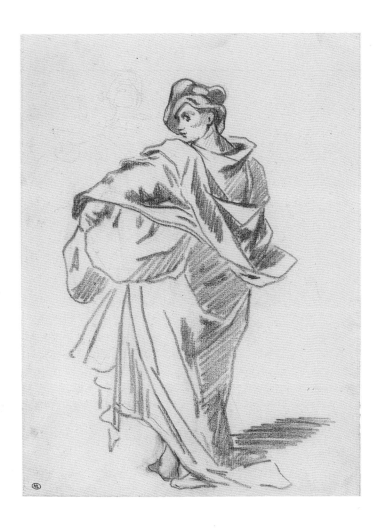

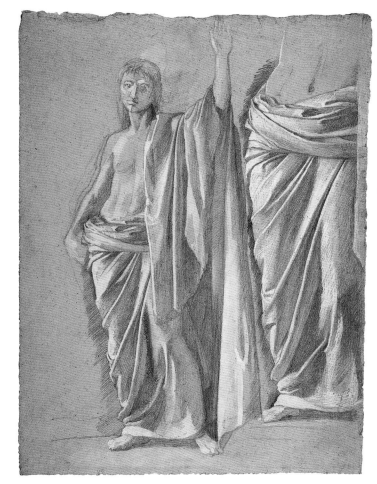

26. Édouard Manet, *Standing Man, after del Sarto*, ca. 1853–57. Red chalk

27. Edgar Degas, *Study of a Draped Figure*, 1857–58. Graphite heightened with white gouache

28. Edgar Degas, *The Old Italian Woman*, 1857. Oil on canvas

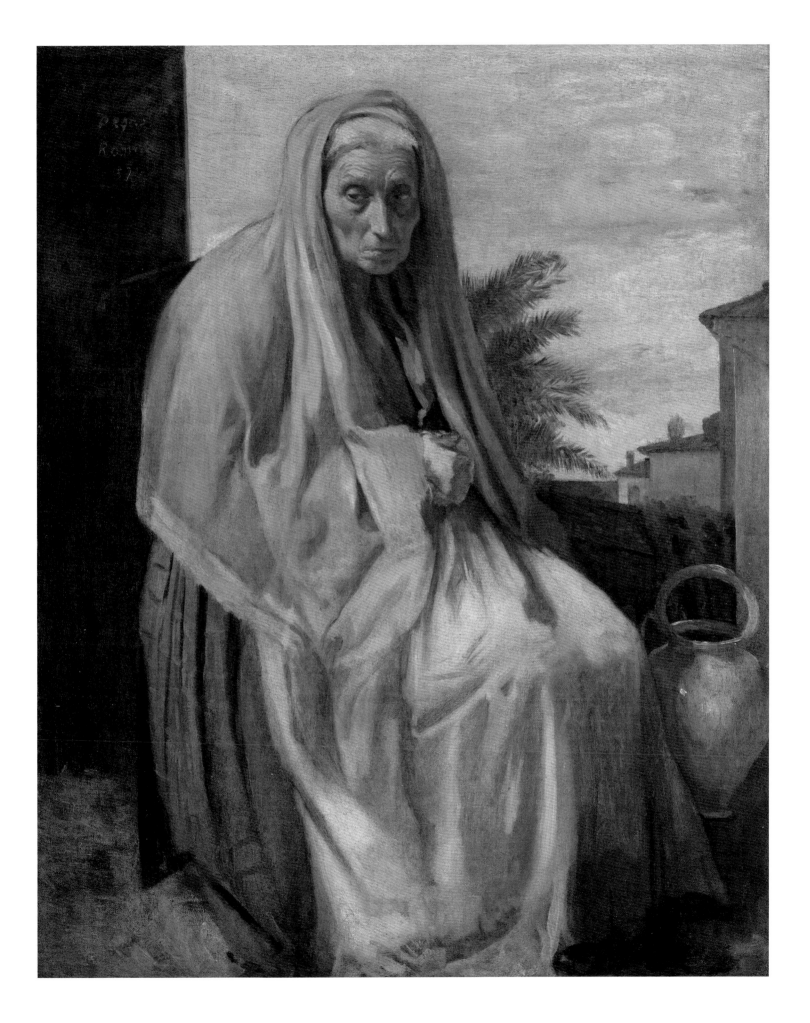

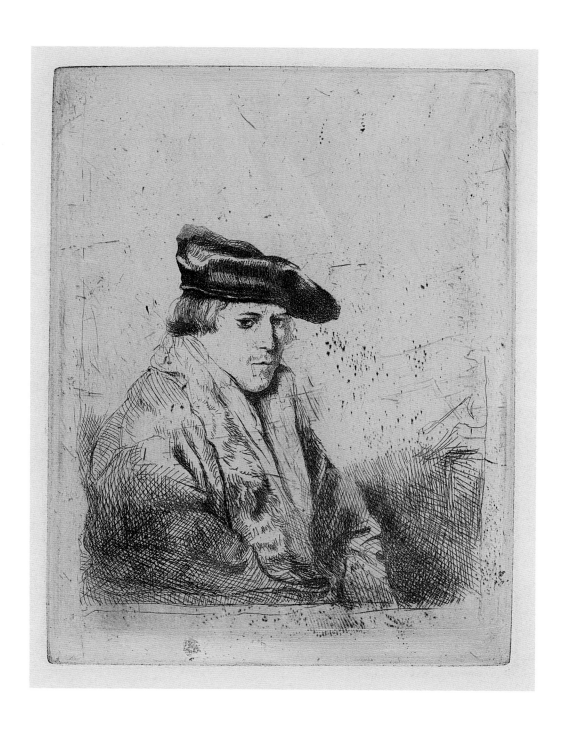

29. Edgar Degas, *Young Man, Seated, in a Velvet Beret, after Rembrandt,* 1857. Etching

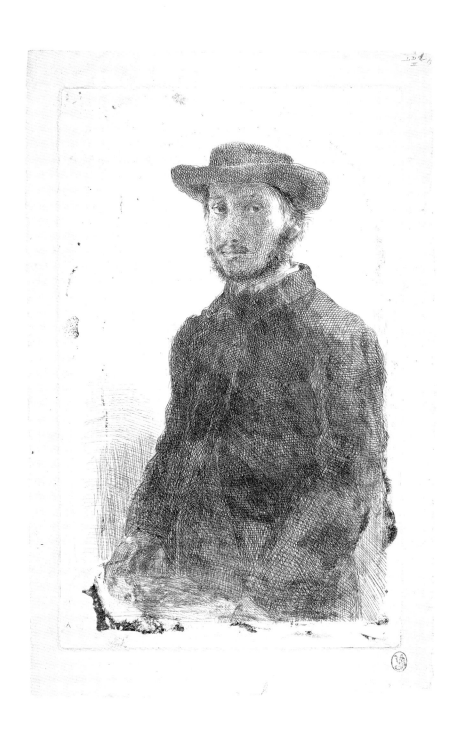

30. Edgar Degas, *Self-Portrait*, 1857. Etching and bitten tone

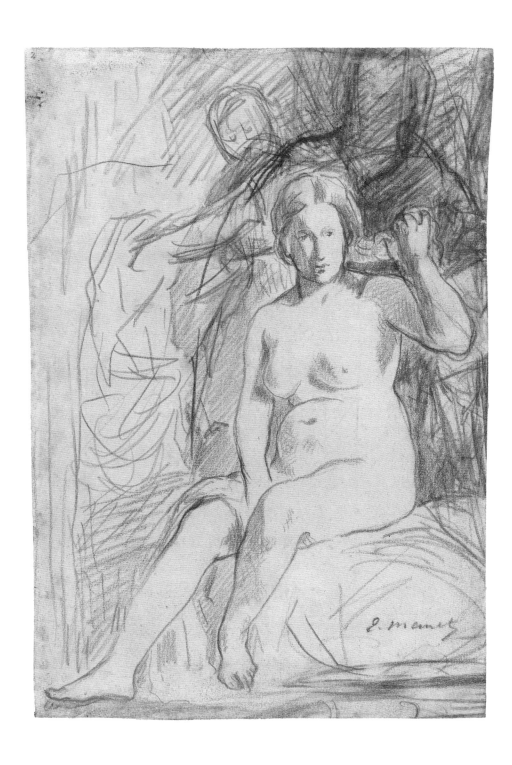

31. Édouard Manet, *Seated Nude*, ca. 1858–60. Red chalk

32. Édouard Manet, *After the Bath*, 1860–61. Pen and brown ink,
brush and wash, over red chalk, with black chalk corrections

33. Édouard Manet, *Fishing*, ca. 1862–63. Oil on canvas

34. Edgar Degas, *Studies of Figures after "Judgment of Paris" and "Parnassus"*
by Marcantonio Raimondi, ca. 1853–56. Brown ink on cream tracing paper

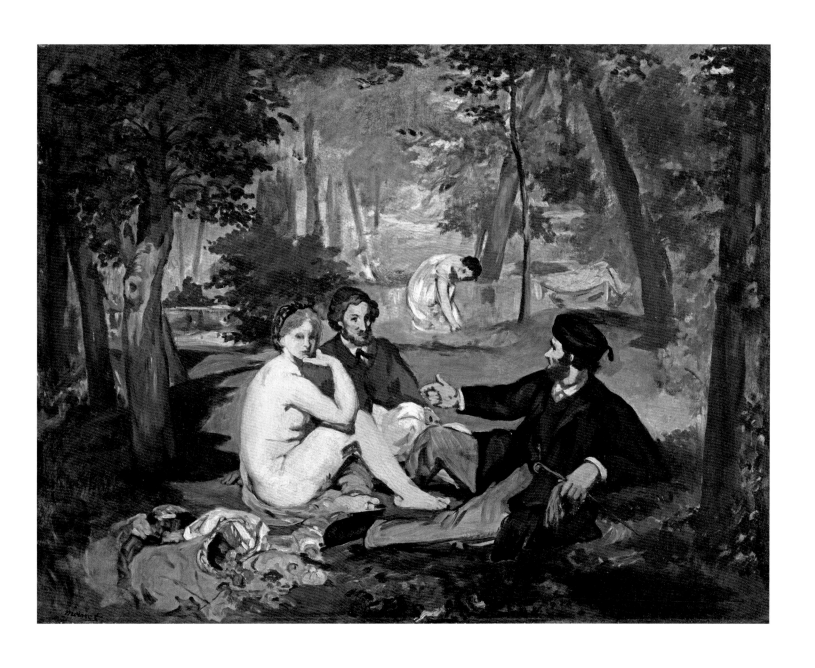

35. Édouard Manet, *Study for "Déjeuner sur l'herbe,"* 1863. Oil on canvas

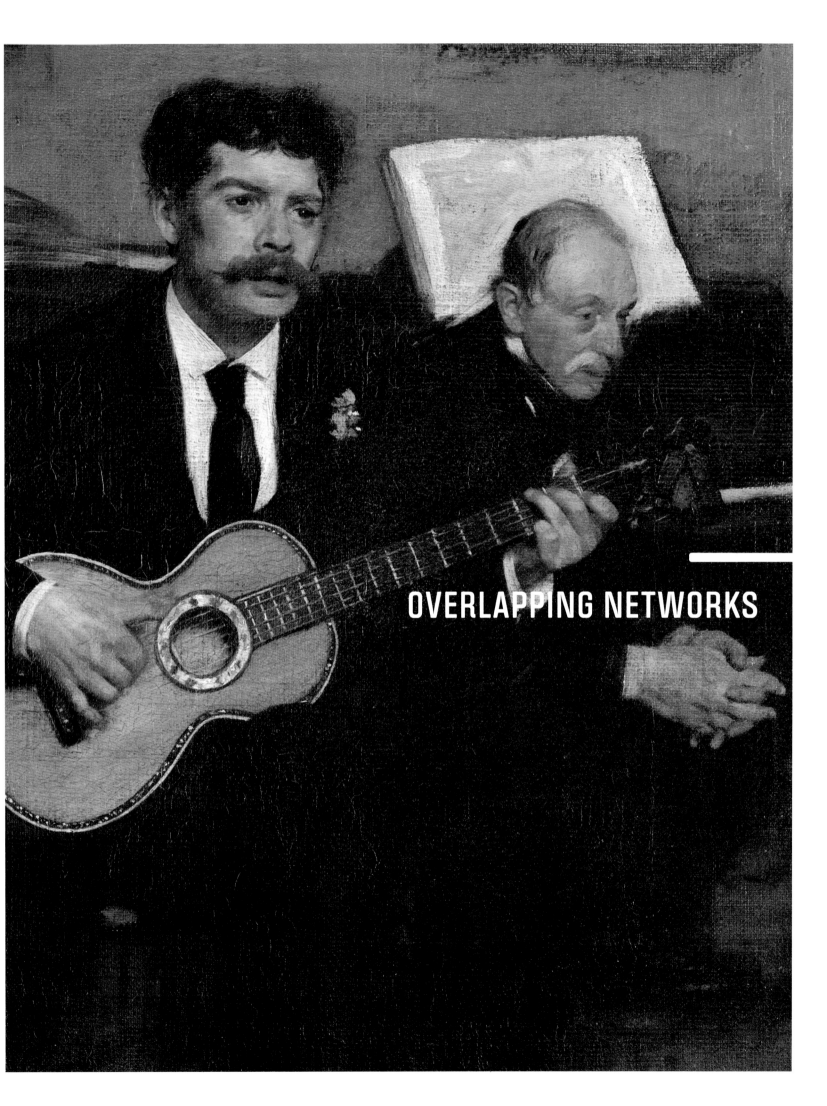

OVERLAPPING NETWORKS

36. Edgar Degas, *Hilaire Degas*, 1857. Oil on canvas

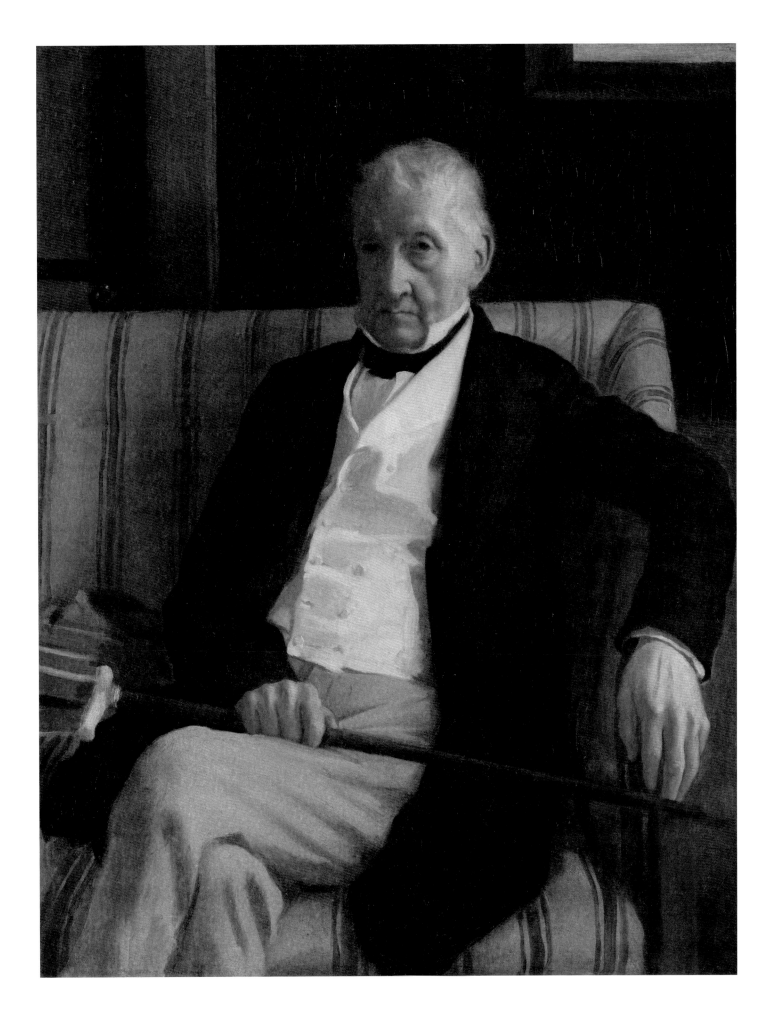

37. Édouard Manet, *Monsieur Manet (The Artist's Father) I*, 1860. Etching and drypoint

38. Édouard Manet, *Monsieur and Madame Auguste Manet*, 1860. Oil on canvas

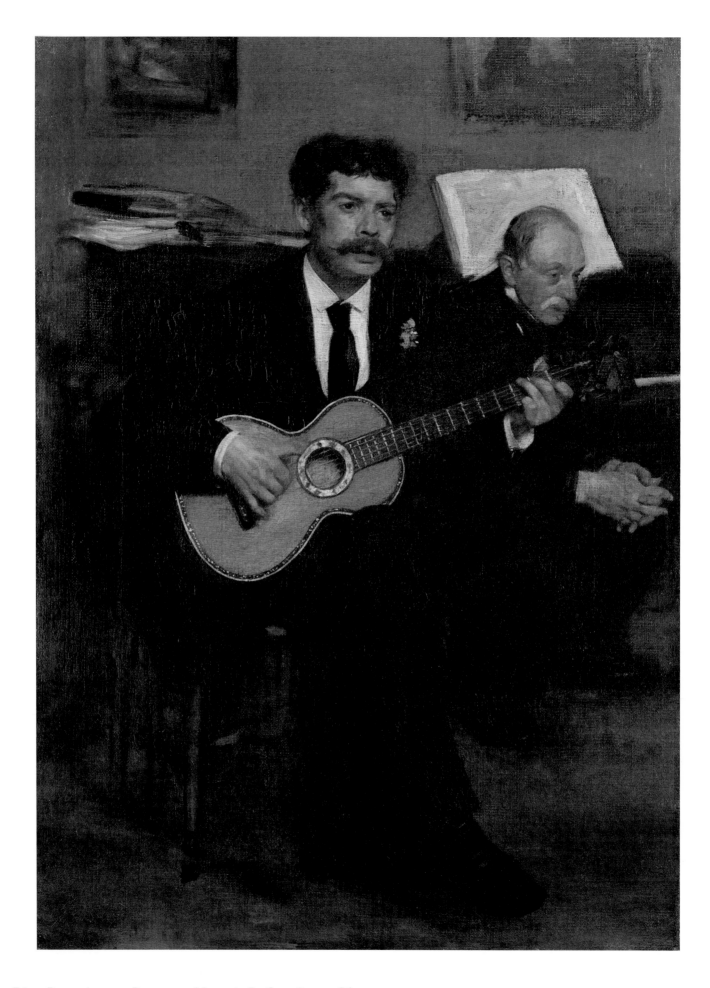

39. Edgar Degas, *Lorenzo Pagans and Auguste De Gas*, 1871–72. Oil on canvas

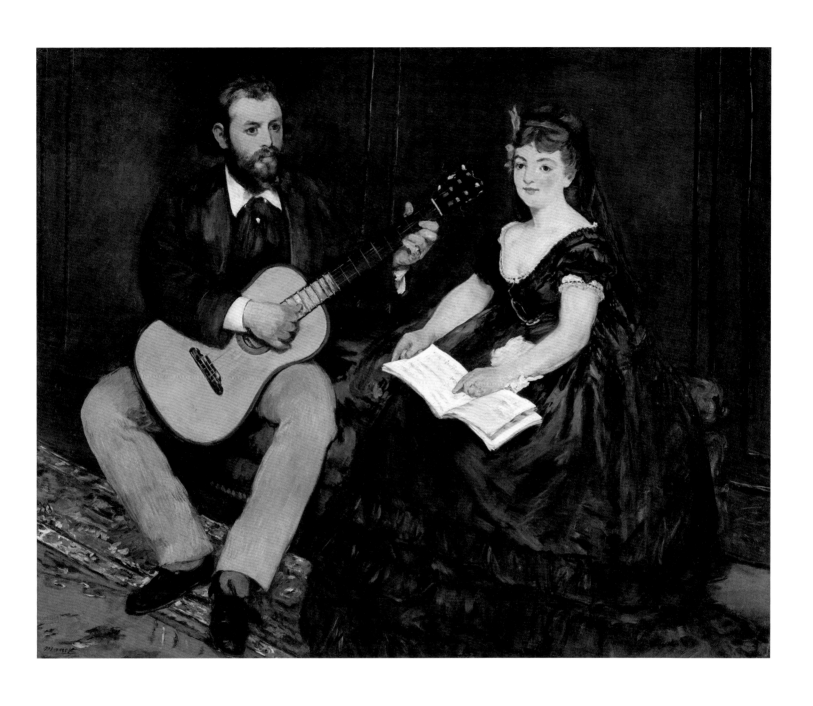

40. Édouard Manet, *Music Lesson*, 1870. Oil on canvas

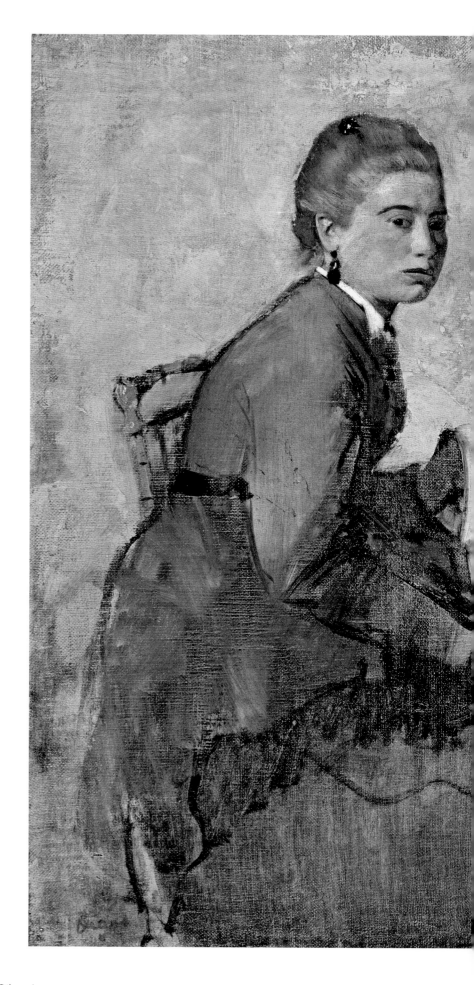

41. Edgar Degas, *Violinist and Young Woman*, ca. 1871. Oil and crayon on canvas

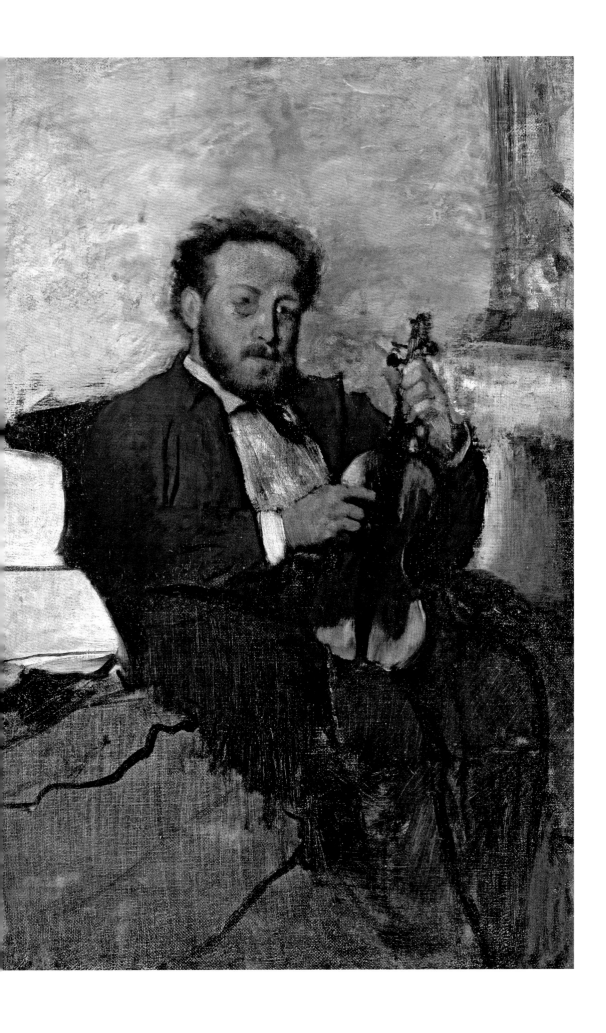

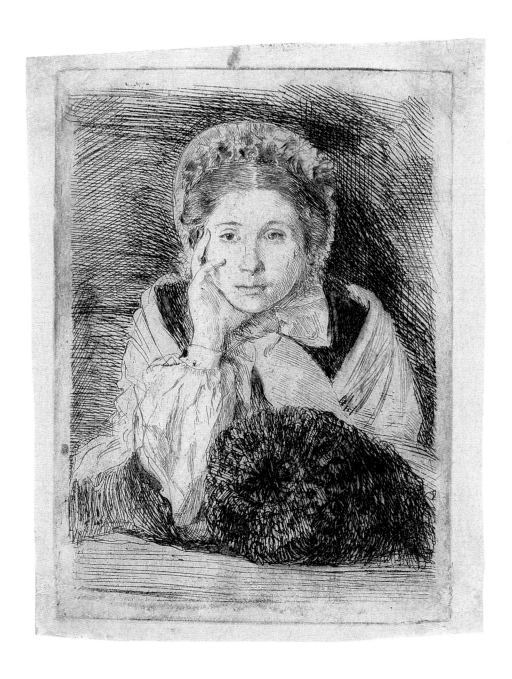

42. Edgar Degas, *Marguerite De Gas, the Artist's Sister*, 1860–62. Etching and drypoint

43. Edgar Degas, *Edmondo and Thérèse Morbilli*, ca. 1865. Oil on canvas

44. Édouard Manet, *Boy with a Sword*, 1861. Oil on canvas

45. Édouard Manet, *Reading*, ca. 1866, probably resumed ca. 1873. Oil on canvas

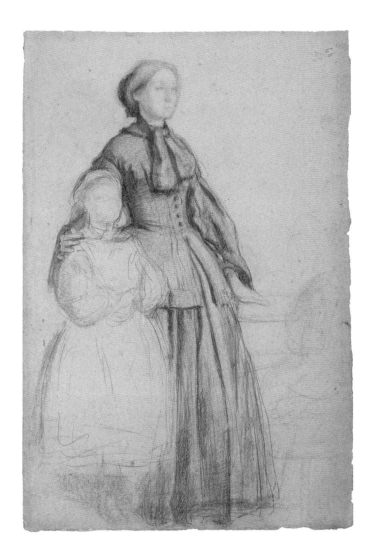 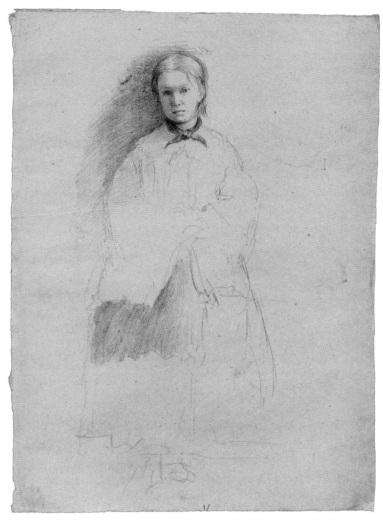

46. Edgar Degas, *Laura Bellelli and her daughter Giovanna,*
Study for "The Bellelli Family," ca. 1858. Black conté crayon on pinkish
buff paper with traces of white heightening

47. Edgar Degas, *Giovanna Bellelli, Study for "The Bellelli Family,"*
ca. 1858. Conté crayon on blue wove paper

48. Edgar Degas, *Giovanna Bellelli, Study for "The Bellelli Family,"*
ca. 1858. Charcoal partially covered and fixed with shellac

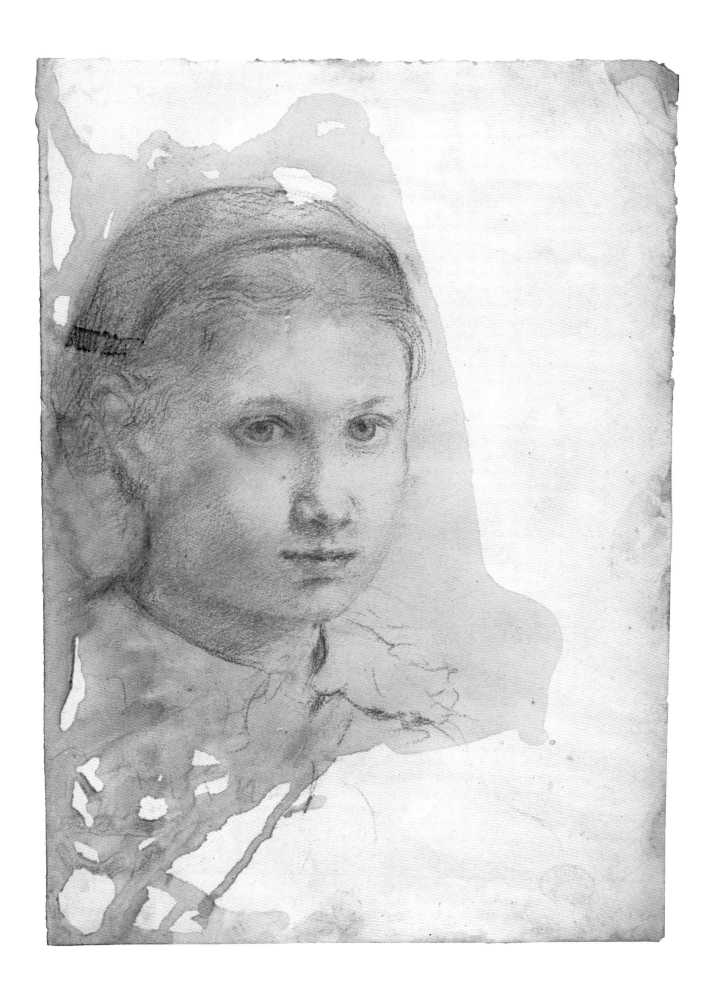

49. Edgar Degas, *Family Portrait (The Bellelli Family),* 1858–69. Oil on canvas

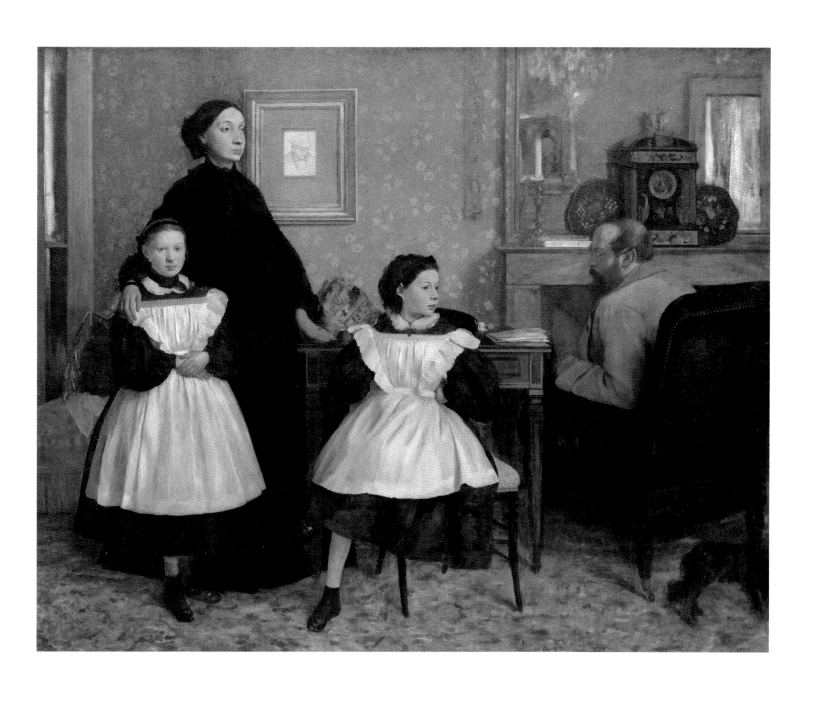

50. Edgar Degas, *Study for "Madame Théodore Gobillard" (Yves Morisot)*, 1869. Graphite

51. Edgar Degas, *Study for "Madame Théodore Gobillard" (Yves Morisot)*, 1869. Graphite, squared, on buff tracing paper, mounted on laid paper

52. Edgar Degas, *Study for "Madame Théodore Gobillard" (Yves Morisot)*, 1869.

Black crayon and graphite with white highlights

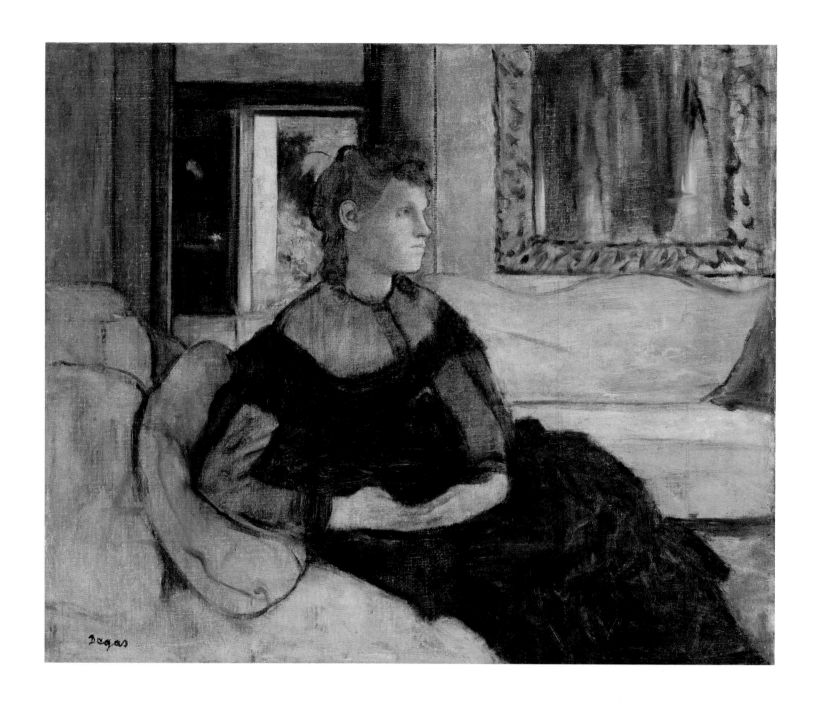

53. Edgar Degas, *Madame Théodore Gobillard (Yves Morisot)*, 1869. Oil on canvas

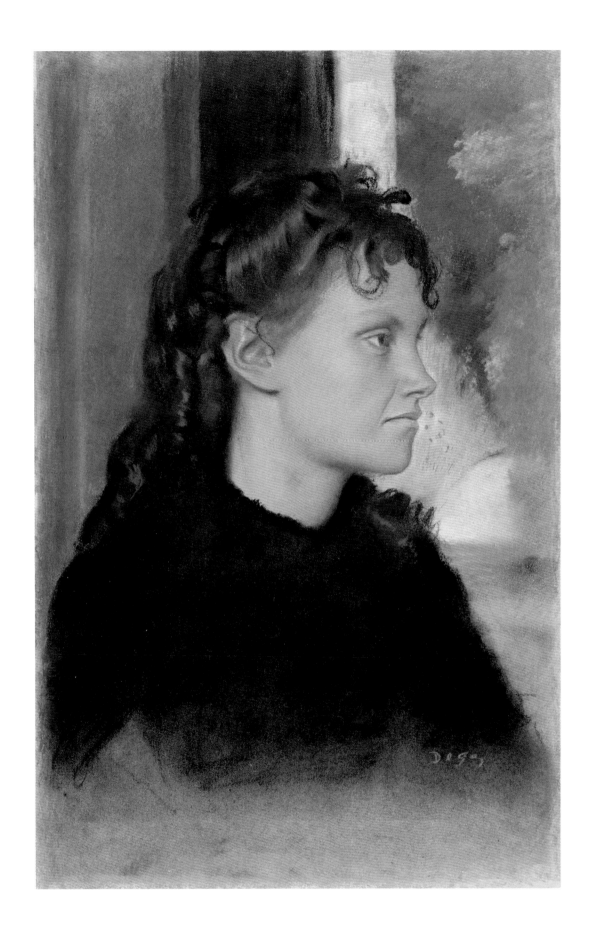

54. Edgar Degas, *Madame Théodore Gobillard (Yves Morisot)*, 1869. Pastel

55. Édouard Manet, *Repose*, ca. 1871. Oil on canvas

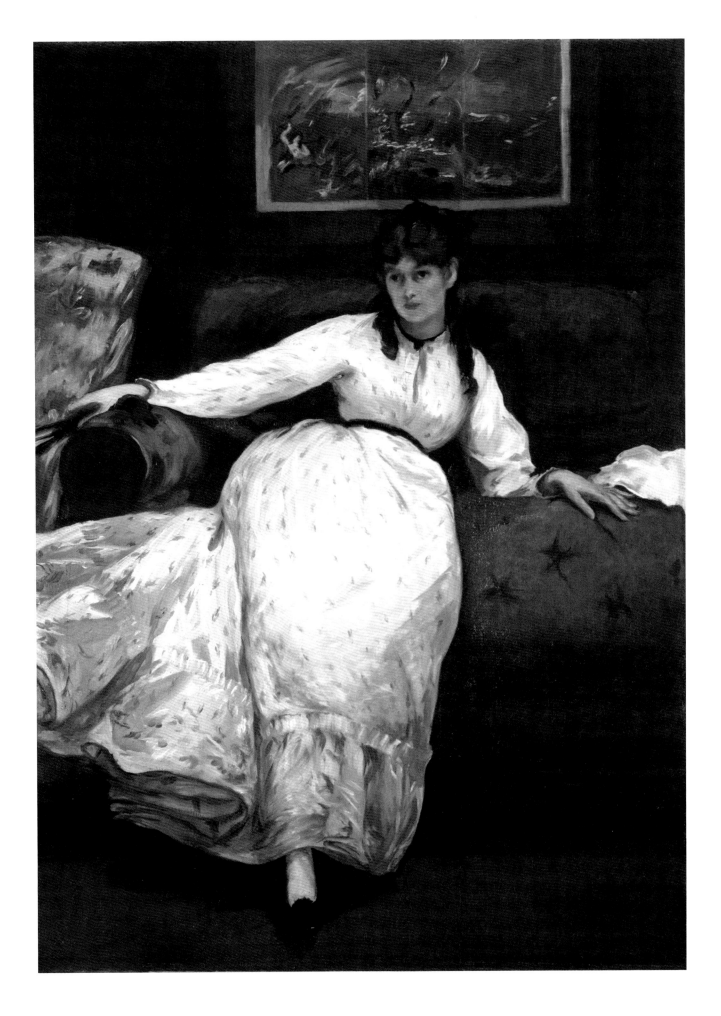

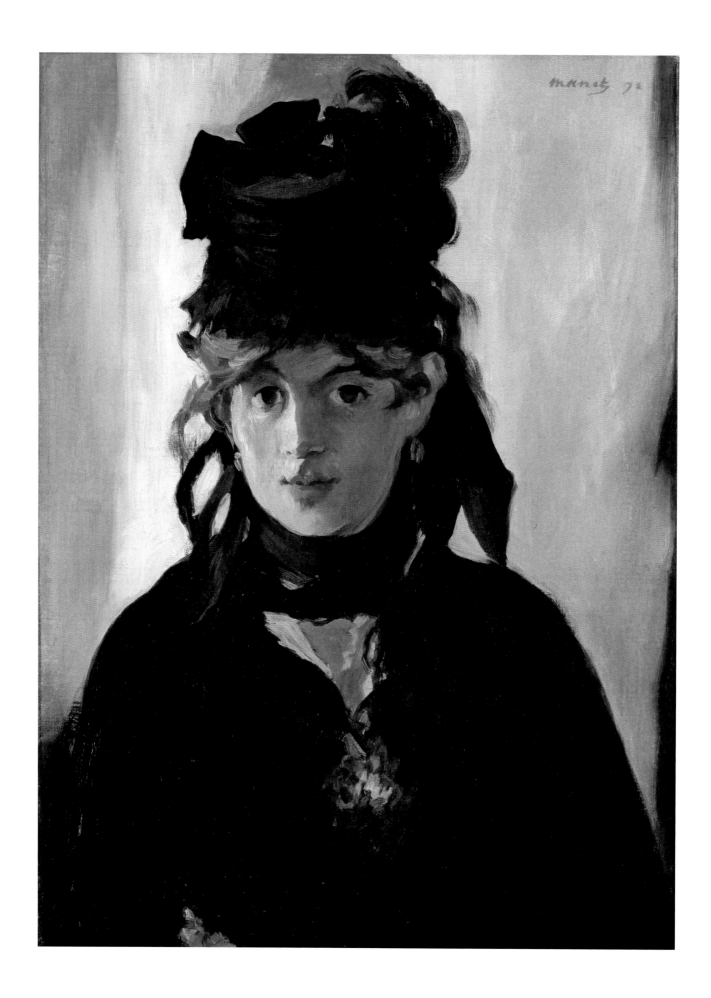

56. Édouard Manet, *Berthe Morisot with a Bouquet of Violets*, 1872. Oil on canvas

57. Édouard Manet, *Berthe Morisot*, 1872. Etching and drypoint

58. Édouard Manet, *Berthe Morisot (in Black)*, 1872–74, published 1884. Lithograph on chine collé

59. Édouard Manet, *Berthe Morisot (in Silhouette)*, 1872–74, published 1884. Lithograph on chine collé

60. Edgar Degas, *Eugène Manet*, 1874. Oil on paper laid down on board

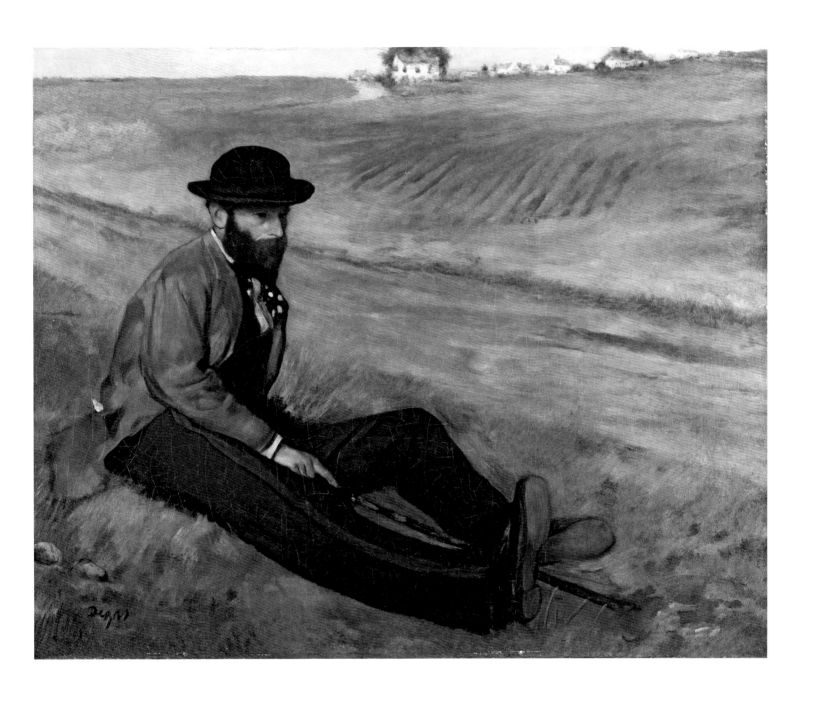

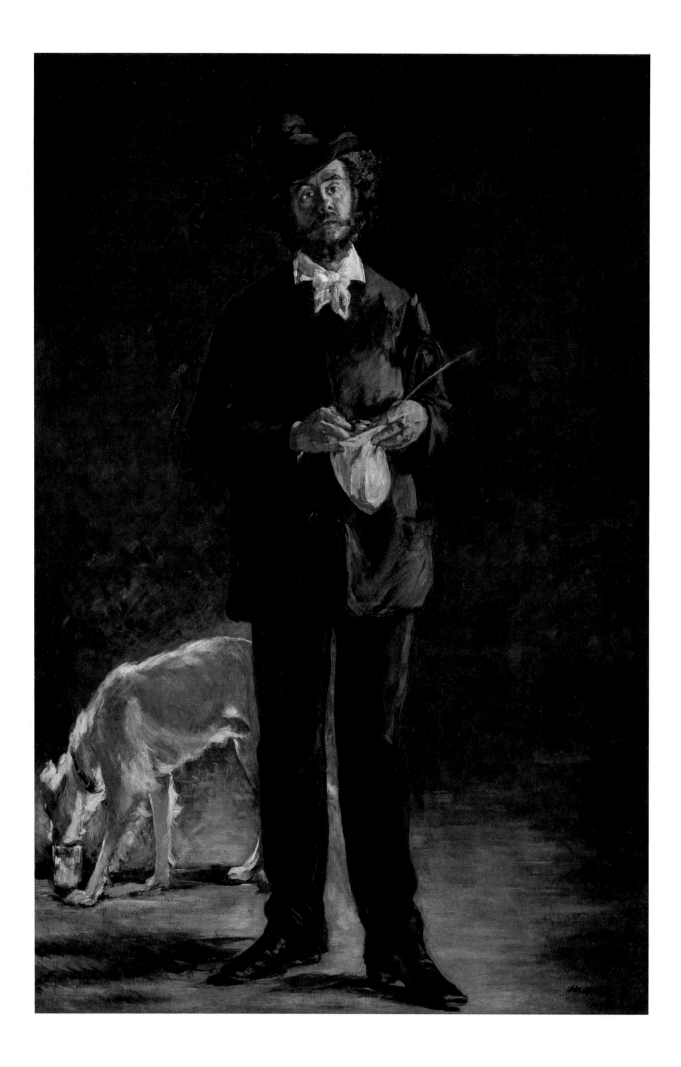

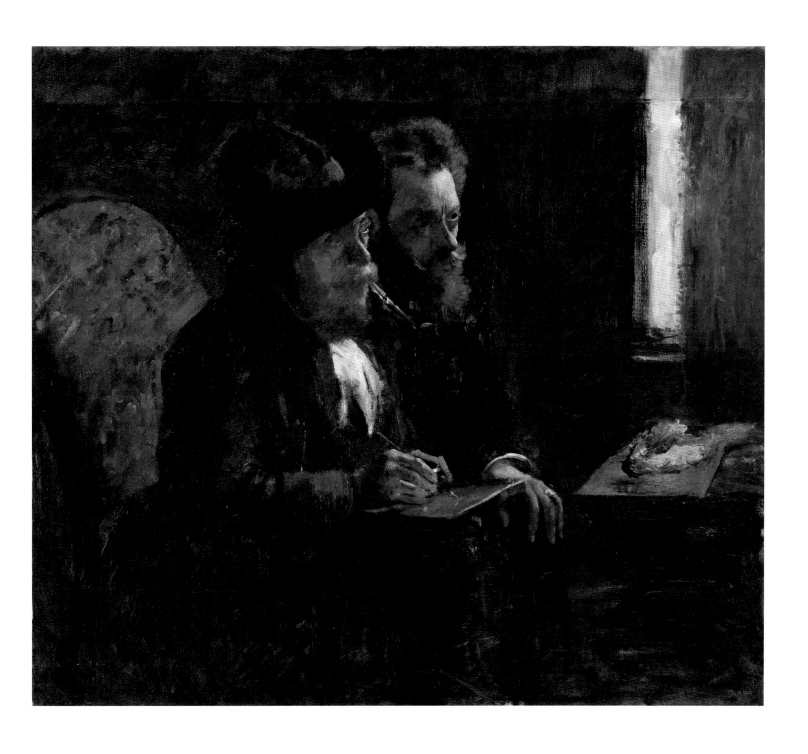

61. Édouard Manet, *The Artist (Marcellin Desboutin)*, 1875. Oil on canvas

62. Edgar Degas, *Marcellin Desboutin and Ludovic Lepic*, 1876–77. Oil on canvas

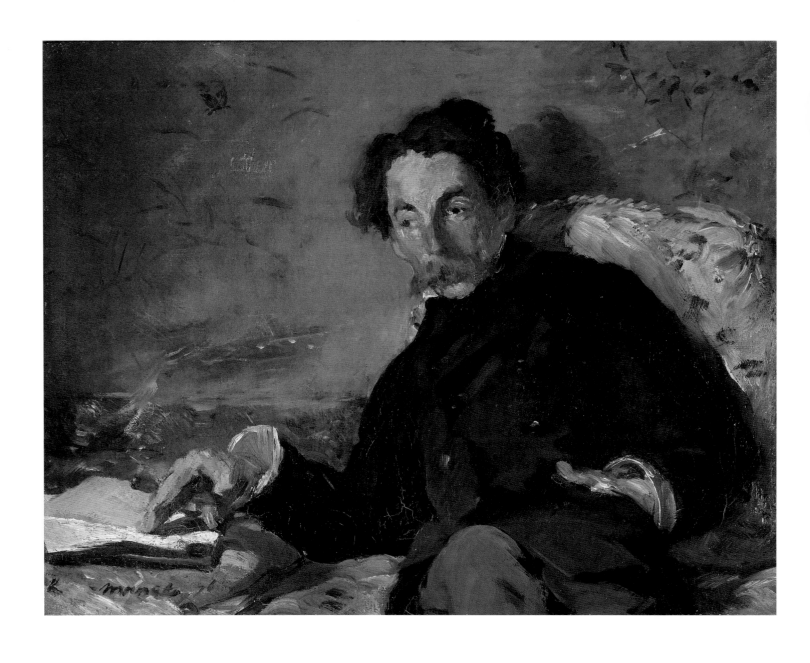

63. Édouard Manet, *Stéphane Mallarmé*, 1876. Oil on canvas

64. Edgar Degas, *Stéphane Mallarmé and Paule Gobillard in front of*
"Young Woman in a Garden" by Manet, 1895. Gelatin silver print

65. Édouard Manet, *George Moore at the Café*, 1878 or 1879. Oil on canvas

66. Édouard Manet, *George Moore*, 1879. Pastel on canvas

67. Edgar Degas, *Edmond Duranty*, 1879. Conté crayon, heightened with white chalk, on blue laid paper

68. Edgar Degas, *Diego Martelli*, 1879. Oil on canvas

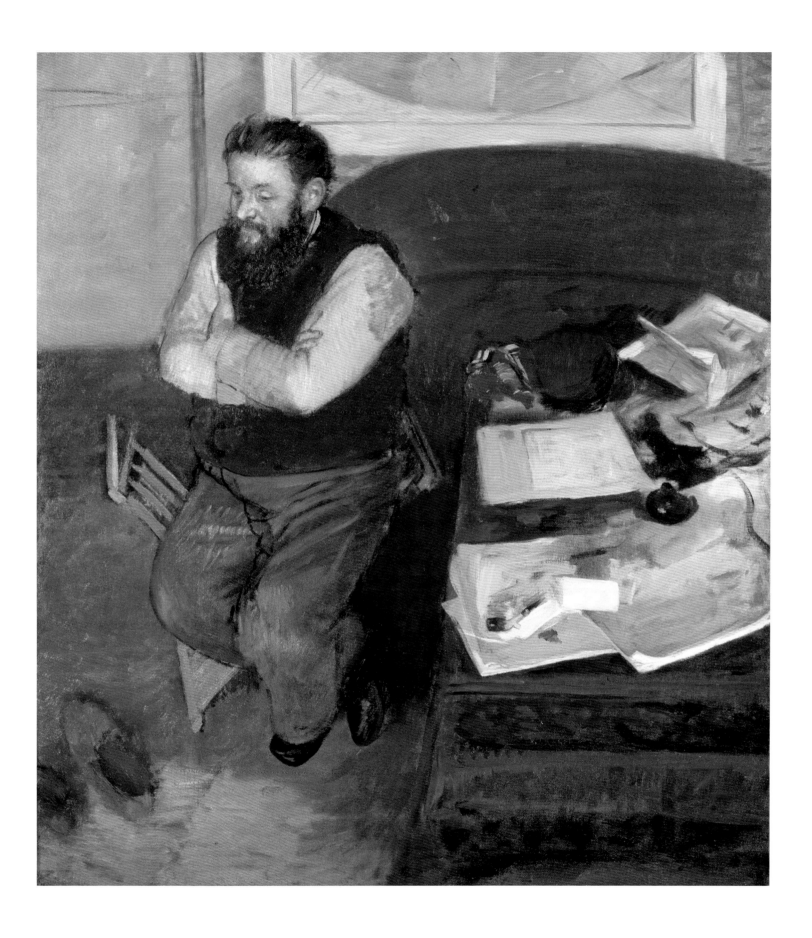

69. Édouard Manet, *Antonin Proust*, 1880. Oil on canvas

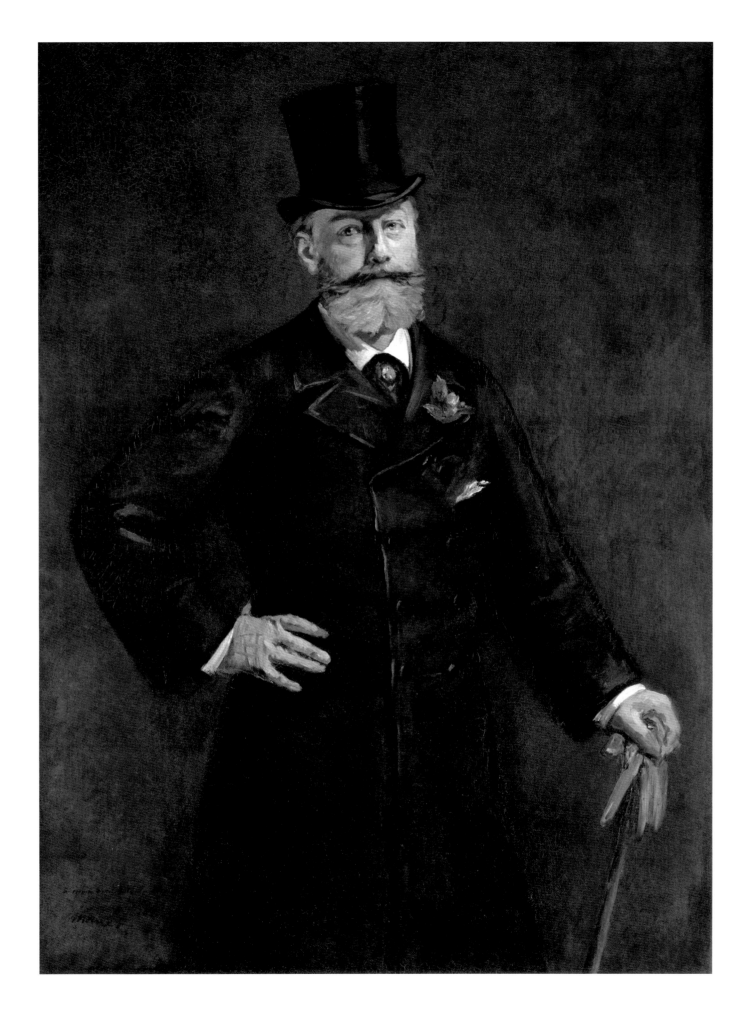

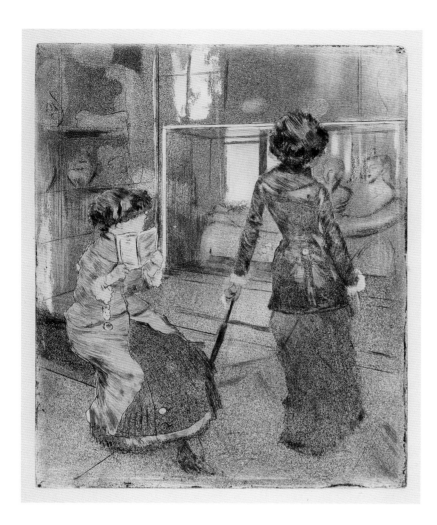

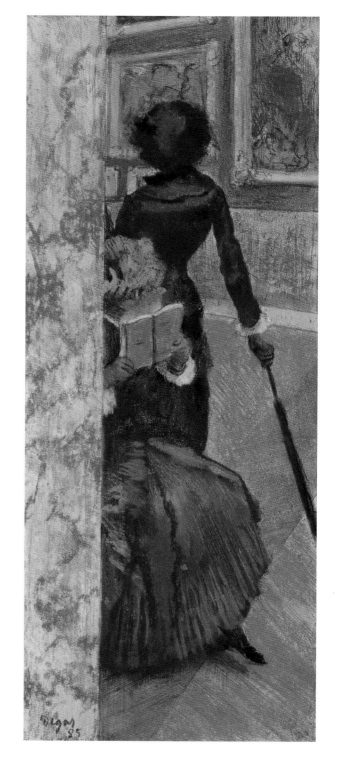

70. Edgar Degas, *Mary Cassatt at the Louvre: The Etruscan Gallery*, 1879–80.

Soft ground, drypoint, aquatint, and etching

71. Edgar Degas, *Mary Cassatt at the Louvre: The Paintings Gallery*, 1885.

Pastel over etching, aquatint, drypoint, and crayon électrique

72. Edgar Degas, *Visit to a Museum*, ca. 1879–90. Oil on canvas

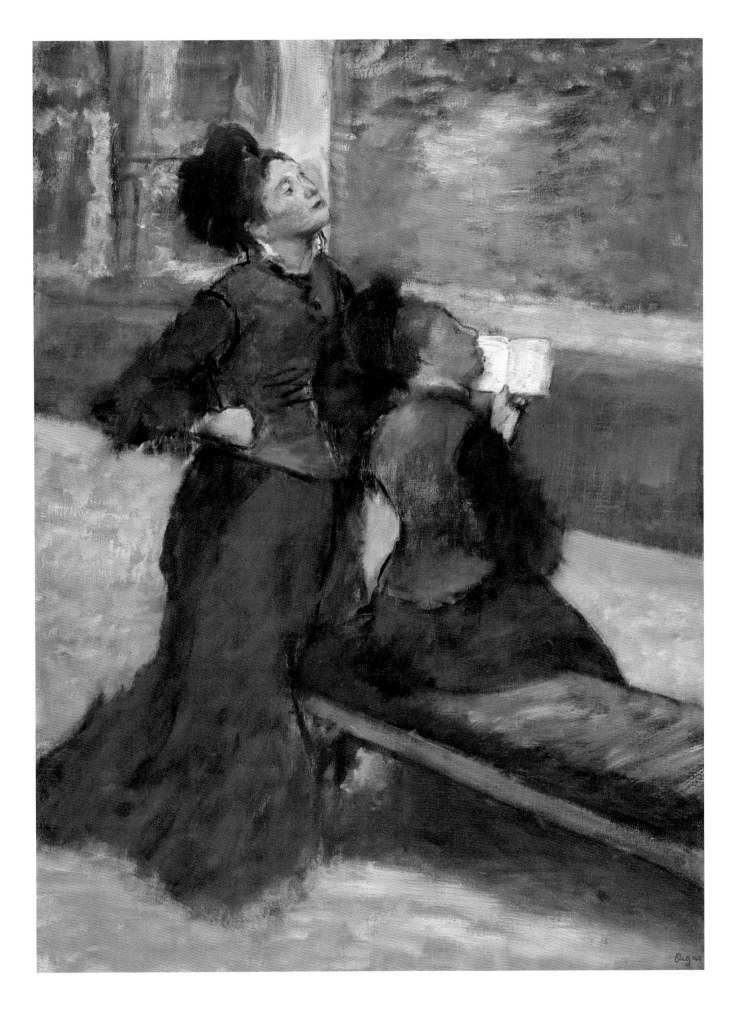

CHALLENGING GENRES

73. Édouard Manet, *The Spanish Singer*, 1860. Oil on canvas

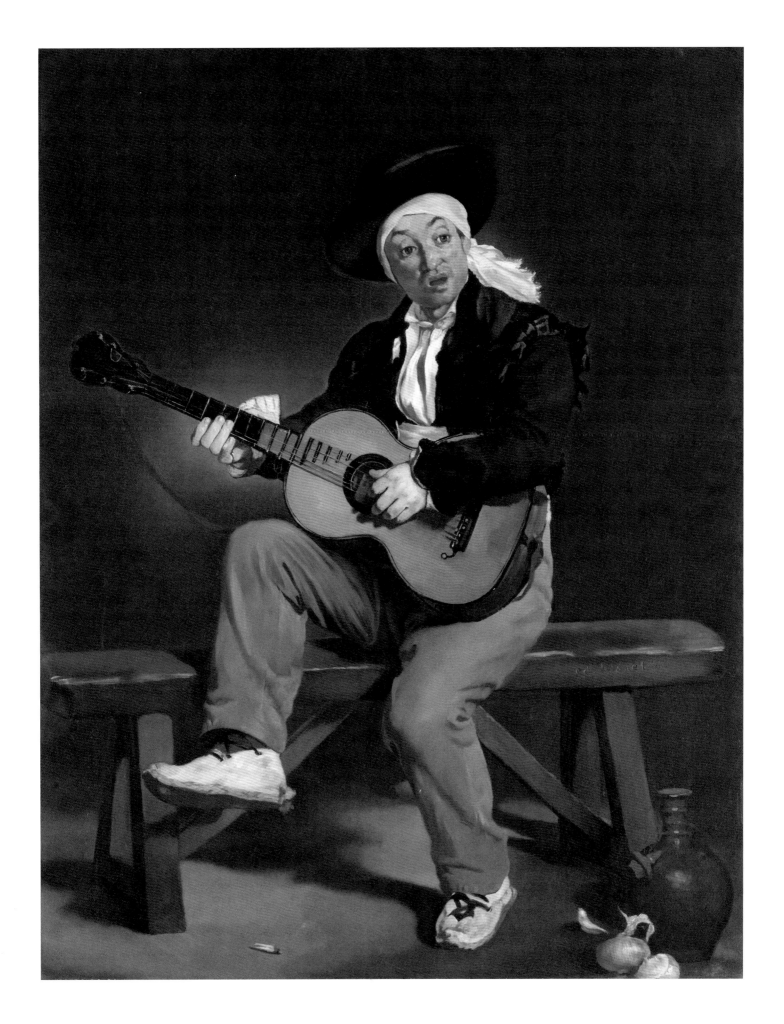

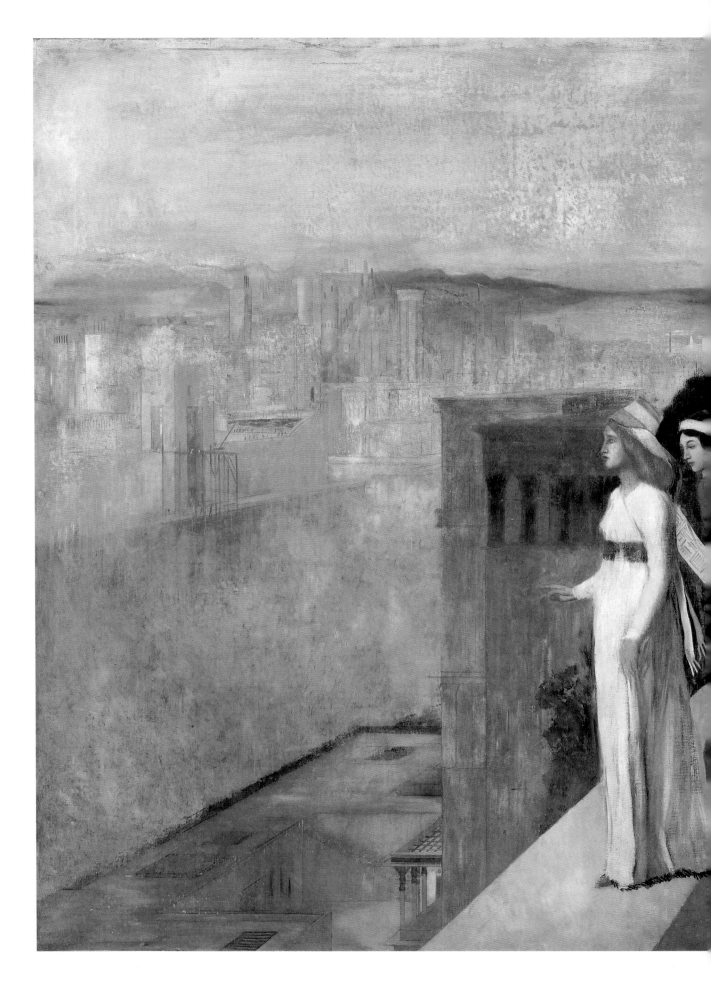

74. Edgar Degas, *Semiramis Building Babylon*, 1861. Oil on canvas

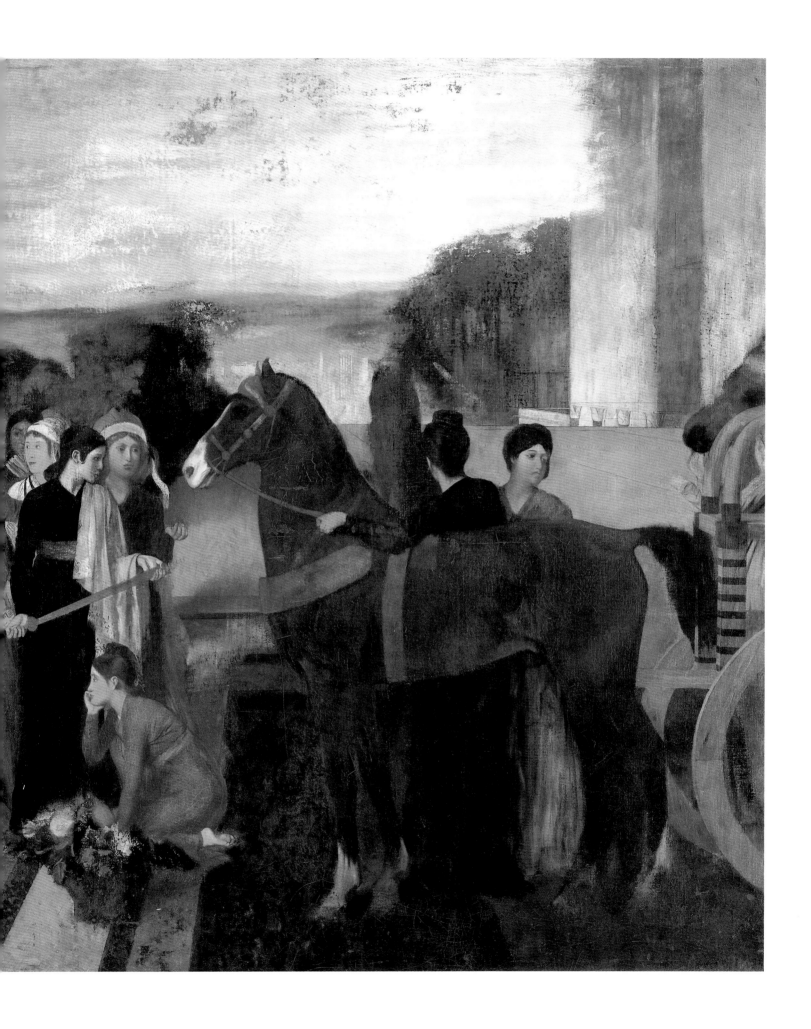

75. Édouard Manet, *The Dead Christ with Angels*, 1864. Oil on canvas

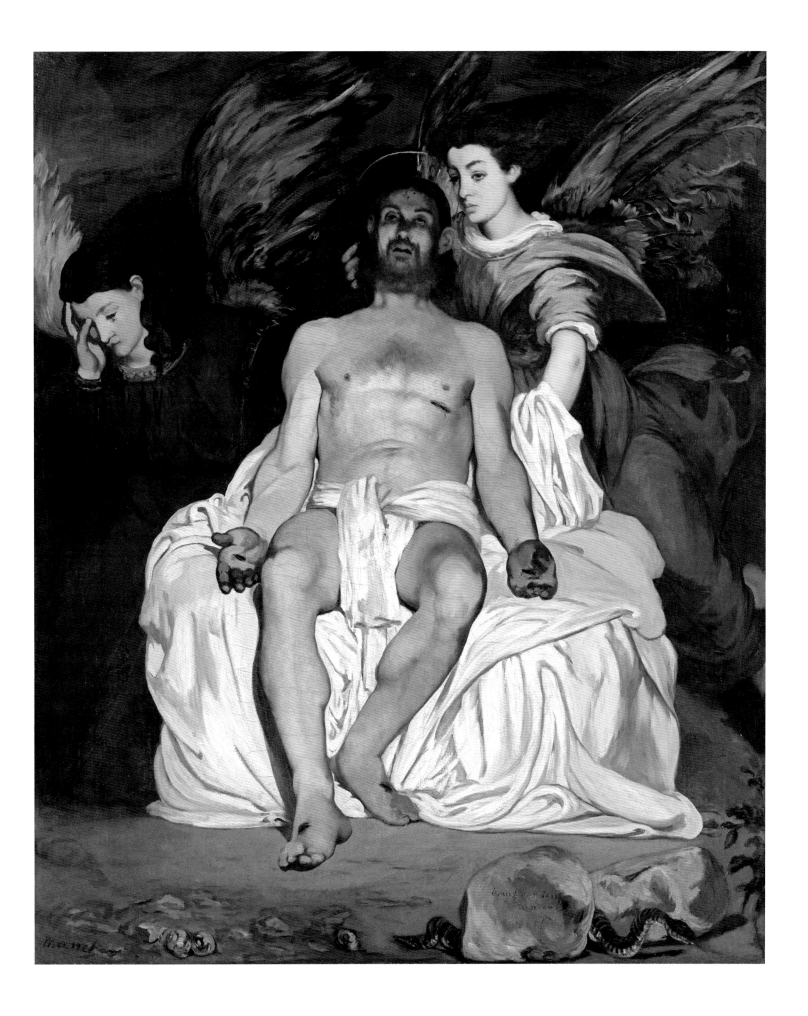

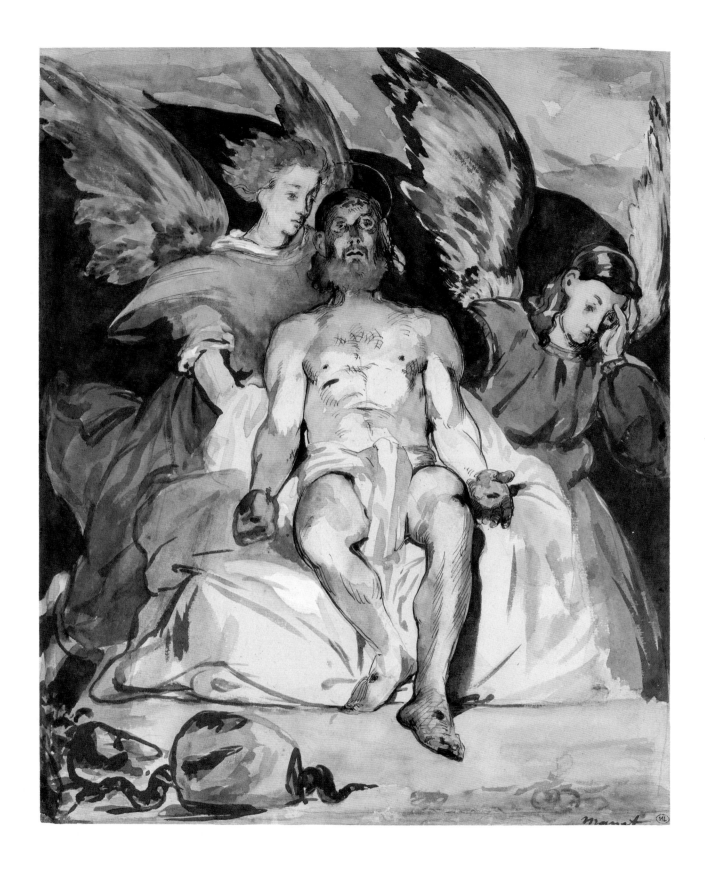

76. Édouard Manet, *The Dead Christ with Angels*, 1864–68. Graphite, watercolor, gouache, and pen and India ink

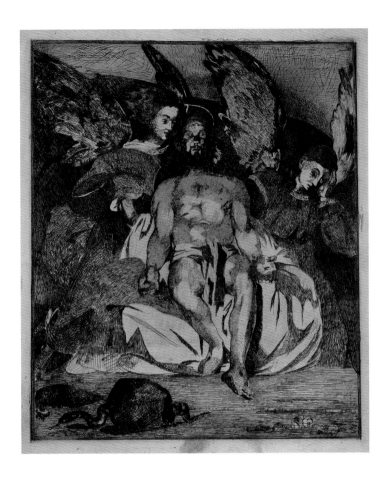

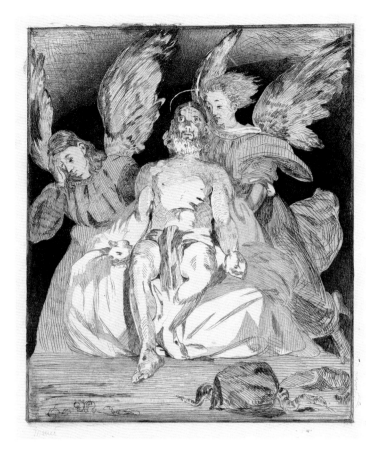

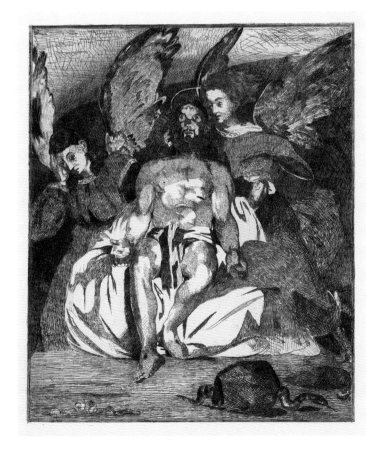

77. Édouard Manet, *Dead Christ with Angels*,
1866–67. Copperplate, etched and aquatinted

78. Édouard Manet, *Dead Christ with Angels*,
1866–67. Etching and aquatint on china paper

79. Édouard Manet, *Dead Christ with Angels*,
1866–67. Etching and aquatint in brown/black ink

80. Édouard Manet, *Reclining Nude*, ca. 1862–63. Red chalk

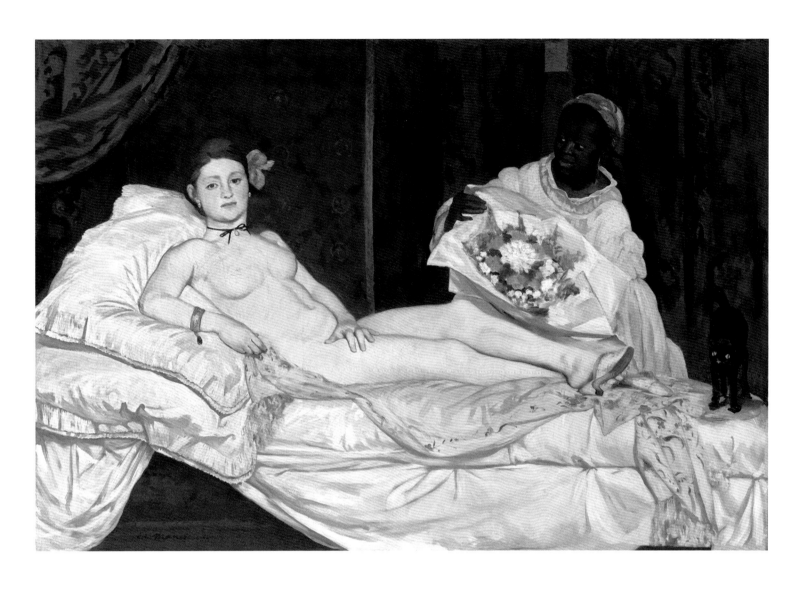

81. Édouard Manet, *Olympia*, 1863–65. Oil on canvas

82. Edgar Degas, *Standing Nude Woman, Study for "Scene of War in the Middle Ages,"*
1864–65. Black crayon with a touch of watercolor

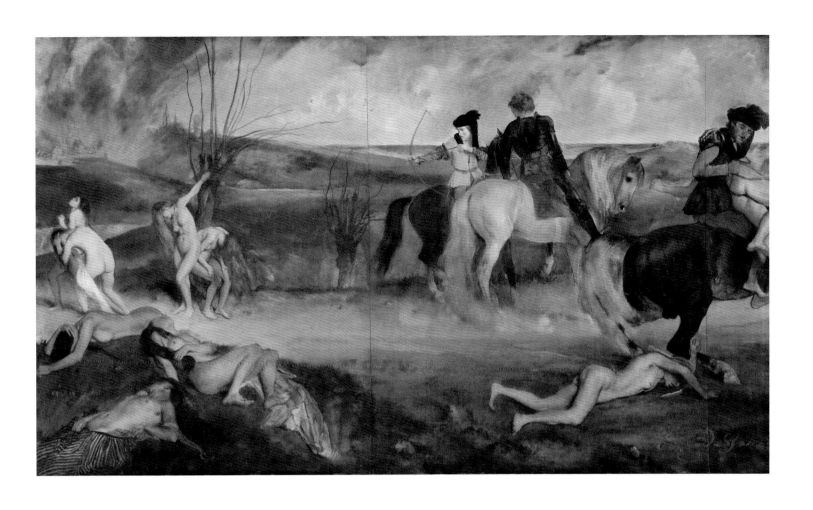

83. Edgar Degas, *Scene of War in the Middle Ages*, ca. 1865. Oil on paper mounted on canvas

84. Edgar Degas, *A Woman Seated beside a Vase of Flowers (Madame Paul Valpinçon?)*, 1865. Oil on canvas

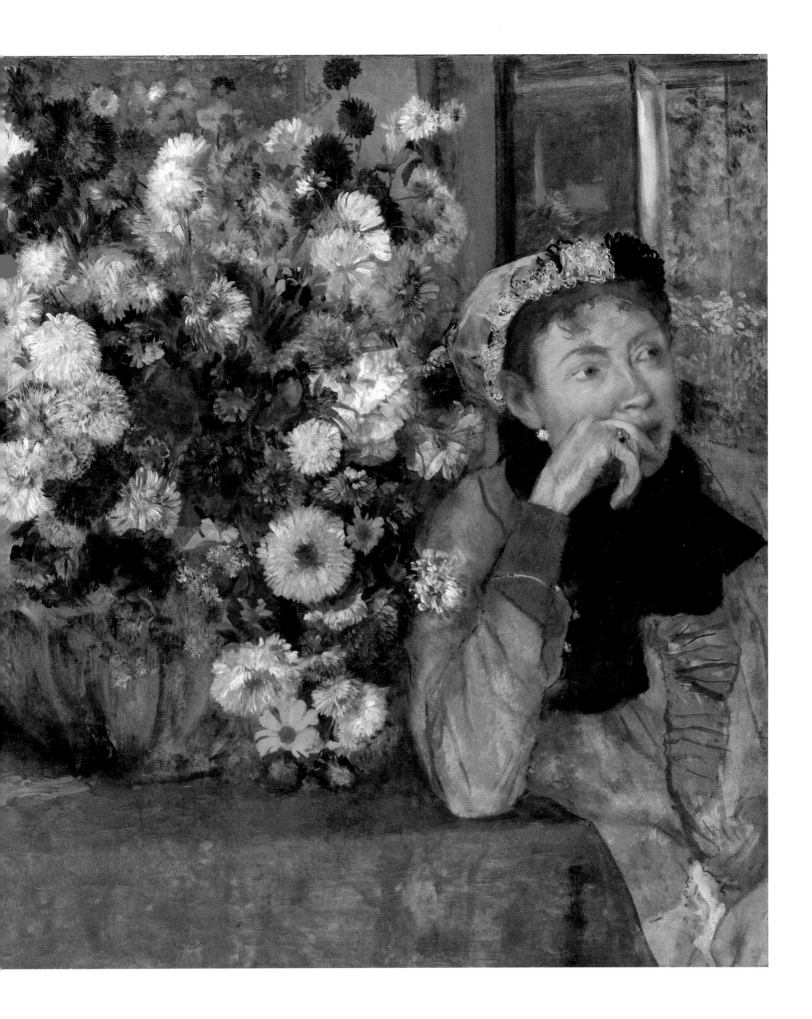

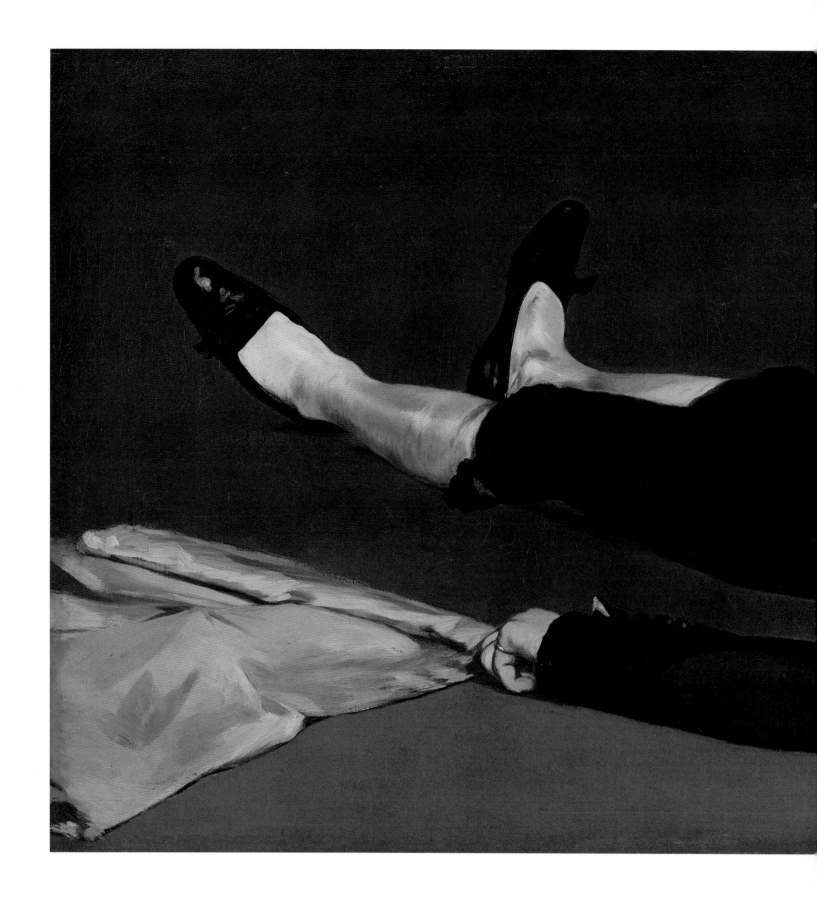

85. Édouard Manet, *The Dead Toreador*, probably 1864. Oil on canvas

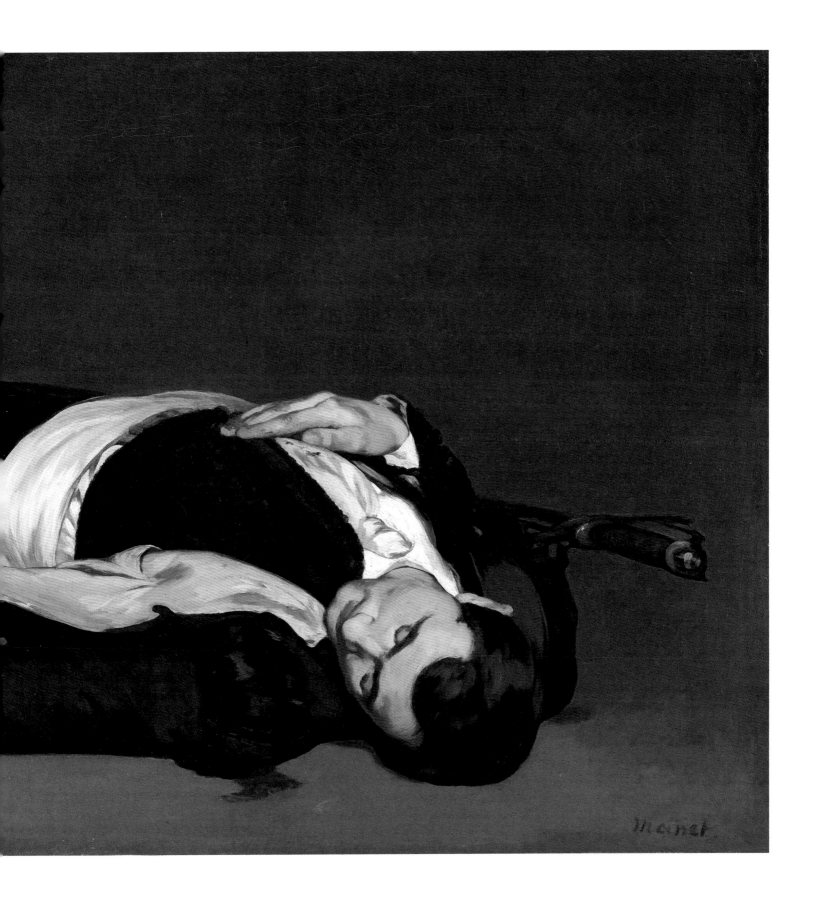

86. Edgar Degas, *Scene from the Steeplechase: The Fallen Jockey*, 1866, reworked 1880–81 and ca. 1897. Oil on canvas

87. Edgar Degas, *James-Jacques-Joseph Tissot*, ca. 1867–68. Oil on canvas

88. Édouard Manet, *Émile Zola*, 1868. Oil on canvas

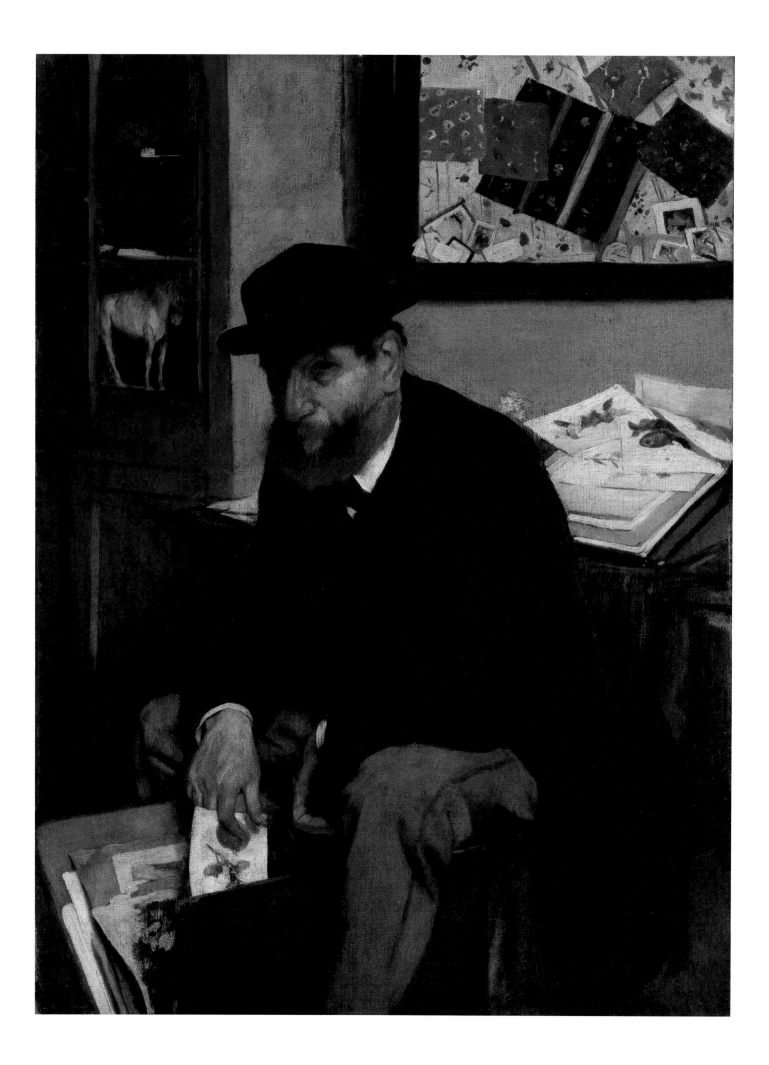

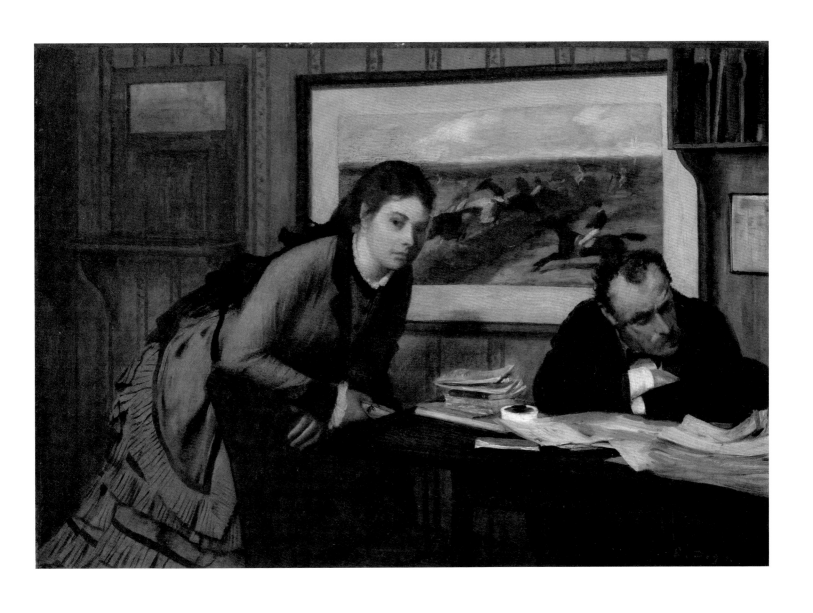

89. Edgar Degas, *The Collector of Prints*, 1866. Oil on canvas

90. Edgar Degas, *Sulking*, ca. 1870. Oil on canvas

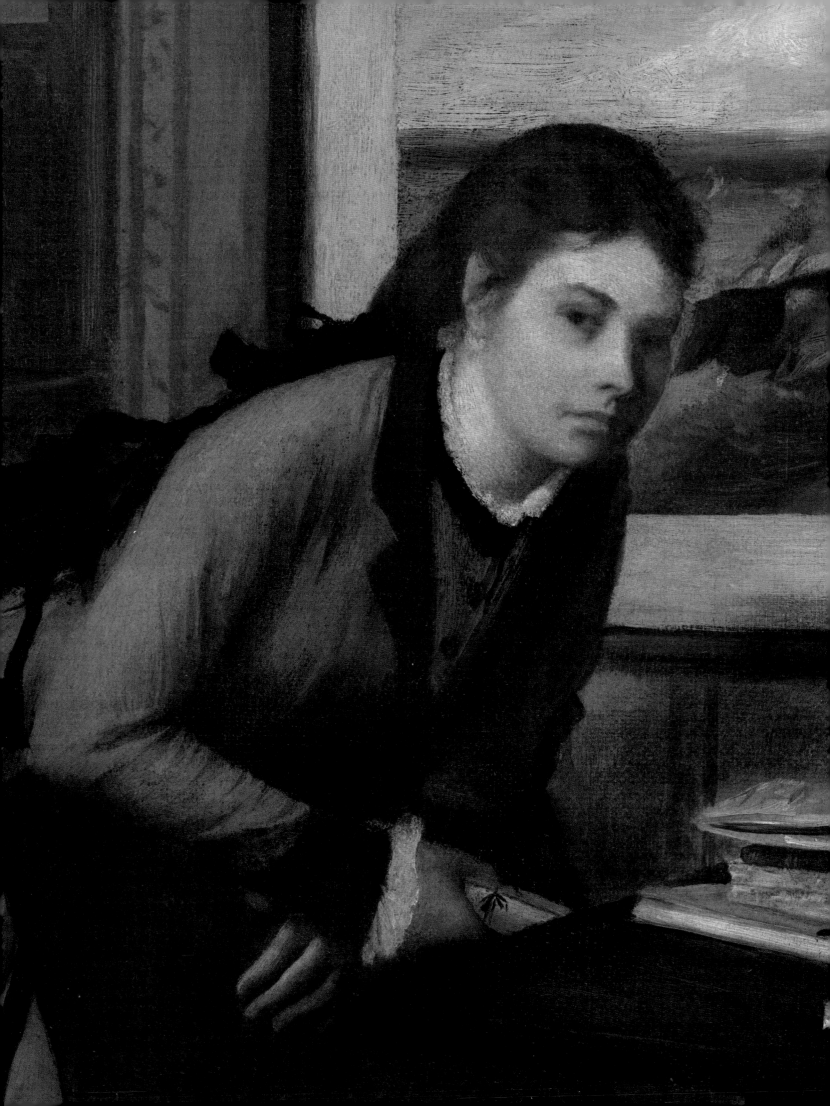

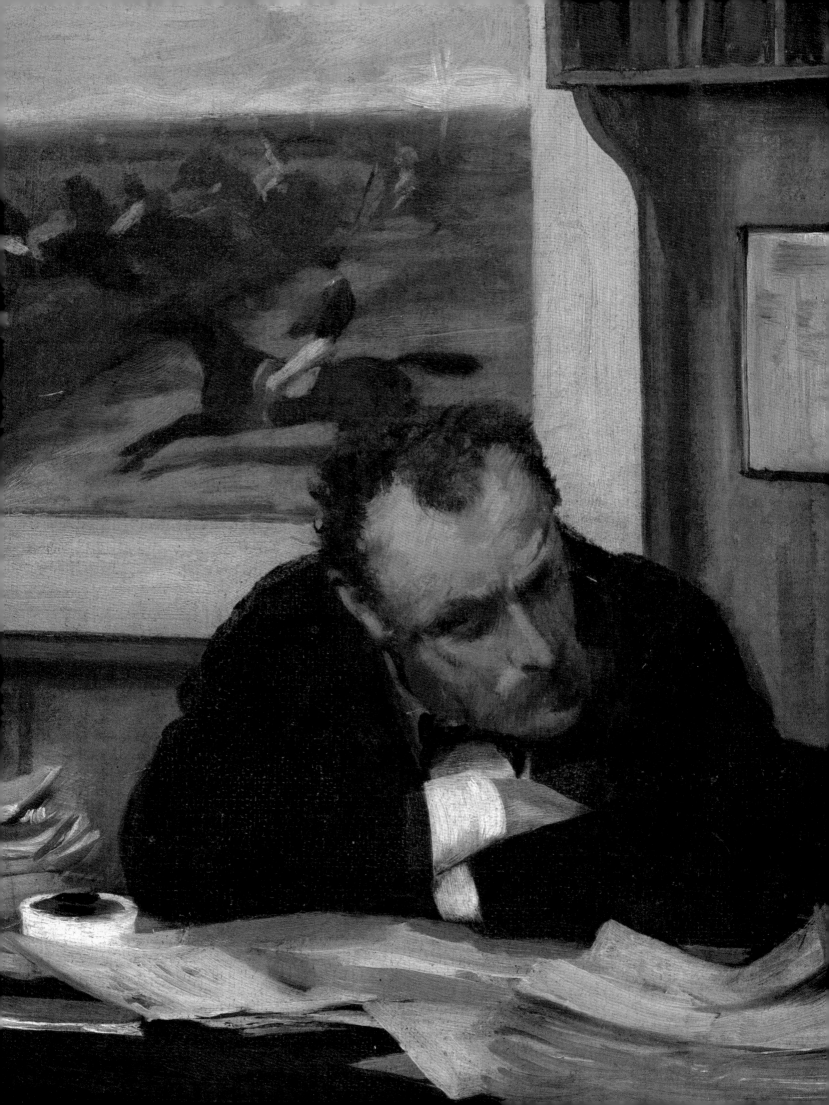

91. Édouard Manet, *Woman with a Fan (Jeanne Duval)*, 1862. Oil on canvas

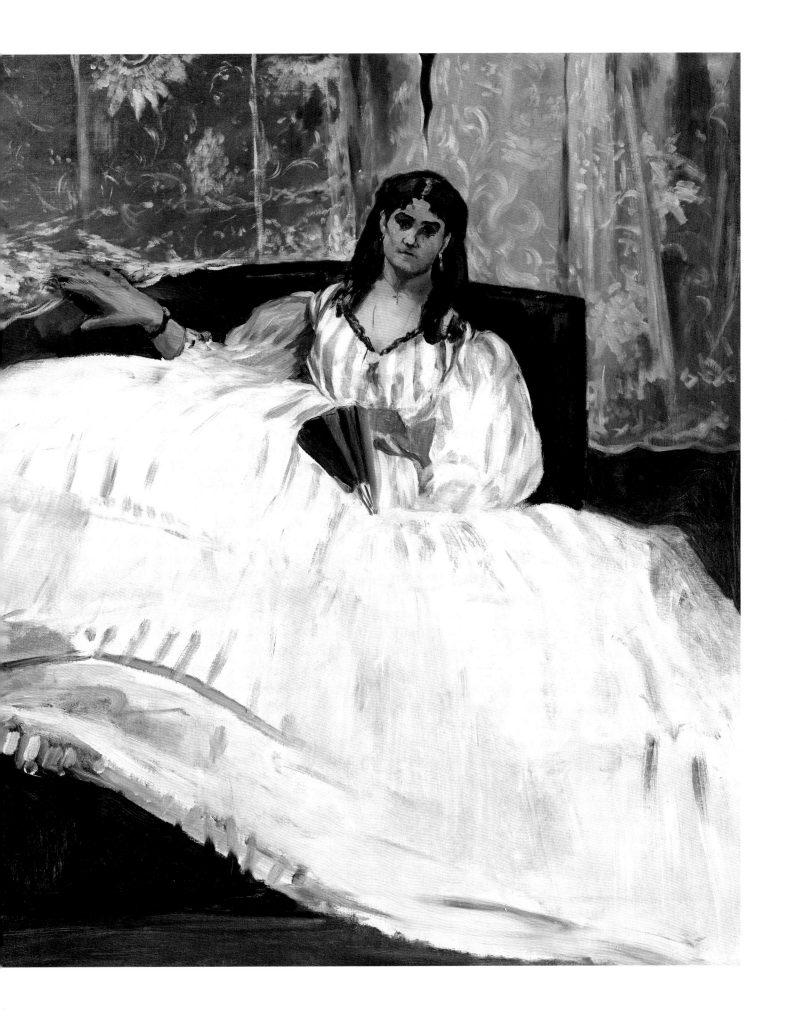

92. Edgar Degas, *Madame Lisle and Madame Loubens*, ca. 1867. Oil on canvas

93. Édouard Manet, *Young Lady in 1866*, 1866. Oil on canvas

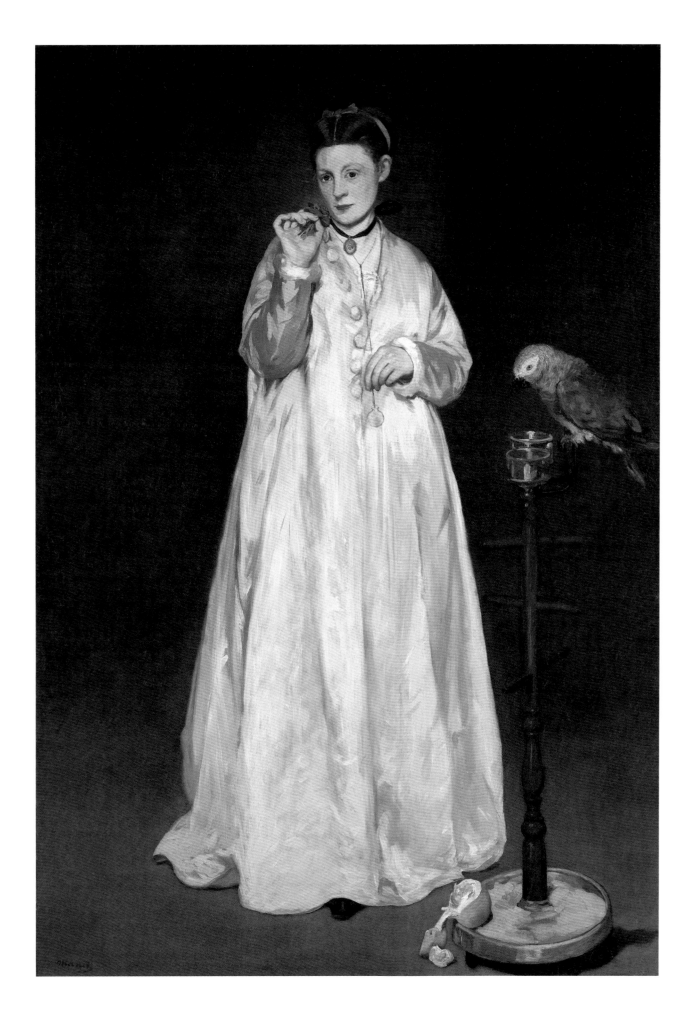

94. Edgar Degas, *Young Woman with Ibis*, 1857–58, reworked 1860–62. Oil on canvas

95. Edgar Degas, *Mademoiselle Fiocre in the Ballet "La Source,"* ca. 1867–68. Oil on canvas

67.

Entre tant de beautés que partout on peut voir
Je comprends bien, amis, que le Désir balance;
Mais on voit scintiller dans Lola de Valence
Le charme inattendu d'un bijou rose et noir. (Ch. Baudelaire)

Ed. Manet sculp.t

Paris, Publié par A. CADART & LUQUET, Editeurs, 79, Rue Richelieu.

Imp. Delâtre, Rue St. Jacques, 303, Paris.

96. Édouard Manet, *Lola de Valence*, 1863. Etching and aquatint with roulette

97. Édouard Manet, *Lola de Valence*, 1862. Oil on canvas

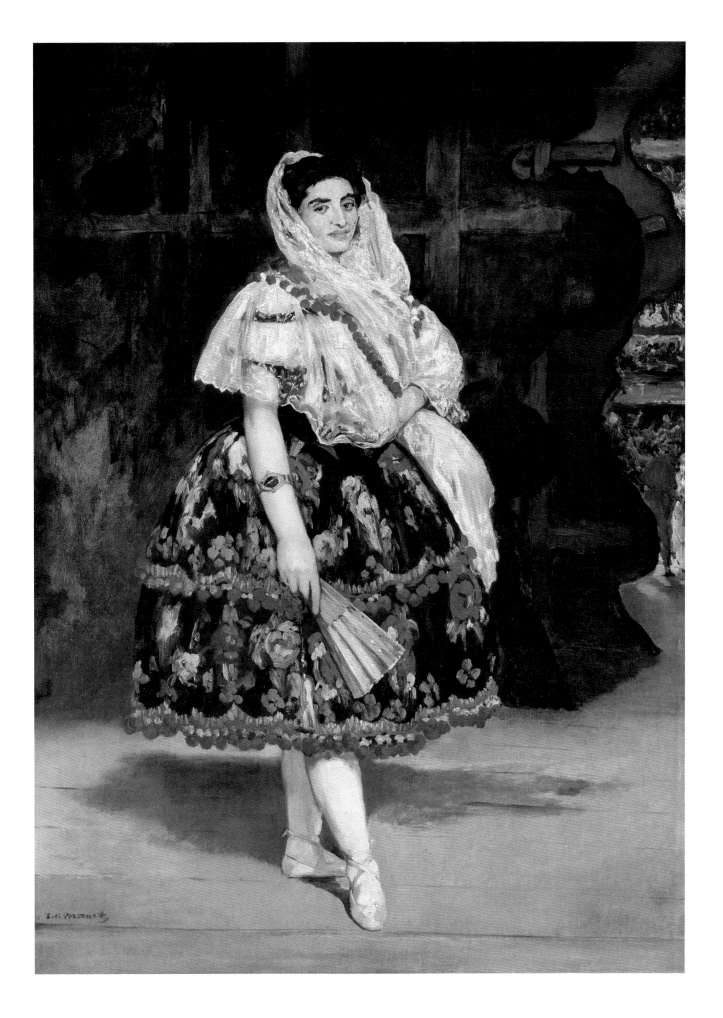

98. Édouard Manet, *The Balcony*, 1868–69. Oil on canvas

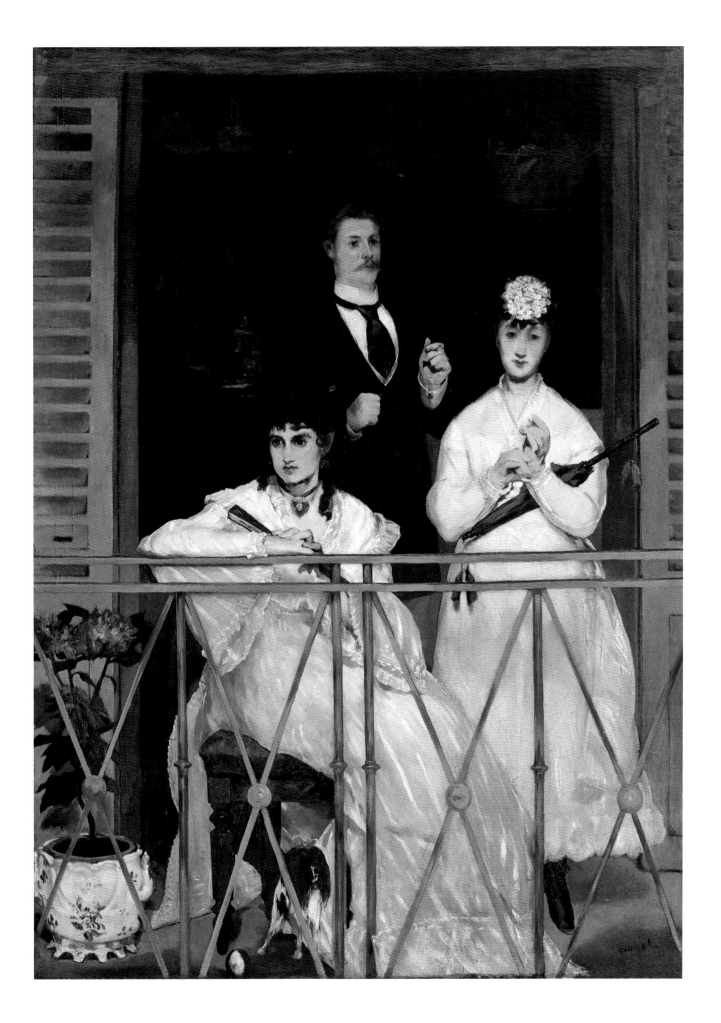

MODERN SUBJECTS

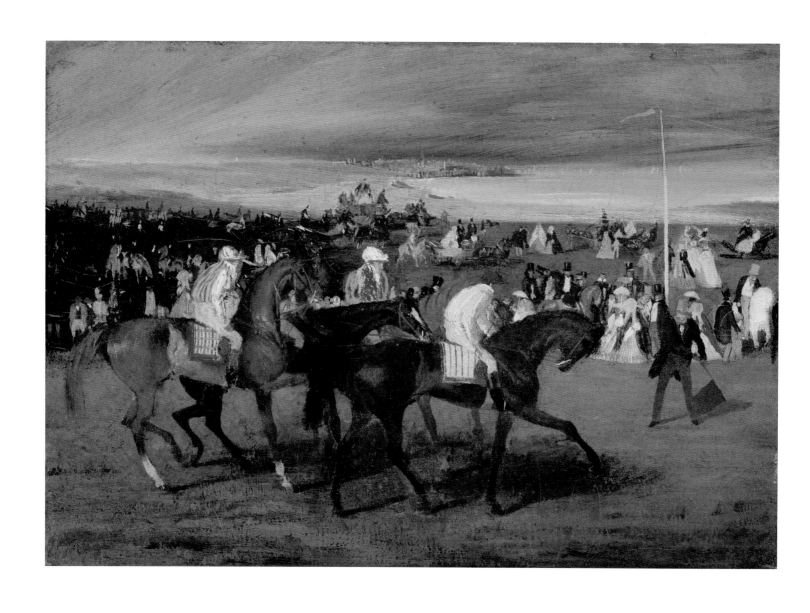

99. Edgar Degas, *At the Races: The Start,* ca. 1860–62. Oil on canvas

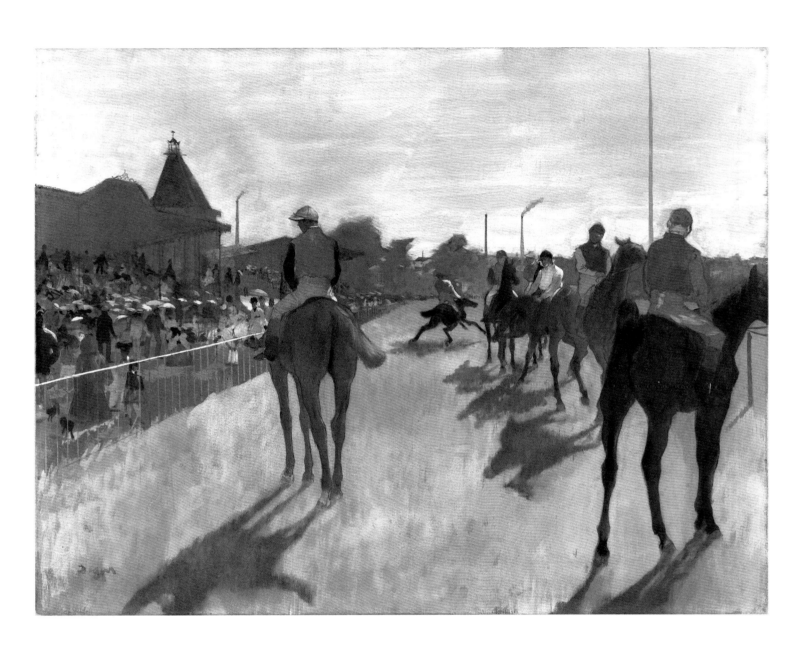

100. Edgar Degas, *Racehorses before the Stands*, 1866–68. Oil on paper mounted on canvas

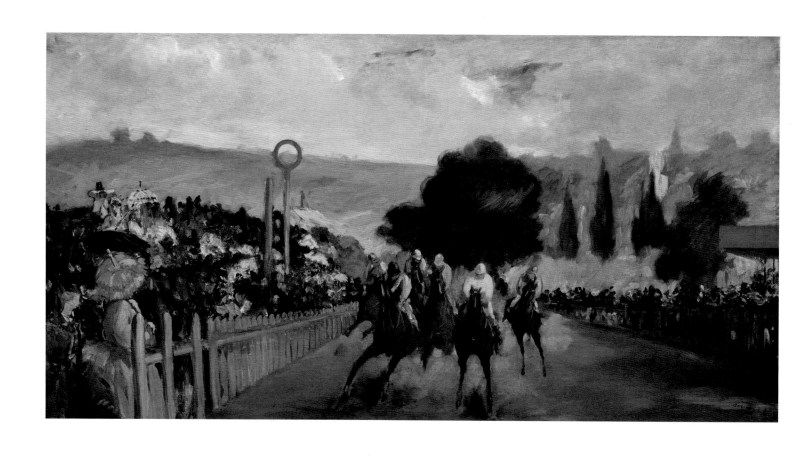

101. Édouard Manet, *The Races at Longchamp*, 1866. Oil on canvas

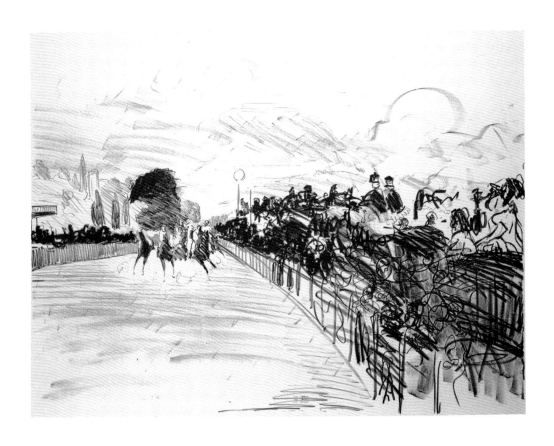

102. Édouard Manet, *The Races*, 1865–72, published 1884. Lithograph on chine collé

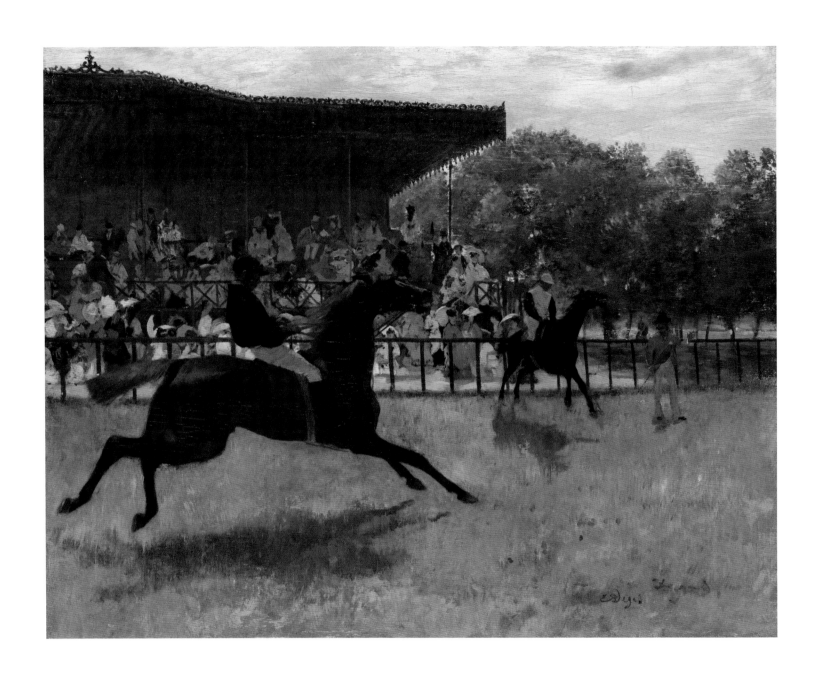

103. Edgar Degas, *The False Start*, ca. 1869–72. Oil on panel

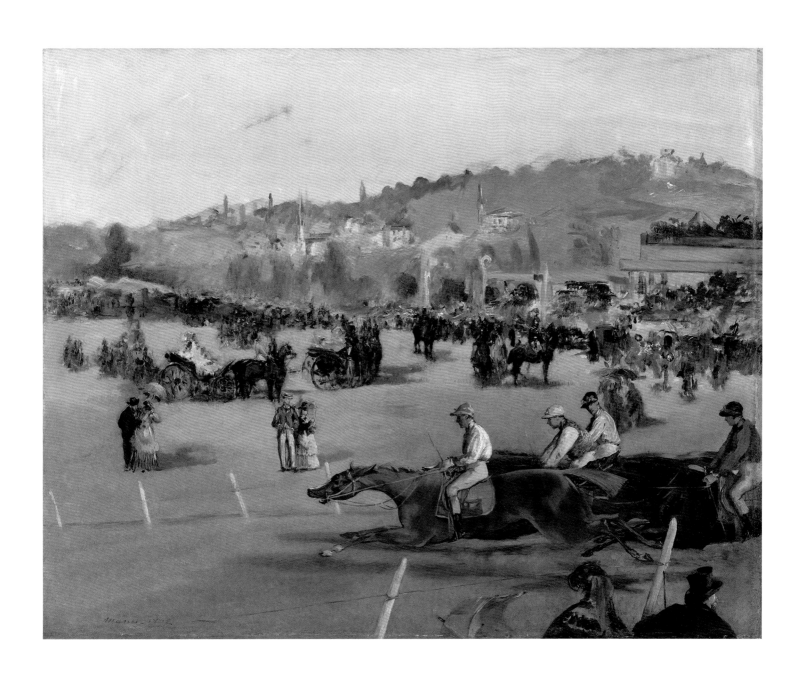

104. Édouard Manet, *The Races in the Bois de Boulogne*, 1872. Oil on canvas

105. Edgar Degas, *The Racecourse, Amateur Jockeys*, 1876–87. Oil on canvas

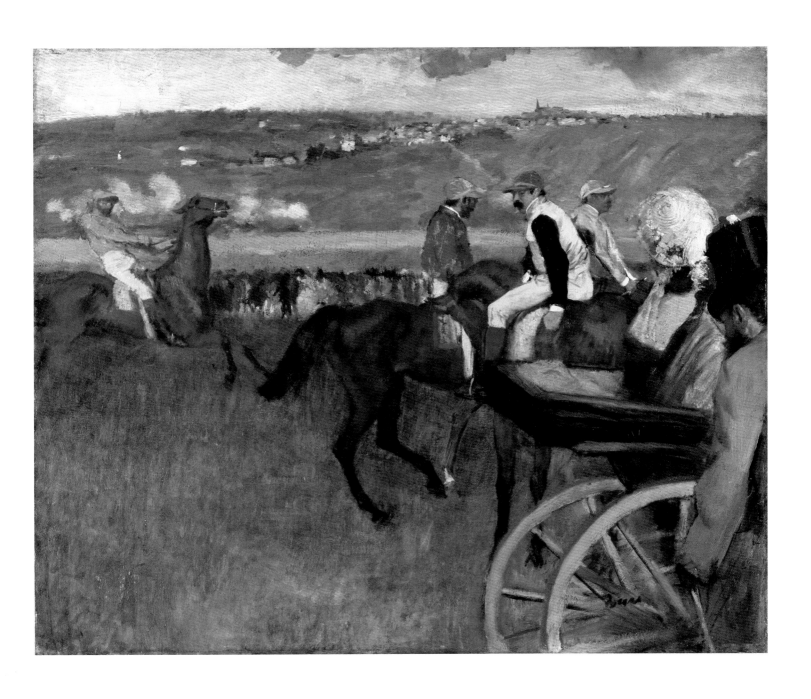

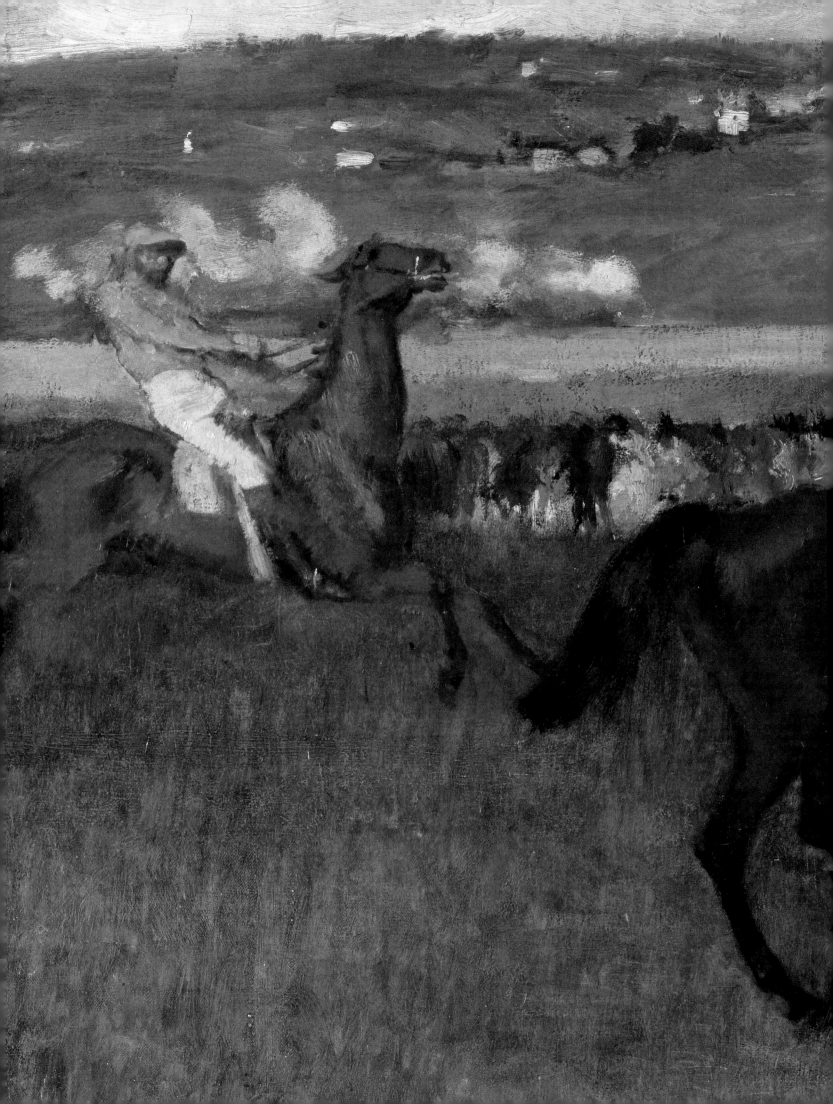

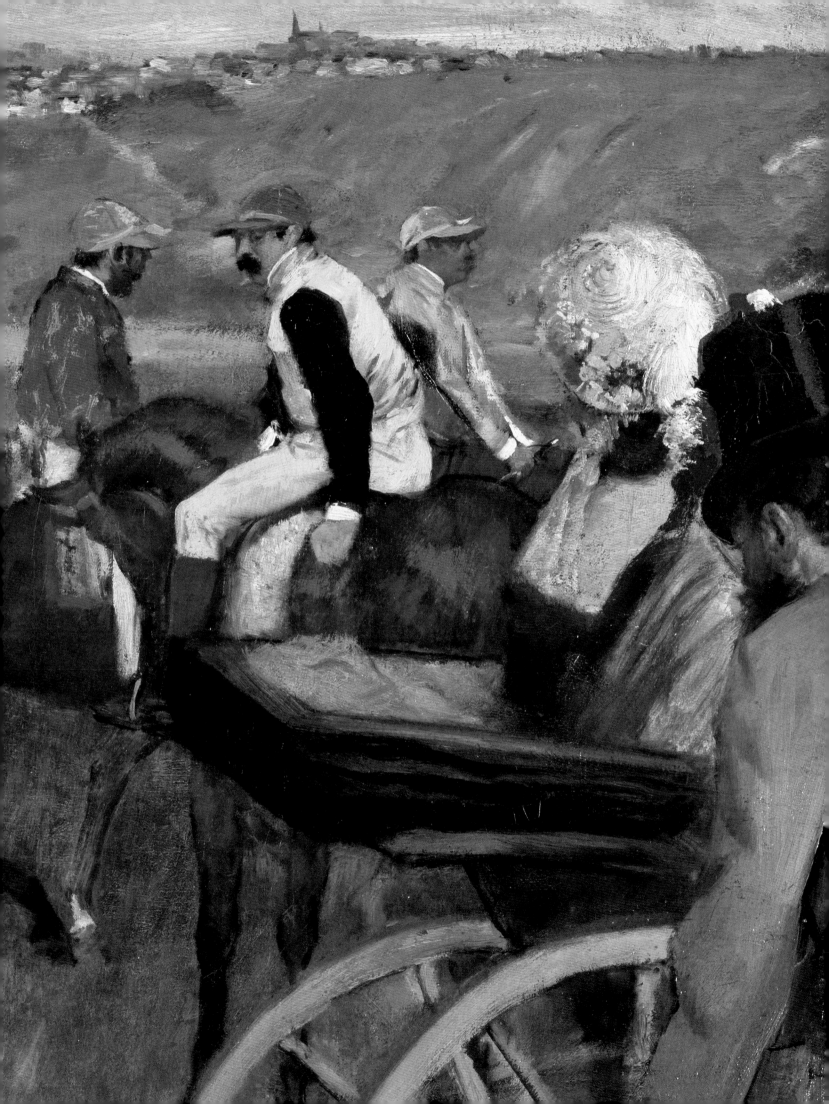

106. Edgar Degas, *Édouard Manet at the Races*, ca. 1868–69. Graphite and black chalk

107. Edgar Degas, *Woman with Field Glasses*, ca. 1877. Oil on cardboard

108. Édouard Manet, *Marine*, ca. 1868. Watercolor

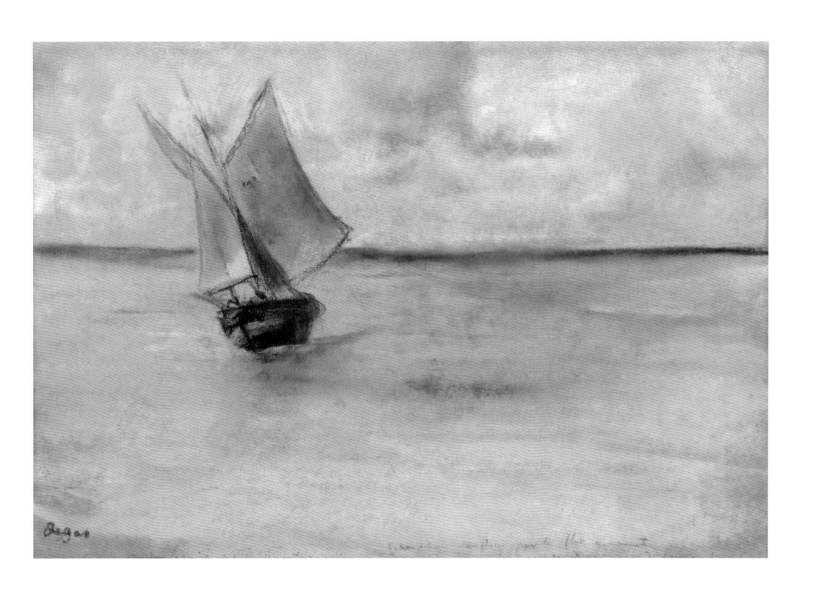

109. Edgar Degas, *Fishing Boat at the Entrance to the Port of Dives*, 1869. Pastel and charcoal

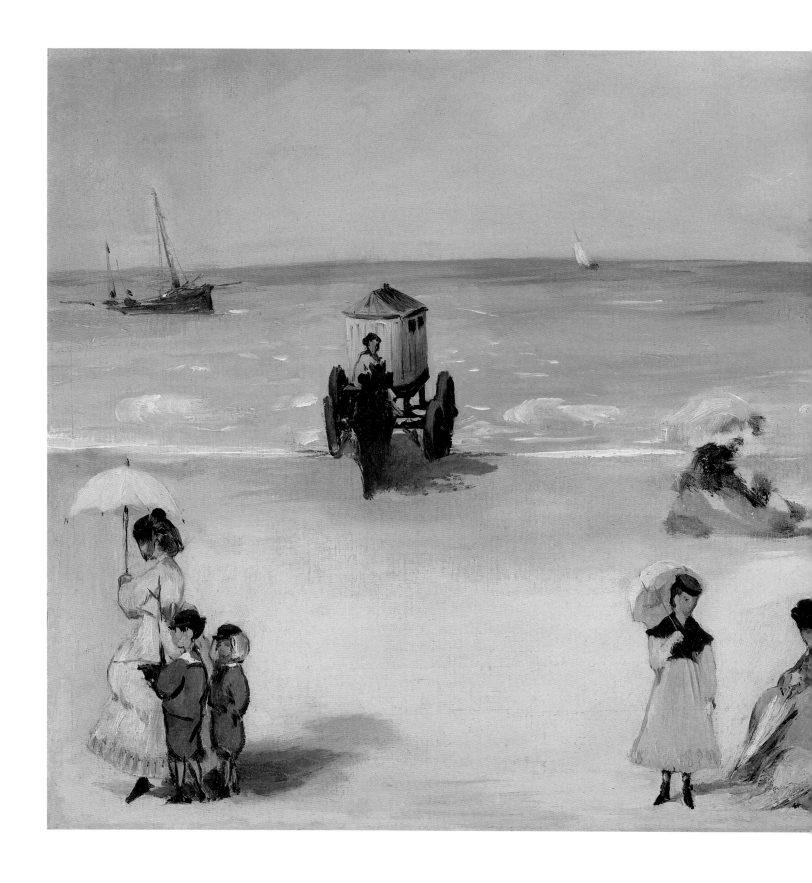

110. Édouard Manet, *On the Beach, Boulogne-sur-Mer*, 1868. Oil on canvas

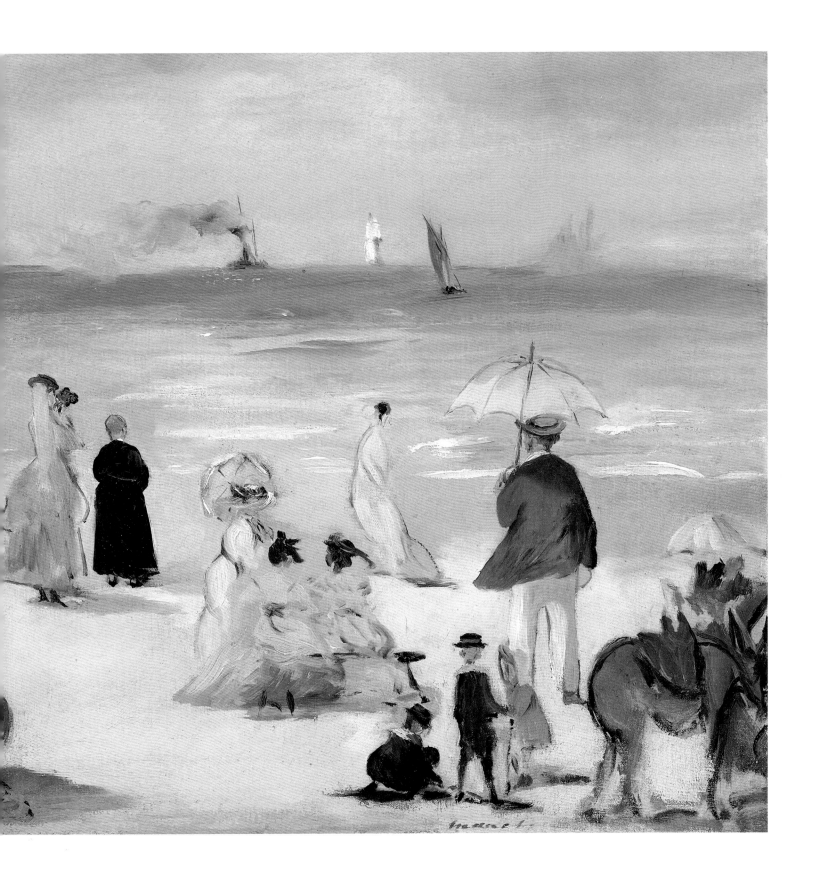

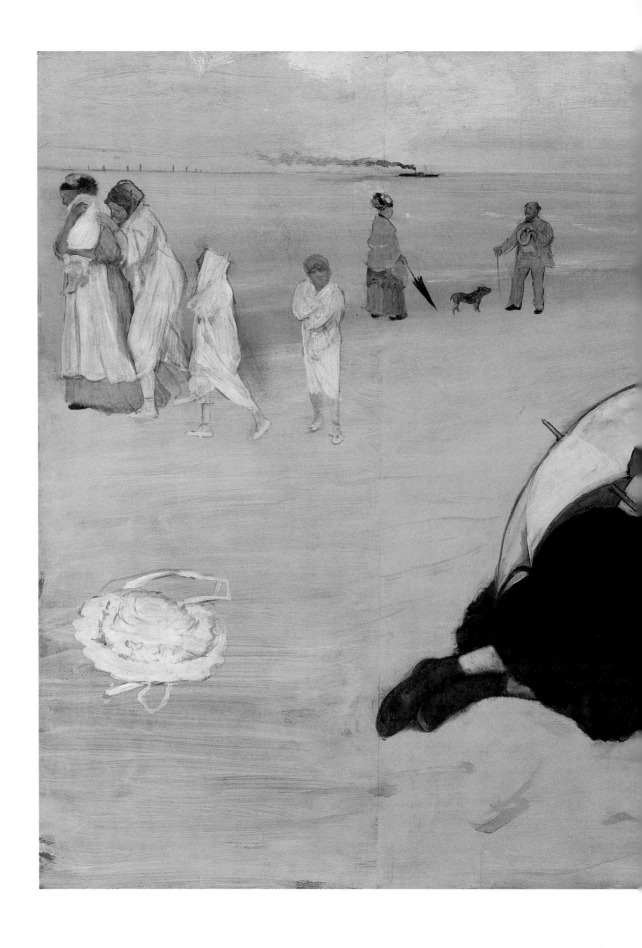

111. Edgar Degas, *Beach Scene*, ca. 1869–70. Oil (essence) on paper on canvas

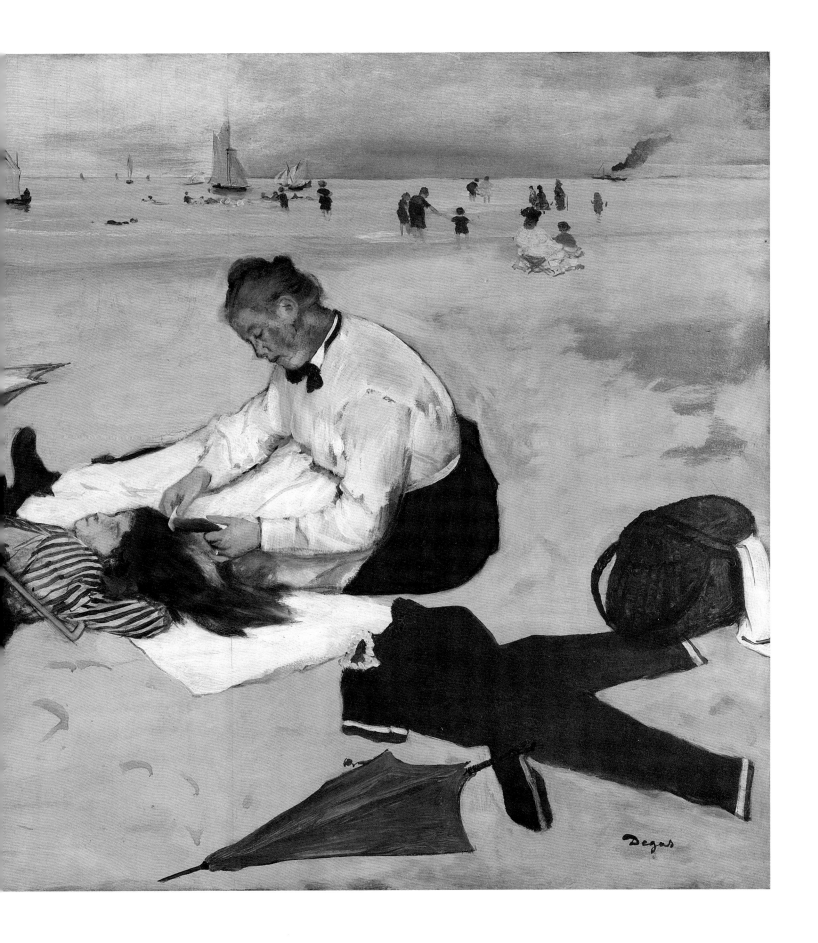

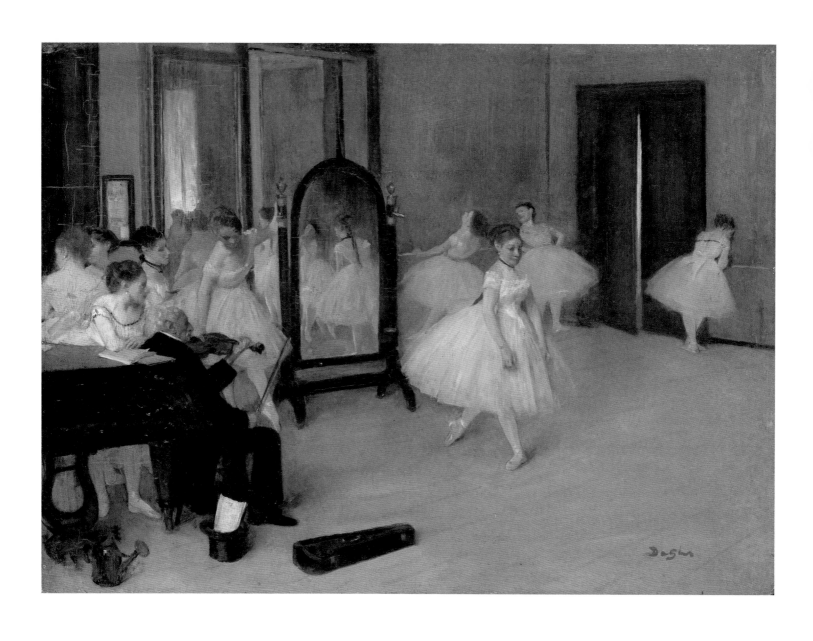

112. Edgar Degas, *The Dancing Class*, ca. 1870. Oil on wood

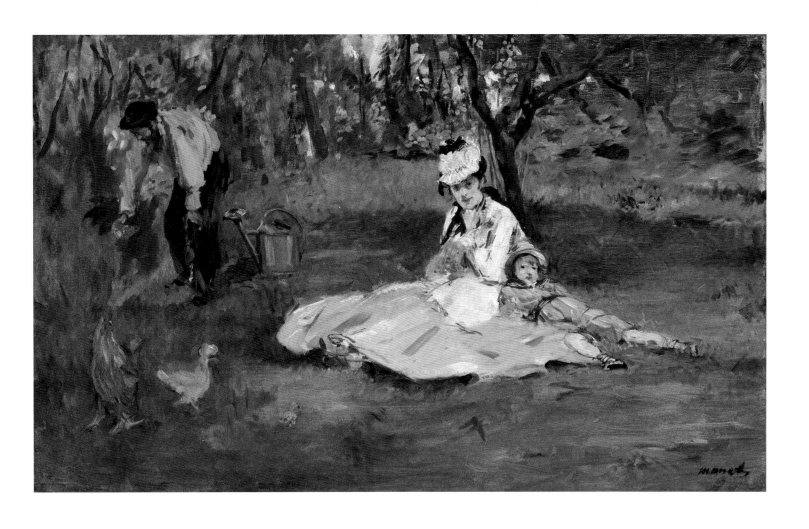

113. Édouard Manet, *The Monet Family in Their Garden at Argenteuil*, 1874. Oil on canvas

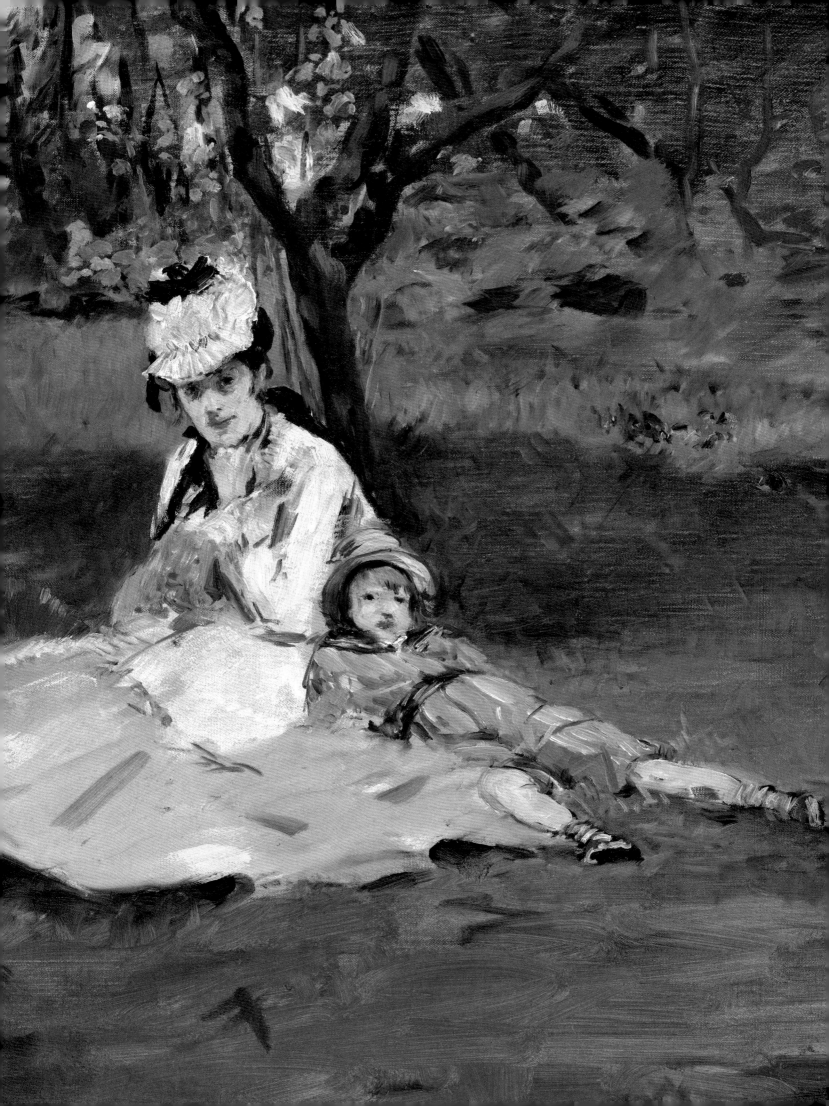

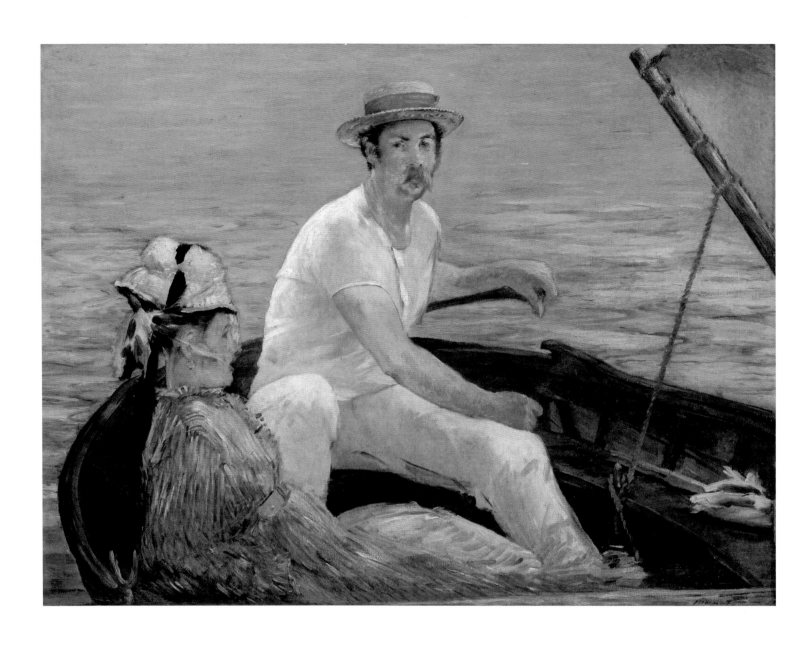

114. Édouard Manet, *Boating*, 1874. Oil on canvas

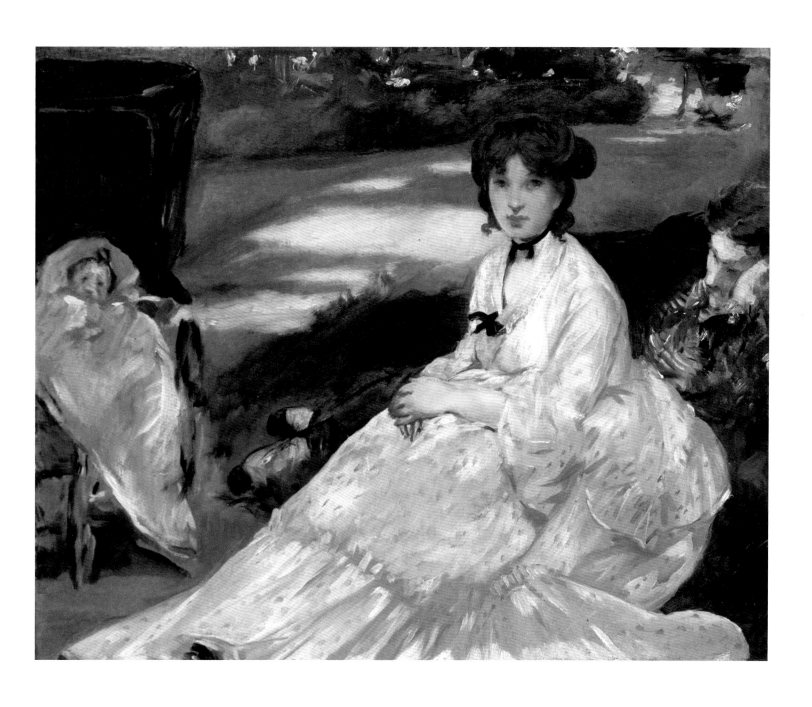

115. Édouard Manet, *In the Garden*, 1870. Oil on canvas

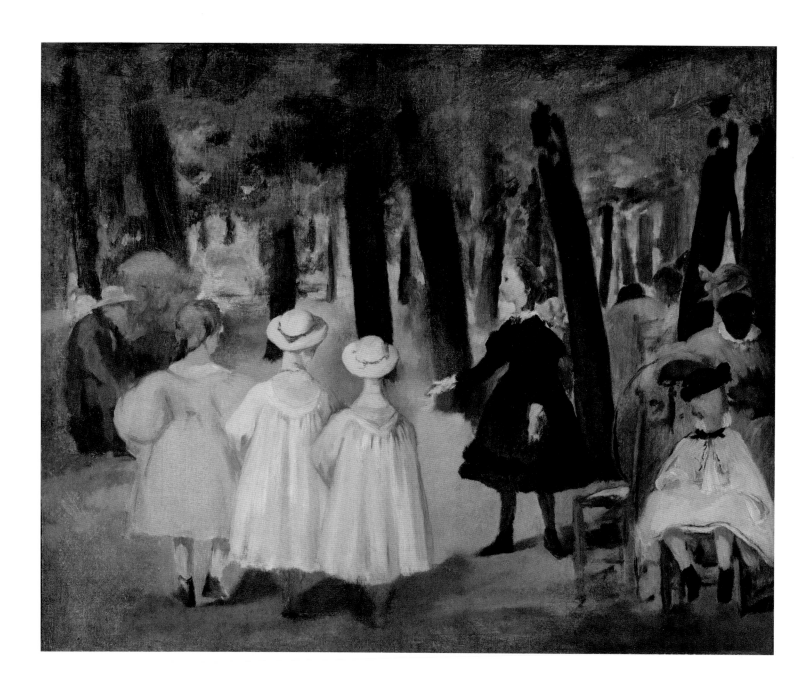

116. Édouard Manet, *Children in the Tuileries Gardens*, ca. 1861–62. Oil on canvas

117. Edgar Degas, *Courtyard of a House (New Orleans, sketch)*, 1873. Oil on canvas

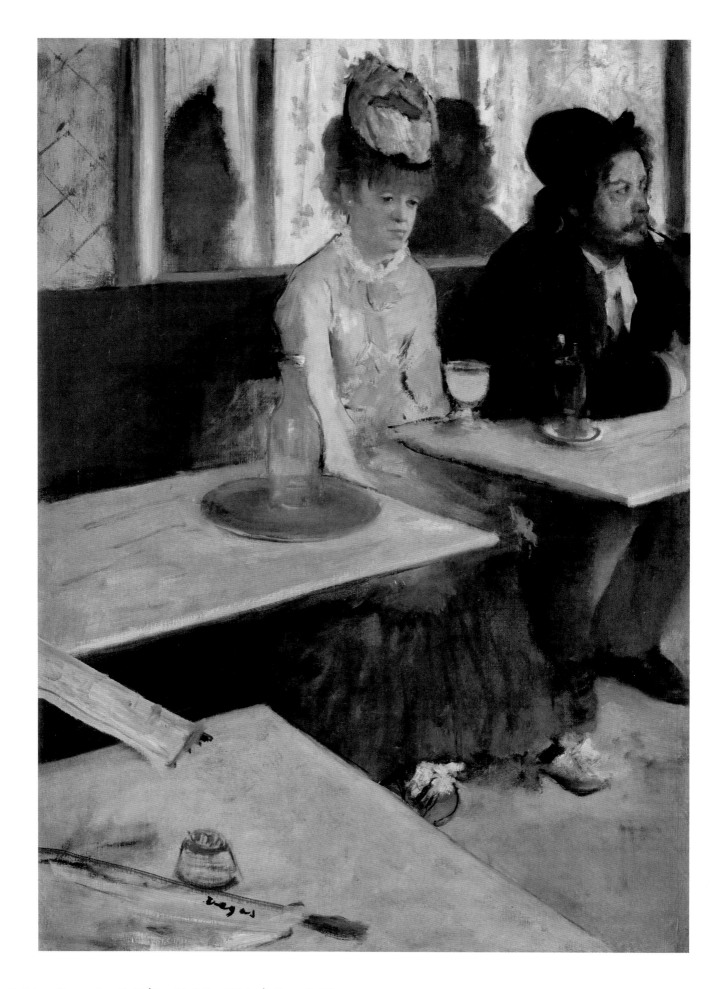

118. Edgar Degas, *In a Café (The Absinthe Drinker)*, 1875–76. Oil on canvas

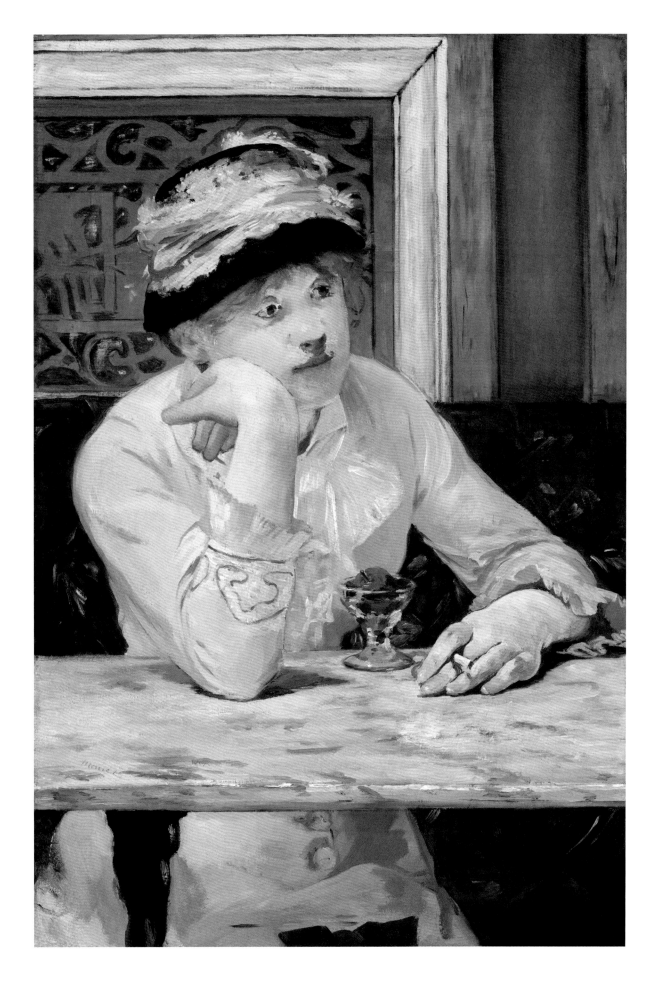

119. Édouard Manet, *Plum Brandy*, ca. 1877. Oil on canvas

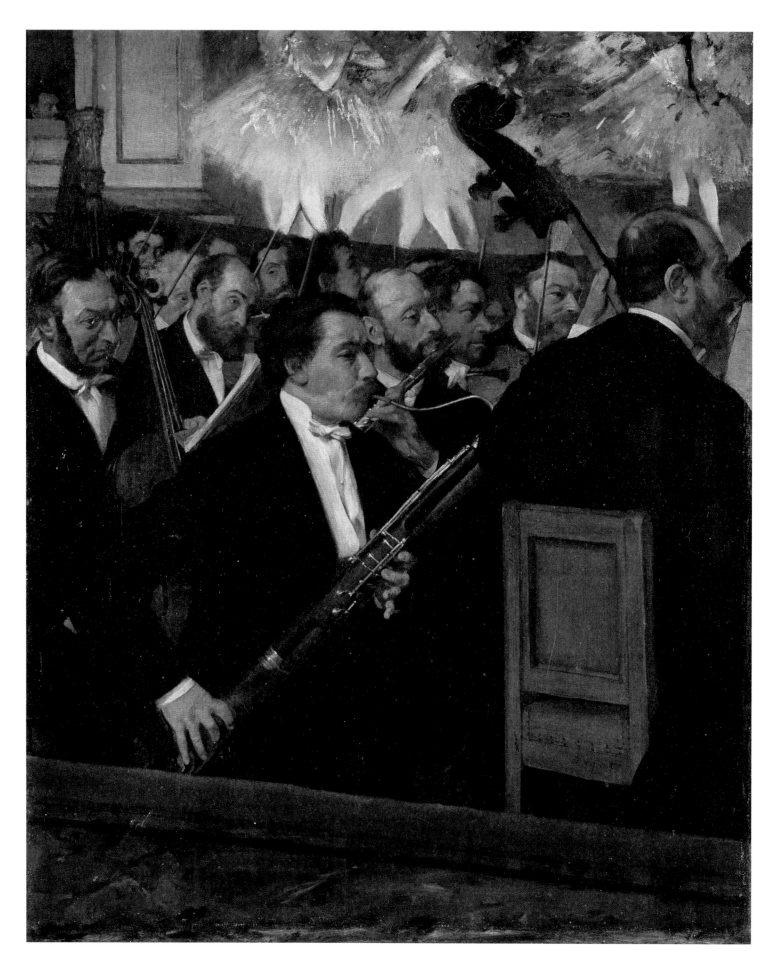

120. Edgar Degas, *The Orchestra of the Opera*, ca. 1870. Oil on canvas

121. Édouard Manet, *The Café-Concert*, ca. 1879. Oil on canvas

122. Edgar Degas, *The Singer in Green*, ca. 1884. Pastel on light blue laid paper

123. Edgar Degas, *Mademoiselle Bécat at the Café des Ambassadeurs, Paris,* 1877–78. Lithograph

124. Edgar Degas, *The Singer*, ca. 1877–78. Pastel over monotype

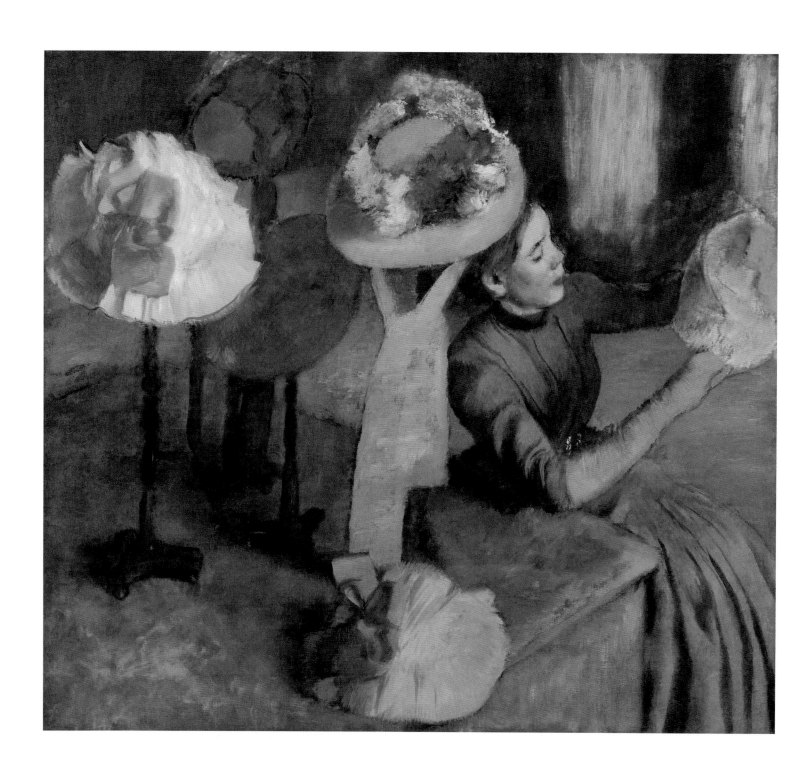

125. Edgar Degas, *The Millinery Shop*, ca. 1879–86. Oil on canvas

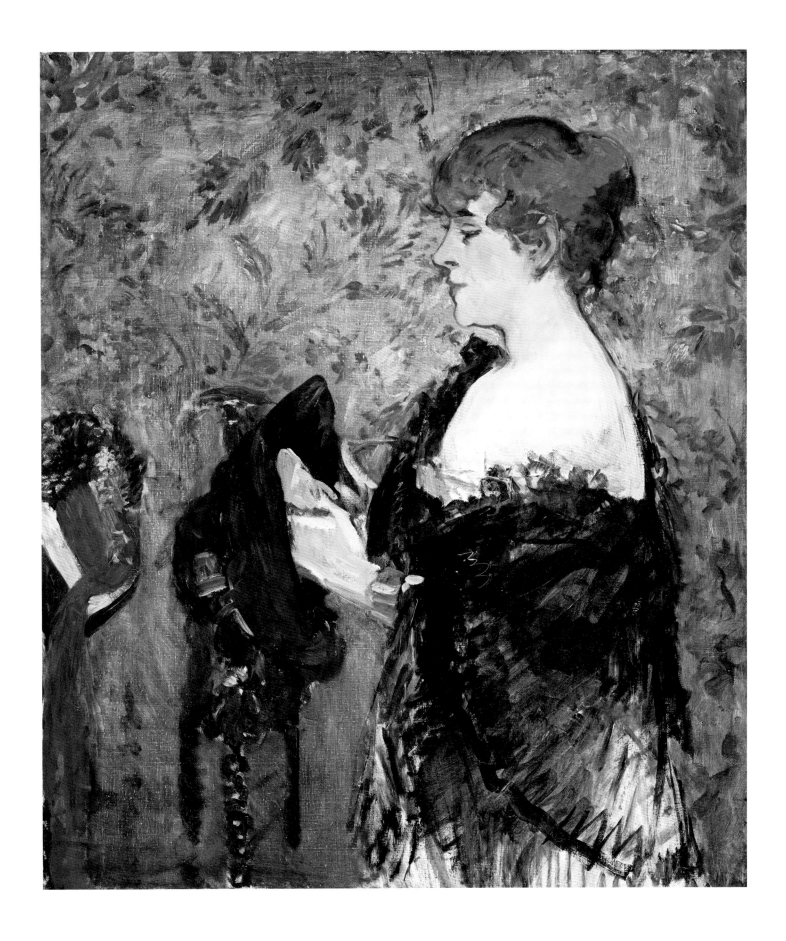

126. Édouard Manet, *At the Milliner's*, 1881. Oil on canvas

127. Edgar Degas, *Interior*, 1868–69. Oil on canvas

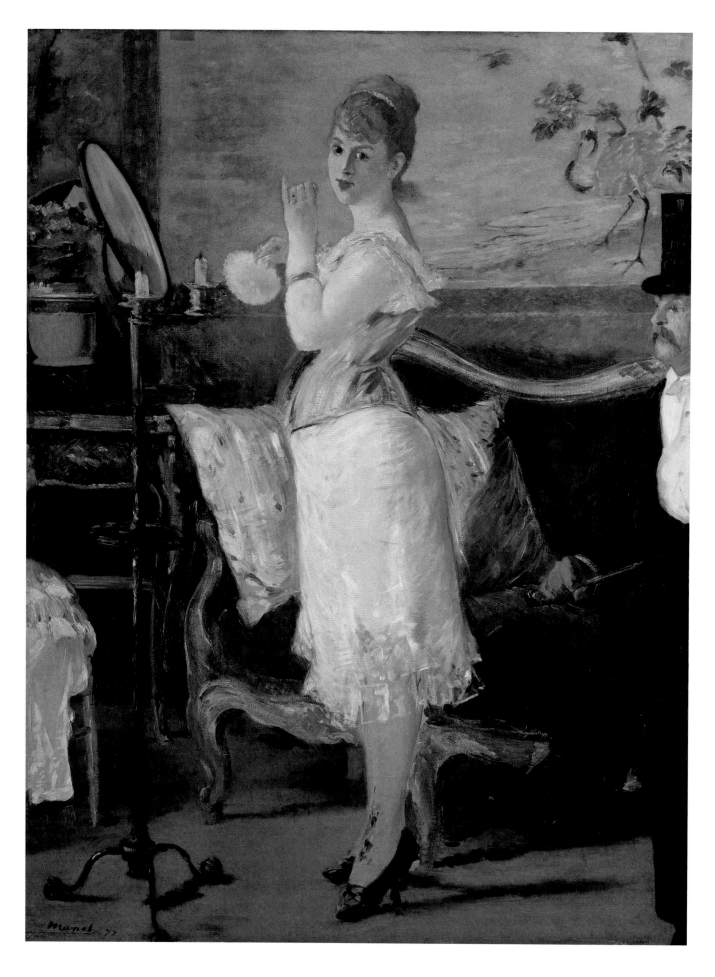

128. Édouard Manet, *Nana*, 1877. Oil on canvas

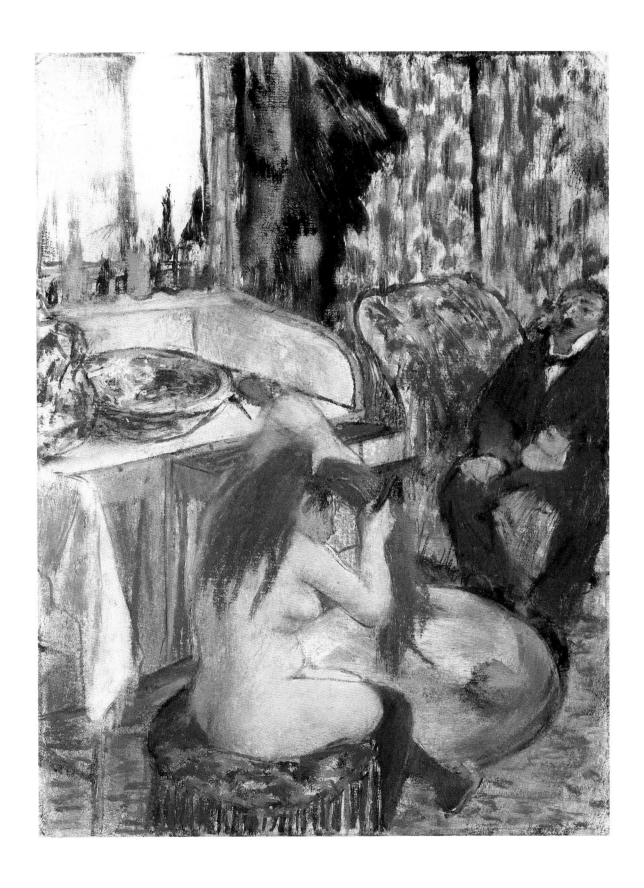

129. Edgar Degas, *Nude Woman Combing Her Hair*, ca. 1877–80. Pastel over monotype

130. Edgar Degas, *Henri Michel-Lévy*, ca. 1878. Oil on canvas

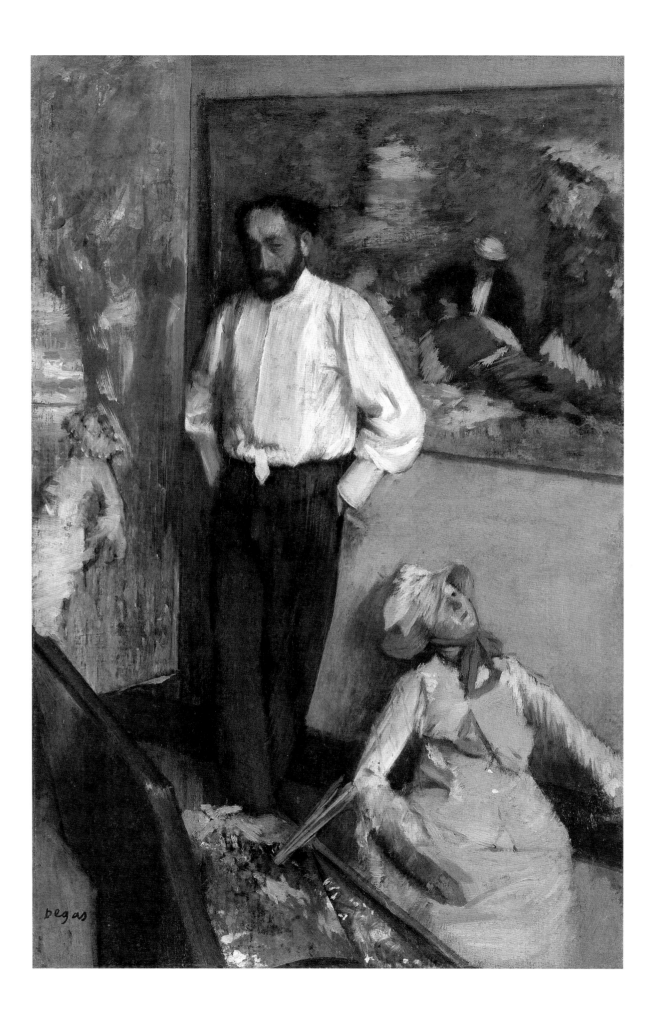

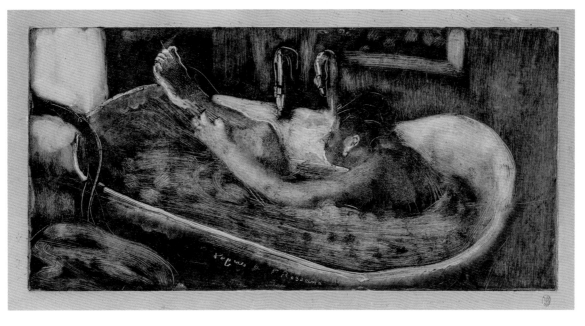

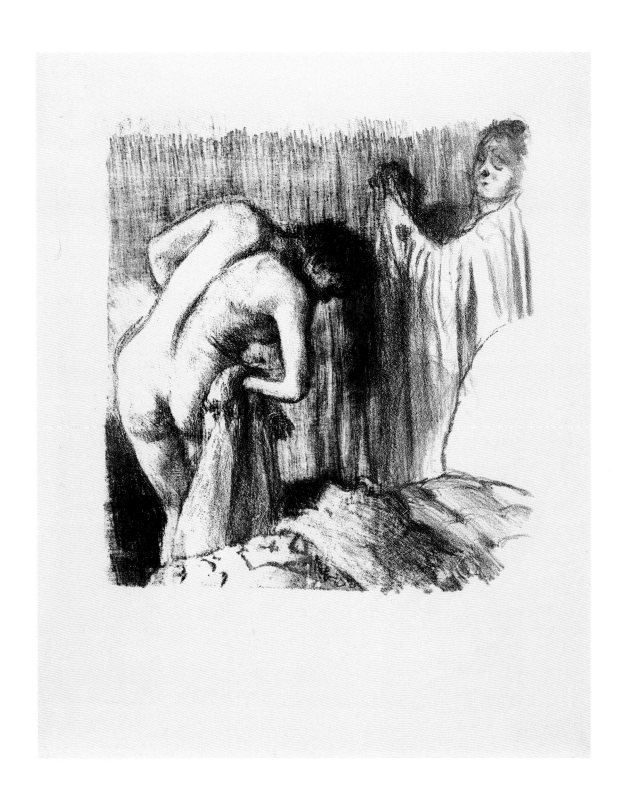

131. Edgar Degas, *Nude Woman Standing, Drying Herself*, 1891–92.

Lithograph (transfer from monotype with crayon, tusche, and scraping)

132. Edgar Degas, *Woman in a Bathtub*, ca. 1880–85. Monotype

133. Edgar Degas, *After the Bath III*, 1891–92. Lithograph (transfer and crayon)

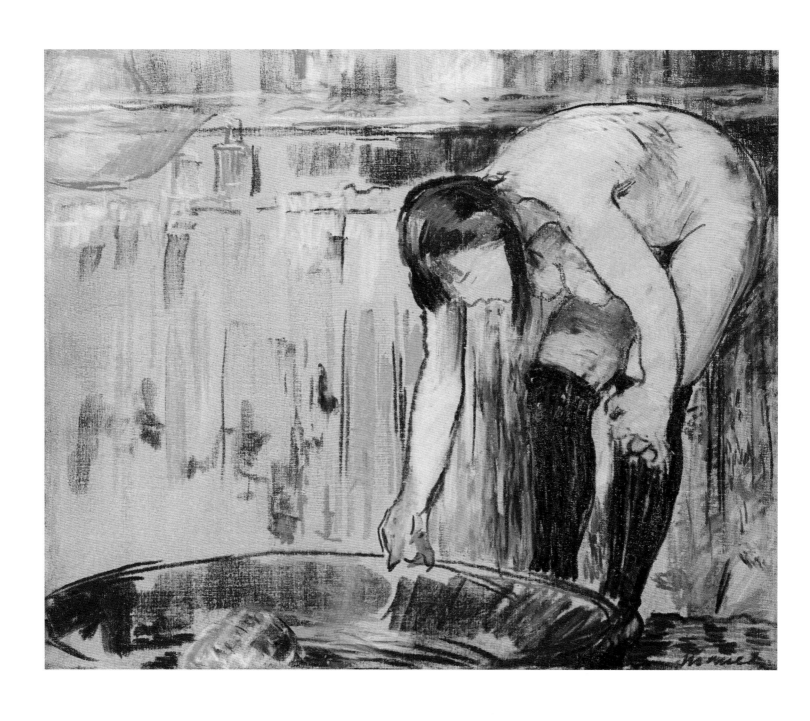

134. Édouard Manet, *Woman with a Tub*, ca. 1878–79. Pastel on linen

135. Edgar Degas, *Woman Bathing in a Shallow Tub*, 1885. Charcoal and pastel on
light green wove paper, now discolored to warm gray, laid down on silk bolting

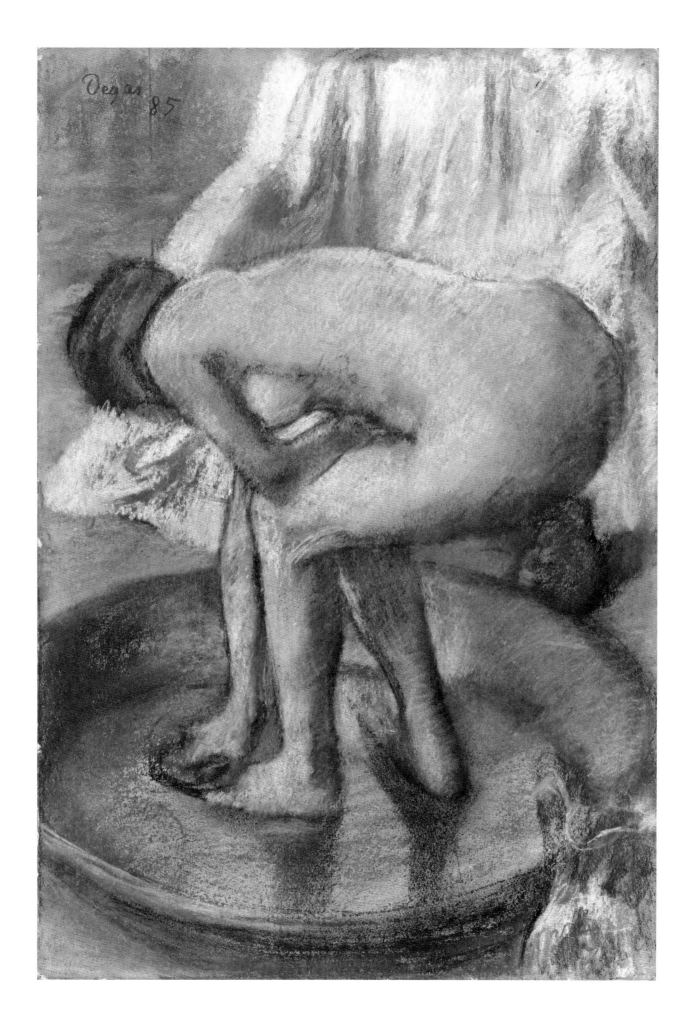

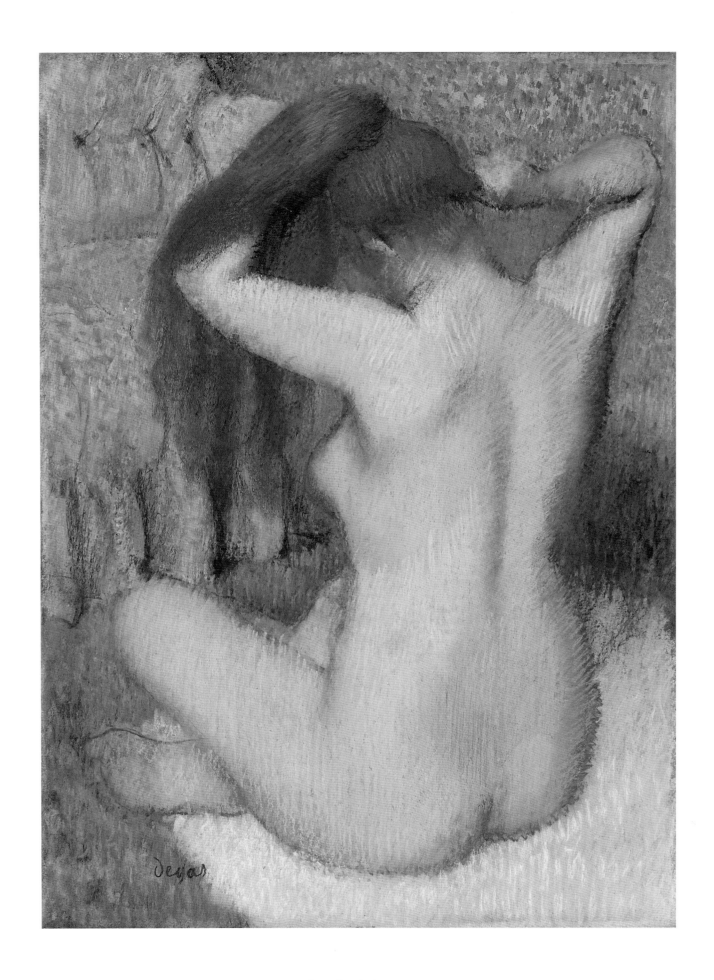

136. Edgar Degas, *Woman Combing Her Hair*, ca. 1888–90. Pastel on light green wove paper, now discolored to warm gray, affixed to original pulpboard mount

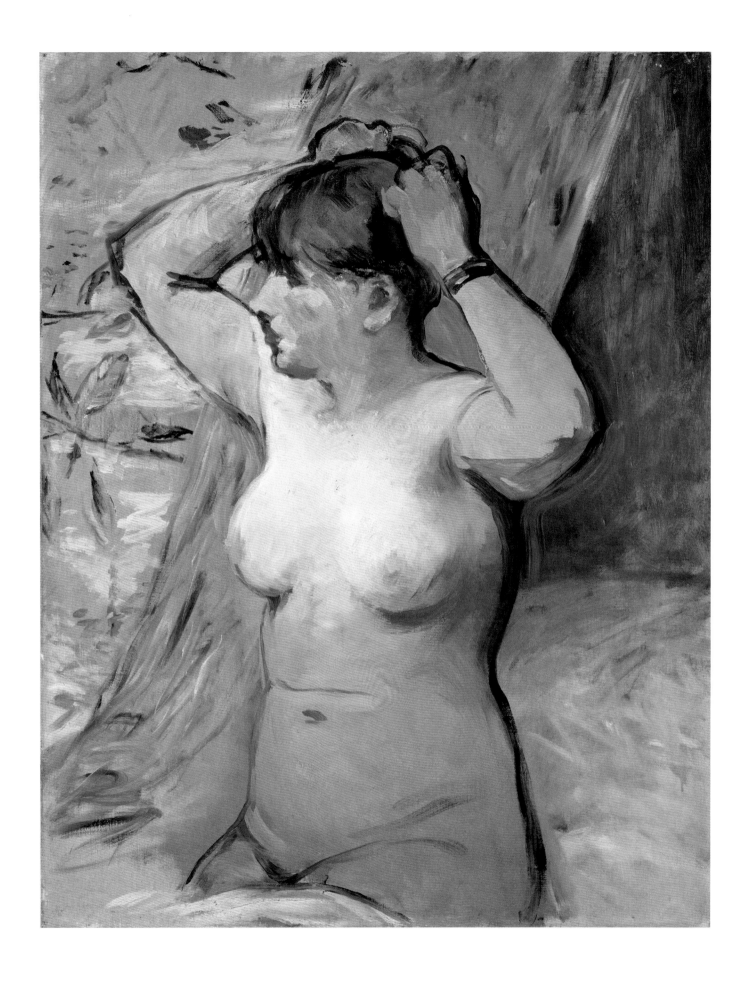

137. Édouard Manet, *Nude Arranging Her Hair*, 1879. Oil on canvas

FROM ONE WAR TO ANOTHER

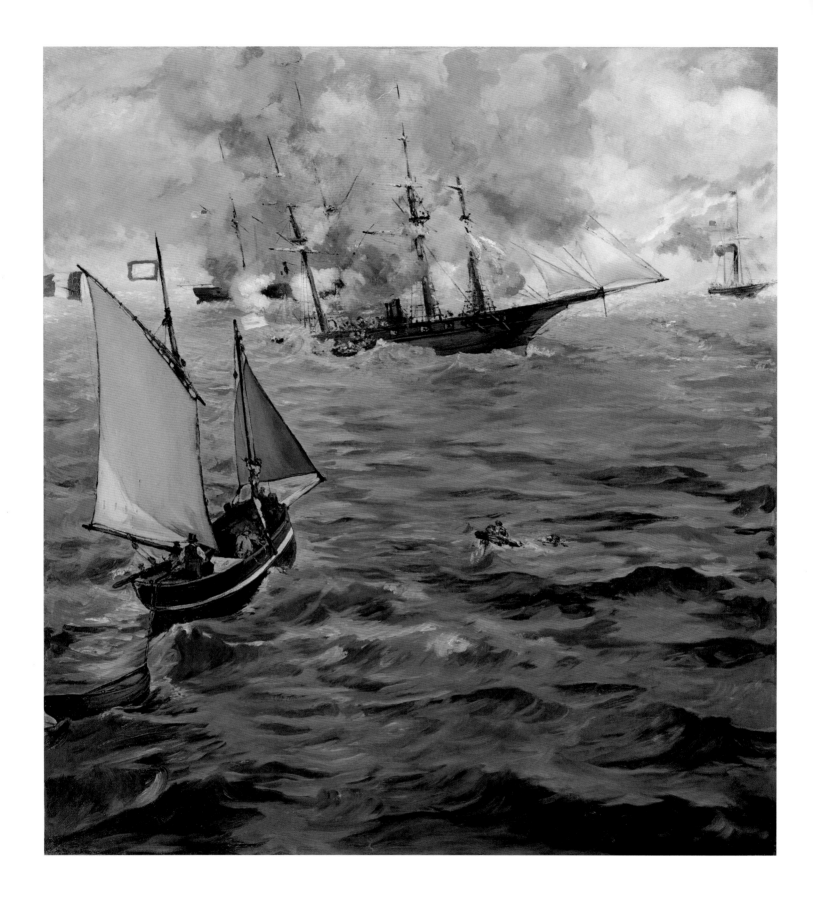

138. Édouard Manet, *The Battle of the USS "Kearsarge" and the CSS "Alabama,"* 1864. Oil on canvas

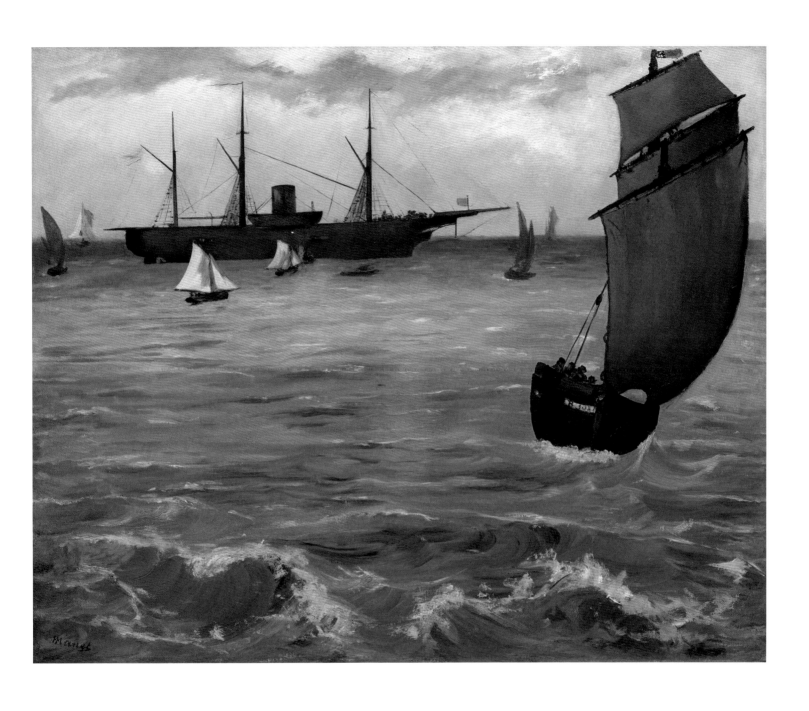

139. Édouard Manet, *The "Kearsarge" at Boulogne*, 1864. Oil on canvas

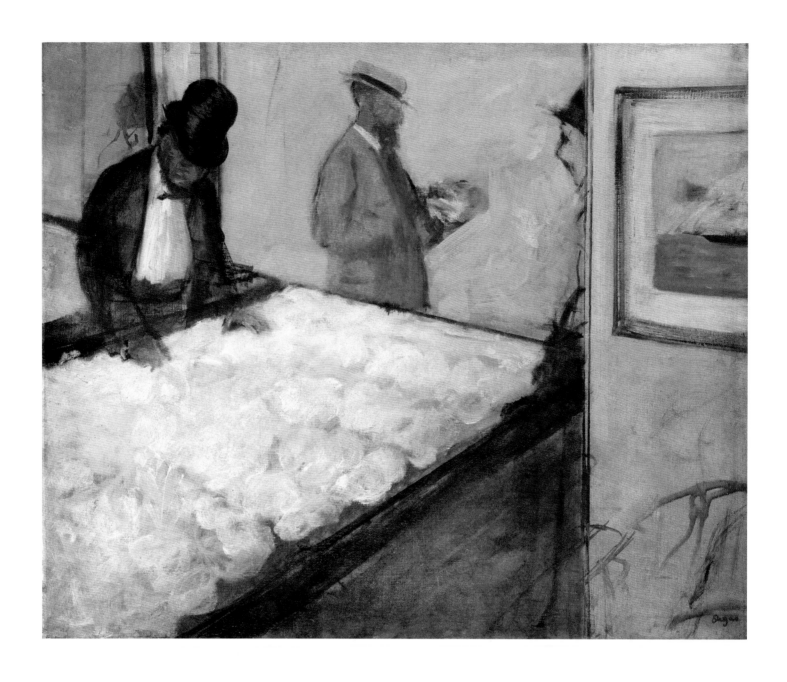

140. Edgar Degas, *Cotton Merchants in New Orleans*, 1873. Oil on linen

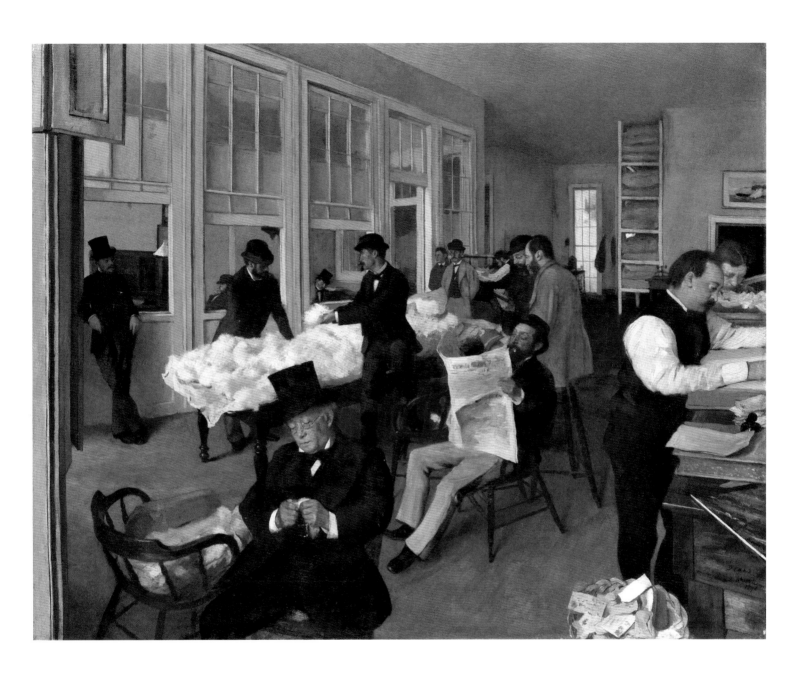

141. Edgar Degas, *A Cotton Office in New Orleans*, 1873. Oil on canvas

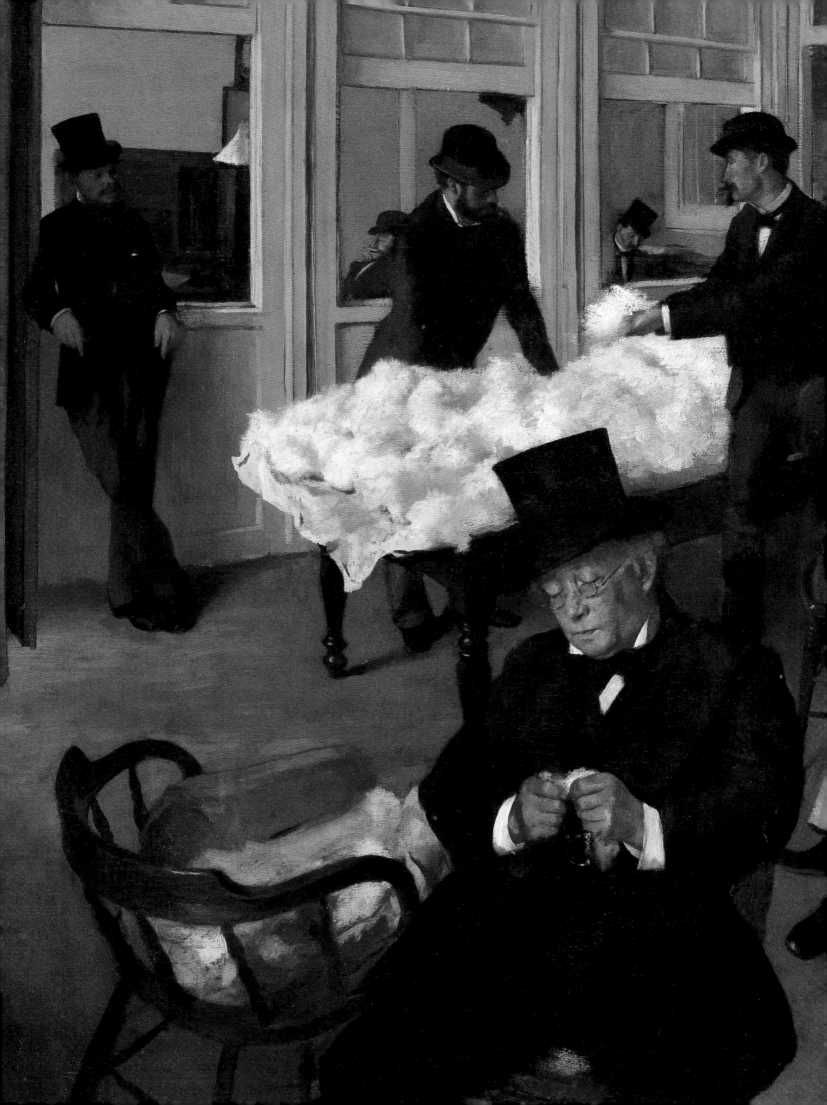

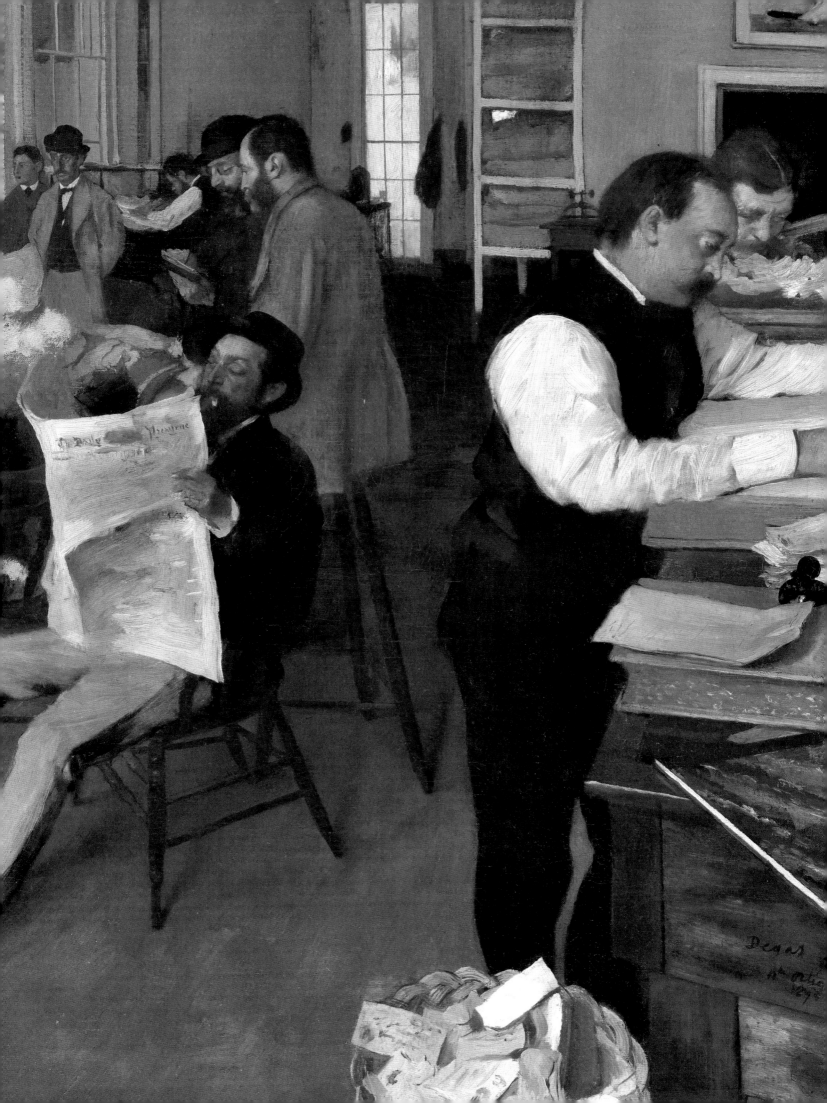

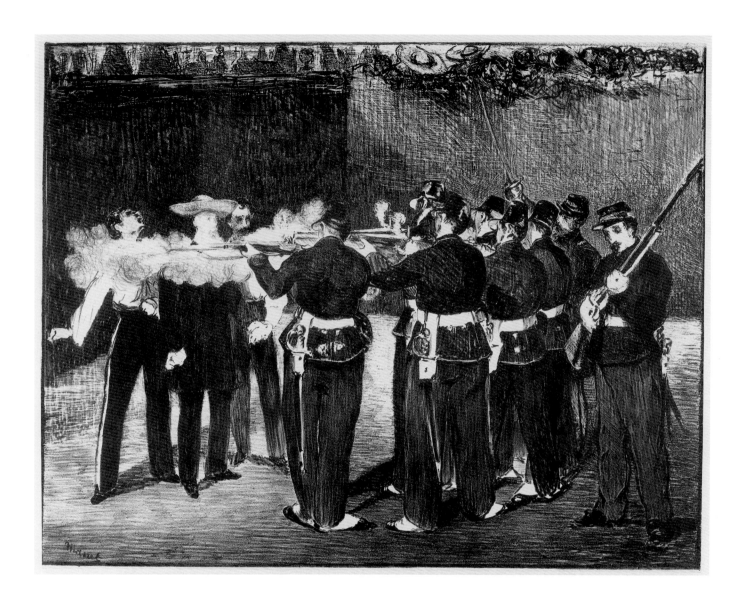

142. Édouard Manet, *The Execution of Maximilian*, 1868, published 1884. Lithograph on chine collé

143 (left, right). Édouard Manet, *The Barricade* (recto); *The Execution of Maximilian* (verso), ca. 1871.

Recto: brush and ink wash, watercolor, and gouache over graphite; verso: graphite

144. Édouard Manet, *The Barricade*, ca. 1871, published 1884. Lithograph on chine collé

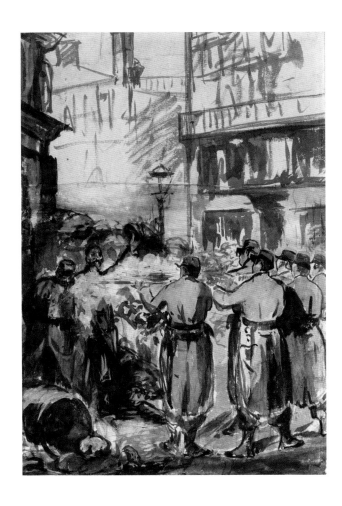

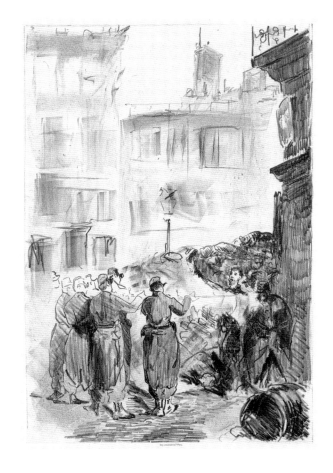

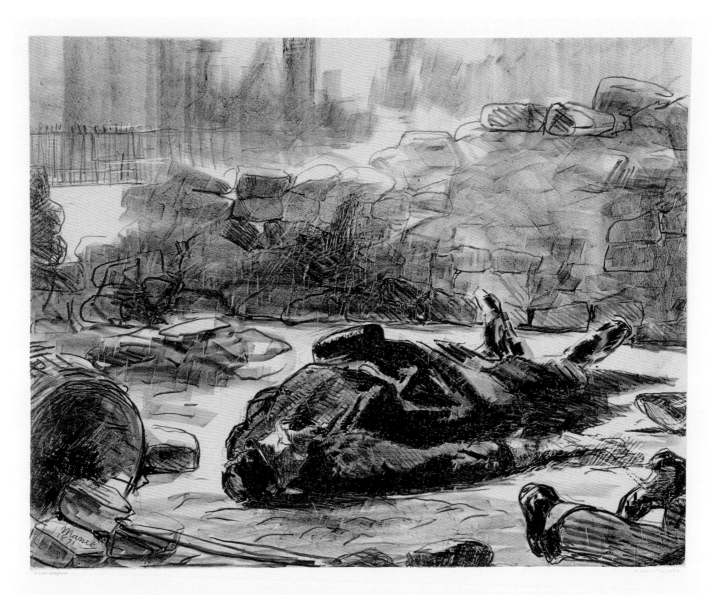

GUERRE CIVILE

145. Édouard Manet, *Civil War*, 1871–73, published 1874. Lithograph on chine collé

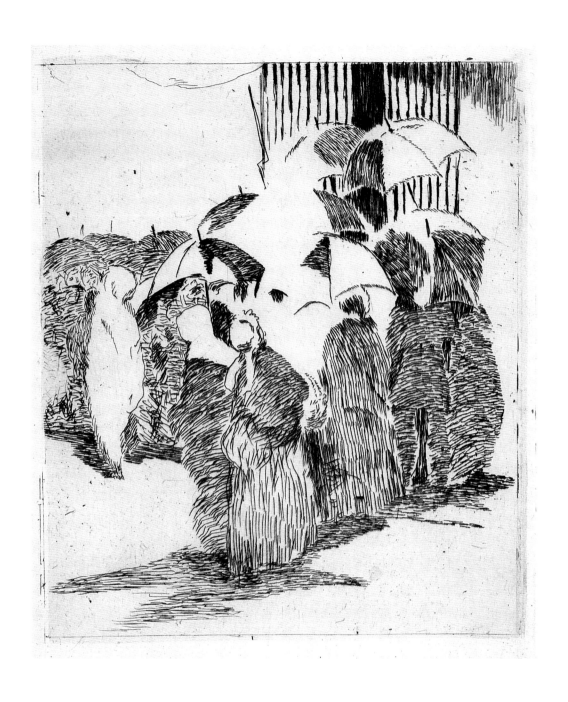

146. Édouard Manet, *Line in front of the Butcher Shop*, 1870–71,
published 1905. Etching on light blue laid paper

147. Édouard Manet, *The Escape of Rochefort*, ca. 1881. Oil on canvas

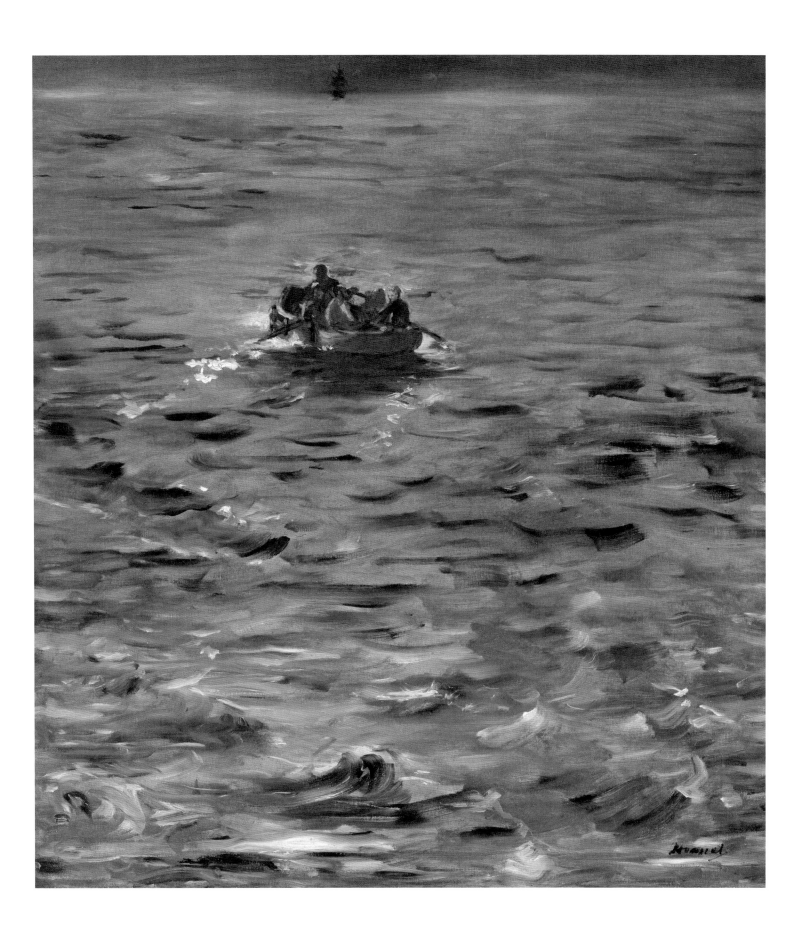

DEGAS COLLECTS MANET

148. Edgar Degas, *Self-Portrait with Paul-Albert Bartholomé*, ca. 1895–97. Modern print from a glass negative

149. Édouard Manet, *The Ham*, ca. 1875–80. Oil on canvas

150. Édouard Manet, *Polichinelle*, 1874. Lithograph printed in seven colors on Japan paper

151. Édouard Manet, *Hat and Guitar, Frontispiece for an Edition of*
Fourteen Etchings, 1862–63. Etching, aquatint, and drypoint

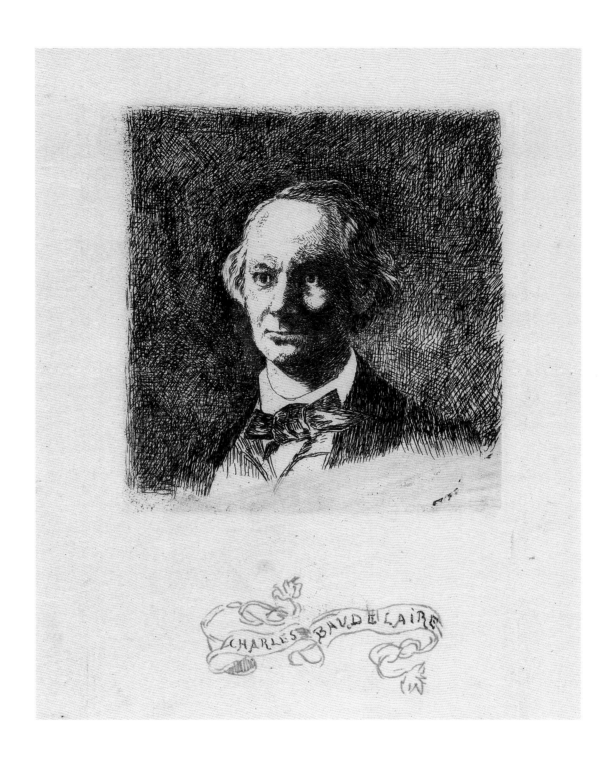

152. Édouard Manet, *Charles Baudelaire, Full Face, after Nadar, III*, 1869.

Etching with pen and brown ink

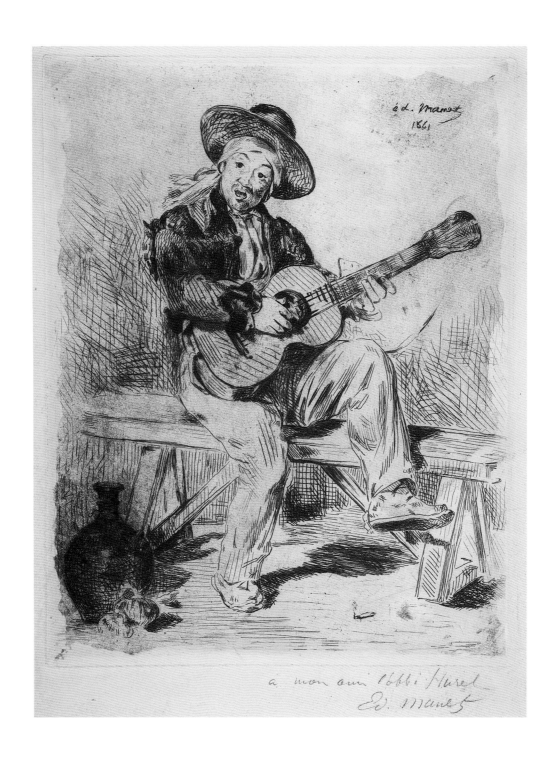

153. Édouard Manet, *The Spanish Singer*, 1861–62. Etching and bitten tone

154. Édouard Manet, *Plainte Moresque* (*Moorish Lament*), 1866. Lithograph

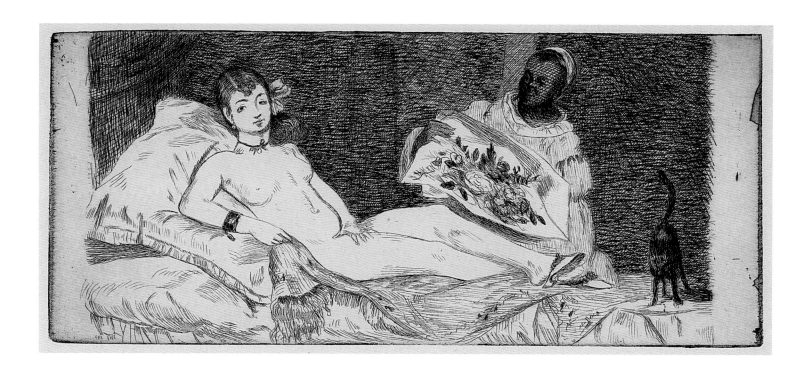

155. Édouard Manet, *Olympia* (published plate), 1867. Etching

156. Édouard Manet, *At the Theater*, ca. 1878–80. Graphite

157. Édouard Manet, *Berthe Morisot in Mourning*, 1874. Oil on canvas

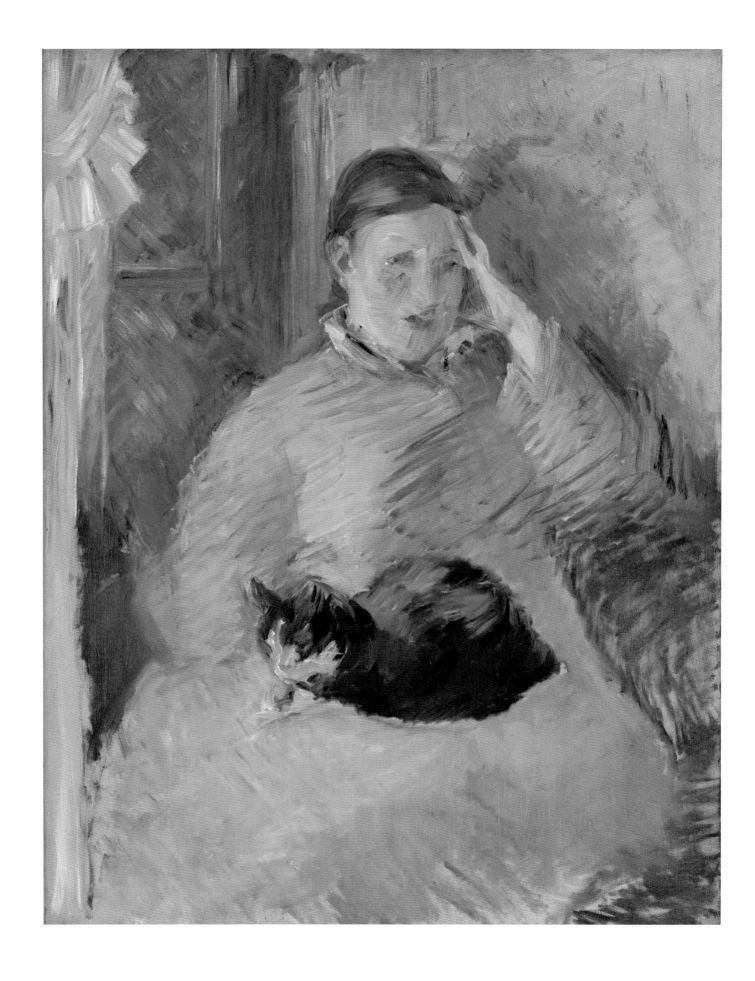

158. Édouard Manet, *Woman with a Cat*, ca. 1880. Oil on canvas

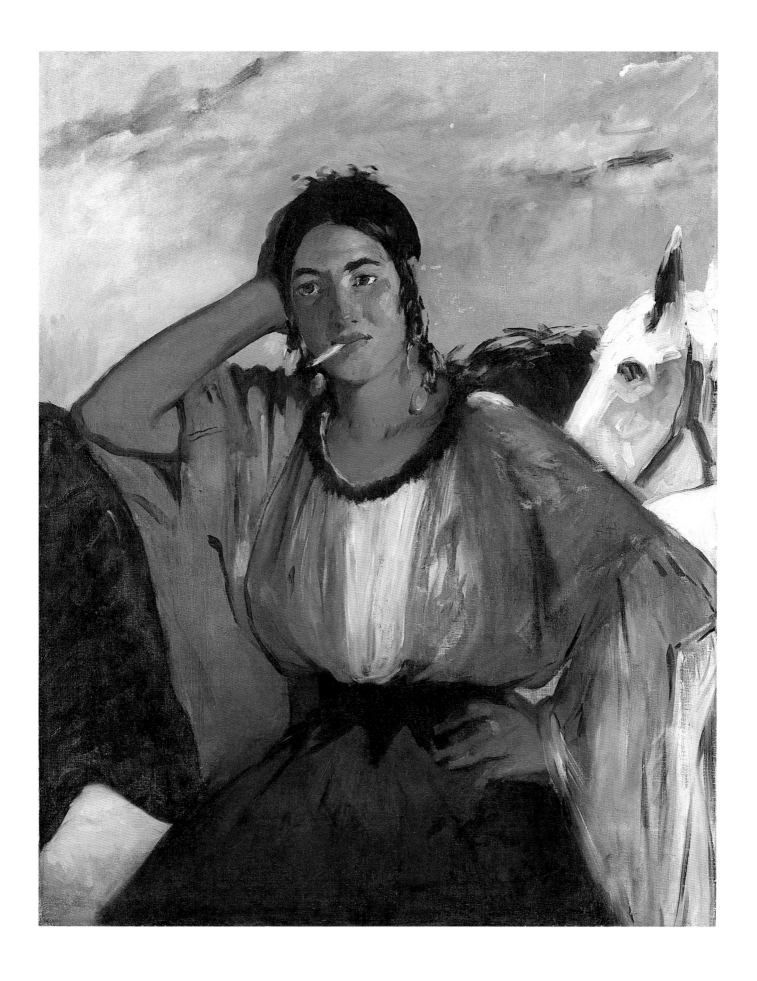

159. Édouard Manet, *Woman with a Cigarette*, ca. 1878–80. Oil on canvas

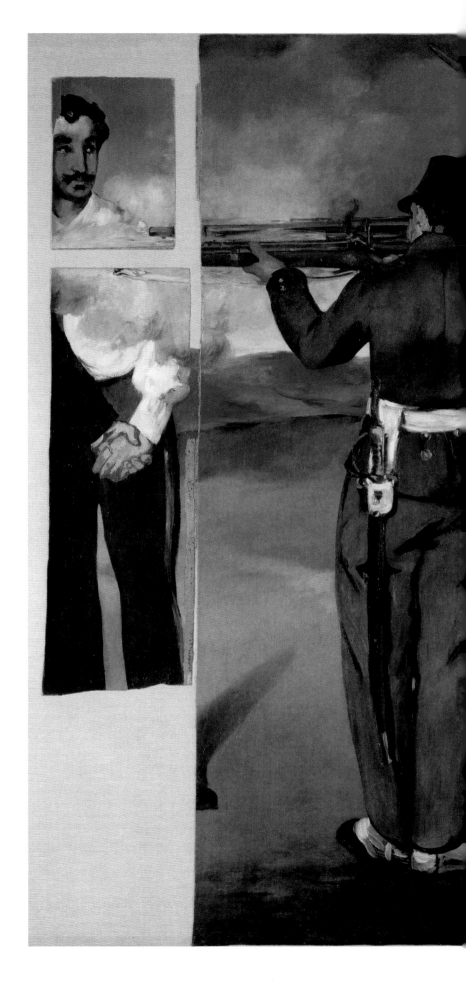

160. Édouard Manet, *The Execution of Maximilian*, ca. 1867–68. Oil on canvas

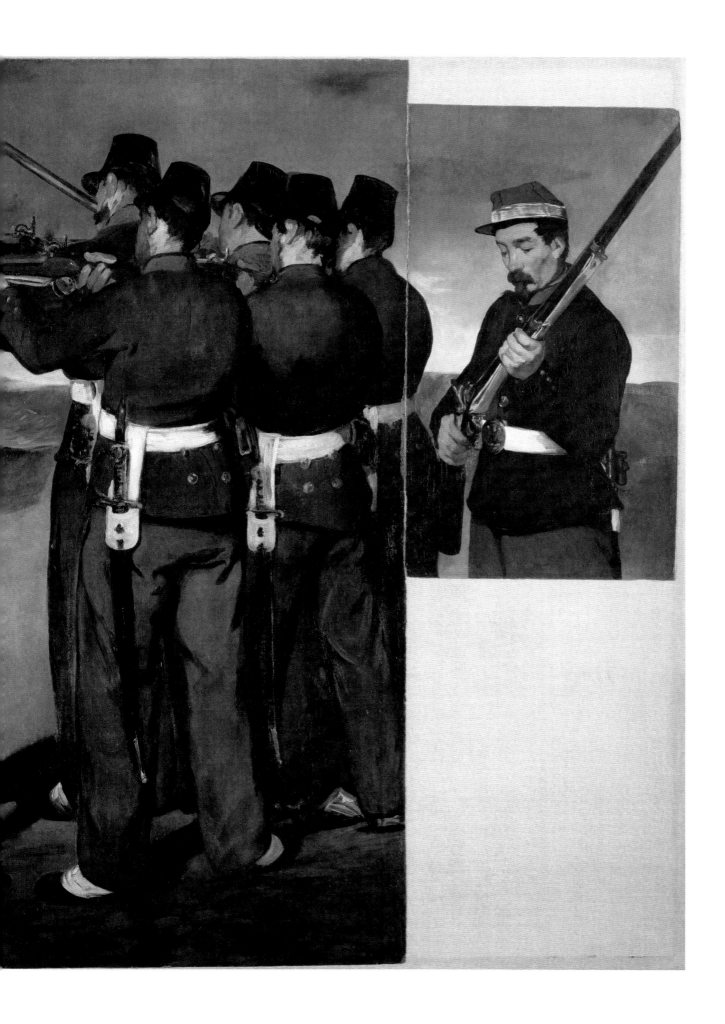

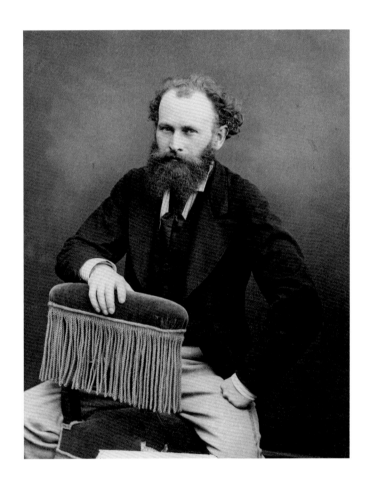

Fig. 36 Nadar (Gaspard-Félix Tournachon)
(French, 1820–1910), *Édouard Manet*, ca. 1865.
Gelatin silver print from a glass negative.
Musée d'Orsay, Paris (NA23702178)

Fig. 37 Joseph Tourtin (French, 1825–after 1870),
Edgar Degas, ca. 1860. Albumen print from a
collodion glass negative, 3½ × 2¼ in. (9 × 5.7 cm).
Musée d'Orsay, Paris (PHO 1992-10-24)

CHRONOLOGY

Samuel Rodary

Condensed and revised by
Haley S. Pierce

ABBREVIATIONS

MMA: The Metropolitan Museum of Art, New York
MO: Musée d'Orsay, Paris
NGA: National Gallery of Art, Washington, D.C.
priv. coll.: private collection
RW I / RW II: Denis Rouart and Daniel Wildenstein, *Édouard Manet: Catalogue raisonné*,
vol. 1, *Peintures*; vol. 2, *Pastels, aquarelles et dessins* (Lausanne: Bibliothèque des Arts, 1975)

NOTES TO THE READER

* Hilaire Degas, Edgar Degas's grandfather, left France after the Reign of Terror (1793–94)
and settled in Naples. He did not use the aristocratic particle of "de" in the spelling of his family name.
His son Auguste, the artist's father, chose to modify his surname to "De Gas" when he settled in Paris.
His children also used "De Gas" as their family name, but the artist changed it to "Degas" in the 1860s.
Accordingly, we use the spelling "Degas" for the artist and the Italian members of his family and
"De Gas" for the French members of his family.

* All streets, quarters, galleries, and other establishments for which no city is
indicated are located in Paris.

1832

January 23: Édouard Manet (fig. 36) is born
in Paris, at 5 rue des Petits-Augustins (now rue
Bonaparte). He is the eldest son of Auguste Manet
(1797–1862), a high official in the Ministry of
Justice, and Eugénie Désirée Fournier (1811–1895),
the daughter of a diplomat stationed in Stockholm.
The couple would have two other sons: Eugène
(1833–1892) and Gustave (1835–1884).

1834

July 19: Hilaire Germain Edgar De Gas (here-
after "Degas") (fig. 37) is born in Paris, at 8 rue
Saint-Georges. He is the son of Auguste De Gas
(1807–1874), a banker in Paris and Naples, and
Marie-Célestine Musson (1815–1847), the daughter
of a former businessman in New Orleans. Two
brothers and two sisters would follow: Achille
(1838–1893), Thérèse (1840–1912), Marguerite
(1842–1895), and René (1845–1921).

1844

In October, Manet enters the Collège Rollin,
near the Panthéon. He is a negligent student
who "does little work and is often distracted"
and has a "difficult character."[1] Nonetheless,
he is favorably disposed toward mathematics
and receives "very good" notices in drawing,
although he "refused to copy the helmeted mod-
els and sketched the heads of his neighbors,"
recalls fellow student Antonin Proust, who would
become a lifelong friend and write a biography
of the painter.[2]

1845

The Manet family moves to 6 rue du Mont-Thabor.

October 5: Degas enters the *classe de septième*
(the equivalent of fifth grade) at the Lycée Louis-
le-Grand, where he remains until obtaining his
bachelor of letters degree in 1853.

1847

September 5: Degas's mother dies.

1848

July: Manet leaves the Collège Rollin. Refusing to honor his parents' wish that he study law, he attempts to enroll in the naval academy but fails the entrance examination.

December 9: Manet embarks from Le Havre on the training ship *Havre et Guadeloupe* bound for Rio de Janeiro.[3] On board, he draws caricatures of the crew. One such sheet is his earliest surviving drawing: *Pierrot* (fig. 38).

1849

February: Manet arrives in Rio de Janeiro on February 4. Writing to his mother the next day, he observes: "For an artistically minded European . . . [the city] has a very special character." He is angered by the existence of slavery, "quite a revolting spectacle for us," and compares the beauty of Brazilian women to that of "Negresses."[4] At his captain's request, Manet gives drawing lessons to his comrades.[5]

Fig. 38 Édouard Manet, *Pierrot*, 1849. Pen and ink with watercolor, dimensions unknown. Private collection (RW II 450)

Manet expresses concern to his loved ones about recent political developments in France, writing on February 26: "How do you feel about the election of L[ouis] Napoléon; for goodness' sake don't go and make him emperor, that would be too much of a good thing."[6]

June 13: Manet returns to Le Havre. He subsequently fails a second attempt to qualify for the naval academy.

At around this time, Suzanne Leenhoff (1830–1906), a young Dutch woman who is a talented pianist, begins to give the three Manet brothers piano lessons.

1850

Manet and Proust enter the atelier of Thomas Couture, a high-profile painter who had gained recognition with his *Romans of the Decadence* (MO) at the Salon of 1847 and whose teaching method was considered innovative.

January 29: Manet identifies himself as a student of Couture in the register of copyists at the Louvre.

1851

December 2: Louis-Napoléon Bonaparte stages a coup d'état in order to remain in power. Manet and Proust watch the events unfold on the street and barely escape a cavalry charge.[7]

1852

January 29: Suzanne Leenhoff gives birth to Léon-Édouard Koëlla, known as Léon Leenhoff. Several assumptions have been made about the identity of his biological father. It could be Édouard Manet himself, or the painter's father, or even an unidentified third person (possibly a member of the Koëlla family of Swiss musicians).[8] Léon would always be identified as Suzanne's younger brother and Manet's godson.

July 19: On a sojourn in Holland, Manet visits the Rijksmuseum in Amsterdam.[9]

1853

Manet travels through Europe and visits collections of paintings by old masters in Kassel, Dresden, Prague, Vienna, and Munich.[10]

March 23: Degas obtains his baccalaureate.

April 7: Degas receives authorization to make copies in the Louvre. He identifies himself as a student of Félix-Joseph Barrias. Two days later, he is granted permission to make copies in the Cabinet des Estampes of the Bibliothèque Impériale (today known as the Bibliothèque Nationale).

September: Manet visits Venice with his brother Eugène.[11]

October: Manet arrives in Florence around October 7. After some ten days he departs for Rome for a stay of indeterminate duration.[12]

November 12: Degas enrolls in law school for the first and last time.

1855

The Manet family moves to 69 rue de Clichy.

Thanks to Édouard Valpinçon, a friend of his father's and a well-known collector, Degas pays a visit to Jean Auguste Dominique Ingres. Many of Degas's early portraits are imbued with Ingres's influence, such as *René De Gas* (pl. 14) and *Achille De Gas in the Uniform of a Cadet* (fig. 39).

With Proust, Manet visits Eugène Delacroix and asks for permission to copy his 1822 *Barque of Dante* (Musée du Louvre) at the Musée du Luxembourg.

April 5: Degas is admitted to the École des Beaux-Arts for the summer term along with Henri Fantin-Latour. Degas is the only student to work under Louis Lamothe.

1856

February: Manet leaves Couture's atelier and moves to 4 rue Lavoisier.[13]

July 17: Degas arrives in Naples, where he makes many copies in the Museo Nazionale and paints a portrait of his cousin Giovanna Bellelli.

October 7: Degas departs for Civitavecchia and Rome, where he remains until the end of July 1857. He attends evening drawing sessions at the Villa Medici and makes copies in various churches and at the Vatican Museums.

Fig. 39 Edgar Degas, *Achille De Gas in the Uniform of a Cadet*, ca. 1856–57. Oil on canvas, 25 3/8 × 18 3/16 in. (64.5 × 46.2 cm). National Gallery of Art, Washington, D.C., Chester Dale Collection (1963.10.123)

1857

August 1: Degas is back in Naples, where he stays with his grandfather at San Rocco di Capodimonte.

October: Having returned to Rome, Degas resides at "18 San Isidoro."[14] He draws assiduously in the churches, galleries, and streets of the city.

October–November: Manet arrives in Florence with his brother Eugène and the sculptor Eugène Brunet on October 21.[15] On November 19 the two artists jointly request permission to copy the frescoes in the cloister of Santissima Annunziata.[16]

1858

Manet gives up his atelier on rue Lavoisier and moves to 52 rue de la Victoire.[17]

January: In Rome, Degas and Gustave Moreau frequent the Villa Medici and become friends.

July–August: Degas leaves Rome for Florence on July 24. He lodges with his aunt Laura Bellelli, where he remains until March or April 1859. While there, Degas makes many copies in the Uffizi. Like Manet a year earlier, Degas requests permission from the Accademia di Belle Arti "to do some studies in the Cloister of the Annunziata."[18]

November 25: In Paris, Manet requests a *carte de travail* for the Bibliothèque Impériale.

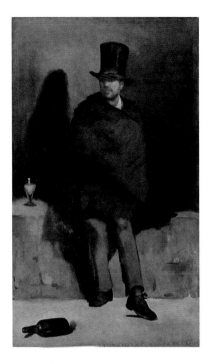

Fig. 40 Édouard Manet, *The Absinthe Drinker*, 1859. Oil on canvas, 71 1/16 × 41 9/16 in. (180.5 × 105.6 cm). Ny Carlsberg Glyptotek, Copenhagen (Nr. MIN 1788)

1859

January–March: Manet shows *The Absinthe Drinker* (fig. 40) to Couture, who judges it severely, thereby making the break between the two men definitive. When submitted for exhibition at the Salon, the painting is refused.[19]

Late March–early April: Degas leaves Florence and returns to Paris,[20] where he resides with his father at 4 rue de Mondovi.

April: Degas leaves the studio of his teacher, Louis Lamothe.

October 1: Degas moves into an atelier at 13 rue Laval (now rue Victor-Massé).

1860

Degas makes sketches after works by Delacroix that are exhibited during the winter and spring by the Association des Artistes at 26 boulevard des Italiens.[21]

Summer: Manet moves in with Suzanne and Léon Leenhoff on rue de l'Hôtel de Ville (now rue des Batignolles) and establishes his atelier on the rue de Douai.

1861

Manet moves his atelier to 81 rue Guyot (now 8 rue Médéric).[22]

January 17: In a letter to their uncle in New Orleans, René De Gas, the artist's brother, reports that Degas "is so absorbed by his painting that he writes to no one despite our objections."[23]

May: Manet exhibits *Monsieur and Madame Auguste Manet* (pl. 38) and *The Spanish Singer* (pl. 73) at the Salon. The latter painting earns him an honorable mention.[24]

September 3: Degas registers as a copyist at the Louvre.

The date of the first encounter between Manet and Degas is uncertain. It probably takes place in the early 1860s, when the two painters, like many young artists of the period, frequently visit the Louvre. At the museum, Manet reportedly stumbles upon Degas working directly on a copperplate to make an etching after the *Portrait of the Infanta Margarita Teresa* by Diego Velázquez and Workshop (fig. 6, pl. 19). Around the same time, Manet also executes an etching after this painting (pl. 18). These prints initiate a dynamic of reciprocal influence—tinged with rivalry—that would continue throughout the painters' lives.

In the early 1860s Degas and Manet frequent the racetracks at Longchamp and the Bois de Vincennes and begin painting horse races. Degas would draw *Édouard Manet at the Races* (pl. 106) in about 1868–69, and Manet would depict his rival in a corner of *The Races in the Bois de Boulogne* (pl. 104) in 1872.

1862

January 14: Degas registers again as a copyist at the Louvre.[25]

May 31: Alfred Cadart and Félix Chevalier establish the Société des Aquafortistes, the goal of which is to foster a revival of etching. Manet is among its founding members, whose ranks also include Fantin-Latour, Félix Bracquemond, Johan Jongkind, and Alphonse Legros.

September 25: Manet's father dies.

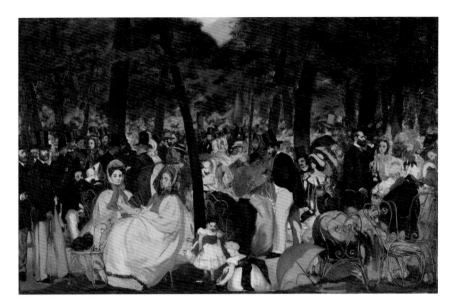

Fig. 41 Édouard Manet, *Music in the Tuileries Gardens*, 1862. Oil on canvas, 30 × 46½ in. (76.2 × 118.1 cm). The National Gallery, London. Sir Hugh Lane Bequest, 1917. In partnership with Hugh Lane Gallery, Dublin (NG3260)

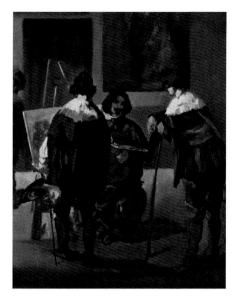

Fig. 42 Édouard Manet, *Spanish Studio Scene (Velázquez Painting)*, ca. 1860. Oil on canvas, 18⅛ × 14¹⁵⁄₁₆ in. (46 × 38 cm). Private collection

1863

March 1: Manet exhibits fourteen paintings at the Galerie Martinet, including *Music in the Tuileries Gardens* (fig. 41), *Boy with a Sword* (pl. 44), and *Lola de Valence* (pl. 97).

March 6: Degas, according to his brother René, "works furiously and thinks of only one thing, his painting. He allows himself no time for amusement he works so much."[26]

May 15: The Salon des Refusés opens. Manet exhibits *Déjeuner sur l'herbe* (MO), *Mademoiselle V... in the Costume of an Espada* (MMA), *Young Man in the Costume of a Majo* (MMA), and three etchings, including an impression of *Lola de Valence* (pl. 96).

August 17: Manet attends Delacroix's funeral with Charles Baudelaire.[27]

October 28: Manet marries Suzanne Leenhoff in the Dutch city of Zaltbommel, her birthplace. The couple spends a month in the Netherlands.[28]

1864

Degas visits Ingres, who has organized "a small exhibition in his atelier in the manner of the old masters."[29]

April 22: Degas, writes his brother René, "still works enormously hard without seeming to. What is fermenting in that head is frightening. I myself believe, and am even convinced, that he has not just talent but even genius. But will he express what he feels? That is the question."[30]

May: At the Salon, Manet exhibits *The Dead Christ with Angels* (pl. 75) and *An Incident in the Bullring*, a work from which he would later cut two separate canvases, *The Dead Toreador* (pl. 85) and *The Bullfight* (Frick Collection, New York).

June 19: The *Kearsarge* of the U.S. Navy sinks the Confederate vessel *Alabama* in a naval battle of the American Civil War off the shore of Cherbourg. Manet soon paints the event (pl. 138).

November: Manet and his wife move into 34 boulevard des Batignolles.[31]

1865

May: At the Salon, Manet exhibits *Jesus Mocked by the Soldiers* (Art Institute of Chicago) and *Olympia* (pl. 81), the latter of which is vilified by critics and the public alike. Degas exhibits *Scene of War in the Middle Ages* (pl. 83).

August–September: Manet travels through Spain, following an itinerary provided by his friend Zacharie Astruc. He returns an ardent enthusiast of the work of Velázquez, who "all by himself makes the journey worthwhile. . . . He is the supreme artist."[32] Manet supposedly depicted the painter previously in his *Spanish Studio Scene*, also called *Velázquez Painting* (fig. 42).

1866

April: The Salon jury refuses Manet's submissions, *The Fifer* (MO) and *The Tragic Actor (Rouvière as Hamlet)* (NGA).

May: At the Salon, Degas exhibits *Scene from the Steeplechase: The Fallen Jockey* (pl. 86).

May 7: In his critique of the Salon, published in *L'Événement*, Émile Zola comes to Manet's defense, drawing thunderous objections from the paper's readers that prompt him to resign.

Fig. 43 Edgar Degas, *The Bellelli Sisters (Giovanna and Giuliana Bellelli)*, 1865–66. Oil on canvas, 36¼ × 28½ in. (92.1 × 72.4 cm). Los Angeles County Museum of Art, Mr. and Mrs. George Gard De Sylva Collection (M.46.3.3)

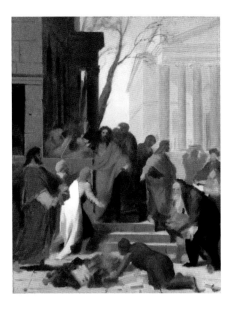

Fig. 44 Edgar Degas, *Copy after "The Preaching of Saint Paul at Ephesus" by Le Sueur*, 1868–69. Oil on canvas, 16¼ × 13⅛ in (41.3 × 33.3 cm). Private collection, New York

Fall: Manet and his family move in with the painter's mother at 49 rue de Saint-Pétersbourg.

November 12: The ballet *La Source* premieres at the Paris Opéra, inspiring Degas to paint his *Mademoiselle Fiocre in the Ballet "La Source"* (pl. 95).

1867

March 30: Manet, together with many other artists, petitions the Surintendant des Beaux-Arts to organize a Salon des Refusés, without success. Degas does not sign the petition but sends an anonymous letter to *Le Figaro* calling for a complete overhaul of the "system" of admission to the Salon.[33]

April 15: At the Salon, Degas exhibits *Family Portrait (The Bellelli Family)* (pl. 49) and *The Bellelli Sisters (Giovanna and Giuliana Bellelli)* (fig. 43).

May 24: Manet opens a solo exhibition, which includes fifty-three canvases and three etchings. It is housed in a pavilion erected, at considerable expense, near the Pont de l'Alma, outside the grounds of the Exposition Universelle. The artist publishes a catalogue with a preface by himself in which he asserts his right to show his work.

June 19: Emperor Maximilian is executed in Mexico. Manet soon begins a series of paintings of the subject (pl. 160, fig. 13).

September 2: Manet hastily returns to Paris from a visit to Trouville to attend the funeral of Baudelaire, who had died on August 31.

1868

Around this time, Degas makes a series of portrait drawings of Manet, later used in the execution of prints (pls. 6–12). At the Louvre, Fantin-Latour introduces the sisters Edma and Berthe Morisot to Manet, who subsequently introduces them to Degas. Both men later attend frequent soirées at the Morisot residence in Passy.

March 26: Degas registers for the last time as a copyist at the Louvre.[34] He continues to study and make copies from the old masters, such as fig. 44 (after *The Preaching of Saint Paul at Ephesus* by Eustache Le Sueur).

July 29: Manet writes to Degas from Boulogne-sur-Mer: "My dear Degas, I'm planning to make a little trip to London . . . do you want to come along? I think we should explore the terrain over there since it could provide an outlet for our products. . . . Let me know immediately because I will write and tell Legros what day we'll be arriving so that he can act as our interpreter and guide. If you can persuade Fantin to come with you, that would be delightful. Regards to [the writer Edmond] Duranty, Fantin, Zola, if you see them tell them I'll be writing to them one of these days."[35]

Degas does not join Manet, who upon his return expresses his regret to Fantin-Latour: "de Gas [*sic*] was really silly not to have come with me."[36]

August 26: From Boulogne-sur-Mer, Manet writes again to Fantin-Latour: "It's clear . . . that you Parisians have all the entertainment you could wish for but I have no one here to talk to; so I envy your being able to discuss with that famous aesthetician Degas the question of whether or not it is advisable to put art within reach of the lower classes, by turning out pictures for sixpence apiece." He asks for news of Degas: "Tell Degas it's about time he wrote to me, I gather from Duranty he's becoming a painter of 'high life'; why not? It's too bad he didn't come to London, those well-trained horses would have inspired a few pictures."[37]

1869

January–February: Manet learns that his painting *The Execution of Maximilian* (fig. 13) will be refused by the Salon and that the publication of his related lithograph (pl. 142) will be prohibited. He tries to mobilize the press to defend his rights and obtains the support, notably, of Zola.[38]

Around this time, Degas paints *Monsieur and Madame Édouard Manet* (pl. 3) and gives it to Manet. Disappointed by the portrait of his wife, Manet cuts away the portion of the canvas with Suzanne's face. This enrages Degas, who writes to the gallerist Ambroise Vollard: "What a shock I had when I saw my study again at Manet's. . . . I left without saying goodbye, carrying my painting with me. When I got home, I took down the little still life he had given me. 'Monsieur,' I wrote him, 'I am returning your *Plums*.'"[39] The painting of *Plums* has not been identified. Vollard, in his later recounting of the story, may have confused it with *Nuts in a Salad Bowl* (fig. 33), which was in Degas's collection.

The quarrel does not last long; "How can one remain on bad terms with Manet,"[40] Degas himself remarked. Around the spring of 1869 Berthe Morisot's mother writes to her daughter: "The Manets and M. Degas are playing host to one another. It seemed to me that they had patched things up."[41]

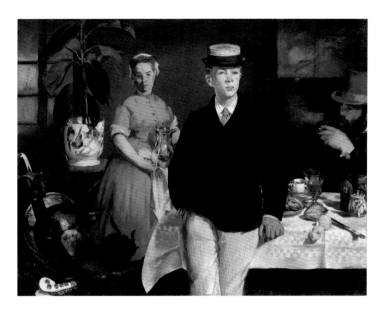

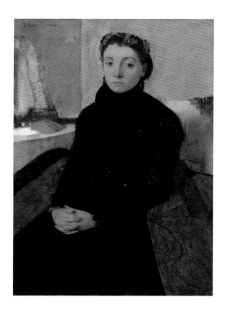

Fig. 45 Édouard Manet, *The Luncheon*, 1868. Oil on canvas, 46 ⅝ × 60 ⅝ in. (118.3 × 154 cm). Bayerische Staatsgemäldesammlungen–Neue Pinakothek, Munich, Acquired in 1911 as a gift from Georg Ernst Schmidt-Reißig as part of the Tschudi donation (8638)

Fig. 46 Edgar Degas, *Joséphine Gaujelin*, 1867. Oil on canvas, 24 ⅛ × 18 in. (61.2 × 45.7 cm). Isabella Stewart Gardner Museum, Boston (P1e4)

May: At the Salon, Manet exhibits *The Balcony* (pl. 98), *The Luncheon* (fig. 45), and five etchings. Degas exhibits *Joséphine Gaujelin* (fig. 46).

Manet and Degas belong to the same interconnected circles of friends. They attend the soirées hosted by the Morisots and by Alfred Stevens and his wife; Degas takes part in Manet's mother's Thursday salons; and Manet is a regular at Degas's father's gatherings. Music figures prominently at these occasions, performed by, among others, the tenor Lorenzo Pagans, the Opéra bassoonist Désiré Dihau, and Suzanne Manet, a gifted pianist.

May 27: Manet writes to Degas: "Friday—My dear Degas, Will your father be receiving tomorrow? I arrived at Tortoni's [Café Tortoni] last Saturday right after you left and Stevens told me that everything had been postponed eight days. Since I didn't see you at his place on Wednesday, I await word from you. I shake your hand. E. Manet."

July 20: Following an article that appeared in *Le Temps* on July 20, 1869, which expressed contempt for Baudelaire, Manet assists his friend the author Hippolyte Babou by writing to Degas: "Tuesday. My dear Degas, I come to ask that you return the two volumes of Baudelaire that I lent you. Hyppolite [*sic*] Babou is asking for them so that he can respond to the article by [Edmond] Scherer. You will have them as soon as he is finished with them and that won't be long. Cordially, E. Manet."[42]

July–August: Degas vacations in Étretat and Villers-sur-Mer. He visits Manet, who is spending the summer at Boulogne-sur-Mer.[43]

1870

While retaining his atelier on the rue Guyot, Manet occupies a second one, at 51 rue de Saint-Pétersbourg, which is adjacent to his residence.

March: Manet joins a committee organized by the painter Julien de La Rochenoire that aims to reform the process by which the Salon jury is selected, such that it would favor the "right of every artist to show his work in the most favorable conditions." Manet seeks Zola's help in obtaining press coverage.[44]

April 12: Degas publishes a letter in *Paris-Journal* calling for the jury to reconsider the way works of art are exhibited at the Salon.

May: At the Salon, Degas exhibits *Madame Camus* (NGA) and *Madame Théodore Gobillard (Yves Morisot)* (pl. 54); Manet exhibits *Music Lesson* (pl. 40) and *Eva Gonzalès* (The National Gallery, London).

July 19: France declares war against Prussia.

August 8: A government decree announces the conscription into the Garde Nationale Sédentaire of all male citizens between the ages of thirty and forty. Manet (age thirty-eight) and Degas (age thirty-six) are drafted. As members of the National Guard, their principal obligation is to surveil the fortifications of Paris: Degas to the north of the Bois de Vincennes, Manet toward the Porte de Saint-Ouen.[45]

September 4: The Third Republic is proclaimed in Paris.

September 13: Degas and Manet attend a lecture at the Folies-Bergère by Gustave Cluseret, future communard and one of the founders of the Republican Central Committee for the National Defense of the Twenty Arrondissements of Paris, a precursor to the Commune. Manet finds the intentions of these "true republicans" "very interesting."[46]

September–October: Degas joins the artillery.[47] The Siege of Paris causes strife in the capital and embitters the relationship between Manet and Degas, who, according to Mme Morisot, "almost came to blows arguing over the methods of defence and the use of the National Guard, although each of them was ready to die to save the country."[48]

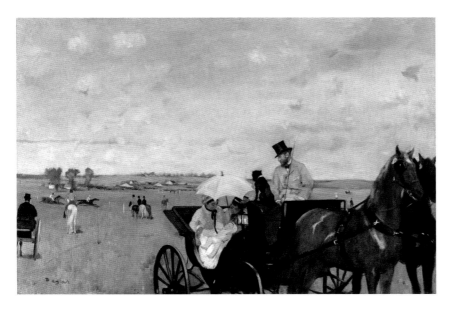

Fig. 47 Edgar Degas, *At the Races in the Countryside*, 1869. Oil on canvas, 14 3/8 × 22 in. (36.5 × 55.9 cm). Museum of Fine Arts, Boston, 1931 Purchase Fund (26.790)

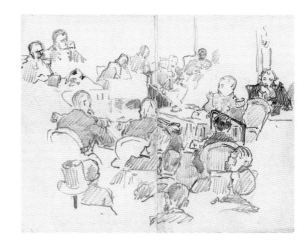

Fig. 48 Édouard Manet, *Bazaine before the War Council*, 1873. Graphite, on two remounted sketchbook leaves, 7 5/16 × 9 3/8 in. (18.5 × 23.8 cm). Museum Boijmans Van Beuningen, Rotterdam, Loan: Stichting Museum Boijmans Van Beuningen 1940, former collection Koenigs (F II 107 recto [PK])

Mid-November: Manet in turn joins the artillery. On November 19 he writes to Eva Gonzalès: "Degas and I are in the artillery, volunteer gunners."[49]

1871

January 28: Franco-Prussian armistice is declared; Paris surrenders.

February 12: Manet leaves Paris to join his family in Oloron-Sainte-Marie.

Mid-March: Degas stays with the Valpinçons at Ménil-Hubert.

March 18: The Paris Commune is proclaimed. The revolutionary government lasts until May 28.

June 5: Mme Morisot writes to Berthe: "[Your brother] has met two Communards, at this moment when they are all being shot . . . Manet and Degas! Even at this stage they are condemning the drastic measures used to repress them. I think they are insane, don't you?"[50]

July 14: Manet's soirées, which Degas attends, resume in the heavy postwar and post-Commune atmosphere. Mme Morisot writes to Berthe: "I found the Manet salon in just the same state as before; . . . Pagans sang, Madame Édouard [Manet] played, and Monsieur Degas was there."[51]

September 30: Degas visits Manet's atelier. In a letter to James Tissot, he writes: "I saw something new from Manet, of average size, finished, polished, a change at last. Such a gifted fellow!" He also complains about his vision problems: "I recently suffered and continue to suffer from small bouts of weakness and discomfort in my eyes. It first happened on the river bank in Chatou under the blazing sun, while painting a watercolor, and it cost me nearly three weeks of being unable to read, work, go outside much, and shook me with fear that I would remain this way."[52]

1872

January: For the first time, the dealer Paul Durand-Ruel buys works by Manet (twenty-four paintings, for 35,000 francs) and Degas (three paintings). He exhibits works by both artists in London over the course of the year, including Manet's *Young Lady in 1866* (pl. 93) and Degas's *At the Races in the Countryside* (fig. 47).

May: At the Salon, Manet exhibits *The Battle of the USS "Kearsarge" and the CSS "Alabama"* (pl. 138).

June: Manet again travels to the Netherlands. He visits the Frans Hals Museum in Haarlem and the Rijksmuseum in Amsterdam.[53]

July 1: Encouraged by his sales to Durand-Ruel, Manet moves into a huge atelier at 4 rue de Saint-Pétersbourg.

October 12: Degas and his brother René depart Liverpool for the United States aboard the *Scotia*. They arrive in New York on October 24 and spend thirty hours there before continuing to New Orleans.[54]

November–December: In a letter dated November 19 from New Orleans, Degas mentions to Tissot: "I haven't yet written to Manet and of course he hasn't sent me a note either."[55] On December 5, he writes to Henri Rouart: "Manet would see here more beautiful things than I have. But he wouldn't do any more than I have. We only give love and art to what we are used to. The new captivates and bores in turn."[56]

1873

February 18: Degas tells Tissot that he is making two versions of the same subject, "Inside a cotton buyers' office in New Orleans," likely referring to his two paintings *Cotton Merchants in New Orleans* and *A Cotton Office in New Orleans* (pls. 140, 141).[57]

Late March: Having returned to Paris, Degas resides at 77 rue Blanche.[58]

May: At the Salon, Manet exhibits *Repose* (pl. 55) and *Le Bon Bock* (Philadelphia Museum of Art). The latter painting enjoys unprecedented success with both critics and the public.

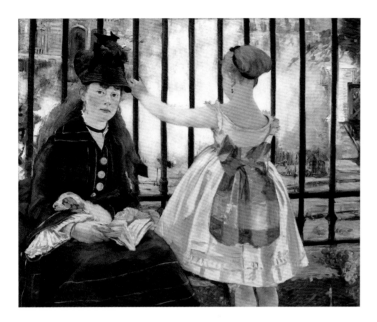

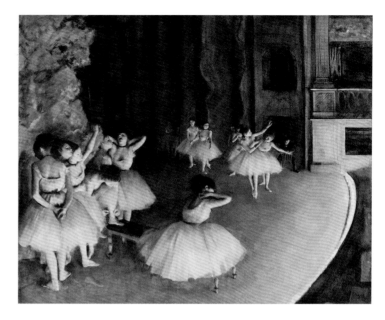

Fig. 49 Édouard Manet, *The Railway*, 1873. Oil on canvas, 36 ¾ × 43 ⅞ in. (93.3 × 111.5 cm). National Gallery of Art, Washington, D.C., Gift of Horace Havemeyer in memory of his mother, Louisine W. Havemeyer (1956.10.1)

Fig. 50 Edgar Degas, *Rehearsal of a Ballet on the Stage*, 1874. Oil on canvas, 25 ⅝ × 32 ⅛ in. (65 × 81.5 cm). Musée d'Orsay, Paris, Bequest of Count Isaac de Camondo, 1911 (RF 1978)

October–December: Manet attends, at the Grand Trianon of Versailles, the trial for treason of French marshal François Achille Bazaine. He makes several sketches there, including *Bazaine before the War Council* (fig. 48), later purchased by Degas.

December 27: Degas, Paul Cézanne, Claude Monet, Berthe Morisot, Camille Pissarro, and other artists establish the Société Anonyme Coopérative des Artistes, Peintres, Sculpteurs et Graveurs (hereafter referred to as the Société Anonyme des Artistes), which is devoted to organizing independent, nonjuried exhibitions, promoting the sale of works on view, and publishing a journal.

1874

February 23: Auguste De Gas dies in Naples, leaving his heirs a company deeply in debt.

March: Degas takes an active hand in organizing the first exhibition of the Société Anonyme des Artistes and tries to recruit his artist friends and colleagues. He hopes to convince Manet to participate and writes to Bracquemond: "Because of Fantin's influence and some self-induced panic, Manet still refuses to join us; but nothing seems to be definitive on this matter yet."[59]

April 12: The Salon jury accepts two works by Manet, *The Railway* (fig. 49) and *Polichinelle* (watercolor; RW II 563), but rejects *The Swallows* (Bührle Collection, Zurich) and *Masked Ball at the Opera* (NGA). The poet Stéphane Mallarmé comes to the painter's defense in the essay "The Painting Jury of 1874 and M. Manet."[60]

Despite the rejection, Manet prefers to continue exhibiting at the official Salon, prompting Degas to write to Tissot: "There needs to be a realist Salon. Manet doesn't understand that. I believe him to be definitely more vain than intelligent."[61]

April 15: The Société Anonyme des Artistes opens its *Première exposition* in the studio of the photographer Nadar at 35 boulevard des Capucines. (It came to be known as the first of eight Impressionist exhibitions, each of which was on view for approximately one month.) Degas shows ten works (including fig. 50) and receives several favorable notices; however, the exhibition is a failure with critics and the public. It closes a month later and the Société Anonyme des Artistes is dissolved.

August: Manet vacations in Gennevilliers, near Monet's home in Argenteuil. Pierre-Auguste Renoir visits them.[62] Manet paints Monet in his studio boat in *The Boat* (Bayerische Staatsgemäldesammlungen–Neue Pinakothek, Munich).

September 13: Manet and his wife arrive in Venice. He often paints on the water (like Monet in Argenteuil), producing *The Grand Canal, Venice* (RW I 230) and *The Grand Canal, Venice (Blue Venice)* (Shelburne Museum, Vermont).

1875

January: The Paris Opéra is inaugurated. At Café Guerbois, Manet declares, "Why, it is Degas who should have painted the foyer of the Opéra."[63]

May: Manet exhibits *Argenteuil* (Musée des Beaux-Arts, Tournai) at the Salon.

May 20: Richard Lesclide publishes *The Raven* (*Le Corbeau*) by Edgar Allan Poe, translated by Mallarmé and illustrated by Manet (fig. 51).

Fig. 51 Édouard Manet, *Open Here I Flung the Shutter.*
Illustration to "The Raven" by Edgar Allan Poe,
1875. Transfer lithograph; fifth state of five, sheet
21 5/16 × 13 3/4 in. (54.2 × 35 cm). The Metropolitan
Museum of Art, New York, Harris Brisbane Dick Fund,
1924 (24.30.27[4])

1876

The Café de la Nouvelle-Athènes on Place Pigalle
is the gathering spot of painters and writers,
including Degas and Manet, for whom "two
tables in the right-hand corner were reserved."[64]
At these meetings, Degas later said, "we talked
endlessly."[65]

The writer Georges Rivière, another habitué,
recalled: "There were often many of us at the
Nouvelles-Athènes, Manet, smiling, elegant,
looking very young, sat down beside Desboutin,
with whom he made for an amusing contrast;
Degas, with the profile of a bourgeois . . . , arrived
well-equipped with cruel comments about his
contemporaries."[66]

The engraver Marcellin Desboutin was also
a regular. Both artists would paint his portrait:
Manet in *The Artist (Marcellin Desboutin)* (pl. 61),
and Degas in *Marcellin Desboutin and Ludovic Lepic*
(pl. 62) and *In a Café (The Absinthe Drinker)*
(pl. 118), which depicts Desboutin beside Ellen
Andrée, who was also a model for Manet, nota-
bly in *At the Café* (Sammlung Oskar Reinhart
"Am Römerholz," Winterthur).

March 30: The *2ᵉ Exposition de peinture* (second
Impressionist exhibition) opens at Galerie Durand-
Ruel, at 11 rue Le Peletier. Degas exhibits twenty-
two works (including fig. 52), nearly all for sale.

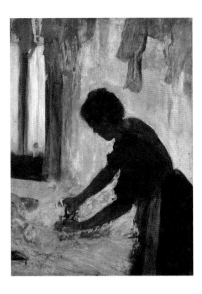

Fig. 52 Edgar Degas, *A Woman Ironing*, 1873.
Oil on canvas, 21 3/8 × 15 1/2 in. (54.3 × 39.4 cm).
The Metropolitan Museum of Art, New York,
H. O. Havemeyer Collection, Bequest of Mrs.
H. O. Havemeyer, 1929 (29.100.46)

April 15–May 1: After his two Salon submissions,
Laundry (fig. 53) and *The Artist (Marcellin
Desboutin)*, have been refused, Manet presents
them to the public in his atelier, along with
other works.

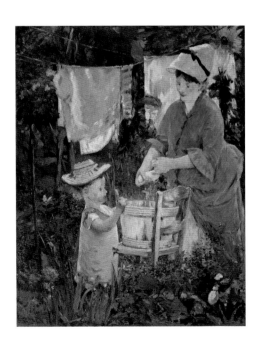

Fig. 53 Édouard Manet, *Laundry*, 1875.
Oil on canvas, 57 1/4 × 45 1/4 in. (145.4 × 114.9 cm).
Barnes Foundation, Philadelphia (BF957)

July: Degas explores printmaking techniques
and works on the production of monotypes.[67]

September 30: Mallarmé publishes, in English,
an article titled "The Impressionists and
Édouard Manet," in which he praises both
Manet and Degas.[68]

1877

March 19: Manet tries to assist the painters pre-
paring for the third Impressionist exhibition by
writing to Albert Wolff, the art critic of *Le Figaro*:
"You may not care for this kind of painting yet,
but some day you will."[69] Edmond Bazire would
later recall Manet's enthusiasm for these artists:
"Ah! Look at this Degas! Look at this Renoir!
Look at this Monet! How talented they are,
my friends!"[70]

April 4: The *3ᵉ Exposition de peinture* (third
Impressionist exhibition) opens at 6 rue
Le Peletier. Degas shows three groups of mono-
types and twenty-three paintings and pastels,
including *café-concert* scenes such as *Café-Concert
at Les Ambassadeurs* (fig. 54) and *In a Café
(The Absinthe Drinker)*. These last are praised
by several critics.

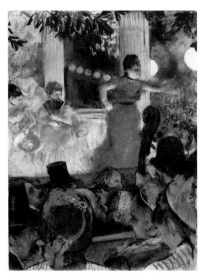

Fig. 54 Edgar Degas, *Café-Concert at Les
Ambassadeurs*, 1876–77. Pastel over monotype,
14 5/8 × 10 1/4 in. (37 × 26 cm). Musée des Beaux-
Arts, Lyon, Acquired in 1910 (L405)

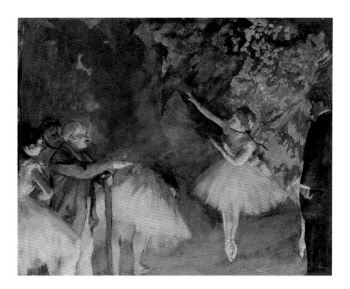

Fig. 55 Edgar Degas, *Rehearsal of the Ballet*, ca. 1876. Gouache and pastel over monotype on laid paper, plate 22 1/4 × 27 1/2 in. (56.5 × 69.9 cm), sheet 23 13/16 × 29 3/16 in. (60.5 × 74.2 cm). Nelson–Atkins Museum of Art, Kansas City, Purchase: the Kenneth A. and Helen F. Spencer Foundation Acquisition Fund (F73-30)

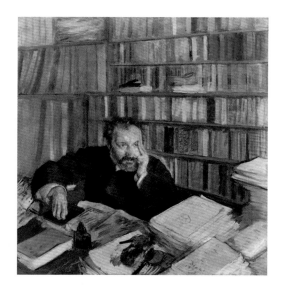

Fig. 56 Edgar Degas, *Portrait of Edmond Duranty*, 1879. Gouache with pastel highlights on linen, 39 3/8 × 39 3/8 in. (100 × 100 cm). Burrell Collection, Glasgow, Gifted by Sir William and Lady Burrell to the City of Glasgow, 1944 (35.232)

Around the same time, Manet's *Portrait of Faure as Hamlet* (Museum Folkwang, Essen) is shown at the Salon. His *Nana* (pl. 128) is rejected, so he instead exhibits it in the fashionable shop window of Giroux's on the boulevard des Capucines.[71]

October: Degas, whose lease on rue Frochot is about to run out, rents an apartment at 50 rue Lepic.

1878

January: The Société Béarnaise des Amis des Arts de Pau exhibits *A Cotton Office in New Orleans* (pl. 141) by Degas. In March, the Musée des Beaux-Arts, Pau, acquires the painting, which becomes the first work by the artist to enter a public collection.

February: Louisine Elder (the future wife of Henry Osborne Havemeyer) lends Degas's *Rehearsal of the Ballet* (fig. 55) to the *Eleventh Annual Exhibition of the American Water Color Society* in New York. It is the first work by the artist to be exhibited in North America.

June: Manet and his family move from 49 rue de Saint-Pétersbourg to an apartment down the street, at no. 39.[72]

July: Manet provisionally sets up shop in a small atelier at 70 rue d'Amsterdam.[73]

1879

January: Degas attends performances at the Cirque Fernando, where he makes several studies for *Miss La La at the Cirque Fernando* (figs. 25, 26).

April 1: Manet takes possession of his last atelier, at 77 rue d'Amsterdam.[74]

April 10: The *4ᵉ Exposition de peinture* (fourth Impressionist exhibition), which Degas was actively involved in organizing, opens at 28 avenue de l'Opéra. He shows twenty paintings and pastels, as well as five fans.

May: At the Salon, Manet exhibits *Boating* (pl. 114) and *In the Conservatory* (Alte National-galerie, Staatliche Museen zu Berlin).

Degas works toward the launch of *Le jour et la nuit*, a serial publication of original prints by Bracquemond, Gustave Caillebotte, Mary Cassatt, Jean-Louis Forain, Pissarro, Jean-François Raffaëlli, Henri Rouart, and Degas himself. However, the project never comes to fruition.[75]

Summer: Degas and Manet take part in weekly dinners organized by Henri Meilhac and Albert Wolff in the Pavillon Henri IV at the Château de Saint-Germain-en-Laye. Actors Sarah Bernhardt and Benoît-Constant Coquelin, composer Jacques Offenbach, dramatists Ludovic Halévy and Victorien Sardou, and painter Édouard Detaille, among others, also attend.[76]

1880

Around this time, at the home of the critic and art historian Philippe Burty, Degas and Manet observe the Japanese artist Watanabe Seitei at work.[77]

The health of Manet, who has contracted syphilis, markedly deteriorates.

April 1: The *5ᵉ Exposition de peinture* (fifth Impressionist exhibition) opens at 10 rue des Pyramides. Degas exhibits eight paintings and pastels, two groups of drawings, and a group of prints.

April 8–30: Galerie La Vie Moderne holds a private exhibition of Manet's work, including ten paintings (such as *Plum Brandy* [pl. 119], *The Café-Concert* [pl. 121], and *Reading* [pl. 45]) and fifteen pastels (such as *George Moore* [pl. 66]). Degas attends the opening.[78] The occasion prompts Degas's comment in the press about Manet: "He is better known than Garibaldi."[79]

April 9: The writer Edmond Duranty dies. Degas adds his *Portrait of Edmond Duranty* (fig. 56) to the Impressionist exhibition and attends the funeral on April 13 with Manet.

April 12: Degas and Manet attend the funeral of the painter Alphonse Maureau, whose pastel portrait by Manet (fig. 57) is on view at the Galerie La Vie Moderne.

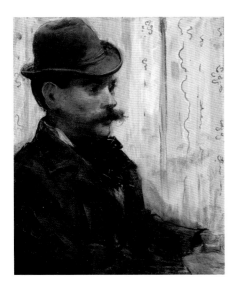

Fig. 57 Édouard Manet, *Portrait of Alphonse Maureau*, 1878–79. Pastel on canvas, prepared with an off-white ground, 21 9/16 × 17 13/16 in. (54.7 × 45.2 cm). Art Institute of Chicago, Bequest of Kate L. Brewster (1950.123)

May: Manet exhibits *Antonin Proust* (pl. 69) and *Chez le Père Lathuille* (Musée des Beaux-Arts, Tournai) at the Salon.

1881

January: Manet, Degas, and Antoine Guillemet prepare a benefit sale for Duranty's widow.[80] Manet contributes a pastel (*Woman in Furs* [priv. coll.]; RW II 26) and nine prints; Degas, the *Portrait of Duranty* (pastel [priv. coll.]),[81] *Woman with Field Glasses* (drawing [Burrell Collection, Glasgow]), and two works titled *Dancer* (a pastel and a sketch).

January 28–29: At the Duranty sale, Degas buys three prints by Manet: likely two versions of *The Little Cavaliers* (after Velázquez) and the color lithograph of *Polichinelle* (pl. 150).[82]

April 2: The *6e Exposition de peinture* (sixth Impressionist exhibition) opens at 35 boulevard des Capucines, after a dispute between Degas and Caillebotte that results in the latter's withdrawal. Degas exhibits four portraits and, from mid-April, his sculpture *Little Dancer Aged Fourteen* (fig. 58).

May: At the Salon, Manet exhibits *M. Eugène Pertuiset, the Lion Hunter* (Museu de Arte de São Paulo Assis Chateaubriand), for which he is awarded a second-class medal, and *Portrait of M. Henri Rochefort* (Kunsthalle, Hamburg).

Fig. 58 Edgar Degas, *Little Dancer Aged Fourteen*, 1878–81. Pigmented beeswax, clay, metal armature, rope, paintbrushes, human hair, silk and linen ribbon, cotton faille bodice, cotton and silk tutu, linen slippers, on wooden base, overall (without base) 38 15/16 × 13 11/16 × 13 7/8 in. (98.9 × 34.7 × 35.2 cm). National Gallery of Art, Washington, D.C., Collection of Mr. and Mrs. Paul Mellon (1999.80.28)

Summer: The sale of works by Degas increases, notably at Galerie Durand-Ruel. Thérèse Morbilli, the painter's sister, writes to her husband: "He has become famous, you know. His pictures are greatly sought after."[83]

Late December: Manet is made a Chevalier of the Légion d'Honneur by Proust, appointed minister of fine arts the previous month.

1882

March 1: The *7e Exposition des artistes indépendants* (seventh Impressionist exhibition) opens at 251 rue Saint-Honoré. Degas pays his membership dues but does not participate owing to a disagreement with Paul Gauguin.

May: At the Salon, Manet exhibits *Jeanne (Spring)* (J. Paul Getty Museum, Los Angeles) and *A Bar at the Folies-Bergère* (fig. 59). Degas writes to Henri Rouart: "Manet stupid and shrewd, a blank playing card, Spanish trompe l'œil, painter."[84]

June 15: Degas gives a housewarming party in his new apartment at 21 rue Pigalle. The guests include Manet, Durand-Ruel, Charles Ephrussi, Halévy, Pagans, and Alexis and Henri Rouart.[85]

Fig. 59 Édouard Manet, *A Bar at the Folies-Bergère*, 1882. Oil on canvas, 37 3/4 × 54 in. (96 × 137.3 cm). The Courtauld, London (Samuel Courtauld Trust) (P.1934.SC.234)

1883

Degas refuses to have a solo exhibition at the Galerie Durand-Ruel, unlike Monet, Pissarro, Renoir, and Alfred Sisley.

April: Degas monitors Manet's declining health. He writes to his friend Albert Bartholomé: "Manet is lost. . . . He has no illusions about his condition and has gangrene on his foot."[86]

April 30: Manet dies.

May 3: At Manet's funeral, a large cortege accompanies the body to the cemetery in Passy. Confronted by his friend's death, Degas declares: "He was greater than we thought."[87]

1884

January 6–28: A retrospective exhibition of Manet's work is held at the École des Beaux-Arts (fig. 60). Degas expresses regret that it was presented in these "official galleries."[88]

February 4–5: A sale of art from Manet's estate is held at the Hôtel Drouot. Durand-Ruel acquires three works by the artist for Degas: *Portrait of Henri Vigneau* (pen and ink, Baltimore Museum of Art), *After the Bath* (pl. 32), and an impression of *Civil War* (pl. 145).[89]

At the same sale, Eugène Manet and Berthe Morisot acquire *The Departure of the Folkestone Boat* (fig. 34) for Edma Morisot and her husband, Adolphe Pontillon. When Pontillon refuses it, the Manets gift it to Degas, who writes to them: "You wanted to give me great pleasure and you succeeded."[90]

December: Degas writes to Léon Leenhoff confirming his intention to attend the banquet marking the anniversary of the posthumous Manet retrospective at the École des Beaux-Arts.[91] The event takes place the following month at the restaurant Le Père Lathuille.

Fig. 60 Anatole Godet (French, 1839–1887), from *Retrospective Exhibition of the Works of Édouard Manet, École des Beaux-Arts, Paris, January 6–28, 1884*, 1884. Annotated album of 20 photographs. Bibliothèque Nationale de France, Département des Estampes et de la Photographie, Paris (4-DC-300 [F,1])

1885

May: In a notebook, Berthe Morisot records comments made by Degas about Manet: "Degas said that the study of nature was unimportant, painting being an art of *convention* . . . ; that Edouard himself, although he boasted about slavishly copying nature, was the most mannered painter in the world, never making a brushstroke without thinking of the [old] masters."[92]

1886

April–May: Twenty-three works by Degas and seventeen by Manet are shown in New York in an exhibition organized by Durand-Ruel titled *Works in Oil and Pastel by the Impressionists of Paris* at the American Art Galleries and at the National Academy of Design.[93]

May 15: The *8ᵉ Exposition de peinture* (eighth and final Impressionist exhibition) opens at 1 rue Laffitte. Degas exhibits ten works (such as fig. 61), despite fifteen having been listed in the catalogue, including *Woman Bathing in a Shallow Tub* (pl. 135).

1888

June 6: At the sale of the collection of Eugène Pertuiset, a collector of works by Manet, who represented him in *M. Eugène Pertuiset, the Lion Hunter* (Museu de Arte de São Paulo Assis Chateaubriand), Degas acquires *A Pear* (priv. coll.; RW I 355) for 80 francs.[94] In his inventory, he notes: "I was wrong not to buy *Lilacs in a Thick Glass Vase* [priv. coll.; RW I 417] at this sale."

In his apartment, Degas hangs *A Pear* not far from a painting of Jupiter by Ingres. When George Moore comments on the arrangement, Degas declares: "I put it there, for a pear painted like that would overthrow any god."[95]

At the same sale, Michel Manzi acquires (for 1,300 francs) *The Ham* by Manet (pl. 149), which he would resell to Degas at an unknown date for other works of art valued at 3,000 francs.[96]

1889

The Met becomes the first museum to acquire work by Manet when it accepts *Boy with a Sword* (pl. 44) and *Young Lady in 1866* (pl. 93) as gifts.

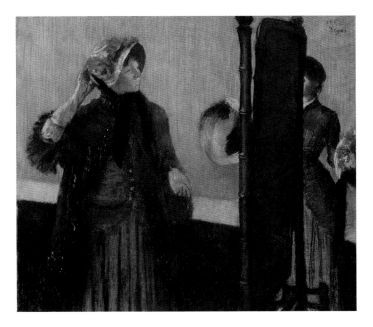

Fig. 61 Edgar Degas, *At the Milliner's*, 1882. Pastel on pale gray wove paper (industrial wrapping paper), laid down on silk bolting, 30 × 34 in. (76.2 × 86.4 cm). The Metropolitan Museum of Art, New York, H. O. Havemeyer Collection, Bequest of Mrs. H. O. Havemeyer, 1929 (29.100.38)

Fig. 62 Edgar Degas, *Landscape*, 1892. Monotype in oil colors, heightened with pastel, 10 × 13 ⅜ in. (25.4 × 34 cm). The Metropolitan Museum of Art, New York, Purchase, Mr. and Mrs. Richard J. Bernhard Gift, 1972 (1972.636)

May 5: The *Exposition Centennale de l'Art Français*, organized by Proust, accords a place of honor to Manet, who is represented by fourteen paintings, one watercolor, two pastels, one drawing, and five prints.

September 8: Degas is in Madrid with the Italian painter Giovanni Boldini.[97]

September 18: Degas is in Tangier. He writes to Bartholomé, reminding him that "Delacroix passed through here" and noting that he would return to Paris via Cádiz and Granada.[98]

1890

Having learned that an American collector was trying to buy Manet's *Olympia*, Monet organizes a subscription to acquire the painting for presentation to the Louvre. Degas writes to Monet: "Please put me on the list for the sum of one hundred francs."[99]

April: In an undated letter, Degas accepts an invitation from Berthe Morisot, mentioning the fatigue caused by his move to a new apartment.[100]

May: Degas and Bartholomé travel to Brussels. The two men then proceed "as far as Amsterdam making the customary pilgrimages to The Hague, Antwerp, Haarlem, Rotterdam."[101]

1891

March 4–5: At the sale of the collection of Philippe Burty, Degas acquires, through his intermediary Manzi, sixty items by Manet (forty-three etchings, thirteen lithographs, four transfer prints), and three wood engravings after his work. He notes about this collection of prints: "Try to complete [it]."[102]

July 6: Degas informs Évariste de Valernes that he plans to execute a series of lithographs of female nudes and another of nude dancers.[103]

1892

April 13: Eugène Manet (pl. 60)—brother of Édouard Manet, husband of Berthe Morisot, and father of Julie Manet—dies.

September: Degas's first-ever solo exhibition, which included landscapes and monotypes (similar to fig. 62), is held at Galerie Durand-Ruel.

1894

March 17: Degas previews the collection of Théodore Duret before it is sold on March 19. It includes eight works by himself and six by Manet.[104]

April 10: The dealer Alphonse Portier buys a pastel from Manet's widow for 1,200 francs. This was doubtless *Madame Manet on a Blue Sofa* (fig. 35), which Portier would later resell to Degas for 2,000 francs.[105]

October 15: Degas acquires Manet's *Woman with a Cat* (pl. 158) from Vollard in exchange for a pastel valued at 500 francs.[106]

October 29: Degas buys the central portion of Manet's *Execution of Maximilian* (pl. 160) from Vollard for the equivalent of 2,000 francs in works of his own art. He already owns the right portion of the canvas (depicting the sergeant loading his rifle), which he had purchased from Portier. Vollard recounts the circumstances of the sale: "When Degas saw the *Soldats épaulant* in my shop, which he recognized at once as having belonged to the same canvas as his *Sergeant*, he was thunderstruck. . . . Then . . . he took his stand between me and the picture, and with his hand on it by way of possession, he added: 'You're going to sell me that. And you'll go back to Mme Manet and tell her I want the legs of the sergeant that are missing from my bit, as well as what's missing from yours: the group formed by Maximilian and the generals. I'll give her something for it.'"[107]

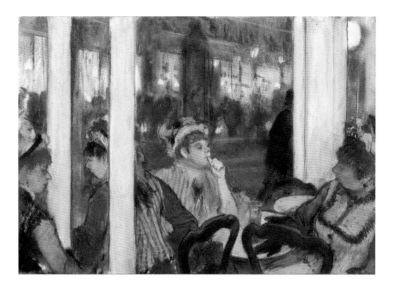

Fig. 63 Edgar Degas, *Women on the Terrace of a Café in the Evening*, 1877. Pastel over monotype, 16⅛ × 23⅝ in. (41 × 60 cm). Musée d'Orsay, Paris (RF 12257)

Fig. 64 Bedford Lemere & Co. (active 1873–1908), view of the exhibition *Pictures by Boudin, Cézanne, Degas, Manet, Monet, Morisot, Pissarro, Renoir, and Sisley* exhibited by Messr. Durand-Ruel & Fils of Paris, Grafton Galleries, London, January–February 1905

According to Julie Manet: "[The dealer Camentron] showed us a photograph of a fragment of the first version [*esquisse*] of *The Execution of Maximilian*. This painting was at the printing shop of the brother of Aunt Suzanne [Manet], M. Léon [Leenhoff], who first cut away the Maximilian to sell it separately, then the rest went to M. Camentron's and M. Portier's. The latter cut away the sergeant behind the soldiers. Such that the painting is now in three fragments. M. Degas is looking for them and has already found two. He is going to reunite them and try to put the painting back as it was."[108]

Degas indeed managed to locate a fragment of the left portion of the picture representing some of the assassinated generals.

November 17–December 20: Galerie Vollard, at 37 rue Laffitte, holds the exhibition *Dessins et croquis de Manet, provenant de son atelier*. Degas buys *Bazaine before the War Council* (fig. 48) and perhaps other drawings by Manet.[109]

1895

February 18: At the Gauguin sale, Degas acquires Gauguin's copy of Manet's *Olympia* (fig. 30).[110]

March 1: On the eve of her death, Morisot writes a farewell letter to her daughter, Julie Manet, and specifies: "Tell M. Degas that if he founds a museum he should select a Manet."[111] This is the most conclusive evidence of Degas's desire to found a museum for his collection.

July 16: Degas purchases from Vollard the *Portrait of Monsieur Brun* (fig. 32) by Manet for 3,500 francs, paid in kind with works of art (a small pastel and four monotypes of brothel scenes).[112]

August: At Mont-Dore, where he is undergoing treatment for bronchitis, Degas writes a series of letters to the paint merchant and framer Guillaume Tasset, who is helping him with the development and printing of his photographs— evidence of the increasing importance of photography in his production.

1896

After extended negotiations, the French nation accepts a portion of Caillebotte's bequest of his collection of works by "Impressionist" painters. Accordingly, seven pastels by Degas (including fig. 63) and two paintings by Manet (including *The Balcony*, pl. 98) enter French public collections (Manet's *Croquet Party* [Nelson-Atkins Museum of Art, Kansas City] is refused).

December 28: Degas acquires from Durand-Ruel Manet's *Woman with a Cigarette* (pl. 159) for 1,500 francs.[113]

1897

February–May: Proust's "Édouard Manet (Souvenirs)" is published, over five issues, in *La Revue Blanche*. Halévy recounts his experience of reading it to Degas, whose eyesight was failing: "He sees a drawing, picks up his magnifying glass. It is a café-concert singer.—'That Manet! As soon as I did dancers, he did them . . . he always imitated. Read.' I read. I had already been reading for some time, and I came to a short sentence about the *Déjeuner sur l'herbe* and *plein air* painting. Degas stopped me.—'It's wrong. He confuses everything. Manet was not thinking of painting *en plein air* when he made *Le déjeuner sur l'herbe*. He only thought of it after seeing the first paintings by Monet. He could never do anything except imitate. Proust mixes everything up. Ah! These literary types, what business is it of theirs? We know how to do ourselves justice. Read!'"[114]

May 22: Degas acquires from Vollard Manet's *Berthe Morisot in Mourning* (pl. 157) for 1,000 francs.[115]

Fig. 65 Albert Bartholomé (French, 1848–1928), *Degas by Bartholomé, view taken in Bartholomé's garden around 1908,* ca. 1908. Gelatin silver print, 6¼ × 4⅞ in. (16 × 12.5 cm). Musée d'Orsay, Paris (PHO 1994 8)

1900

April 15–November 12: The Exposition Universelle and the affiliated *Exposition Centennale de l'Art Français* are held. On view are twelve canvases by Manet and two by Degas.

May 31: Degas attends the double marriage of Jeannie Gobillard and Paul Valéry, and of Julie Manet and Ernest Rouart, for whose union he had advocated (fig. 29).

1901

August 6: Henri Rouart writes to his daughter-in-law Julie Manet-Rouart: "I had lunch at my friend Degas's place, where I saw beautiful sketches by your uncle [Édouard Manet]."[116]

1903

July 22: Degas writes to his friend Louis Braquaval: "I must finish this sculpture, should I lose my old age in it. I won't stop until I fall, and I still feel like standing well enough, despite the weight of just turning 69 years old."[117]

1904

September: In a letter to his wife, Valéry describes a visit to Degas: "Many recollections of Manet which he recounts with a mixture of admiration, emotion, and real nastiness. A mixture so deep and natural, so true in its coloring pleases me."[118]

1905

January–February: An exhibition organized by Durand-Ruel at the Grafton Galleries in London includes thirty-five works by Degas and nineteen by Manet (fig. 64).[119]

1906

October–December: Degas visits Naples.

1908

Around this time, Bartholomé photographs Degas in Bartholomé's garden (fig. 65).

1912

The pending demolition of his apartment building on rue Victor-Massé forces Degas to move out. He finds a new residence at 6 boulevard de Clichy, but the relocation greatly distresses him.

1917

September 27: Degas dies from a cerebral hemorrhage. His funeral takes place the following day, and he is buried in his family vault at Montmartre cemetery.

1918

March 26–27: The first of three sales of Degas's collection is held at Galerie Georges Petit, 8 rue de Sèze, in Paris. The two following sales are held in the fall at Hôtel Drouot, Paris, on November 6–7 and 15–16. The works assembled by the painter are dispersed, including those by Manet: eight paintings, over a dozen drawings, and an almost complete set of prints.

May 6–8: The first of four sales of Degas's studio is held at Galerie Georges Petit, where The Met acquires ten drawings by Degas, including three portraits of Manet. The three following sales take place December 11–13, 1918; April 7–9, 1919; and July 2–4, 1919.

WORKS IN THE EXHIBITION

ABBREVIATIONS OF REFERENCES CITED

Brame and Reff
Philippe Brame and Theodore Reff, *Degas et son oeuvre: A Supplement*
(New York: Garland, 1984)

Daniel
Malcolm Daniel, *Edgar Degas: Photographer*, exh. cat.
(New York: The Metropolitan Museum of Art, 1998)

Guérin
Marcel Guérin, *L'œuvre gravé de Manet: Avec un supplément nouvellement ajouté*
(1944; New York: Da Capo Press, 1969)

Harris
Jean C. Harris, *Edouard Manet: The Graphic Work; A Catalogue Raisonné*, rev. ed.,
Joel M. Smith (San Francisco: A. Wofsy Fine Arts, 1990)

Jamot and Wildenstein
Paul Jamot and Georges Wildenstein, *Manet*, 2 vols.
(Paris: Les Beaux-Arts, Édition d'Études et de Documents, 1932)

Janis
Eugenia Parry Janis, *Degas Monotypes*, exh. cat.
(Cambridge, Mass.: Fogg Art Museum, Harvard University, 1968)

Lemoisne
Paul-André Lemoisne, *Degas et son œuvre*, 4 vols.
(Paris: Paul Brame et C. M. de Hauke, aux Arts et Métiers Graphiques, 1946–49)

Moreau-Nélaton
Étienne Moreau-Nélaton, *Manet: Graveur et lithographe*
(Paris: Éditions du "Peintre-Graveur Illustré," Loys Delteil, 1906)

Reed and Shapiro
Sue Welsh Reed and Barbara Stern Shapiro, *Edgar Degas: The Painter
as Printmaker*, exh. cat. (Boston: Museum of Fine Arts, 1984)

Reff
Theodore Reff, ed., *The Notebooks of Edgar Degas: A Catalogue of the
Thirty-Eight Notebooks in the Bibliothèque Nationale and Other Collections*,
rev. ed. (New York: Hacker Art Books, 1985)

RW I / RW II
Denis Rouart and Daniel Wildenstein, *Édouard Manet: Catalogue raisonné*, vol. 1,
Peintures; vol. 2, *Pastels, aquarelles et dessins* (Lausanne: Bibliothèque des Arts, 1975)

EDGAR DEGAS

French, Paris 1834–1917 Paris

Studies of Figures after "Judgment of Paris"
and "Parnassus" by Marcantonio Raimondi
ca. 1853–56
Brown ink on cream tracing paper
6 × 12 5/16 in. (15.2 × 31.2 cm)
Harvard Art Museums/Fogg Museum, Anonymous
Gift in memory of W. G. Russell Allen (1956.10)
Pl. 34

Portrait of the Artist
1855
Oil on paper mounted on canvas
32 1/16 × 25 9/16 in. (81.5 × 65 cm)
Musée d'Orsay, Paris (RF 2649)
Lemoisne 5
Pl. 2

René De Gas
1855
Graphite
12 × 9 5/16 in. (30.5 × 23.7 cm)
National Gallery of Art, Washington, D.C., Collection
of Mr. and Mrs. Paul Mellon (1995.47.32.a)
See Lemoisne 6
Pl. 14

Hilaire Degas
1857
Oil on canvas
20 7/8 × 16 1/8 in. (53 × 41 cm)
Musée d'Orsay, Paris (RF 3661)
Lemoisne 27
Pl. 36

The Old Italian Woman
1857
Oil on canvas
29 1/2 × 24 in. (74.9 × 61 cm)
The Metropolitan Museum of Art, New York, Bequest
of Charles Goldman, 1966 (66.65.2)
Lemoisne 29
Pl. 28

Self-Portrait
1857
Etching and bitten tone; second state of four
Plate 9 1/16 × 5 11/16 in. (23 × 14.4 cm), sheet 10 3/8 × 6 3/4 in.
(26.3 × 17.2 cm)
The Metropolitan Museum of Art, New York,
Purchase, Jacob H. Schiff Bequest, 1922 (22.63.31)
Reed and Shapiro 8 II/IV
Pl. 30

Young Man, Seated, in a Velvet Beret,
after Rembrandt
1857
Etching; only state
Plate 4 11/16 × 3 3/4 in. (11.9 × 9.5 cm), sheet 14 3/16 ×
10 5/16 in. (36.1 × 26.2 cm)
The Metropolitan Museum of Art, New York, The
Elisha Whittelsey Collection, The Elisha Whittelsey
Fund, 1977 (1977.500)
Reed and Shapiro 6
Pl. 29

Study of a Draped Figure
1857–58
Graphite heightened with white gouache
11 1/2 × 8 7/8 in. (29.2 × 22.5 cm)
The Metropolitan Museum of Art, New York,
Rogers Fund, 1975 (1975.5)
Pl. 27

Young Woman with Ibis
1857–58, reworked 1860–62
Oil on canvas
39 3/8 × 29 1/2 in. (100 × 74.9 cm)
The Metropolitan Museum of Art, New York,
Gift of Stephen Mazoh and Purchase, Bequest of
Gioconda King, by exchange, 2008 (2008.277)
Lemoisne 87
Pl. 94

Giovanna Bellelli, Study for "The Bellelli Family"
ca. 1858
Charcoal partially covered and fixed with shellac
12 3/4 × 9 1/2 in. (32.4 × 24.1 cm)
Private collection
Pl. 48

Giovanna Bellelli, Study for "The Bellelli Family"
ca. 1858
Conté crayon on blue wove paper
12 1/4 × 9 3/8 in. (31.1 × 23.8 cm)
Private collection
Pl. 47

Laura Bellelli and her daughter Giovanna,
Study for "The Bellelli Family"
ca. 1858
Black conté crayon on pinkish buff paper with
traces of white heightening
16 5/8 × 11 1/2 in. (42.3 × 29.2 cm)
Private collection
Pl. 46

Memory of Velázquez
ca. 1858
Oil on canvas
12 3/16 × 9 15/16 in. (31 × 25.2 cm)
Bayerische Staatsgemäldesammlungen–Neue
Pinakothek, Munich (12760)
Brame and Reff 12
Pl. 20

Self-Portrait in the Manner of Filippino Lippi
ca. 1858
Graphite
6 1/2 × 4 3/4 in. (16.5 × 12.1 cm)
Private collection, San Francisco
Pl. 25

Family Portrait (The Bellelli Family)
1858–69
Oil on canvas
79 1/8 × 98 1/4 in. (201 × 249.5 cm)
Musée d'Orsay, Paris (RF 2210)
Lemoisne 79
Pl. 49

Marguerite De Gas, the Artist's Sister
1860–62
Etching and drypoint; unique impression of the
second state of six
Plate 4 9/16 × 3 7/16 in. (11.6 × 8.8 cm), sheet (unevenly
trimmed) 5 1/16 × 3 15/16 in. (12.8 × 10 cm)
The Metropolitan Museum of Art, New York, Purchase,
Charles and Jessie Price, Friends of Drawings and
Prints, and Barbara and Howard Fox Gifts, A. Hyatt
Mayor Purchase Fund, Marjorie Phelps Starr Bequest,
and Charles Z. Offin Fund, 2020 (2020.10)
Reed and Shapiro 14 II/VI
Pl. 42

The Entry of the Crusaders into Constantinople,
after Delacroix
ca. 1860
Oil on cardboard
13 3/4 × 14 15/16 in. (35 × 38 cm)
Kunsthaus Zürich, Donated by René Wehrli, 2005
(2006.19)
Brame and Reff 35
Pl. 16

At the Races: The Start
ca. 1860–62
Oil on canvas
13 × 18 1/2 in. (33 × 47 cm)
Harvard Art Museums/Fogg Museum, Bequest of
Annie Swan Coburn (1934.30)
Lemoisne 76
Pl. 99

Semiramis Building Babylon
1861
Oil on canvas
59 5/8 in. × 8 ft. 5 9/16 in. (151.5 × 258 cm)
Musée d'Orsay, Paris (RF 2207)
Lemoisne 82
Pl. 74

The Crucifixion, after Mantegna
ca. 1861
Oil on canvas
27 3/16 × 36 7/16 in. (69 × 92.5 cm)
Musée des Beaux-Arts de Tours (1934-6-1)
Lemoisne 194
Pl. 23

The Infanta Margarita, after Velázquez
ca. 1861–62
Etching and drypoint; second state of two
(only known impression)
Plate 6 11/16 × 4 3/4 in. (17 × 12 cm), sheet 7 1/16 × 5 7/8 in.
(18 × 15 cm)
The Metropolitan Museum of Art, New York, Purchase,
R. W. Moncrief Gift, in honor of Janet Ruttenberg
and A. Hyatt Mayor Purchase Fund, Marjorie Phelps
Starr Bequest, 1997 (1997.240)
Reed and Shapiro 16 II/II
Pl. 19

*Standing Nude Woman, Study for "Scene of War
in the Middle Ages"*
1864–65
Black crayon with a touch of watercolor
14 1/8 × 9 1/16 in. (35.8 × 23 cm)
Musée d'Orsay, Paris (RF 15517)
Pl. 82

*A Woman Seated beside a Vase of Flowers
(Madame Paul Valpinçon?)*
1865
Oil on canvas
29 × 36 1/2 in. (73.7 × 92.7 cm)
The Metropolitan Museum of Art, New York,
H. O. Havemeyer Collection, Bequest of
Mrs. H. O. Havemeyer, 1929 (29.100.128)
Lemoisne 125
Pl. 84

Edmondo and Thérèse Morbilli
ca. 1865
Oil on canvas
45 7/8 × 34 3/4 in. (116.5 × 88.3 cm)
Museum of Fine Arts, Boston, Gift of Robert
Treat Paine, 2nd (31.33)
Lemoisne 164
Pl. 43

Scene of War in the Middle Ages
ca. 1865
Oil on paper mounted on canvas
32 7/8 × 58 7/16 in. (83.5 × 148.5 cm)
Musée d'Orsay, Paris (RF 2208)
Lemoisne 124
Pl. 83

The Collector of Prints
1866
Oil on canvas
20 7/8 × 15 3/4 in. (53 × 40 cm)
The Metropolitan Museum of Art, New York,
H. O. Havemeyer Collection, Bequest of
Mrs. H. O. Havemeyer, 1929 (29.100.44)
Lemoisne 138
Pl. 89

Scene from the Steeplechase: The Fallen Jockey
1866, reworked 1880–81 and ca. 1897
Oil on canvas
70 7/8 × 59 13/16 in. (180 × 152 cm)
National Gallery of Art, Washington, D.C., Collection
of Mr. and Mrs. Paul Mellon (1999.79.10)
Lemoisne 140
Pl. 86

Racehorses before the Stands
1866–68
Oil on paper mounted on canvas
18 1/8 × 24 in. (46 × 61 cm)
Musée d'Orsay, Paris (RF 1981)
Lemoisne 262
Pl. 100

Madame Lisle and Madame Loubens
ca. 1867
Oil on canvas
33 1/16 × 38 1/16 in. (84 × 96.6 cm)
The Art Institute of Chicago, Gift of Annie Laurie
Ryerson in memory of Joseph Turner Ryerson
(1953.335)
Lemoisne 265
Pl. 92

James-Jacques-Joseph Tissot
ca. 1867–68
Oil on canvas
59 5/8 × 44 in. (151.4 × 111.8 cm)
The Metropolitan Museum of Art, New York,
Rogers Fund, 1939 (39.161)
Lemoisne 175
Pl. 87

Mademoiselle Fiocre in the Ballet "La Source"
ca. 1867–68
Oil on canvas
51 1/2 × 57 1/8 in. (130.8 × 145.1 cm)
Brooklyn Museum, Gift of James H. Post, A. Augustus
Healy, and John T. Underwood (21.111)
Lemoisne 146
Pl. 95

Édouard Manet
ca. 1868
Graphite with white highlights on pink wove paper
15 3/4 × 10 1/16 in. (40 × 25.5 cm)
Musée d'Orsay, Paris (RF 51770)
See Reed and Shapiro 18
Pl. 9

Édouard Manet, Bust-Length Portrait
ca. 1868
Etching, drypoint, and aquatint; third state of four
Plate 5 1/8 × 4 1/8 in. (13 × 10.5 cm), sheet 11 1/8 × 8 in.
(28.2 × 20.3 cm)
The Metropolitan Museum of Art, New York, Gift of
Mrs. Imrie de Vegh, 1949 (49.127.7)
Reed and Shapiro 19 III/IV
Pl. 12

Édouard Manet, Seated, Holding His Hat
ca. 1868
Graphite and black chalk
13 1/16 × 9 1/16 in. (33.1 × 23 cm)
The Metropolitan Museum of Art, New York,
Rogers Fund, 1918 (19.51.7)
Reed and Shapiro 17a
Pl. 6

Édouard Manet, Seated, Right Profile
ca. 1868
Black chalk on faded pink wove paper
14 1/8 × 11 in. (35.9 × 27.9 cm)
The Metropolitan Museum of Art, New York,
Rogers Fund, 1918 (19.51.6)
Pl. 11

Édouard Manet, Seated, Turned to the Left
ca. 1868
Etching; first state of two
Plate 6 3/4 × 4 3/4 in. (17.1 × 12 cm), sheet 12 5/16 × 8 3/4 in.
(31.2 × 22.2 cm)
The Metropolitan Museum of Art, New York,
Purchase, Mr. and Mrs. Derald H. Ruttenberg Gift,
and several members of The Chairman's Council
Gifts, 2003 (2003.329)
Reed and Shapiro 17 I/II
Pl. 7

Édouard Manet, Seated, Turned to the Right
ca. 1868
Etching and drypoint; first state of four
Plate 7 11/16 × 5 1/8 in. (19.5 × 13 cm), sheet 12 7/16 × 8 3/4 in.
(31.6 × 22.2 cm)
The Metropolitan Museum of Art, New York,
Rogers Fund, 1921 (21.83.2)
Reed and Shapiro 18 I/IV
Pl. 8

Édouard Manet Standing
ca. 1868
Graphite and ink wash
13 3/4 × 7 7/8 in. (35 × 20 cm)
Musée d'Orsay, Paris (RF 41651)
Pl. 10

Interior
1868–69
Oil on canvas
32 × 45 in. (81.3 × 114.3 cm)
Philadelphia Museum of Art: The Henry P. McIlhenny
Collection in memory of Frances P. McIlhenny, 1986
(1986-26-10)
Lemoisne 348
Pl. 127

Monsieur and Madame Édouard Manet
1868–69
Oil on canvas
25 9/16 × 27 15/16 in. (65 × 71 cm)
Kitakyushu Municipal Museum of Art (0-119)
Lemoisne 127
Pl. 3

Caricatures of Napoleon III and Otto von Bismarck,
from Notebook no. 21
1868–72
Sketchbook
Sheet 4 3/16 × 2 9/16 in. (10.6 × 6.5 cm), closed book
4 7/16 × 2 7/8 × 11/16 in. (11.2 × 7.3 × 1.8 cm)
Bibliothèque Nationale de France, Département
des Estampes et de la Photographie, Paris
(RESERVE DC-327 [D,21]-4)
Reff 23
Fig. 14

Édouard Manet at the Races
ca. 1868–69
Graphite and black chalk
12 5/8 × 9 11/16 in. (32.1 × 24.6 cm)
The Metropolitan Museum of Art, New York,
Rogers Fund, 1918 (19.51.8)
Pl. 106

Fishing Boat at the Entrance to the Port of Dives
1869
Pastel and charcoal
8 11/16 × 12 11/16 in. (22 × 32.2 cm)
Private collection
Lemoisne 246
Pl. 109

Madame Théodore Gobillard (Yves Morisot)
1869
Pastel
18 7/8 × 11 13/16 in. (48 × 30 cm)
The Metropolitan Museum of Art, New York, Bequest
of Joan Whitney Payson, 1975 (1976.201.8)
Lemoisne 214
Pl. 54

Madame Théodore Gobillard (Yves Morisot)
1869
Oil on canvas
21 3/4 × 25 5/8 in. (55.2 × 65.1 cm)
The Metropolitan Museum of Art, New York,
H. O. Havemeyer Collection, Bequest of
Mrs. H. O. Havemeyer, 1929 (29.100.45)
Lemoisne 213
Pl. 53

Study for "Madame Théodore Gobillard"
(Yves Morisot)
1869
Graphite
13 1/8 × 17 5/16 in. (33.3 × 44 cm)
The Metropolitan Museum of Art, New York,
Gift of John R. Gaines, 1985 (1985.48)
Pl. 50

Study for "Madame Théodore Gobillard"
(Yves Morisot)
1869
Graphite, squared, on buff tracing paper,
mounted on laid paper
12 3/8 × 17 5/16 in. (31.5 × 44 cm)
The Metropolitan Museum of Art, New York,
Purchase, Harris Brisbane Dick Fund, David T. Schiff
Gift, and Gifts in memory of Joseph Thomas, 1984
(1984.76)
Pl. 51

Study for "Madame Théodore Gobillard"
(Yves Morisot)
1869
Black crayon and graphite with white highlights
18 7/8 × 12 13/16 in. (48 × 32.5 cm)
Musée d'Orsay, Paris (RF 29881)
Pl. 52

Beach Scene
ca. 1869–70
Oil (essence) on paper on canvas
18 11/16 × 32 5/8 in. (47.5 × 82.9 cm)
The National Gallery, London, Sir Hugh Lane
Bequest, 1917. In partnership with Hugh Lane
Gallery, Dublin (NG3247)
Lemoisne 406
Pl. 111

The False Start
ca. 1869–72
Oil on panel
12 5/8 × 15 7/8 in. (32.1 × 40.3 cm)
Yale University Art Gallery, John Hay Whitney, B.A.
1926, Hon. 1956, Collection (1982.111.6)
Lemoisne 258
Pl. 103

The Dancing Class
ca. 1870
Oil on wood
7 3/4 × 10 5/8 in. (19.7 × 27 cm)
The Metropolitan Museum of Art, New York,
H. O. Havemeyer Collection, Bequest of
Mrs. H. O. Havemeyer, 1929 (29.100.184)
Lemoisne 297
Pl. 112

The Orchestra of the Opera
ca. 1870
Oil on canvas
22 5/16 × 18 1/8 in. (56.6 × 46 cm)
Musée d'Orsay, Paris (RF 2417)
Lemoisne 186
Pl. 120

Sulking
ca. 1870
Oil on canvas
12 3/4 × 18 1/4 in. (32.4 × 46.4 cm)
The Metropolitan Museum of Art, New York,
H. O. Havemeyer Collection, Bequest of
Mrs. H. O. Havemeyer, 1929 (29.100.43)
Lemoisne 335
Pl. 90

Violinist and Young Woman
ca. 1871
Oil and crayon on canvas
18 1/4 × 22 in. (46.4 × 55.9 cm)
Detroit Institute of Arts, Bequest of Robert H.
Tannahill (70.167)
Lemoisne 274
Pl. 41

Lorenzo Pagans and Auguste De Gas
1871–72
Oil on canvas
21 7/16 × 15 9/16 in. (54.5 × 39.5 cm)
Musée d'Orsay, Paris (RF 3736)
Lemoisne 256
Pl. 39

Cotton Merchants in New Orleans
1873
Oil on linen
23 1/8 × 28 1/4 in. (58.7 × 71.8 cm)
Harvard Art Museums/Fogg Museum,
Gift of Herbert N. Straus (1929.90)
Lemoisne 321
Pl. 140

A Cotton Office in New Orleans
1873
Oil on canvas
28 ¾ × 36 ¼ in. (73 × 92 cm)
Musée des Beaux-Arts, Pau (878.1.2)
Lemoisne 320
Pl. 141

Courtyard of a House (New Orleans, sketch)
1873
Oil on canvas
23 ⅝ × 28 ¹⁵⁄₁₆ in. (60 × 73.5 cm)
Ordrupgaard, Copenhagen (238 WH)
Lemoisne 309
Pl. 117

Eugène Manet
1874
Oil on paper laid down on board
24 ¹³⁄₁₆ × 31 ⁵⁄₁₆ in. (63 × 79.5 cm)
Private collection
Lemoisne 339
Pl. 60

In a Café (The Absinthe Drinker)
1875–76
Oil on canvas
36 ¼ × 26 ¹⁵⁄₁₆ in. (92 × 68.5 cm)
Musée d'Orsay, Paris (RF 1984)
Lemoisne 393
Pl. 118

Marcellin Desboutin and Ludovic Lepic
1876–77
Oil on canvas
27 ¹⁵⁄₁₆ × 31 ⅞ in. (71 × 81 cm)
Musée d'Orsay, Paris (RF 2209)
Lemoisne 395
Pl. 62

The Racecourse, Amateur Jockeys
1876–87
Oil on canvas
25 ¹¹⁄₁₆ × 31 ¹⁵⁄₁₆ in. (65.2 × 81.2 cm)
Musée d'Orsay, Paris (RF 1980)
Lemoisne 461
Pl. 105

Mademoiselle Bécat at the Café des
Ambassadeurs, Paris
1877–78
Lithograph; only state
Image 8 ⅛ × 7 ⅝ in. (20.6 × 19.4 cm),
sheet 13 ½ × 10 ¾ in. (34.3 × 27.3 cm)
The Metropolitan Museum of Art, New York,
Rogers Fund, 1919 (19.29.3)
Reed and Shapiro 31
Pl. 123

Woman with Field Glasses
ca. 1877
Oil on cardboard
18 ⅞ × 12 ⅝ in. (48 × 32 cm)
Albertium I Galerie Neue Meister, Staatliche
Kunstsammlungen Dresden (Gal.-Nr. 2601)
Lemoisne 431
Pl. 107

The Singer
ca. 1877–78
Pastel over monotype
6 ¼ × 4 ½ in. (15.9 × 11.4 cm)
Reading Public Museum, Reading, Pennsylvania.
Gift, Miss Martha Elizabeth Dick Estate (1976.46.1)
Lemoisne 462; Janis 43
Pl. 124

Nude Woman Combing Her Hair
ca. 1877–80
Pastel over monotype
Plate 8 ⁷⁄₁₆ × 6 ⁵⁄₁₆ in. (21.5 × 16.1 cm),
sheet 11 ¼ × 9 ⅛ in. (28.6 × 23.1 cm)
Private collection
Lemoisne 456; Janis 185
Pl. 129

Henri Michel-Lévy
ca. 1878
Oil on canvas
15 ¾ × 11 in. (40 × 28 cm)
Calouste Gulbenkian Foundation, Lisbon–Calouste
Gulbenkian Museum (420)
Lemoisne 326
Pl. 130

Diego Martelli
1879
Oil on canvas
43 ⁷⁄₁₆ × 39 ⁵⁄₁₆ in. (110.4 × 99.8 cm)
National Galleries of Scotland. Purchased 1932
(NG 1785)
Lemoisne 519
Pl. 68

Edmond Duranty
1879
Conté crayon, heightened with white chalk,
on blue laid paper
12 ⅛ × 18 ⁹⁄₁₆ in. (30.8 × 47.2 cm)
The Metropolitan Museum of Art, New York,
Rogers Fund, 1918 (19.51.9a)
See Lemoisne 517
Pl. 67

Mary Cassatt at the Louvre: The Etruscan Gallery
1879–80
Soft ground, drypoint, aquatint, and etching;
third state of nine
Plate 10 ⁹⁄₁₆ × 9 ⅛ in. (26.8 × 23.2 cm), sheet 17 × 12 in.
(43.2 × 30.5 cm)
The Metropolitan Museum of Art, New York,
Rogers Fund, 1919 (19.29.2)
Reed and Shapiro 51 III/IX
Pl. 70

The Millinery Shop
ca. 1879–86
Oil on canvas
39 ⅜ × 43 ⁹⁄₁₆ in. (100 × 110.7 cm)
The Art Institute of Chicago, Mr. and Mrs. Lewis
Larned Coburn Memorial Collection (1933.428)
Lemoisne 832
Pl. 125

Visit to a Museum
ca. 1879–90
Oil on canvas
36 ⅛ × 26 ¾ in. (91.8 × 68 cm)
Museum of Fine Arts, Boston, Gift of Mr. and
Mrs. John McAndrew (69.49)
Lemoisne 464
Pl. 72

Woman in a Bathtub
ca. 1880–85
Monotype
Plate 7 ⅞ × 16 ⅜ in. (20 × 41.6 cm),
sheet 12 ⁵⁄₁₆ × 20 ³⁄₁₆ in. (31.3 × 51.3 cm)
Private collection
Janis 119
Pl. 132

The Singer in Green
ca. 1884
Pastel on light blue laid paper
23 ¾ × 18 ¼ in. (60.3 × 46.4 cm)
The Metropolitan Museum of Art, New York,
Bequest of Stephen C. Clark, 1960 (61.101.7)
Lemoisne 772
Pl. 122

Mary Cassatt at the Louvre: The Paintings Gallery
1885
Pastel over etching, aquatint, drypoint,
and crayon électrique
Plate 12 × 5 in. (30.5 × 12.7 cm),
sheet 12 ⁵⁄₁₆ × 5 ⅜ in. (31.3 × 13.7 cm)
The Art Institute of Chicago, Bequest of Kate L.
Brewster (1949.515)
Lemoisne 583; Reed and Shapiro 52 XII–XIIIa/XX
Pl. 71

Woman Bathing in a Shallow Tub
1885
Charcoal and pastel on light green wove paper, now
discolored to warm gray, laid down on silk bolting
32 × 22 ⅛ in. (81.3 × 56.2 cm)
The Metropolitan Museum of Art, New York,
H. O. Havemeyer Collection, Bequest of
Mrs. H. O. Havemeyer, 1929 (29.100.41)
Lemoisne 816
Pl. 135

Woman Combing Her Hair
ca. 1888–90
Pastel on light green wove paper, now discolored
to warm gray, affixed to original pulpboard mount
24 ⅛ × 18 ⅛ in. (61.3 × 46 cm)
The Metropolitan Museum of Art, New York, Gift of
Mr. and Mrs. Nate B. Spingold, 1956 (56.231)
Brame and Reff 115
Pl. 136

After the Bath III
1891–92
Lithograph (transfer and crayon); first state of two
Image 9 ¹³⁄₁₆ × 9 ¹⁄₁₆ in. (25 × 23 cm), sheet 14 ¹¹⁄₁₆ × 12 in.
(37.3 × 30.5 cm)
The Metropolitan Museum of Art, New York, Bequest
of Clifford A. Furst and Harris Brisbane Dick Fund,
by exchange, 1972 (1972.571)
Reed and Shapiro 65 I/II
Pl. 133

Nude Woman Standing, Drying Herself
1891–92
Lithograph (transfer from monotype with crayon,
tusche, and scraping); fifth state of six
Image 13 × 9 ⅝ in. (33 × 24.5 cm), sheet 14 ¾ × 10 ⅜ in.
(37.5 × 26.3 cm)
The Metropolitan Museum of Art, New York, Purchase,
Mr. and Mrs. Douglas Dillon Gift, 1972 (1972.626)
Reed and Shapiro 61 V/VI
Pl. 131

*Stéphane Mallarmé and Paule Gobillard in front
of "Young Woman in a Garden" by Manet*
1895
Gelatin silver print
11 ⅝ × 14 ⁹⁄₁₆ in. (29.5 × 37 cm)
Musée d'Orsay, Paris (PHO 1986 83)
Daniel 18a
Pl. 64

Self-Portrait with Paul-Albert Bartholomé
ca. 1895–97
Modern print from a glass negative
Image 3 ½ × 5 ¹⁄₁₆ in. (8.9 × 12.9 cm), sheet 3 ¾ × 5 ¼ in.
(9.6 × 13.3 cm)
Bibliothèque Nationale de France, Département des
Estampes et de la Photographie, Paris (N-2 [Degas])
Daniel 24
Pl. 148

ÉDOUARD MANET

French, Paris 1832–1883 Paris

The Madonna of the Rabbit, after Titian
ca. 1850–60
Oil on canvas
27 ⁹⁄₁₆ × 33 ¹⁄₁₆ in. (70 × 84 cm)
Musée du Louvre, Paris, Département des Peintures
(RF 2017 7)
RW I 5
Pl. 22

Standing Man, after del Sarto
ca. 1853–57
Red chalk
11 ⅜ × 8 ⅝ in. (28.9 × 21.9 cm)
Musée d'Orsay, Paris (RF 30508)
RW II D.28
Pl. 26

Portrait of a Young Man
ca. 1856
Pastel
14 × 11 ¼ in. (35.6 × 28.6 cm)
Detroit Institute of Arts, Gift of Mr. and Mrs.
Edward E. Rothman (69.2)
RW II 1
Pl. 13

Portrait of the Artist, after Filippino Lippi
ca. 1857
Oil on cradled panel
16 ⅛ × 12 ⅝ in. (41 × 32 cm)
Musée d'Orsay, Paris (RF MO P 2020 3)
RW I 2
Pl. 24

Seated Nude
ca. 1858–60
Red chalk
11 × 7 ⅞ in. (28 × 20 cm)
The Art Institute of Chicago, Purchased with funds
provided by the Joseph and Helen Regenstein
Foundation (1967.30)
RW II D.363
Pl. 31

Spanish Cavaliers
1859
Oil on canvas
17 ¹³⁄₁₆ × 10 ¼ in. (45.3 × 26.1 cm)
Musée des Beaux-Arts, Lyon (B 1153-b)
RW I 26
Pl. 21

Copy after Delacroix's "Barque of Dante"
ca. 1859
Oil on canvas
13 × 16 ⅛ in. (33 × 41 cm)
The Metropolitan Museum of Art, New York,
H. O. Havemeyer Collection, Bequest of
Mrs. H. O. Havemeyer, 1929 (29.100.114)
RW I 3
Pl. 15

Head of a Young Woman (Suzanne Manet)
1859–61
Red chalk with traces of black chalk
11 ¹³⁄₁₆ × 10 ¹⁄₁₆ in. (30 × 25.5 cm)
Bibliothèque Nationale de France, Département
des Estampes et de la Photographie, Paris
(RESERVE DC-300 [D, 1]-BOITE ECU)
RW II D.356
Pl. 4

Monsieur Manet (The Artist's Father) I
1860
Etching and drypoint; only state
Plate 6 ⅞ × 4 ½ in. (17.4 × 11.5 cm), sheet 8 ⅛ × 9 ⅜ in.
(20.6 × 23.8 cm)
Nationalmuseum, Stockholm (NMG 321/1924)
Moreau-Nélaton 50; Guérin 5; Harris 6
Pl. 37

Monsieur and Madame Auguste Manet
1860
Oil on canvas
43 ⅞ × 35 ¹³⁄₁₆ in. (111.5 × 91 cm)
Musée d'Orsay, Paris (RF 1977 12)
RW I 30
Pl. 38

The Spanish Singer
1860
Oil on canvas
58 × 45 in. (147.3 × 114.3 cm)
The Metropolitan Museum of Art, New York, Gift of
William Church Osborn, 1949 (49.58.2)
RW I 32
Pl. 73

After the Bath
1860–61
Pen and brown ink, brush and wash, over red chalk,
with black chalk corrections
10 ½ × 8 in. (26.7 × 20.3 cm)
Private collection
RW II D.362
Pl. 32

Boy with a Sword
1861
Oil on canvas
51 5/8 × 36 3/4 in. (131.1 × 93.4 cm)
The Metropolitan Museum of Art, New York,
Gift of Erwin Davis, 1889 (89.21.2)
RW I 37
Pl. 44

The Infanta Margarita, after Velázquez
1861–62
Etched copperplate
9 1/8 × 7 9/16 in. (23.2 × 19.2 cm)
Bibliothèque de l'Institut National d'Histoire
de l'Art, Paris, Collections Jacques Doucet
(EM Manet 22)
See Moreau-Nélaton 14; Guérin 6; Harris 14
Pl. 17

The Infanta Margarita, after Velázquez
1861–62
Etching; only state
Sheet 9 1/16 × 7 1/2 in. (23 × 19 cm)
Nationalmuseum, Stockholm (NMG 310/1924)
Moreau-Nélaton 14; Guérin 6; Harris 14
Pl. 18

The Spanish Singer
1861–62
Etching and bitten tone; second state of seven
Plate 12 1/8 × 9 5/8 in. (30.8 × 24.4 cm), sheet 13 7/16 ×
10 5/16 in. (34.2 × 26.2 cm)
The Metropolitan Museum of Art, New York, The
Elisha Whittelsey Collection, The Elisha Whittelsey
Fund, 1952 (52.608.2)
Moreau-Nélaton 4 III/V; Guérin 16 II/V; Harris 12 II/
VII
Pl. 153

Children in the Tuileries Gardens
ca. 1861–62
Oil on canvas
14 7/8 × 18 1/8 in. (37.8 × 46 cm)
Museum of Art, Rhode Island School of Design,
Providence, Museum Appropriation Fund (42.190)
Jamot and Wildenstein 35
Pl. 116

Lola de Valence
1862
Oil on canvas
48 7/16 × 36 1/4 in. (123 × 92 cm)
Musée d'Orsay, Paris (RF 1991)
RW I 53
Pl. 97

Woman with a Fan (Jeanne Duval)
1862
Oil on canvas
35 1/4 × 44 1/2 in. (89.5 × 113 cm)
Szépművészeti Múzeum / Museum of Fine Arts,
Budapest (368.B)
RW I 48
Pl. 91

*Hat and Guitar, Frontispiece for an Edition of
Fourteen Etchings*
1862–63
Etching, aquatint, and drypoint; first state of four
Sheet 17 1/4 × 11 9/16 in. (43.8 × 29.4 cm)
Nationalmuseum, Stockholm (NMG 303/1924)
Moreau-Nélaton 1 I/III; Guérin 62 I/III; Harris 39 I/IV
Pl. 151

Fishing
ca. 1862–63
Oil on canvas
30 1/4 × 48 1/2 in. (76.8 × 123.2 cm)
The Metropolitan Museum of Art, New York,
Purchase, Mr. and Mrs. Richard J. Bernhard Gift,
1957 (57.10)
RW I 36
Pl. 33

Reclining Nude
ca. 1862–63
Red chalk
9 3/4 × 17 15/16 in. (24.7 × 45.6 cm)
Musée d'Orsay, Paris (RF 24335)
RW II D.376
Pl. 80

Lola de Valence
1863
Etching and aquatint with roulette; sixth state of eight
Printed by Auguste Delâtre (French, 1822–1907)
Published by Cadart & Luquet (French, active 1863–67)
Plate 10 3/8 × 7 1/8 in. (26.4 × 18.1 cm), sheet 15 9/16 ×
11 5/8 in. (39.5 × 29.5 cm)
The Metropolitan Museum of Art, New York,
Rogers Fund, 1918 (18.88.28)
Moreau-Nélaton 3 IV/V; Guérin 23 III/III;
Harris 33 VI/VIII
Pl. 96

Study for "Déjeuner sur l'herbe"
1863
Oil on canvas
35 1/4 × 45 7/8 in. (89.5 × 116.5 cm)
The Courtauld, London (Samuel Courtauld Trust)
(P.1932.SC.232)
RW I 66
Pl. 35

Olympia
1863–65
Oil on canvas
51 3/8 × 75 3/16 in. (130.5 × 191 cm)
Musée d'Orsay, Paris (RF 644)
RW I 69
Pl. 81

*The Battle of the USS "Kearsarge" and the
CSS "Alabama"*
1864
Oil on canvas
54 1/4 × 50 3/4 in. (137.8 × 128.9 cm)
Philadelphia Museum of Art: The John G. Johnson
Collection, 1917 (Cat. 1027)
RW I 76
Pl. 138

The Dead Christ with Angels
1864
Oil on canvas
70 5/8 × 59 in. (179.4 × 149.9 cm)
The Metropolitan Museum of Art, New York,
H. O. Havemeyer Collection, Bequest of
Mrs. H. O. Havemeyer, 1929 (29.100.51)
RW I 74
Pl. 75

The "Kearsarge" at Boulogne
1864
Oil on canvas
32 1/8 × 39 3/8 in. (81.6 × 100 cm)
The Metropolitan Museum of Art, New York, Gift
of Peter H. B. Frelinghuysen, and Purchase, Mr. and
Mrs. Richard J. Bernhard Gift, by exchange, Gifts
of Mr. and Mrs. Richard Rodgers and Joanne Toor
Cummings, by exchange, and Drue Heinz Trust,
The Dillon Fund, The Vincent Astor Foundation,
Mr. and Mrs. Henry R. Kravis, The Charles Engelhard
Foundation, and Florence and Herbert Irving Gifts,
1999 (1999.442)
RW I 75
Pl. 139

The Dead Toreador
probably 1864
Oil on canvas
29 ⅞ × 60 ⅜ in. (75.9 × 153.3 cm)
National Gallery of Art, Washington, D.C.,
Widener Collection (1942.9.40)
RW I 72
Pl. 85

The Dead Christ with Angels
1864–68
Graphite, watercolor, gouache, and pen and India ink
12 ¹³⁄₁₆ × 10 ⅝ in. (32.5 × 27 cm)
Musée d'Orsay, Paris (RF 4520)
RW II D.130
Pl. 76

The Races
1865–72, published 1884
Lithograph on chine collé; third state of three
Image 15 ¼ × 20 ⅛ in. (38.7 × 51.1 cm), sheet 20 ⅞ ×
26 ⅞ in. (53 × 68.3 cm)
The Metropolitan Museum of Art, New York,
Rogers Fund, 1920 (20.17.2)
Moreau-Nélaton 85; Guérin 72 II/II; Harris 41 III/III
Pl. 102

Reading
ca. 1866, probably resumed ca. 1873
Oil on canvas
24 × 28 ¹³⁄₁₆ in. (61 × 73.2 cm)
Musée d'Orsay, Paris (RF 1944 17)
RW I 136
Pl. 45

Plainte Moresque (Moorish Lament)
1866
Lithograph; first state of two
Sheet 12 ⁷⁄₁₆ × 9 ¼ in. (31.6 × 23.5 cm)
Nationalmuseum, Stockholm (NMG 324/1924)
Moreau-Nélaton 78 I/II; Guérin 70 I/II; Harris 29 I/II
Pl. 154

The Races at Longchamp
1866
Oil on canvas
17 ⁵⁄₁₆ × 33 ⅛ in. (44 × 84.2 cm)
The Art Institute of Chicago, Potter Palmer
Collection (1922.424)
RW I 98
Pl. 101

Young Lady in 1866
1866
Oil on canvas
72 ⅞ × 50 ⅝ in. (185.1 × 128.6 cm)
The Metropolitan Museum of Art, New York,
Gift of Erwin Davis, 1889 (89.21.3)
RW I 115
Pl. 93

Dead Christ with Angels
1866–67
Copperplate, etched and aquatinted
15 ⅞ × 13 ¹⁄₁₆ in. (40.3 × 33.2 cm)
The Art Institute of Chicago, Clarence Buckingham
Collection (1984.1114)
See Moreau-Nélaton 59; Guérin 34; Harris 51
Pl. 77

Dead Christ with Angels
1866–67
Etching and aquatint on china paper; first state
of three
Image 12 ¾ × 11 in. (32.4 × 27.9 cm), plate 15 ⅜ × 12 ¾ in.
(39.1 × 32.4 cm), sheet 17 ⅛ × 12 ⅞ in. (43.5 × 32.7 cm)
Detroit Institute of Arts, Founders Society Purchase,
General Endowment Fund (70.588)
Moreau-Nélaton 59 I/III; Guérin 34 I/IV; Harris 51 I/III
Pl. 78

Dead Christ with Angels
1866–67
Etching and aquatint in brown/black ink; third state
of three
Printed by Henri Charles Guerard (French, 1846–1897)
Plate 15 ½ × 12 ⅞ in. (39.4 × 32.7 cm), sheet 17 ¾ ×
14 ½ in. (45.1 × 36.8 cm)
The Metropolitan Museum of Art, New York,
Purchase, Florance Waterbury Bequest, 1970
(1970.572)
Moreau-Nélaton 59 III/III; Guérin 34 III/IV; Harris 51
III/III
Pl. 79

Olympia (published plate)
1867
Etching; second state of six
Plate 3 ⅜ × 8 ⅛ in. (8.6 × 20.6 cm), sheet 3 ⅞ × 8 ½ in.
(9.8 × 21.6 cm)
The Metropolitan Museum of Art, New York, The
Elisha Whittelsey Collection, The Elisha Whittelsey
Fund, 1983 (1983.1093)
Moreau-Nélaton 17 II-III/IV; Guérin 39 II/VI;
Harris 53 II/VI
Pl. 155

The Execution of Maximilian
ca. 1867–68
Oil on canvas
76 in. × 9 ft. 3 ¹³⁄₁₆ in. (193 × 284 cm)
The National Gallery, London. Bought, 1918
(NG3294)
RW I 126
Pl. 160

Émile Zola
1868
Oil on canvas
57 ½ × 44 ⅞ in. (146 × 114 cm)
Musée d'Orsay, Paris (RF 2205)
RW I 128
Pl. 88

The Execution of Maximilian
1868, published 1884
Lithograph on chine collé; first state of three
Image 13 ⅜ × 17 ¼ in. (34 × 43.8 cm), sheet 17 ½ ×
23 ¾ in. (44.5 × 60.3 cm)
The Metropolitan Museum of Art, New York,
Rogers Fund, 1921 (21.48)
Moreau-Nélaton 79 I/II; Guérin 73 I/II; Harris 54 I/III
Pl. 142

On the Beach, Boulogne-sur-Mer
1868
Oil on canvas
12 ¾ × 26 in. (32.4 × 66 cm)
Virginia Museum of Fine Arts, Richmond,
Collection of Mr. and Mrs. Paul Mellon (85.498)
RW I 148
Pl. 110

Marine
ca. 1868
Watercolor
4 ⁵⁄₁₆ × 8 ¼ in. (11 × 21 cm)
Musée d'Orsay, Paris (RF 31283)
RW II D.224
Pl. 108

The Balcony
1868–69
Oil on canvas
66 ¹⁵⁄₁₆ × 49 ³⁄₁₆ in. (170 × 125 cm)
Musée d'Orsay, Paris (RF 2772)
RW I 134
Pl. 98

Madame Manet at the Piano
ca. 1868–69
Oil on canvas
15 3/16 × 18 5/16 in. (38.5 × 46.5 cm)
Musée d'Orsay, Paris (RF 1994)
RW I 131
Pl. 5

Charles Baudelaire, Full Face, after Nadar, III
1869
Etching with pen and brown ink; second state of four
Sheet 6 13/16 × 4 3/16 in. (17.3 × 10.6 cm)
Nationalmuseum, Stockholm (NMG 313/1924)
Moreau-Nélaton 16 II/VII; Guérin 38 II/IV;
Harris 61 II/IV
Pl. 152

In the Garden
1870
Oil on canvas
17 1/2 × 21 1/4 in. (44.5 × 54 cm)
Shelburne Museum, Shelburne, Vermont, Gift of
Dunbar W. and Electra Webb Bostwick, 1981–82
(27.1.1–200)
RW I 155
Pl. 115

Music Lesson
1870
Oil on canvas
55 1/2 × 68 1/8 in. (141 × 173.1 cm)
Museum of Fine Arts, Boston, Anonymous Centennial
gift in memory of Charles Deering (69.1123)
RW I 152
Pl. 40

Line in front of the Butcher Shop
1870–71, published 1905
Etching on light blue laid paper; first state of two
Published by Alfred Strölin (French, 1871–1954)
Plate 9 1/4 × 6 1/8 in. (23.5 × 15.6 cm), sheet 14 1/2 ×
9 1/2 in. (36.8 × 24.1 cm)
The Metropolitan Museum of Art, New York,
Rogers Fund, 1921 (21.76.28)
Moreau-Nélaton 45; Guérin 58; Harris 70 I/II
Pl. 146

The Barricade (recto); *The Execution of Maximilian*
(verso)
ca. 1871
Recto: brush and ink wash, watercolor, and gouache
over graphite; verso: graphite
18 3/16 × 12 13/16 in. (46.2 × 32.5 cm)
Szépművészeti Múzeum / Museum of Fine Arts,
Budapest (1935-2734)
RW II D.319
Pl. 143

The Barricade
ca. 1871, published 1884
Lithograph on chine collé; second state of two
Printed and published by Lemercier & Cie., Paris
Image 18 5/16 × 13 1/8 in. (46.5 × 33.4 cm), sheet 23 15/16 ×
17 5/16 in. (60.8 × 44 cm)
The Metropolitan Museum of Art, New York,
Purchase, Friends of Drawings and Prints Gifts,
2022 (2022.18)
Moreau-Nélaton 82 II/II; Guérin 76 II/II; Harris 71 II/II
Pl. 144

Repose
ca. 1871
Oil on canvas
59 1/8 × 44 7/8 in. (150.2 × 114 cm)
Museum of Art, Rhode Island School of Design,
Providence, Bequest of Mrs. Edith Stuyvesant
Vanderbilt Gerry (59.027)
RW I 158
Pl. 55

Civil War
1871–73, published 1874
Lithograph on chine collé; second state of two
Printed and published by Lemercier & Cie., Paris
Image 15 5/8 × 20 in. (39.7 × 50.8 cm), sheet 19 1/8 ×
24 3/4 in. (48.6 × 62.9 cm)
The Metropolitan Museum of Art, New York,
Rogers Fund, 1922 (22.60.18)
Moreau-Nélaton 81 II/II; Guérin 75 II/II; Harris 72 II/II
Pl. 145

Berthe Morisot
1872
Etching and drypoint; first state of three
Plate 4 11/16 × 3 1/8 in. (11.9 × 7.9 cm), sheet 8 3/8 ×
6 5/16 in. (21.3 × 16 cm)
The Metropolitan Museum of Art, New York,
Harris Brisbane Dick Fund, 1926 (26.67.4)
Moreau-Nélaton 41; Guérin 59 I/II; Harris 75 I/III
Pl. 57

Berthe Morisot with a Bouquet of Violets
1872
Oil on canvas
21 7/8 × 15 15/16 in. (55.5 × 40.5 cm)
Musée d'Orsay, Paris (RF 1998 30)
RW I 179
Pl. 56

The Races in the Bois de Boulogne
1872
Oil on canvas
28 3/4 × 37 in. (73 × 94 cm)
Private collection
RW I 184
Pl. 104

Berthe Morisot (in Black)
1872–74, published 1884
Lithograph on chine collé; second state of two
Printed and published by Lemercier & Cie., Paris
Image 9 13/16 × 6 15/16 in. (24.9 × 17.6 cm), sheet 15 3/4 ×
11 7/8 in. (40 × 30.2 cm)
The Metropolitan Museum of Art, New York,
Harris Brisbane Dick Fund, 1923 (23.21.22)
Moreau-Nélaton 83 II/II; Guérin 77 II/II; Harris 73 II/II
Pl. 58

Berthe Morisot (in Silhouette)
1872–74, published 1884
Lithograph on chine collé; second state of two
Printed and published by Lemercier & Cie., Paris
Image 8 1/2 × 6 1/2 in. (21.6 × 16.5 cm), sheet 17 1/2 ×
12 3/8 in. (44.5 × 31.4 cm)
The Metropolitan Museum of Art, New York,
Rogers Fund, 1921 (21.60.3)
Moreau-Nélaton 84 II/II; Guérin 78 II/II; Harris 74 II/II
Pl. 59

Berthe Morisot in Mourning
1874
Oil on canvas
23 5/8 × 18 7/8 in. (60 × 47.9 cm)
Private collection
RW I 228
Pl. 157

Boating
1874
Oil on canvas
38 1/4 × 51 1/4 in. (97.2 × 130.2 cm)
The Metropolitan Museum of Art, New York,
H. O. Havemeyer Collection, Bequest of
Mrs. H. O. Havemeyer, 1929 (29.100.115)
RW I 223
Pl. 114

The Monet Family in Their Garden at Argenteuil
1874
Oil on canvas
24 × 39 1/4 in. (61 × 99.7 cm)
The Metropolitan Museum of Art, New York, Bequest
of Joan Whitney Payson, 1975 (1976.201.14)
RW I 227
Pl. 113

Polichinelle
1874
Verse by Théodore de Banville (French, Moulins 1823–1891 Paris)
Lithograph printed in seven colors on Japan paper; third state of four
Image 20 ½ × 14 ⁹⁄₁₆ in. (52 × 37 cm), sheet 22 ¹³⁄₁₆ × 16 ¹³⁄₁₆ in. (58 × 42.7 cm)
The Metropolitan Museum of Art, New York, Rogers Fund, 1922 (22.104.1)
Moreau-Nélaton 87; Guérin 79 III/III; Harris 80 III/IV
Pl. 150

The Artist (Marcellin Desboutin)
1875
Oil on canvas
76 ¹⁵⁄₁₆ × 51 ¾ in. (195.5 × 131.5 cm)
Museu de Arte de São Paulo Assis Chateaubriand, Purchase, 1958 (MASP.00077)
RW I 244
Pl. 61

The Ham
ca. 1875–80
Oil on canvas
12 ¾ × 16 ¼ in. (32.4 × 41.2 cm)
Lent by Glasgow Life (Glasgow Museums) on behalf of Glasgow City Council: from the Burrell Collection with the approval of the Burrell Trustees. Gifted by Sir William and Lady Burrell to the City of Glasgow, 1944 (35.308)
RW I 351
Pl. 149

Stéphane Mallarmé
1876
Oil on canvas
10 ¹¹⁄₁₆ × 14 ¹⁄₁₆ in. (27.2 × 35.7 cm)
Musée d'Orsay, Paris (RF 2661)
RW I 249
Pl. 63

Nana
1877
Oil on canvas
60 ⅝ × 45 ¼ in. (154 × 115 cm)
Hamburger Kunsthalle, acquired 1924 (HK-2376)
RW I 259
Pl. 128

Plum Brandy
ca. 1877
Oil on canvas
29 × 19 ¾ in. (73.6 × 50.2 cm)
National Gallery of Art, Washington, D.C., Collection of Mr. and Mrs. Paul Mellon (1971.85.1)
RW I 282
Pl. 119

George Moore at the Café
1878 or 1879
Oil on canvas
25 ¾ × 32 in. (65.4 × 81.3 cm)
The Metropolitan Museum of Art, New York, Gift of Mrs. Ralph J. Hines, 1955 (55.193)
RW I 296
Pl. 65

Portrait of the Artist (Manet with a Palette)
ca. 1878–79
Oil on canvas
33 ¹¹⁄₁₆ × 27 ¹⁵⁄₁₆ in. (85.5 × 71 cm)
Private collection
RW I 276
Pl. 1

Woman with a Tub
ca. 1878–79
Pastel on linen
18 ⅛ × 19 ⅞ in. (46 × 50.5 cm)
Koons Collection
RW II 23
Pl. 134

At the Theater
ca. 1878–80
Graphite
7 ¼ × 10 ⅝ in. (18.4 × 27 cm)
Roberta J. M. Olson and Alexander B. V. Johnson
RW II D.526
Pl. 156

Woman with a Cigarette
ca. 1878–80
Oil on canvas
36 ¼ × 28 ¹⁵⁄₁₆ in. (92 × 73.5 cm)
Princeton University Art Museum. Bequest of Archibald S. Alexander, Class of 1928 (y1979-55)
RW I 46
Pl. 159

George Moore
1879
Pastel on canvas
21 ¾ × 13 ⅞ in. (55.2 × 35.2 cm)
The Metropolitan Museum of Art, New York, H. O. Havemeyer Collection, Bequest of Mrs. H. O. Havemeyer, 1929 (29.100.55)
RW II 11
Pl. 66

Nude Arranging Her Hair
1879
Oil on canvas
31 ⅞ × 25 ⅝ in. (81 × 65 cm)
Koons Collection
RW I 318
Pl. 137

The Café-Concert
ca. 1879
Oil on canvas
18 ⅝ × 15 ⅜ in. (47.3 × 39.1 cm)
The Walters Art Museum, Baltimore, Maryland (37.893)
RW I 280
Pl. 121

Antonin Proust
1880
Oil on canvas
51 × 37 ¾ in. (129.5 × 95.9 cm)
Toledo Museum of Art, Gift of Edward Drummond Libbey (1925.108)
RW I 331
Pl. 69

Woman with a Cat
ca. 1880
Oil on canvas
36 ¼ × 28 ¾ in. (92.1 × 73 cm)
Tate: Purchased 1918 (N03295)
RW I 337
Pl. 158

At the Milliner's
1881
Oil on canvas
33 ½ × 29 in. (85.1 × 73.7 cm)
Fine Arts Museums of San Francisco, museum purchase, Mildred Anna Williams Collection (1957.3)
RW I 373
Pl. 126

The Escape of Rochefort
ca. 1881
Oil on canvas
31 ⅛ × 28 ⅜ in. (79 × 72 cm)
Musée d'Orsay, Paris (RF 1984 158)
RW I 370
Pl. 147

NOTES

INTRODUCTION
Stephan Wolohojian and Ashley E. Dunn

1. See the essay by Stephan Wolohojian in this volume, and *The Private Collection of Edgar Degas*, by Ann Dumas, Colta Ives, Susan Alyson Stein, and Gary Tinterow, exh. cat. (New York: The Metropolitan Museum of Art, 1997).

2. See the Chronology in this volume for excerpts from the three surviving dated letters from Manet to Degas. The fourth letter, a brief invitation to dinner with fellow painters Alfred Stevens and Pierre Puvis de Chavannes, is undated. Henri Loyrette, *Degas* (Paris: Fayard, 1991), pp. 221–22.

3. The identity of the sitter in the photograph found in the album presently and annotated "Degas" by a later hand is questionable. The original carte de visite (now lost) was published by Étienne Moreau-Nélaton when he was in possession of the album. Étienne Moreau-Nélaton, *Manet: Raconté par lui-même* (Paris: Henri Laurens, 1926), vol. 1, fig. 100.

4. Many of the major comments in their correspondence are gathered in the Chronology in this volume. The principal accounts of their relationship come from Jacques-Émile Blanche, George Moore, the Morisots, and Giuseppe De Nittis.

5. See the essay by Ashley E. Dunn in this volume.

6. See *Copier créer: De Turner à Picasso; 300 œuvres inspirées par les maîtres du Louvre*, exh. cat., Musée du Louvre, Paris (Paris: Réunion des Musées Nationaux, 1993); Ann Dumas, ed., *Inspiring Impressionism: The Impressionists and the Art of the Past*, exh. cat., High Museum of Art, Atlanta; Denver Art Museum; Seattle Art Museum (Denver: Denver Art Museum; New Haven: Yale University Press, 2007).

7. Michael Fried, "Manet's Sources: Aspects of His Art, 1859–1865," special issue, *Artforum* 7, no. 7 (March 1969), pp. 28–82; Theodore Reff, "'Manet's Sources': A Critical Evaluation," *Artforum* 8, no. 1 (September 1969), pp. 40–48.

8. See Jean Sutherland Boggs, *Portraits by Degas* (Berkeley: University of California Press, 1962); Felix Baumann and Marianne Karabelnik, eds., *Degas Portraits* (London: Merrell Holberton, 1994); *Manet: Portraying Life*, exh. cat. (Toledo, Ohio: Toledo Museum of Art; London: Royal Academy of Arts, 2012).

9. See Moreau-Nélaton, *Manet: Raconté par lui-même*, vol. 2, p. 40, for Manet's account, and Ambroise Vollard, *Degas (1834–1917)* (Paris: G. Crès et Cie., 1924), pp. 85–86, for Degas's.

10. See Samuel Rodary, ed., *Édouard Manet: Correspondance du siège de Paris et de la Commune, 1870–1871* (Paris: L'Échoppe, 2014).

11. For an analysis of the impact of the Siege on their work, see Hollis Clayson, *Paris in Despair: Art and Everyday Life under Siege (1870–71)* (Chicago: University of Chicago Press, 2002).

12. See Jean Sutherland Boggs, *Degas at the Races*, exh. cat. (Washington, D.C.: National Gallery of Art; New Haven: Yale University Press, 1998); T. J. Clark, *The Painting of Modern Life: Paris in the Art of Manet and His Followers* (Princeton, N.J.: Princeton University Press, 1984).

13. See George T. M. Shackelford and Xavier Rey, *Degas and the Nude*, exh. cat. (Boston: Museum of Fine Arts, 2011); Beatrice Farwell, *Manet and the Nude: A Study in Iconography in the Second Empire* (New York: Garland, 1981).

14. See Jodi Hauptman, ed., *Degas: A Strange New Beauty*, exh. cat. (New York: Museum of Modern Art, 2016).

15. See Frances Weitzenhoffer, "First Manet Paintings to Enter an American Museum," *Gazette des Beaux-Arts*, ser. 6, 97 (March 1981), pp. 125–29; Katharine Baetjer and Joan R. Mertens, "The Founding Decades," in *Making The Met, 1970–2020*, ed. Andrea Bayer, exh. cat. (New York: The Metropolitan Museum of Art, 2020), p. 43.

16. *Catalogue of the Paintings in the Metropolitan Museum of Art* (New York: The Metropolitan Museum of Art, 1898), p. 170.

17. Cassatt to Pissarro: "I declined to contribute. M. Eugène Manet told me that an American had wished to buy the picture & it was to prevent its leaving France that the subscription was opened. I wish it had gone to America"; quoted in Erica E. Hirshler, "Helping 'Fine Things Across the Atlantic': Mary Cassatt and Art Collecting in the United States," in *Mary Cassatt: Modern Woman*, exh. cat., Art Institute of Chicago; Museum of Fine Arts, Boston; National Gallery of Art, Washington, D.C. (New York: Art Institute of Chicago, in association with Harry N. Abrams, 1998), p. 180.

18. Laura D. Corey and Alice Cooney Frelinghuysen, "Visions of Collecting," in Bayer, *Making The Met*, pp. 133–34; Louisine W. Havemeyer, *Sixteen to Sixty: Memoirs of a Collector*, ed. Susan Alyson Stein (New York: Ursus Press, 1993), pp. 236–37.

19. B[ryson] B[urroughs], "Principal Accessions," *The Metropolitan Museum of Art Bulletin* 5, no. 5 (May 1910), p. 123, ill. p. 127.

20. It is unclear what that painting was, but Susan Alyson Stein proposes it was probably *Scene of War in the Middle Ages* (pl. 83) in "The Metropolitan Museum's Purchases from the Degas Sales: New Acquisitions and Lost Opportunities," in Dumas et al., *The Private Collection of Edgar Degas*, pp. 274–75.

21. B[ryson] B[urroughs], "Nineteenth-Century French Painting," *The Metropolitan Museum of Art Bulletin* 13, no. 8 (August 1918), p. 180.

22. On the Havemeyer works by Degas, see Gary Tinterow, "The Havemeyer Pictures," in Alice Cooney Frelinghuysen, Gary Tinterow, Susan Alyson Stein, Gretchen Wold, and Julia Meech, *Splendid Legacy: The Havemeyer Collection*, exh. cat. (New York: The Metropolitan Museum of Art, 1993), pp. 36–47.

23. Françoise Cachin and Charles S. Moffett, eds., *Manet 1832–1883*, exh. cat., Galeries Nationales du Grand Palais, Paris; The Metropolitan Museum of Art, New York (New York: The Metropolitan Museum of Art; Harry N. Abrams, 1983); Jean Sutherland Boggs, Douglas W. Druick, Henri Loyrette, Michael Pantazzi, and Gary Tinterow, *Degas*, exh. cat., Galeries Nationales du Grand Palais, Paris; National Gallery of Canada, Ottawa; The Metropolitan Museum of Art, New York (New York: The Metropolitan Museum of Art; Ottawa: National Gallery of Canada, 1988).

24. They have each received relatively recent retrospective reappraisals in *Manet: The Man Who Invented Modernity*, exh. cat. (Paris: Gallimard; Musée d'Orsay, 2011); Henri Loyrette, *Degas: A New Vision*, exh. cat., National Gallery of Victoria, Melbourne; Museum of Fine Arts, Houston (Melbourne: Council of Trustees of the National Gallery of Victoria, 2016). Publications that specifically address their relationship include: Henri Loyrette, cat. 82, in Boggs et al., *Degas*, pp. 140–42; Éric Darragon, *Manet* (Paris: Fayard, 1989); Loyrette, *Degas*, pp. 218–22; Barbara Ehrlich White, "Degas & Manet," in *Impressionists Side by Side: Their Friendships, Rivalries, and Artistic Exchanges* (New York: Alfred A. Knopf, 1996), pp. 23–55; Mari Kálmán Meller and Juliet Wilson-Bareau, "Manet and Degas: A Never-Ending Dialogue," in Dumas et al., *The Private Collection of Edgar Degas*, pp. 177–95; Jeffrey Meyers, "Degas and Manet, 1861–1883," in *Impressionist Quartet: The Intimate Genius of Manet and Morisot, Degas and Cassatt* (Orlando, Fla.: Harcourt, 2005), pp. 200–215; Éric Darragon, *Il était plus grand que nous ne pensions: Édouard Manet et Degas* (Paris: Nouvelles Éditions Scala, 2011); MaryAnne Stevens, "Degas–Manet: Eine facettenreiche und vitale Beziehung," in *Degas: Klassik und Experiment*, ed. Alexander Eiling, exh. cat. (Munich: Hirmer; Karlsruhe: Staatliche Kunsthalle Karlsruhe, 2014), pp. 42–53; Henri Loyrette, "Degas and Manet," in *Degas: A New Vision*, pp. 49–56; Sebastian Smee, "Manet and Degas," in *The Art of Rivalry: Four Friendships, Betrayals, and Breakthroughs in Modern Art* (New York: Random House, 2016), pp. 91–176.

25. Richard R. Brettell, "Artistic Collaboration: A Brief History," in *Innovative Impressions: Prints by Cassatt, Degas, and Pissarro*, by Sarah Lees and Richard R. Brettell, exh. cat. (Tulsa, Okla.: Philbrook Museum of Art; Munich: Hirmer, 2018), pp. 1–9.
 "Dialogical" is Joachim Pissarro's term; see Joachim Pissarro, *Cézanne/Pissarro, Johns/Rauschenberg: Comparative Studies on Intersubjectivity in Modern Art* (Cambridge: Cambridge University Press, 2006), p. 5.

MANET AND DEGAS MEET: ENCOUNTERS IN ETCHING
Ashley E. Dunn

Translations are by the author unless otherwise noted.

1. Loys Delteil, *Le peintre-graveur illustré*, vol. 9, *Degas* (Paris: Chez l'Auteur, 1919), no. 12.

2. Adolphe Tabarant, *Manet et ses œuvres* (Paris: Gallimard, 1947), p. 37, gives the date of 1862. Copyist records confirm.

3. According to Moreau-Nélaton, Degas gratefully accepted Manet's advice on how best to proceed; Étienne Moreau-Nélaton, *Manet: Raconté par lui-même* (Paris: Henri Laurens, 1926), vol. 1, p. 36.

4. Ibid.

5. Juliet Wilson[-Bareau], ed., *Manet: Dessins, aquarelles, eaux-fortes, lithographies, correspondance*, exh. cat. (Paris: Huguette Berès, 1978), cat. 21.

6. For example, Théodore de Banville described etching as "a drawing of which one can have several copies" in "La Société des Aquafortistes," *L'Union des Arts* (October 1, 1864), p. 1. In his preface to the inaugural edition of the Société des Aquafortistes' *Eaux-fortes modernes* (1862–63), the critic Théophile Gautier insisted that "no method is simpler, more direct, more personal than etching" and that finish "does not suit it"; Théophile Gautier, "Société des Aquafortistes: Un mot sur l'eau-forte," *Eaux-fortes modernes originales et inédites* 1 (1862–63), n.p. Both reprinted in Janine Bailly-Herzberg, *L'eau-forte de peintre au dix-neuvième siècle: La Société des Aquafortistes 1862–1867* (Paris: Léonce Laget, 1972), vol. 1, pp. 129, 266.

7. See Valérie Sueur-Hermel, "Graver sur le motif au XIXᵉ siècle: Le cas singulier d'Eugène Bléry," in *Dessiner en plein air: Variations du dessin sur nature dans la première moitié du XIXᵉ siècle*, ed. Marie-Pierre Salé, exh. cat., Musée du Louvre, Paris (Paris: LienArt, Louvre Editions, 2017), pp. 71–89. In the 1870s, Manet and Degas's friend Marcellin Desboutin made drypoint portraits of his friends from life while socializing at the Café Guerbois, according to Noël Clément-Janin, *La curieuse vie de Marcellin Desboutin: Peintre, graveur, poète* (Paris: Floury, 1922); cited in Amy Marquis, *Marcellin Desboutin: Drypoints*, exh. cat. (Cambridge: Fitzwilliam Museum, 2017), p. 10.

8. Sue Welsh Reed and Barbara Stern Shapiro, *Edgar Degas: The Painter as Printmaker*, exh. cat., Museum of Fine Arts, Boston; Philadelphia Museum of Art; Arts Council of Great Britain, Hayward Gallery, London (Boston: Museum of Fine Arts, 1984), cat. 16, pp. 43–45; Henri Loyrette, *Degas: A New Vision*, exh. cat., National Gallery of Victoria, Melbourne; Museum of Fine Arts, Houston (Melbourne: Council of Trustees of the National Gallery of Victoria, 2016), p. 54.

9. Others have proposed that the orientation of the print in reverse of the painting supports the idea of the artist drawing from the motif; however, drawing from a reproduction in the original orientation would produce the same result. Degas worked on the plate in the same orientation as the painting and did not take the intermediate step to correct the reversal in the resulting print. See Gary Tinterow, cat. 103, in *Manet/Velázquez: The French Taste for Spanish Painting*, by Gary Tinterow and Geneviève Lacambre; exh. cat., Musée d'Orsay, Paris; The Metropolitan Museum of Art, New York (New York: The Metropolitan Museum of Art; New Haven: Yale University Press, 2003), pp. 473–74. According to Paul Valéry, "Degas rejected *facility*" and "knew how to labor at his task . . . through the recalcitrance and rebelliousness of the medium"; Paul Valéry, "Degas, Dance, Drawing," in *Degas, Manet, Morisot*, trans. David Paul, Bollingen series 45, vol. 12 (New York: Pantheon Books, 1960), pp. 6, 63. On Degas appreciating the difficulty of materials, see Jodi Hauptman, introduction to *Degas: A Strange New Beauty*, ed. Jodi Hauptman, exh. cat. (New York: Museum of Modern Art, 2016), p. 15.

10. Jay Fisher suggests that Manet's first etching, *The Little Gypsies* (1861), was an exception to the rule. He attributes its awkwardness to "the fact that Manet was trying to work in reverse from a model"; Jay McKean Fisher, *The Prints of Edouard Manet*, exh. cat. (Washington, D.C.: International Exhibitions Foundation, 1985), pp. 31–32, cat. 1. On the role of watercolors in Manet's translation of paintings into prints, see Kathryn Kremnitzer, "Manet's Watercolors: Transition and Translation in the 1860s," PhD diss., Columbia University, New York, 2020.

11. Jean C. Harris, *Edouard Manet: Graphic Works; A Definitive Catalogue Raisonné* (New York: Collectors Editions, 1970), fig. 32, p. 57; Juliet Wilson-Bareau, "Manet and Spain," in Tinterow and Lacambre, *Manet/Velázquez: The French Taste for Spanish Painting*, fig. 9.3, p. 206.

12. Reed and Shapiro, *Edgar Degas: The Painter as Printmaker*, cat. 1, p. 2.

13. Ibid., cat. 14, pp. 37–41; Douglas Druick and Peter Zegers, "Degas and the Printed Image, 1856–1914," in ibid., p. xviii.

14. The paintings are in the Musée d'Orsay, Paris (RF 3584; RF 3585); Paul-André Lemoisne, *Degas et son œuvre* (1946–49; repr., New York: Garland, 1984), vol. 2, nos. 60, 61, pp. 28–29.

15. Michel Melot, "Manet and the Print," in *Manet 1832–1883*, ed. Françoise Cachin and Charles S. Moffett; exh. cat., Galeries Nationales du Grand Palais, Paris; The Metropolitan Museum of Art, New York (New York: The Metropolitan Museum of Art; Harry N. Abrams, 1983), p. 36; "Although about half of these hundred-odd prints . . . remained unpublished during his lifetime, probably all were executed with a view to publication."

16. Nancy Locke, *Manet and the Family Romance* (Princeton, N.J.: Princeton University Press, 2001), pp. 48–52; Stéphane Guégan, *Manet: The Man Who Invented Modernity*, exh. cat. (Paris: Gallimard; Musée d'Orsay, 2011), p. 132.

17. Denis Rouart and Daniel Wildenstein, *Edouard Manet: Catalogue raisonné*, vol. 2, *Pastels, aquarelles et dessins* (Lausanne: Bibliothèque des Arts, 1975), p. 132, no. 345; Alain de Leiris, *The Drawings of Edouard Manet* (Berkeley: University of California Press, 1969), p. 104, no. 149, fig. 196; reproduced in color in Marianne Mathieu, ed., *Julie Manet: An Impressionist Heritage*, exh. cat. (Paris: Hazan, Musée Marmottan Monet; New Haven: Yale University Press, 2021), p. 6.

18. Fisher (*The Prints of Edouard Manet*, pp. 32–33, cat. 2) notes that the use of etching over drypoint produced an awkward result. He also describes the gauntness of Manet's father's appearance in the first etching as a reason for Manet abandoning it to start a second plate. The second version more successfully captured "the gentle countenance and the fuller face" of the drawing, though the artist must have remained dissatisfied as he never published the print.

19. Jean-Paul Bouillon speculates that Manet and Bracquemond met in or before 1857, at either the Louvre or the Cabinet des Estampes of the Bibliothèque Impériale; Jean-Paul Bouillon, "Manet and Bracquemond: A Comparative Chronology," in *Manet to Bracquemond: Newly Discovered Letters to an Artist and Friend*, ed. Jean-Paul Bouillon; trans. Trista Selous (London: Ad Ilissum, an imprint of Paul Holberton Publishing, for the Fondation Custodia, 2020), p. 83. In May 1861 Bracquemond and Legros were among the artists who visited Manet to express their admiration of *The Spanish Singer*.

20. Bailly-Herzberg, *L'eau-forte de peintre au dix-neuvième siècle: La Société des Aquafortistes, 1862–1867* (see note 6 above). The authoritative source on the Société des Aquafortistes, Bailly-Herzberg offers a history of the society, a dictionary of all participants and supporters, and a catalogue of their published etchings.

21. [Philippe Burty], "Bibliographie: Estampe," *La Chronique des Arts et de la Curiosité*, no. 20 (April 13, 1862), p. 4; [Charles Baudelaire], "L'eau-forte est à la mode," *Revue Anecdotique*, April 15–30, 1862, p. 171.

22. Kathryn Kremnitzer, "*Le Christ aux anges* de Manet à travers les techniques," *Nouvelles de l'Estampe* 267 (2022), pp. 1–23; https://doi.org/10.4000/estampe.1944.

23. Carol Armstrong, *Manet Manette* (New Haven: Yale University Press, 2002), p. 83.

24. Manet's first published etching was *The Gypsies* as part of *Eaux-fortes modernes* (*Modern Etchings*), the monthly distribution of etchings to subscribers, first issued September 1, 1862. Both Bracquemond and Legros also contributed etchings to the first issue.

25. In these "'autographic' reproduction[s]," according to Michel Melot, Manet "acted as his own interpreter, and within the framework of reproduction was able to take liberties that inspired a new idiom, one that was no longer an image of an image, but was itself an expressive representation"; Melot, "Manet and the Print," in Cachin and Moffett, *Manet 1832–1883*, p. 37. The "original" compositions are *The Toilette* and *The Boy with the Dog*.

26. Fisher, *The Prints of Edouard Manet*, pp. 65–66, cat. 30.

27. Juliet Wilson-Bareau describes it as "perhaps unfinished" in "Lithographs and Etchings: Spanish or Hispanic Themes, 1862–74," in Tinterow and Lacambre, *Manet/Velázquez: The French Taste for Spanish Painting*, p. 510.

28. I agree with Henri Loyrette's recent argument that this portrait campaign more likely dates to around 1868 than the mid-1860s, to which the drawings and prints were previously dated; Loyrette, *Degas: A New Vision*, p. 51. It was around 1868 that the artists were closest, as attested by letters, and it was also when they were engaged in a pictorial dialogue between their portraits of friends and peers, such as Émile Zola, Tissot, and others. Reed and Shapiro (*Edgar Degas: The Painter as Printmaker*, cat. 19, p. 56) note that an impression of the bust-length etching in a private collection in Germany is inscribed "Degas 1868."

29. A second-state impression in the collection of the Detroit Institute of Arts is illustrated in Reed and Shapiro, *Edgar Degas: The Painter as Printmaker*, cat. 18, p. 53.

30. Delteil (*Le peintre-graveur illustré*, vol. 9, no. 16) listed seventeen impressions, fourteen of which Reed and Shapiro located (*Edgar Degas: The Painter as Printmaker*, cat. 18, p. 50). A fourth-state impression in the collection of the Baltimore Museum of Art is illustrated in ibid., cat. 18, p. 55.

31. It was in the collection of Ernest Rouart in 1937. See Jacqueline Bouchot-Saupique and Marie Delaroche-Vernet, *Degas*, exh. cat., Musée de l'Orangerie, Paris (Lille: Imprimeries L. Danel, 1937), cat. 71.

32. A fourth-state impression from the collection of the Museum of Fine Arts, Boston, is illustrated in Reed and Shapiro, *Edgar Degas: The Painter as Printmaker*, cat. 19, p. 58.

33. This is supported by the fact that Bracquemond's son Pierre inherited a unique second-state impression of *Édouard Manet, Bust-length Portrait*; ibid., cat. 19, pp. 57–58. Juliet Wilson-Bareau noted, in the provenance of cat. 18, in Cachin and Moffett, *Manet 1832–1883*, p. 82, that Bracquemond "acquired many proofs in rare states, amassing a fine collection," as a result of helping his friends. Bracquemond's important collection of Manet's prints eventually formed the basis of Degas's own after it was bought by Philippe Burty, whose collection Degas acquired via Michel Manzi.

34. *Catalogue des tableaux, pastels et dessins par Edgar Degas et provenant de son atelier*, sale cat., Galeries Georges Petit, Paris, July 2–4, 1919, lot 248 [two drawings framed together]. One is now in the collection of the Harvard Art Museums (1965.261) and the other is still in private hands. A third group of portrait drawings of Manet by Degas relates to a painting project at the racetrack; it includes *Édouard Manet at the Races* (pl. 106) and *Portrait of Édouard Manet* (Museum Boijmans Van Beuningen, Rotterdam, 1940 [F II 123; formerly Koenigs Collection]).

35. Julie Manet was the only daughter of Manet's brother Eugène and Berthe Morisot. She married Ernest Rouart in 1900. Ernest and Julie lent three of the drawings (pls. 9, 10, fig. 10) to exhibitions in 1931 and 1937. See Bouchot-Saupique and Delaroche-Vernet, *Degas*, cats. 70–72; Mathieu, *Julie Manet: An Impressionist Heritage*, p. 262.

36. One of these exceptions was *Line in front of the Butcher Shop*, a work that pushes the abstraction already evident in his *Infanta* to an even greater degree with its radical use of the reserve of the paper to signify form (pl. 146).

37. Druick and Zegers, "Degas and the Printed Image, 1856–1914," in Reed and Shapiro, *Edgar Degas: The Painter as Printmaker*, pp. xxxix–li.

38. Druick and Zegers (ibid., p. xxxiii) infer "a connection between Degas's interest in techniques more associated with industry than with art and the recent activities of Manet . . . from two addresses in Degas's notebooks." Degas made note of Ferdinand Lefman, who assisted Manet in making transfer lithographs and Alphonse-Alfred Prunaire, a wood engraver with whom Manet made two prints in 1874. Degas owned *In the Upper Gallery*, printed by Lefman, as well as impressions of Manet's two wood engravings by Prunaire; see Colta Ives, Susan Alyson Stein, and Julie A. Steiner, comps., *The Private Collection of Edgar Degas: A Summary Catalogue* (New York: The Metropolitan Museum of Art, 1997), p. 100, nos. 876, 880, 881. For more on Manet's involvement with commercial processes, see Sarah Mirseyedi, "Process Work: Édouard Manet (1832–1883) and the Mass Image Industry," PhD diss., Harvard University, Cambridge, Mass., 2022.

POLITICAL SENSIBILITIES: MANET AND DEGAS ON BOTH SIDES OF THE ATLANTIC

Isolde Pludermacher

I would like to express my deepest gratitude to Theodore Reff and Barbara Divver, with whom I had fascinating discussions on Manet and Degas, some of which have informed this essay. My warmest thanks also go to Jérémie Koering and Caroline Gaillard.

1. Theodore Reff, introduction to *The Letters of Edgar Degas*, ed. Theodore Reff (New York: Wildenstein Plattner Institute, 2020), vol. 1, p. 38.

2. Paul Valéry, "Degas, Dance, Drawing," in *Degas, Manet, Morisot*, trans. David Paul, Bollingen series 45, vol. 12 (New York: Pantheon Books, 1960), p. 52.

3. Pinturicchio [Louis Vauxcelles], "Le carnet des ateliers: De M. Degas," *Le Carnet de la Semaine*, October 7, 1917, p. 7.

4. Antonin Proust, *Édouard Manet: Souvenirs*, ed. Auguste Barthélemy (Paris: Henri Laurens, 1913), p. 2.

5. On the reasons behind Hilaire Degas's flight, see Valéry, "Degas, Dance, Drawing," in *Degas, Manet, Morisot*, pp. 26–27; Jeanne Fèvre, *Mon oncle Degas: Souvenirs et documents inédits*, ed. Pierre Borel (Geneva: Pierre Cailler, 1949), pp. 18–21; Henri Loyrette, *Degas* (Paris: Fayard, 1991), pp. 11–13.

6. His first cousin, Gustavo Morbilli, was killed on the barricades in Naples in May 1848.

7. Reff, *Letters of Edgar Degas*, letter 6, vol. 1 p. 121, vol. 3 p. 11.

8. Proust, *Édouard Manet: Souvenirs*, pp. 11–12.

9. Edmond Bazire, *Manet* (Paris: A. Quantin, 1884), pp. 6–8; Proust, *Édouard Manet: Souvenirs*, p. 25.

10. Letter from Manet to his mother, February 5, 1849; quoted in translation in Juliet Wilson-Bareau, ed., *Manet by Himself: Correspondence and Conversation; Paintings, Pastels, Prints and Drawings* (Boston: Little, Brown; Bulfinch Press, 1991), p. 23.

11. Ibid., p. 25, letter from Manet to his father, March 22, 1849: "try and keep a decent republic against our return, for I fear that L[ouis] Napoleon is not a good republican." On this subject, see Philip Nord, "Manet and Radical Politics," *Journal of Interdisciplinary History* 19, no. 3 (Winter 1989), pp. 447–80.

12. Proust, *Édouard Manet: Souvenirs*, p. 29.

13. See Michelle Foa, "In Transit: Edgar Degas and the Matter of Cotton, between New World and Old," *Art Bulletin* 102, no. 3 (September 2020), pp. 60–61.

14. The sale, which took place at Hôtel Drouot, Paris, on March 9–10 and April 8, 1863, netted approximately 10,000 francs.

15. Many people took the train to watch the spectacular battle. See Françoise Cachin, cat. 83, in *Manet 1832–1883*, ed. Françoise Cachin and Charles S. Moffett, exh. cat. Galeries Nationales du Grand Palais, Paris; The Metropolitan Museum of Art, New York (New York: The Metropolitan Museum of Art; Harry N. Abrams, 1983), pp. 218–21; Juliet Wilson-Bareau and David Degener, *Manet and the Sea*, exh. cat., Art Institute of Chicago; Philadelphia Museum of Art; Van Gogh Museum, Amsterdam (Philadelphia: Philadelphia Museum of Art, 2003); Juliet Wilson-Bareau with David C. Degener, *Manet and the American Civil War: The Battle of U.S.S.* Kearsarge *and C.S.S.* Alabama, exh. cat. (New York: The Metropolitan Museum of Art; New Haven: Yale University Press, 2003).

16. Letter from Manet to Philippe Burty, cited in Étienne Moreau-Nélaton, *Manet: Raconté par lui-même* (Paris: Henri Laurens, 1926), vol. 1, p. 61; the letter is undated but it refers to an article in *La Presse*, July 18, 1864.

17. Loyrette, *Degas*, p. 18.

18. Marilyn Brown, "Degas's New Orleanian Spaces," in *Sweet Spots: In-Between Spaces in New Orleans*, ed. Teresa A. Toulouse and Barbara C. Ewell (Jackson: University Press of Mississippi, 2018), pp. 95, 104–5n20.

19. E[ugène] M[usson], "To Monsieur Mocquard, Secretary to the Emperor, Chef du Cabinet at the Tuileries," in *Letter to Napoleon III on Slavery in the Southern States, by a Creole of Louisiana* (London: W. S. Kirkland & Co., 1862), pp. 1–2. He continued in a postscript to his letter to the emperor (ibid., p. 114): "what we people of the South ask of Europe is: that she should give us arms in exchange for our crops of cotton, so that we may be able to defend the cause we support—the cause of labour, and to prevent our black labourers from relapsing into barbarism, and the white operatives of Europe from continuing unemployed."

20. Reff, *Letters of Edgar Degas*, letter 11, vol. 1 pp. 135–36, vol. 3 p. 15.

21. The painting has sometimes been known by another title, *Les Malheurs de la ville d'Orléans* (*The Misfortunes of the City of Orléans*); see Hélène Adhémar, "Edgar Degas et la *Scène de guerre au Moyen Âge*," *Gazette des Beaux-Arts*, ser. 6, 70 (November 1967), pp. 295–98.

22. See Henri Loyrette, cat. 45, in *Degas*, by Jean Sutherland Boggs, Douglas W. Druick, Henri Loyrette, Michael Pantazzi, and Gary Tinterow; exh. cat., Galeries Nationales du Grand Palais, Paris; National Gallery of Canada, Ottawa; The Metropolitan Museum of Art, New York (New York: The Metropolitan Museum of Art; Ottawa: National Gallery of Canada, 1988), p. 106.

23. See Isolde Pludermacher, "Olympia au Salon: De la guerre de Sécession au contexte parisien," in *Le modèle noir: De Géricault à Matisse*, exh. cat. (Paris: Musée d'Orsay; Flammarion, 2019), pp. 150–58; Henry M. Sayre, *Value in Art: Manet and the Slave Trade* (Chicago: University of Chicago Press, 2022).

24. On *The Execution of Maximilian*, see Nils Gösta Sandblad, "L'Execution de Maximilien," in *Manet: Three Studies in Artistic Conception* (Lund, Sweden: C.W.K. Gleerup, 1954), pp. 109–58; Juliet Wilson-Bareau, *Manet, The Execution of Maximilian: Painting, Politics, and Censorship*, exh. cat. (London: National Gallery Publications, 1992); Theodore Reff, *Manet's Incident in a Bullfight* (New York: Council of the Frick Collection Lecture Series, 2005); John Elderfield, ed., *Manet and The Execution of Maximilian*, exh. cat. (New York: Museum of Modern Art, 2006).

25. See Hélène Toussaint, "The Dossier on 'The Studio' by Courbet," in *Gustave Courbet: 1819–1877*, exh. cat., Galeries Nationales d'Exposition du Grand Palais, Paris; Royal Academy of Arts, London (London: Arts Council of Great Britain, 1978), pp. 265–66.

26. Albert Wolff, "Gazette du Mexique," *Le Figaro*, August 11, 1867, p. 1.

27. [Émile Zola], "Faits divers," *La Tribune*, January 31, 1869, [Émile Zola], "Coups d'épingle," *La Tribune*, February 4, 1869; quoted in Cachin and Moffett, *Manet 1832–1883*, Appendix 2, docs. 2, 3, pp. 531–32.

28. [Zola], "Coups d'épingle," *La Tribune*, February 4, 1869; quoted in ibid.

29. *Lettre de Victor Hugo à Juárez, président de la République mexicaine* (Brussels: Tous les Libraires, 1867), pp. 3, 12.

30. None of the versions were exhibited at the Manet's posthumous retrospective exhibition organized at the École des Beaux-Arts in 1884 or at the sale of the contents of the artist's studio the same year.

31. In Degas's notes about the works in his collection, he mentions that he had in his possession "one of the two *Executions of Maximilian*."

32. Samuel Rodary, ed., *Édouard Manet: Correspondance du siège de Paris et de la Commune, 1870–1871* (Paris: L'Échoppe, 2014).

33. Éric Darragon, *Manet* (Paris: Fayard, 1989), p. 188.

34. Proust, *Édouard Manet: Souvenirs*, p. 57.

35. Berthe Morisot wrote with bemusement of the way Manet "spent his time during the siege changing his uniform"; Denis Rouart, ed., *The Correspondence of Berthe Morisot, with Her Family and Friends: Manet, Puvis de Chavannes, Degas, Monet, Renoir and Mallarmé*, trans. Betty W. Hubbard (London: Camden Press, 1986), p. 61. This lends weight to the significance of his having altered the uniforms represented in some of his works, including *The Dead Toreador* and *The Execution of Maximilian*.

36. Rodary, *Édouard Manet: Correspondance du siège de Paris*, p. 34.

37. Cuvelier was a friend of Degas's (ibid., pp. 58, 71), and Bazille was an intimate friend of Manet's (ibid., pp. 110–11). For Henri Regnault's friendship with Degas, see Daniel Halévy, *Degas parle . . .* (Paris: La Palatine, 1960), p. 134.

38. Mme Morisot, letter to a daughter, October 18, 1870; Rouart, *Correspondance of Berthe Morisot, with Her Family and Friends*, p. 56.

39. Rodary, *Édouard Manet: Correspondance du siège de Paris*, p. 133.

40. Letter from Mme Morisot to her daughter Berthe, June 5, 1871; Rouart, *Correspondance of Berthe Morisot, with Her Family and Friends*, p. 73.

41. Halévy, *Degas parle . . .*, p. 9; Degas, letters to James Tissot, September 18, 1871, and November 19, 1872, Reff, *Letters of Edgar Degas*, letter 23 and note 11, vol. 1 pp. 152–54, vol. 3 p. 21; letter 29 and note 9, vol. 1 pp. 165, 166, vol. 3 p. 25.

42. I would like to thank Theodore Reff for bringing evidence of this sheet to my attention (lot 131a in *Catalogue des tableaux, pastels et dessins par Edgar Degas et provenant de son atelier*, sale cat., Galeries Georges Petit, Paris, July 2–4, 1919), as well as the caricatures in notebooks 24 (BnF no. 22), p. 110, and 34 (BnF no. 2), pp. 224, 227, 228 (Theodore Reff, ed., *The Notebooks of Edgar Degas: A Catalogue of the Thirty-Eight Notebooks in the Bibliothèque Nationale and Other Collections*, rev. ed. [New York: Hacker Art Books, 1985], pp. 120, 142).

43. Rodary, *Édouard Manet: Correspondance du siège de Paris*, p. 74; see also ibid., pp. 52, 74n3.

44. Darragon, *Manet*, p. 193.

45. Rodary, *Édouard Manet: Correspondance du siège de Paris*, p. 71.

46. Cachin and Moffett, *Manet 1832–1883*, p. 323.

47. Manet witnessed the military execution of three communards at Satory on November 28, 1871; Darragon, *Manet*, pp. 200–201.

48. "I did not think that France could be represented by such dotards, not excepting the little Thiers whom I hope will die one day on the tribune and dispense of his little old self for us"; ibid., p. 194; quoting Manet, letter to Félix Bracquemond, March 18, 1871, in Jean-Paul Bouillon, "Les lettres de Manet à Bracquemond," *Gazette des Beaux-Arts*, ser. 6, 101 (April 1983), p. 151.

49. Fèvre, *Mon oncle Degas*, p. 29.

50. Loyrette, *Degas*, p. 291.

51. On Degas's sojourn in Louisiana, see Marilyn R. Brown, "The DeGas–Musson Papers at Tulane University," *Art Bulletin* 72, no. 1 (March 1990), pp. 118–30; Marilyn R. Brown, *Degas and the Business of Art: A Cotton Office in New Orleans* (University Park, Pa.: Published for College Art Association by Pennsylvania State University Press, 1994); Christopher Benfey, *Degas in New Orleans: Encounters in the Creole World of Kate Chopin and George Washington Cable* (New York: Alfred A. Knopf, 1997); Gail Feigenbaum and Jean Sutherland Boggs, *Degas and New Orleans: A French Impressionist in America*, exh. cat. (New Orleans: New Orleans Museum of Art, in conjunction with Ordrupgaard, Copenhagen, 1999); Brown, "Degas's New Orleanian Spaces," in Toulouse and Ewell, *Sweet Spots*, pp. 87–107; Foa, "In Transit: Edgar Degas and the Matter of Cotton, between New World and Old"; Darcy Grimaldo Grigsby, "Creole Degas," in *Creole: Portraits of France's Foreign Relations during the Long Nineteenth Century* (University Park: Pennsylvania State University Press, 2022), pp. 261–93.

52. Reff, *Letters of Edgar Degas*, letter 31, vol. 1 p. 172, vol. 3 p. 27.

53. Ibid., letter 28, vol. 1 p. 159, vol. 3 p. 23; letter 30, vol. 1 p. 168, vol. 3 p. 26. Degas evokes in turn "pale and pristine looking children wrapped in black arms," "negresses in all their varying shades, holding in their arms such white little white children," "children dressed all in white and all white held in black arms"; ibid., letter 29, vol. 1 p. 165, vol. 3 p. 25; letter 30, vol. 1 p. 168, vol. 3 p. 26; letter 31, vol. 1 p. 172, vol. 3 p. 27.

54. On Degas's Creole lineage, see Reff, *Letters of Edgar Degas*, letter 218 note 1, vol. 1 p. 341; Brown, "The DeGas–Musson Papers at Tulane University," p. 129. The artist's mother was the first cousin of Norbert Rillieux, son of a New Orleans engineer and a free woman of color; see Benfey, *Degas in New Orleans*, p. 125. See also Grigsby, "Creole Degas."

55. Reff, *Letters of Edgar Degas*, letter 30, vol. 1 p. 168, vol. 3 p. 30.

56. Ibid., letter 31, vol. 1 p. 173, vol. 3 p. 28.

57. Ibid., letter 33, vol. 1 p. 178, vol. 3 p. 30 (translation modified).

58. Ibid., letter 30, vol. 1 p. 169, vol. 3 p. 26.

59. Ibid., letter 29, vol. 1 p. 165, vol. 3 p. 25; "So long live the fine linen laundress, in France!," letter 31, vol. 1 p. 172, vol. 3 p. 28. *Portraits in an Office (New Orleans)* and *Children on a Doorstep (New Orleans)*, exhibited under the title *Cour d'une maison (Nouvelle-Orléans)*, figured in the second Impressionist exhibition (1876), together with several paintings of laundresses, whose "black arms" offended the critics. In this context, it is worth noting that the French word for laundress, *blanchisseuse*, derives from the verb *blanchir*, meaning "to whiten." For the link between Degas's laundresses and New Orleans cotton, see Marine Kisiel, "'Et vive donc la blanchisserie de fin en France!,'" in *Les Villes ardentes: Art, travail, révolte (1870–1914)*, ed. Emmanuelle Delapierre and Bertrand Tillier; exh. cat. (Caen, France: Musée des Beaux-Arts de Caen; Ghent, Belgium: Éditions Snoeck, 2020), pp. 33–43; Grigsby, "Creole Degas," pp. 287–93.

60. Reff, *Letters of Edgar Degas*, letter 31, vol. 1 p. 172, vol. 3 p. 27.

61. Ibid., letter 29, vol. 1 p. 164, vol. 3 p. 24.

62. Ibid., letter 33, vol. 1 p. 177, vol. 3 p. 29 (Degas's French title is followed here by his own English translation: "Cotton Buyer's Office").

63. The office of Michel Musson's firm, in which his partners were James Prestridge and John Livaudais, was located at 63 Carondelet Street.

64. Reff, *Letters of Edgar Degas*, letter 33, vol. 1 p. 177, vol. 3 p. 29.

65. Ibid., letter 30, vol. 1 p. 168, vol. 3 p. 26.

66. Note that what he described as an "immense black animal force" at the beginning of his sojourn became, several months later, "moving silhouettes," with whom he was on sufficiently familiar terms that he could imagine finding it "odd to go back to Paris and live solely among the whites" (ibid., letter 33, vol. 1 p. 178, vol. 3 p. 30).

67. Degas's own financial situation would be precarious for several years, as he made it a point of honor to help settle the family debt.

68. See Brown, "The DeGas–Musson Papers at Tulane University," p. 125.

69. Émile Zola, "Lettres de Paris: Deux expositions d'art au mois de mai," *Le Messager de l'Europe*, June 1876; quoted in translation in Loyrette, cat. 115, in Boggs et al., *Degas*, pp. 186, 188n9.

70. See Theodore Reff, cat. 40, in *Manet and Modern Paris: One Hundred Paintings, Drawings, Prints, and Photographs by Manet and His Contemporaries*, exh. cat. (Washington, D.C.: National Gallery of Art, 1982), p. 124.

71. Trained as a lawyer, Gambetta was linked in his youth to members of the Manet family active in the same profession: Jules Dejouy and Gustave Manet, respectively a cousin and brother of the artist.

72. Degas also visited Clemenceau, for whom he realized in 1884 a decorative print for the program of an evening event organized by former students of the Lycée de Nantes. His feeble attempt to discuss politics with Clemenceau in the foyer of the Paris Opéra is recounted by Paul Valéry, "Degas, Dance, Drawing," in *Degas, Manet, Morisot*, pp. 53–54.

73. According to Valéry, Degas credited Rochefort as "a miracle of *common sense*" (ibid., p. 52), a judgment that probably dates later than Manet's portrait from the latter's violent anti-Semitic campaign against Dreyfus, which aligned with Degas's own views.

74. Claude Monet, letter to Théodore Duret, December 9, 1880, Archives du Louvre; quoted in Adolphe Tabarant, *Manet et ses œuvres* (Paris: Gallimard, 1947), p. 403.

75. See Darragon, *Manet*, pp. 355–57.

76. See Giuseppe De Nittis, *Notes et souvenirs du peintre Joseph de Nittis* (Paris: Librairies–Imprimeries Réunies, 1895), p. 188; Jacques-Émile Blanche, *Manet*, trans. F. C. de Sumichrast (New York: Dodd, Mead, 1925), p. 49.

77. "Chronique: Exposition d'œuvres nouvelles de M. Edouard Manet," *Le Temps*, April 10, 1880, p. 2. See the Chronology in this volume, entry for the year 1880.

78. Degas would also acquire from Vollard a drawing that Manet made in 1873, during Bazaine's trial before the Council of War. See the Chronology in this volume, entry for the year 1894 (fig. 48).

MANET, DEGAS, AND THE DEMIMONDE OF ALEXANDRE DUMAS FILS

Denise Murrell

Translations are by the author unless otherwise noted.

1. Dumas fils's mother, a white French dressmaker named Marie-Laure-Catherine Labay, was not his father's wife.

2. Claude Schopp, introduction to *Correspondance: George Sand, Alexandre Dumas père et fils*, ed. Thierry Bodin and Claude Schopp (Paris: Phébus, 2019), p. 10; quoting George Sand, *Histoire de ma vie* (Paris: Michel Lévy Frères, 1856), p. 18.

3. Schopp, introduction to Bodin and Schopp, *Correspondance: George Sand, Alexandre Dumas père et fils*, p. 10; quoting *Mémoires du comte Horace de Viel-Castel sur le règne de Napoléon III (1851–1864), publiés . . . d'après le manuscrit original* (Paris: Chez Tous les Libraires, 1883–85), vol. 1, p. 108.

4. Schopp, introduction to Bodin and Schopp, *Correspondance: George Sand, Alexandre Dumas père et fils*, pp. 10–11; quoting Alexandre Dumas fils, *Affaire Clémenceau: Mémoire de l'accusé*, 6th ed. (Paris: Michel Lévy Frères, 1866), p. 35.

5. Alexandre Dumas fils, letter to George Sand, June 5, 1866; see Bodin and Schopp, *Correspondance: George Sand, Alexandre Dumas père et fils*, letter 66-38, p. 457.

6. Several writers across the twentieth century have linked the title of Manet's painting to the Dumas play. See, for example, Thomas Bodkin, "Letters: Manet, Dumas, Goya and Titian," *Burlington Magazine* 50, no. 288 (March 1927), pp. 166–67; Theodore Reff, "The Meaning of Manet's Olympia," *Gazette des Beaux-Arts*, ser. 6, 63 (February 1964), pp. 120–21.

7. Alexandre Dumas fils, "Le Demi-Monde: Avant-propos," in Alexandre Dumas fils, *Théâtre complet avec préfaces inédites*, vol. 2 (Paris: Calmann Lévy, 1898), p. 11; reprinted from Alexandre Dumas fils, "La préface du Demi-Monde," *Théâtre-Journal*, nos. 7–12 (August 16–September 20, 1868).

8. Étienne Moreau-Nélaton, *Manet: Raconté par lui-même* (Paris: Henri Laurens, 1926), vol. 1, p. 65.

9. Théodore de Banville, *Mes souvenirs: Petites études* (Paris: G. Charpentier, 1882), pp. 74–75.

10. Roberto Calasso characterizes the emotional aspect of Duval and Baudelaire's relationship and details their visits to cafés and galleries; Roberto Calasso, *La Folie Baudelaire*, trans. Alastair McEwan (New York: Farrar, Straus and Giroux, 2012), pp. 34, 40–41.

11. Ibid., p. 41.

12. Dumas fils, "Le Demi-Monde: Avant-propos," in Dumas fils, *Théâtre complet avec préfaces inédites*, vol. 2, p. 11.

13. Antonin Proust, "Edouard Manet (Souvenirs)," *La Revue Blanche* 12 (February 1, 1897), p. 130. See also Paul Jamot and Georges Wildenstein, *Manet* (Paris: Les Beaux-Arts, Édition d'Études et de Documents, 1932), vol. 1, p. 74, citing Edmond Bazire, *Manet* (Paris: A. Quantin, 1884), p. 10, who mentions the trip to Florence without giving a date. According to Jamot and Wildenstein, the trip to Florence was in 1853 and Manet was accompanied by Émile Ollivier. Ollivier's journal (*Journal d'Émile Ollivier*, Archives Nationales, Paris [542 AP/2]) dates the trip to October 7, 1853. Thus the Normandy trip seems to have taken place in 1852, following the premiere of *La dame aux camélias* that February, rather than in 1853. It is noteworthy that the reference to Dumas's presence on this trip disappears in the subsequent publication of Proust's memories in 1913: see Antonin Proust, *Edouard Manet: Souvenirs*, ed. Auguste Barthélemy (Paris: Henri Laurens, 1913), p. 27; but reappears in the 1988 publication: see Antonin Proust, *Edouard Manet: Souvenirs* (Caen, France: L'Echoppe, 1988), pp. 17–18. Profuse thanks to Paris-based researcher Marie-Isabelle Pinet for sorting out these discrepancies in past publications' dating of this seaside stroll.

14. Paul Jamot, "Manet," in Jamot and Wildenstein, *Manet*, vol. 1, p. 29. See also François Mathey, *Olympia, Manet* (Paris: Vendôme, 1948), n.p.; Nils Gösta Sandblad, *Manet: Three Studies in Artistic Conception* (Lund, Sweden: C. W. K. Gleerup, 1954), p. 97; Reff, "The Meaning of Manet's Olympia," p. 120. For a reference to the poem, see T. J. Clark, *The Painting of Modern Life: Paris in the Art of Manet and His Followers* (Princeton, N.J.: Princeton University Press, 1984), pp. 83, 283n9.

15. As described in *Le Figaro*, January 19, 1874, p. 1. See also Jamot, "Manet," in Jamot and Wildenstein, *Manet*, vol. 1, p. 29.

16. Tom Reiss, *The Black Count: Glory, Revolution, Betrayal, and the Real Count of Monte Cristo* (New York: Broadway Books, 2012), pp. 14–15.

17. See Griselda Pollock, *Differencing the Canon: Feminist Desire and the Writing of Art's Histories* (London: Routledge, 1999), p. 263; Maud Sulter, "Maud Sulter on Jeanne Duval," in Maud Sulter, *Jeanne Duval: A Melodrama*, exh. cat. (Edinburgh: National Galleries of Scotland, 2003), pp. 21–22.

18. See Deborah Cherry, "Poetry—In Motion," in *Maud Sulter: Passion*, ed. Deborah Sherry, exh. cat., Street Level Photoworks, Glasgow (London: Altitude Editions, 2015), p. 18. For an extended analysis of exoticism in Baudelaire's portrayal of Duval, see Deborah Cherry, "Image-Making with Jeanne Duval in Mind: Photoworks by Maud Sulter, 1989–2002," in *Women, the Arts and Globalization: Eccentric Experience*, ed. Marsha Meskimmon and Dorothy C. Price (Manchester, U.K.: Manchester University Press, 2013), pp. 148–49.

19. Therese Dolan notes Baudelaire's comment that that the crinoline was "the principal sign of civilization for women of his time" in "Skirting the Issue: Manet's Portrait of Baudelaire's *Mistress, Reclining*," *Art Bulletin* 79, no. 4 (December 1997), p. 619; citing Charles Baudelaire, *Œuvres complètes*, ed. Claude Pichois (Paris: Gallimard, 1975–76), vol. 2, p. 705.

20. Nadar, *Charles Baudelaire intime: Le poète vierge* (Paris: A. Blaizot, 1911), p. 16.

21. Charles Baudelaire, *Correspondance*, ed. Charles Pichois (Paris: Gallimard, 1973), vol. 1, pp. 234, 833n1.

22. Manet, *La négresse (Portrait of Laure)*, 1862–63, oil on canvas, 24 × 19 11/16 in. (61 × 50 cm), Pinacoteca Giovanni e Marella Agnelli, Turin; Manet, *Victorine Meurent*, ca. 1862, oil on canvas, 16 7/8 × 17 1/4 in. (42.9 × 43.8 cm), Museum of Fine Arts, Boston (46.846).

23. Period accounts of Duval's own thoughts and emotions come mainly from Baudelaire's biographers, although in recent years artists and writers have sought to reimagine her subjective position. See Lorraine O'Grady's diptych *Lena-Jeanne*, in which she pairs a photograph of her mother in her early thirties with Baudelaire's drawing of Duval at a similar age, and her related installation *Studies for Flowers of Evil and Good* (1998–ongoing; https://www.alexandergray.com/series-projects/lorraine-o-grady9). See also Sulter, "Maud Sulter on Jeanne Duval," in Sulter, *Jeanne Duval: A Melodrama*, pp. 21–22; Cherene Sherrard's persona poems, which assume Duval's voice, in *Mistress, Reclining* (Georgetown, Ky.: Finishing Line Press, 2010), pp. 1–12.

24. Letter to Manet from "Nozeril, Administrateur," dated March 20, 1867, with Théâtre de la Gaîté as return address, Morgan Library & Museum, New York (MA 3950, Misc Tabarant, record no. 224305): "Missi Menken accepts your proposal to make a portrait to be shown at an exhibition and that after the show, the portrait will become her property. . . . Please come tonight or tomorrow night to discuss with her a time for a sitting." Thanks to Isolde Pludermacher and Samuel Rodary for alerting me and my colleague Marie-Isabelle Pinet to this letter.

25. Degas attended dinners at the home of Ludovic Halévy along with Dumas fils; see Theodore Reff, ed., *The Letters of Edgar Degas* (New York: Wildenstein Plattner Institute, 2020), letter 207, vol. 1 p. 333. Dumas fils and Degas attended the funeral of the Italian painter Giuseppe De Nittis on August 24, 1884; see ibid., letter 224 note 5, vol. 1 p. 348. Degas attended theater events with Halévy and Dumas fils, for instance, in 1886; see ibid., letter 286, vol. 1, p. 403.

26. See Charles Sterling, "Chassériau et Degas," *Beaux-Arts* 72, no. 21 (May 26, 1933), p. 2. Recent publications that describe Degas's matrilineal family as pre–Civil War enslavers and their support for the Confederacy and Reconstruction-era white supremacist groups include Marilyn R. Brown, "Degas's New Orleanian Spaces," in *Sweet Spots: In-Between Spaces in New Orleans*, ed. Teresa A. Toulouse and Barbara C. Ewell (Jackson: University Press of Mississippi, 2018), pp. 95–96; Michelle Foa, "In Transit: Edgar Degas and the Matter of Cotton, between New World and Old," *Art Bulletin* 102, no. 3 (September 2020), pp. 56, 61.

27. Philip Nord, *Impressionists and Politics: Art and Democracy in the Nineteenth Century* (London: Routledge, 2000), pp. 31–34.

28. Manet, letter to Mme Auguste Manet, February 5, 1849; Édouard Manet, *Lettres de jeunesse: 1848–1849 voyage à Rio* (Paris: Louis Rouart et fils, 1928), p. 52.

29. Foa, "In Transit: Edgar Degas and the Matter of Cotton, between New World and Old," pp. 57, 61; Brown, "Degas's New Orleanian Spaces," in Toulouse and Ewell, *Sweet Spots*, pp. 95–96. See also Gail Feigenbaum and Jean Sutherland Boggs, *Degas and New Orleans: A French Impressionist in America*, exh. cat. (New Orleans: New Orleans Museum of Art, in conjunction with Ordrupgaard, Copenhagen, 1999), esp. Christopher Benfey, "Degas and New Orleans: Exorcising the Exotic," pp. 28–30.

30. Edgar Degas, letter from New Orleans to Henri Rouart, December 5, 1872; Reff, *Letters of Edgar Degas*, letter 31, vol. 1 p. 172, vol. 3 p. 27.

31. For a comprehensive discussion of New Orleans's free Black population, see Emily Clark, *The Strange History of the American Quadroon: Free Women of Color in the Revolutionary Atlantic World* (Chapel Hill: University of North Carolina Press, 2013). Tyler Stovall describes the practice of elite Black New Orleans families sending their children to Paris for education in *Paris Noir: African Americans in the City of Light* (New York: Houghton Mifflin, 1996), p. xiv.

32. Brown, "Degas's New Orleanian Spaces," in Toulouse and Ewell, *Sweet Spots*, p. 91.

33. Edgar Degas, letter from New Orleans to Lorenz Frolich, November 27, 1872; Reff, *Letters of Edgar Degas*, letter 30, vol. 1 p. 168, vol. 3 p. 26.

34. Colin Bailey, introduction to Édouard Manet, *Carnet de notes (1860–1862): Nombreuses adresses, notamment de modèles; et quelques croquis*, Morgan Library & Museum, MA 3950, notebook 1, fol. 107; https://www.themorgan.org/collection/edouard-manet/notebook/introduction.

35. Edgar Degas, letter from New Orleans to James Tissot, dated February 18, 1873; Reff, *Letters of Edgar Degas*, letter 33, vol. 1 p. 178, vol. 3 p. 30.

36. For a discussion of the tiered levels of the women who exist within the demi-monde, see Beth Archer Brombert, *Edouard Manet: Rebel in a Frock Coat* (Chicago: University of Chicago Press, 1997), p. 114. Brombert also discusses the impact and influence of Dumas fils's plays in defining this world; ibid., pp. 142, 146.

37. For in-depth studies of Degas's portrayals of Miss La La (Olga Albertine Brown), see Marilyn R. Brown, "'Miss La La's' Teeth: Reflections on Degas and 'Race,'" *Art Bulletin* 89, no. 4 (December 2007), pp. 738–65; Linda Wolk-Simon, *Degas, Miss La La, and the Cirque Fernando*, exh. cat. (New York: Morgan Library & Museum, 2013). For an extended catalogue entry about the final *Miss La La* painting that also discusses the studies, see David Bomford et al., *Degas: Art in the Making*, exh. cat. (London: National Gallery Company, 2004), cat. 4, pp. 82–91.

38. Brown, "'Miss La La's' Teeth: Reflections on Degas and 'Race,'" pp. 744–47, 751.

PRESENCE OF ABSENCE: DEGAS, MANET, VALÉRY
Stéphane Guégan

In memory of Roberto Calasso.

1. Paul Valéry, "Degas, Dance, Drawing," in *Degas, Manet, Morisot*, trans. David Paul, Bollingen series 45, no. 12 (New York: Pantheon Books, 1960), p. 26.

2. The 1936 edition was published by Ambroise Vollard and included twenty-six etchings.

3. See Michel Jarrety, "Degas Danse Dessin," in *Degas, danse, dessin: Hommage à Degas avec Paul Valéry*, ed. Leïla Jarbouai and Marine Kisiel, exh. cat. (Paris: Gallimard; Musée d'Orsay, 2017), p. 27.

4. Paul Valéry, "Triomphe de Manet" (1932) in *Paul Valéry: Œuvres*, ed. Jean Hytier (Paris: Gallimard, 1957–60), vol. 2, p. 1333.

5. On the strange relationship between Degas and Rouart, see, most recently, Stéphane Guégan, "Edgar D. vu par Ernest R.," in Jarbouai and Kisiel, *Degas, danse, dessin*, p. 95.

6. Paul Valéry, "Triomphe de Manet," preface to *Exposition Manet 1832–1883*, ed. Charles Sterling, exh. cat., Musée de l'Orangerie, Paris (Paris: Édition des Musées Nationaux, 1932), pp. v–xvi.

7. Jacques-Émile Blanche, *Manet*, trans. F. C. de Sumichrast (New York: Dodd, Mead, 1925), p. 7.

8. Ibid., p. 8.

9. Ibid., p. 16.

10. See Claire Maingon, "Un impressionniste de la ligne: La réception de l'œuvre de Degas en 1918," in *Face à l'impressionnisme: Réception d'un mouvement, 1900–1950*, ed. Félicie Faizand de Maupeou and Claire Maingon (Mont-Saint-Aignan: Presses Universitaires de Rouen et du Havre, 2019), pp. 29–42.

11. "Degas n'est pas un impressionniste de la lumière, mais il existe aussi un impressionniste de la ligne"; Louis Hourticq, *Les tableaux du Louvre: Histoire-guide de la peinture* (Paris: Hachette, 1921), p. 153; quoted in ibid., p. 42.

12. Jacques-Émile Blanche, *Manet* (Paris: F. Rieder & Cie., 1924), p. 26.

13. On Manet's *Ingrisme*, see Antonin Proust, "L'art d'Édouard Manet," *Le Studio* 21, no. 94 (January 15, 1901), suppl., no. 28, pp. 71–77.

14. Blanche, *Manet*, trans. F. C. de Sumichrast (1925), p. 60.

15. Valéry, "Triomphe de Manet," in Hytier, *Paul Valéry: Œuvres*, vol. 2, p. 1327.

16. Ibid., vol. 2, p. 1328.

17. Ibid., vol. 2, pp. 1328–29.

18. Ibid., vol. 2, p. 1329. Valéry's brilliant commentary here is an extension of a passage in Jacques-Émile Blanche's *Manet* (trans. F. C. de Sumichrast [1925], pp. 36–37): "Baudelaire was attracted by the savour of the 'Olympia', that marvel of still, incomplete gracefulness, and stirred by the touch of perversity of that witching maid painted in silver, milk and soft rose, who lays her hand on that part of herself which a winner of the Rome Prize would have veiled."

19. Valéry, "Triomphe de Manet," in Hytier, *Paul Valéry: Œuvres*, vol. 2, p. 1333.

20. Valéry, "Degas, Dance, Drawing," in *Degas, Manet, Morisot*, p. 6.

21. Regarding the notes of Ernest Rouart and Valéry's selection from them, see Guégan, "Edgar D. vu par Ernest R.," in Jarbouai and Kisiel, *Degas, danse, dessin*, pp. 94–103. On Valéry and the Rouart circle, see Jean-Marie Rouart, "Le Prométhée familial," in *Une famille dans l'impressionnisme* (Paris: Gallimard, 2001), pp. 78–95.

22. Valéry, "Degas, Dance, Drawing," in *Degas, Manet, Morisot*, p. 54.

23. For Valéry, an important index of human governance is the degree to which it impedes the visibility of sexualized representations within public space, as their impurity should not be displayed in plain sight. And Degas holds to such governance by adopting an in-between aesthetic morality, one closer to Rembrandt than to Titian.

DEGAS, AFTER MANET
Stephan Wolohojian

Translations are by the author unless otherwise noted.

1. Daniel Halévy, *Degas parle . . .* (Paris: La Palatine, 1960), p. 77.

2. For the subscription, led by Claude Monet and John Singer Sargent, see Gustave Geffroy, *Claude Monet, sa vie, son oeuvre* (Paris: G. Crès et Cie., 1924), vol. 1, pp. 242–58. Degas's contribution, made in 1889, was well below what other subscribers contributed. This may have had more to do with his ambivalence about public institutions than his commitment to Manet. In a letter to Camille Pissarro, the American artist Mary Cassatt explained her own refusal to support the campaign, writing, "an American had wished to buy the picture & it was to prevent its leaving France that the subscription was opened"; Nancy Mowll Mathews, ed., *Mary Cassatt and Her Circle: Selected Letters* (New York: Abbeville Press, 1984), p. 213.

3. Most works by Manet in Degas's collection are catalogued in *The Private Collection of Edgar Degas: A Summary Catalogue*, comp. Colta Ives, Susan Alyson Stein, and Julie A. Steiner (New York: The Metropolitan Museum of Art, 1997), pp. 87–100, nos. 794–878. A helpful supplement is found in the Appendix at the end of Henri Loyrette, "Degas's Collection," *Burlington Magazine* 140, no. 1145 (August 1998), p. 558.

4. See the many essays in Ann Dumas, Colta Ives, Susan Alyson Stein, and Gary Tinterow, *The Private Collection of Edgar Degas*, exh. cat. (New York: The Metropolitan Museum of Art, 1997).

5. Roger Fry, "A Monthly Chronicle: The Sale of Degas's Collection," *Burlington Magazine* 32, no. 180 (March 1918), p. 118.

6. Gustave Geffroy, "Salon de 1886: VIII, Hors du Salon—les impressionnistes," *La Justice* 7, no. 2324 (May 26, 1886), p. 2.

7. Roberta Crisci-Richardson, *Mapping Degas: Real Spaces, Symbolic Spaces and Invented Spaces in the Life and Work of Edgar Degas (1834–1917)* (Newcastle upon Tyne, U.K.: Cambridge Scholars Publishing, 2015), p. 292.

8. For a list of works by Manet in Degas's collection, see note 3.

9. Reproductions authorized by the artist were in circulation as early as 1889, with William Thornley's lithographs. Although Degas does not seem to have worked with the authors, several books followed the first short study by Max Liebermann, *Degas* (Berlin: Bruno u. Paul Cassirer, 1899).

10. Halévy, *Degas parle . . .*, pp. 110–11.

11. In the 1870s Stéphane Mallarmé had already examined Manet's connection to the group in "The Impressionists and Édouard Manet," *Art Monthly Review and Photographic Portfolio* 1, no. 9 (September 30, 1876), p. 117–22, an essay that appeared in print only in an English translation.

12. Halévy, *Degas parle . . .*, pp. 110–11.

13. Gustave Geffroy's essay on Degas in *La vie artistique* (3rd ser., *Histoire de l'impressionnisme* [Paris: E. Dentu, 1894], pp. 147–80) is still the most insightful into the contradictions of his person and career. On the late monotypes, see Richard Kendall, "An Anarchist in Art: Degas and the Monotype," in *Degas: A Strange New Beauty*, ed. Jodi Hauptman, exh. cat. (New York: Museum of Modern Art, 2016), p. 35.

14. Paul Lafond, *Degas* (Paris: H. Floury, 1918–19), vol. 1, pp. 114–21.

15. Gary Tinterow, "Degas's Degases," in Dumas et al., *The Private Collection of Edgar Degas*, p. 76.

16. For Manet's engagement with the subject, see John Elderfield, *Manet and the Execution of Maximilian*, exh. cat. (New York: Museum of Modern Art, 2006).

17. Elderfield (ibid., p. 107) aligns the *Young Spartans* with this project.

18. John Leighton and Juliet Wilson-Bareau, "The Maximilian Paintings: Provenance and Exhibition History," in *Manet, The Execution of Maximilian: Painting, Politics, and Censorship*, by Juliet Wilson-Bareau, exh. cat. (London: National Gallery Publications, 1992), pp. 112–13; quoting *Growing Up with the Impressionists: The Diary of Julie Manet*, trans. and ed. Rosalind de Boland Roberts and Jane Roberts (London: Sotheby's Publications, 1987), p. 54.

19. Ann Dumas, "Degas and His Collection," in Dumas et al., *The Private Collection of Edgar Degas*, pp. 20, 24, 69n112.

20. Years later, Degas apparently referred to the still life as one of plums, but the painting is likely Édouard Manet, *Nuts in a Salad Bowl* (1866, E. G. Bührle Collection, Zurich); Denis Rouart and Daniel Wildenstein, *Édouard Manet: Catalogue raisonné* (Lausanne: Bibliothèque des Arts, 1975), vol. 1, no. 119, pp. 114–15.

21. For the painting, see Henri Loyrette, cat. 82, in *Degas*, by Jean Sutherland Boggs, Douglas W. Druick, Henri Loyrette, Michael Pantazzi, and Gary Tinterow; exh. cat., Galeries Nationales du Grand Palais, Paris; National Gallery of Canada, Ottawa; The Metropolitan Museum of Art, New York (New York: The Metropolitan Museum of Art; Ottawa: National Gallery of Canada, 1988), pp. 140–42.

22. Ambroise Vollard, *Degas (1834–1917)* (Paris: G. Crès et Cie., 1924), pp. 85–86.

23. Ibid., p. 85.

24. A strip with a studio stamp from the 1918 sale of Degas's collection was later added to the painting (see "Chronology" in this volume).

25. Dumas, "Degas and His Collection," in Dumas et al., *The Private Collection of Edgar Degas*, p. 11.

26. Ibid., p. 68n58.

27. In a letter of thanks to Eugène, written shortly after Manet's studio sale (February 4–5, 1884), Degas wrote: "Your gift even contains several intentions which allow me to fully understand your thoughtfulness"; Theodore Reff, ed., *The Letters of Edgar Degas* (New York: Wildenstein Plattner Institute, 2020), letter 215, vol. 1 p. 339, vol. 3 p. 79.

28. Manet, letter to Degas, from Boulogne, July 29, 1868; Juliet Wilson-Bareau, ed., *Manet by Himself: Correspondence and Conversation; Paintings, Pastels, Prints and Drawings* (Boston: Little, Brown; Bulfinch Press, 1991), p. 47.

29. Mari Kálmán Meller and Juliet Wilson-Bareau, "Manet and Degas: A Never-Ending Dialogue," in Dumas et al., *The Private Collection of Edgar Degas*, p. 177.

30. Louis Dimier, "Les arts pendant la guerre: La collection Degas," *L'Action Française*, April 2, 1918, p. 4; cited in Rebecca A. Rabinow, comp., "The Degas Collection Sales and the Press: Selected Reviews and Articles," in Dumas et al., *The Private Collection of Edgar Degas*, p. 320.

31. Loyrette, "Degas's Collection," p. 558.

32. Marcel Guérin, ed., *Lettres de Degas*, rev. ed. (Paris: B. Grasset, 1945), p. 253. Poujaud claims that Delacroix's *Count de Mornay's Apartment* (ca. 1833, Musée du Louvre, Paris), was the third.

33. Louis-Antoine Prat, *Le dessin français au XIXᵉ siècle* (Paris: Musée du Louvre; Musée d'Orsay; Somogy, 2011), p. 512.

34. See Marni R. Kessler, "Unmasking Manet's Morisot," *Art Bulletin* 81, no. 3 (September 1999), pp. 473–89, for an analysis of this group of paintings.

35. Morisot was imagining a Manet from her collection for such a project. Denis Rouart, ed., *The Correspondence of Berthe Morisot, with Her Family and Friends: Manet, Puvis de Chavannes, Degas, Monet, Renoir and Mallarmé*, trans. Betty W. Hubbard (London: Camden Press, 1986), p. 212.

CHRONOLOGY

Samuel Rodary with Haley S. Pierce

The authors wish to acknowledge their debt to *Manet 1832–1883*, ed. Françoise Cachin and Charles S. Moffett, exh. cat., Galeries Nationales du Grand Palais, Paris; The Metropolitan Museum of Art, New York (New York: The Metropolitan Museum of Art; Harry N. Abrams, 1983); and *Degas*, by Jean Sutherland Boggs, Douglas W. Druick, Henri Loyrette, Michael Pantazzi, and Gary Tinterow; exh. cat., Galeries Nationales du Grand Palais, Paris; National Gallery of Canada, Ottawa; The Metropolitan Museum of Art, New York (New York: The Metropolitan Museum of Art; Ottawa: National Gallery of Canada, 1988).

1. Étienne Moreau-Nélaton, *Manet: Raconté par lui-même* (Paris: Henri Laurens, 1926), vol. 1, p. 7.

2. Antonin Proust, *Édouard Manet: Souvenirs*, ed. Auguste Barthélemy (Paris: Henri Laurens, 1913), p. 8.

3. Édouard Manet, *Lettres de jeunesse: 1848–1849 voyage à Rio* (Paris: Louis Rouart et fils, 1928).

4. Édouard Manet (hereafter, EM) to his mother, February 5, 1849; Juliet Wilson-Bareau, ed., *Manet by Himself: Correspondence and Conversation; Paintings, Pastels, Prints and Drawings* (Boston: Little, Brown; Bulfinch Press, 1991), p. 23.

5. Ibid.

6. EM to Jules Dejouy, February 26, 1849; ibid., p. 24.

7. Ibid., pp. 25–26.

8. For more on the current state of the debate on Léon's paternity, see Nancy Locke, "Letters: Suzanne Manet," *Burlington Magazine* 165, no. 1434 (February 2023), p. 108.

9. J. Verbeek, "Bezoekers van het Rijksmuseum in het Trippenhuis 1844–1885," *Bulletin van het Rijksmuseum* 6, no. 3/4, Het Rijksmuseum, 1808–1958 (1958), p. 64.

10. Edmond Bazire, *Manet* (Paris: A. Quantin, 1884), p. 10.

11. *Journal d'Émile Ollivier*, Archives Nationales, Paris (542 AP/2).

12. Ibid.

13. Juliet Wilson-Bareau, "Édouard Manet dans ses ateliers," *Ironie* 161 (January/February 2012), http://interrogationcritiqueludique.blogspot.com/2012/10/ironie-n161-janvierfevrier-2012.html.

14. Henri Loyrette, *Degas* (Paris: Fayard, 1991), p. 107.

15. Alluded to in a letter from EM to Berthe Morisot [February–March 1882]; Wilson-Bareau, *Manet by Himself*, p. 264.

16. Édouard Manet to the president of the Academy of Fine Arts in Florence, November 19, 1857; Wilson-Bareau, *Manet by Himself*, p. 27.

17. Wilson-Bareau, "Édouard Manet dans ses ateliers."

18. Edgar Degas (hereafter ED) to the director of the academy, August 19, 1858; Theodore Reff, ed., *The Letters of Edgar Degas* (New York: Wildenstein Plattner Institute, 2020), letter 4 and note 1, vol. 1 p. 114–15, vol. 3 p. 9.

19. Proust, *Édouard Manet: Souvenirs*, p. 33.

20. Loyrette, *Degas*, pp. 149–50.

21. Theodore Reff, ed., *The Notebooks of Edgar Degas: A Catalogue of the Thirty-Eight Notebooks in the Bibliothèque Nationale and Other Collections*, rev. ed. (New York: Hacker Art Books, 1985), pp. 90, notebook 16 ([BnF, Carnet 27], p. 20A); 94, notebook 18 ([BnF, Carnet 1], p. 53).

22. Wilson-Bareau, "Édouard Manet dans ses ateliers."

23. Unpublished letter from René De Gas (hereafter RDG), in Paris, to his uncle Michel Musson, in New Orleans (Tulane University Library, New Orleans).

24. Fernand Desnoyers, *La Peinture en 1863: Salon des refusés* (Paris: Azur Dutil, 1863), pp. 40–41; Paul Alexis, "Marbres et plâtres: Manet," *Le Voltaire*, July 25, 1879, pp. 2–3.

25. Theodore Reff, "Copyists in the Louvre, 1850–1870," *Art Bulletin* 46, no. 4 (December 1964), p. 555.

26. Letter of March 6, 1863, from RDG, quoted in Paul-André Lemoisne, *Degas et son œuvre* (Paris: Paul Brame et C. M. de Hauke, aux Arts et Métiers Graphiques, 1946–49), vol. 1, p. 41.

27. Adolphe Tabarant, *La vie artistique au temps de Baudelaire* (1942; repr., Paris: Mercure de France, 1963), p. 320.

28. Adolphe Tabarant, *Manet et ses œuvres* (Paris: Gallimard, 1947), p. 80.

29. Étienne Moreau-Nélaton, "Deux heures avec Degas," *L'Amour de l'Art*, July 1931, p. 270.

30. RDG to the Musson family in New Orleans (Tulane University Library, New Orleans).

31. Adolphe Tabarant, *Manet: Histoire catalographique* (Paris: Éditions Montaigne, 1931), p. 128; Wilson-Bareau, "Édouard Manet dans ses ateliers."

32. EM to Fantin-Latour, [September 3, 1865]; Wilson-Bareau, *Manet by Himself*, p. 34.

33. "Correspondance," *Le Figaro*, April 25, 1867, p. 3.

34. Archives du Louvre, Paris (LL 11).

35. EM to ED, July 29, 1868; Wilson-Bareau, *Manet by Himself*, p. 47.

36. EM to Fantin-Latour, [August 10] 1868; ibid.

37. EM to Fantin-Latour, August 26, 1868; ibid., p. 49.

38. Juliet Wilson-Bareau, ed., "Appendix 2: Documents Relating to the 'Maximilian Affair,'" in Cachin and Moffett, *Manet 1832–1883*, pp. 531–34.

39. Ambroise Vollard, *Degas (1834–1917)* (Paris: G. Crès et Cie., 1924), p. 85.

40. Ibid., p. 86.

41. Denis Rouart, ed., *The Correspondence of Berthe Morisot, with Her Family and Friends: Manet, Puvis de Chavannes, Degas, Monet, Renoir and Mallarmé*, trans. Betty W. Hubbard (London: Camden Press, 1986), p. 84 (erroneously dated 1871).

42. Manet's letters to Degas (private collection) from May 27 and July 20, 1869, are transcribed in full in Loyrette, *Degas*, p. 721nn62, 64.

43. Lemoisne, *Degas et son œuvre*, vol. 1, p. 61.

44. EM to La Rochenoire, [March 20, 1870], Wilson-Bareau, *Manet by Himself*, p. 53; EM to Émile Zola, [March 12, 1870], Colette Becker, ed., "Appendix 1: Letters from Manet to Zola," in Cachin and Moffett, *Manet 1832–1883*, pp. 522–23.

45. Samuel Rodary, preface to *Édouard Manet: Correspondance du siège de Paris et de la Commune, 1870–1871*, ed. Samuel Rodary (Paris: L'Échoppe, 2014), pp. 8–9; Reff, *Letters of Edgar Degas*, letter 22 note 2, vol. 1 p. 151.

46. EM to Suzanne Manet, September 15, 1870; Rodary, *Édouard Manet: Correspondance du siège de Paris*, pp. 33–34.

47. Rouart, *Correspondence of Berthe Morisot, with Her Family and Friends*, p. 56.

48. Ibid. (Mme Morisot to an unidentified recipient, likely Edma or Yves Élisabeth Morisot, October 18, 1870).

49. Rodary, *Édouard Manet: Correspondance du siège de Paris*, p. 70.

50. Rouart, *Correspondence of Berthe Morisot, with Her Family and Friends*, p. 73.

51. Mme Morisot to Berthe Morisot, July 14, 1871; ibid., p. 81.

52. Reff, *Letters of Edgar Degas*, letter 23, vol. 1 p. 152, vol. 3 p. 21.

53. Verbeek, "Bezoekers van het Rijksmuseum in het Trippenhuis 1844–1885," p. 64.

54. Reff, *Notebooks of Edgar Degas*, p. 122, notebook 25 ([BnF, Carnet 24], p. 166).

55. Reff, *Letters of Edgar Degas*, letter 29, vol. 1 p. 166, vol. 3 p. 25.

56. Ibid., letter 31, vol. 1 p. 172, vol. 3 p. 27.

57. Ibid., letter 33, vol. 1 p. 177, vol. 3 p. 29.

58. Lemoisne, *Degas et son œuvre*, vol. 1, p. 81.

59. Reff, *Letters of Edgar Degas*, letter 41, vol. 1 p. 189, vol. 3 p. 33.

60. Stéphane Mallarmé, "Le jury de peinture pour 1874 et M. Manet," *La Renaissance littéraire et artistique*, April 12, 1874; Musée Départemental Stéphane-Mallarmé, Vulaines-sur-Seine, France (989-1-1).

61. Reff, *Letters of Edgar Degas*, letter 40, vol. 1 p. 187, vol. 3 p. 32.

62. Daniel Wildenstein, *Claude Monet: Biographie et catalogue raisonné* (Lausanne: Bibliothèque des Arts, 1974–91), vol. 1, pp. 72–73.

63. Proust, *Édouard Manet: Souvenirs*, p. 96.

64. George Moore, *Hail and Farewell!*, vol. 3, *Vale* (London: William Heinemann, 1914), p. 134.

65. Daniel Halévy, *Degas parle . . .* (Paris: La Palatine, 1960), p. 47.

66. Georges Rivière, *Renoir et ses amis* (Paris: H. Floury, 1921), p. 26.

67. Michael Pantazzi, "The First Monotypes," in Boggs et al., *Degas*, pp. 258, 258–59n8; citing Marcellin Desboutin, Dijon, July 17, 1876, letter to Leontine De Nittis, in Mary Pittaluga and Enrico Piceni, *De Nittis* (Milan: Bramante, 1963), p. 359, as translated in Douglas Druick and Peter Zegers, "Degas and the Printed Image, 1856–1914," in Sue Welsh Reed and Barbara Stern Shapiro, *Edgar Degas: The Painter as Printmaker*, exh. cat., Museum of Fine Arts, Boston; Philadelphia Museum of Art; Arts Council of Great Britain, Hayward Gallery, London (Boston: Museum of Fine Arts, 1984), p. xxix.

68. Stéphane Mallarmé, "The Impressionists and Édouard Manet," *Art Monthly Review and Photographic Portfolio* 1, no. 9 (September 30), 1876, pp. 117–22.

69. EM to Albert Wolff, March 19, 1877; Wilson-Bareau, *Manet by Himself*, 1991, p. 181.

70. Bazire, *Manet*, p. 74.

71. Tabarant, *Manet et ses œuvres*, p. 305.

72. Ibid., p. 319.

73. Ibid.

74. Ibid., p. 326.

75. Reff, *Letters of Edgar Degas*, letter 108, vol. 1 pp. 252–53, vol. 3 pp. 52–53.

76. Loyrette, *Degas*, p. 336.

77. Colta Ives, Susan Alyson Stein, and Julie A. Steiner, comps., *The Private Collection of Edgar Degas: A Summary Catalogue* (New York: The Metropolitan Museum of Art, 1997), p. 114, no. 996.

78. "Échos de Paris: Aujourd'hui," *L'Événement*, April 10, 1880, p. 1.

79. "Chronique: Exposition d'oeuvres nouvelles de M. Édouard Manet," *Le Temps*, April 10, 1880, p. 2.

80. Guillemet to EM, January 7, 1881, Morgan Library & Museum, New York (MA 3950, Notebook 1, p. 47); ED to Guillemet, January 6, 1881, Reff, *Letters of Edgar Degas*, letter 146, vol. 1 p. 284, vol. 3 p. 62.

81. Lemoisne, *Degas et son œuvre*, vol. 2, pp. 288–89, no. 518.

82. Ives, Stein, and Steiner, *Private Collection of Edgar Degas: A Summary Catalogue*, pp. 92, 99, nos. 826, 827, 875.

83. Gary Tinterow, "Chronology III: 1881–1890," in Boggs et al., *Degas*, p. 375.

84. Reff, *Letters of Edgar Degas*, letter 170, vol. 1 p. 301, vol. 3 p. 68 (translation modified).

85. Ibid., letter 202 note 4, vol. 1 p. 328.

86. Ibid., letter 195, vol. 1 p. 323, vol. 3 p. 74.

87. Jacques-Émile Blanche, *Essais et portraits* (Paris: Les Bibliophiles Fantaisistes, Dorbon aîné, 1912), p. 160. Degas's comment in French, "Il était plus grand que nous ne le croyions," which was supposedly pronounced before Manet's coffin at his funeral, can be understood as "he was greater," and as "he was larger," demonstrating Degas's sense of humor as he bid farewell to his friend.

88. Jacques-Émile Blanche, *Manet*, trans. F. C. de Sumichrast (New York: Dodd, Mead, 1925), p. 61.

89. Ives, Stein, and Steiner, *Private Collection of Edgar Degas: A Summary Catalogue*, pp. 89, 90, 98, nos. 805, 816, 868. According to Juliet Wilson-Bareau, the lithograph acquired by Degas from Manet's posthumous sale was "catalogued under lot 167 with the incorrect title *Derrière la barricade*,

suggesting that it was probably a proof before lettering [of *Civil War*] and the same as the one now in Oslo"; Juliet Wilson-Bareau, "Appendix: Degas, Connoisseur of Manet's Prints," in *The Private Collection of Edgar Degas*, by Ann Dumas, Colta Ives, Susan Alyson Stein, and Gary Tinterow, exh. cat. (New York: The Metropolitan Museum of Art, 1997), p. 193.

90. Reff, *Letters of Edgar Degas*, letter 215, vol. 1 p. 339, vol. 3 p. 79.

91. Ibid., letters 234, 236, vol. 1 pp. 357, 359, vol. 3 p. 86.

92. Samuel Rodary, ed., "Carnets de Berthe Morisot," in *Berthe Morisot*, ed. Sylvie Patry, exh. cat. (Paris: Flammarion; Musée d'Orsay, 2019), p. 256.

93. Lionello Venturi, *Les archives de l'impressionnisme: Lettres de Renoir, Monet, Pissarro, Sisley et autres; Mémoires de Paul Durand-Ruel; Documents* (Paris: Durand-Ruel, 1939), vol. 1, pp. 77–78.

94. Ives, Stein, and Steiner, *Private Collection of Edgar Degas: A Summary Catalogue*, p. 88, no. 801.

95. Moore, *Hail and Farewell!*, vol. 3, *Vale*, p. 149.

96. Ives, Stein, and Steiner, *Private Collection of Edgar Degas: A Summary Catalogue*, p. 87, no. 797.

97. Reff, *Letters of Edgar Degas*, letter 374, vol. 1 pp. 474–75, vol. 3 p. 125.

98. Ibid., letter 375, vol. 1 p. 476, vol. 3 p. 126.

99. Ibid., letter 377, vol. 1 p. 478, vol. 3 p. 127.

100. Ibid., letter 383, vol. 1 p. 481, vol. 3 p. 128.

101. Ibid., letter 386 note 3, vol. 1 p. 485, quoting a letter from Bartholomé to an unidentified recipient.

102. Ives, Stein, and Steiner, *Private Collection of Edgar Degas: A Summary Catalogue*, pp. 90–99, nos. 817–83; Ann Dumas, "Degas and His Collection," in Dumas et al., *The Private Collection of Edgar Degas*, pp. 17, 69n94, citing Lemoisne, *Degas et son œuvre*, vol. 1, p. 176.

103. Reff, *Letters of Edgar Degas*, letter 455, vol. 2 p. 47, vol. 3 p. 151.

104. Julie Manet, *Journal (1893–1899): Sa jeunesse parmi les peintres impressionnistes et les hommes de lettres* (Paris: Librairie C. Klincksieck, 1979), p. 30.

105. Sales book of Suzanne Manet, Morgan Library & Museum (M 3950, Notebook 2); Ives, Stein, and Steiner, *Private Collection of Edgar Degas: A Summary Catalogue*, p. 89, no. 806.

106. Ives, Stein, and Steiner, *Private Collection of Edgar Degas: A Summary Catalogue*, p. 88, no. 799.

107. Ambroise Vollard, *Recollections of a Picture Dealer*, trans. Violet M. MacDonald (Boston: Little, Brown, 1936), p. 55.

108. Julie Manet, *Journal*, p. 50.

109. Rebecca A. Rabinow and Jayne Warman, "Selected Chronology," in *Cézanne to Picasso: Ambroise Vollard, Patron of the Avant-Garde*, ed. Rebecca A. Rabinow, exh. cat., The Metropolitan Museum of Art, New York; Art Institute of Chicago; Musée d'Orsay, Paris (New York: The Metropolitan Museum of Art; New Haven: Yale University Press, 2006), p. 276.

110. Halévy, *Degas parle . . .*, p. 77.

111. Rouart, *Correspondence of Berthe Morisot, with Her Family and Friends*, p. 212.

112. Ives, Stein, and Steiner, *Private Collection of Edgar Degas: A Summary Catalogue*, p. 87, no. 795.

113. Ibid., p. 88, no. 800.

114. Halévy, *Degas parle . . .*, pp. 104–5, 110–11.

115. Ives, Stein, and Steiner, *Private Collection of Edgar Degas: A Summary Catalogue*, p. 87, no. 798.

116. Reff, *Letters of Edgar Degas*, letter 892 note 1, vol. 2 p. 319, quoting an unpublished letter from Rouart to Julie Manet-Rouart. Six drawings of Manet were included in Degas's estate sale in 1918, including pls. 6, 11, and 106.

117. Reff, *Letters of Edgar Degas*, letter 957, vol. 2 p. 351, vol. 3 p. 262.

118. Ibid., letter 170 note 9, vol. 1 p. 302, quoting a letter from Valéry to his wife; cited in Agathe Rouart-Valéry, "Introduction Biographique," in *Paul Valéry: Œuvres*, ed. Jean Hytier (Paris: Gallimard, 1957–60), vol. 1, p. 30.

119. *Pictures by Boudin, Cezanne, Degas, . . . [et al.]: Exhibited by Messrs. Durand-Ruel & Sons of Paris, at the Grafton Galleries, . . . January–February 1905* (London: Durand-Ruel, 1905).

Allan, Scott, Emily A. Beeny, and Gloria Groom, eds. 2019. *Manet and Modern Beauty: The Artist's Last Years*. Exh. cat. Los Angeles: J. Paul Getty Museum.

Armstrong, Carol. 1991. *Odd Man Out: Readings of the Work and Reputation of Edgar Degas*. Chicago: University of Chicago Press.

———. 2002. *Manet Manette*. New Haven: Yale University Press.

Bazire, Edmond. 1884. *Manet*. Paris: A. Quantin.

Berson, Ruth. 1996. *The New Painting, Impressionism 1874–1886: Documentation*. 2 vols. San Francisco: Fine Arts Museums of San Francisco.

Blanche, Jacques-Émile. 1912. *Essais et portraits*. Paris: Les Bibliophiles Fantaisistes, Dorbon aîné.

———. 1919. *Propos de peintre: De David à Degas; Première série: Ingres, David, Manet, Degas, Renoir, Cézanne, Whistler, Fantin-Latour, Ricard, Conder, Beardsley, etc.* Paris: Émile-Paul Frères.

———. 1924. *Manet*. Paris: F. Rieder & Cie. Translated by F. C. de Sumichrast as *Manet* (New York: Dodd, Mead, 1925).

Boggs, Jean Sutherland. 1962. *Portraits by Degas*. California Studies in the History of Art 2. Berkeley: University of California Press.

———. 1998. *Degas at the Races*. Exh. cat. Washington, D.C.: National Gallery of Art; New Haven: Yale University Press.

Boggs, Jean Sutherland, Douglas W. Druick, Henri Loyrette, Michael Pantazzi, and Gary Tinterow. 1988. *Degas*. Exh. cat. New York: The Metropolitan Museum of Art; Ottawa: National Gallery of Canada.

Boggs, Jean Sutherland, and Anne Maheux. 1992. *Degas Pastels*. New York: George Braziller.

Bouillon, Jean-Paul, ed. 2020. *Manet to Bracquemond: Newly Discovered Letters to an Artist and Friend*. Translated by Trista Selous. London: Ad Ilissum, an imprint of Paul Holberton Publishing, for the Fondation Custodia.

Brame, Philippe, and Theodore Reff. 1984. *Degas et son oeuvre: A Supplement*. New York: Garland.

Brombert, Beth Archer. 1997. *Edouard Manet: Rebel in a Frock Coat*. Chicago: University of Chicago Press.

Brown, Marilyn R. 1990. "The DeGas–Musson Papers at Tulane University." *Art Bulletin* 72, no. 1 (March), pp. 118–30.

———. 1994. *Degas and the Business of Art: A Cotton Office in New Orleans*. University Park, Pa.: Published for College Art Association by Pennsylvania State University Press.

———. 2018. "Degas's New Orleanian Spaces." In *Sweet Spots: In-Between Spaces in New Orleans*, edited by Teresa A. Toulouse and Barbara C. Ewell, pp. 87–107. Jackson: University Press of Mississippi.

Cachin, Françoise, and Charles S. Moffett, eds. 1983. *Manet 1832–1883*. Exh. cat. New York: The Metropolitan Museum of Art; Harry N. Abrams.

Clark, T. J. 1984. *The Painting of Modern Life: Paris in the Art of Manet and His Followers*. Rev. ed. Princeton, N.J.: Princeton University Press, 1999.

Clayson, Hollis. 1991. *Painted Love: Prostitution in French Art of the Impressionist Era*. New Haven: Yale University Press. See esp. chap. 2, "In the Brothel," pp. 27–46.

———. 2002. *Paris in Despair: Art and Everyday Life under Siege (1870–71)*. Chicago: University of Chicago Press.

Crisci-Richardson, Roberta. 2015. *Mapping Degas: Real Spaces, Symbolic Spaces and Invented Spaces in the Life and Work of Edgar Degas (1834–1917)*. Newcastle upon Tyne, U.K.: Cambridge Scholars Publishing.

Daniel, Malcolm. 1998. *Edgar Degas: Photographer*. Exh. cat. New York: The Metropolitan Museum of Art.

Darragon, Éric. 1989. "Degas sans Manet." In *Degas inédit: Actes du Colloque Degas, Musée d'Orsay, 18–21 avril 1988*, pp. 89–101. Paris: Documentation Française.

———. 2011. *Il était plus grand que nous ne pensions: Édouard Manet et Degas*. Paris: Nouvelles Éditions Scala.

Delteil, Loys. 1919. *Le peintre-graveur illustré*. Vol. 9, *Degas*. Paris: Chez l'Auteur.

De Nittis, Giuseppe. 1895. *Notes et souvenirs du peintre Joseph de Nittis*. Paris: Librairies–Imprimeries Réunies.

Dumas, Ann, Colta Ives, Susan Alyson Stein, and Gary Tinterow. 1997. *The Private Collection of Edgar Degas*. Exh. cat. New York: The Metropolitan Museum of Art.

Duranty, Edmond. 1946. *La nouvelle peinture: À propos du groupe d'artistes qui expose dans les galeries Durand-Ruel (1876)*. New ed. Annotated by Marcel Guérin. Paris: Floury.

Duret, Théodore. 1902. *Histoire de Édouard Manet et de son œuvre*. Paris: H. Floury.

Elderfield, John. 2006. *Manet and the Execution of Maximilian*. Exh. cat. New York: Museum of Modern Art.

Farwell, Beatrice. 1981. *Manet and the Nude: A Study in Iconography in the Second Empire*. New York: Garland.

Feigenbaum, Gail, and Jean Sutherland Boggs. 1999. *Degas and New Orleans: A French Impressionist in America*. Exh. cat. New Orleans: New Orleans Museum of Art, in conjunction with Ordrupgaard, Copenhagen.

Fèvre, Jeanne. 1949. *Mon oncle Degas: Souvenirs et documents inédits*. Edited by Pierre Borel. Geneva: Pierre Cailler.

Fisher, Jay McKean. 1985. *The Prints of Edouard Manet*. Exh. cat. Washington, D.C.: International Exhibitions Foundation.

Foa, Michelle. 2020. "In Transit: Edgar Degas and the Matter of Cotton, between New World and Old." *Art Bulletin* 102, no. 3 (September), pp. 54–76.

Fried, Michael. 1996. *Manet's Modernism, or, The Face of Painting in the 1860s*. Chicago: University of Chicago Press.

Guégan, Stéphane. 2011. *Manet: The Man Who Invented Modernity*. Exh. cat. Paris: Gallimard; Musée d'Orsay.

Guérin, Marcel. 1944. *L'œuvre gravé de Manet: Avec un supplément nouvellement ajouté*. Paris: Floury. Repr., New York: Da Capo Press, 1969.

———, ed. 1945. *Lettres de Degas*. Rev. ed. Paris: B. Grasset.

Halévy, Daniel. 1960. *Degas parle....* Paris: La Palatine.

Hansen, Dorothee, ed. 2021. *Manet and Astruc: Friendship and Inspiration*. Exh. cat. Madrid: Centro de Estudios Europa Hispánica.

Harris, Jean C. 1990. *Edouard Manet: The Graphic Work; A Catalogue Raisonné*. Rev. ed. Edited by Joel M. Smith. San Francisco: A. Wofsy Fine Arts.

Hauptman, Jodi, ed. 2016. *Degas: A Strange New Beauty*. Exh. cat. New York: Museum of Modern Art.

Ives, Colta, Susan Alyson Stein, and Julie A. Steiner, comps. 1997. *The Private Collection of Edgar Degas: A Summary Catalogue*. New York: The Metropolitan Museum of Art.

Jamot, Paul, and Georges Wildenstein. 1932. *Manet*. 2 vols. Paris: Les Beaux-Arts, Édition d'Études et de Documents.

Janis, Eugenia Parry. 1968. *Degas Monotypes*. Exh. cat. Cambridge, Mass.: Fogg Art Museum, Harvard University.

Jarbouai, Leïla, and Marine Kisiel, eds. 2017. *Degas, danse, dessin: Hommage à Degas avec Paul Valéry*. Exh. cat. Paris: Gallimard; Musée d'Orsay.

Kelly, Simon, and Esther Bell. 2017. *Degas, Impressionism, and the Paris Millinery Trade*. Exh. cat. San Francisco: Fine Arts Museums of San Francisco–Legion of Honor; Munich: DelMonico Books, Prestel.

Kendall, Richard, ed. 1987. *Degas by Himself: Drawings, Prints, Paintings, Writings*. Boston: Little, Brown.

Kendall, Richard, and Griselda Pollock, eds. 1992. *Dealing with Degas: Representations of Women and the Politics of Vision*. London: Pandora.

Kessler, Marni R. 1999. "Unmasking Manet's Morisot." *Art Bulletin* 81, no. 3 (September), pp. 473–89.

———. 2017. "Édouard Manet's *Ham* and Suzanne's Lost Body in Edgar Degas's *Salon*." *Contemporary French Civilization* 42, nos. 3–4 (January), pp. 279–300.

———. 2021. "Berthe Morisot in Mourning." *Yale French Studies* 139 (Fall–Winter), pp. 67–84.

———. 2022. "Degas's Breath and the Materiality of Pastel Veils." *Dix-Neuf: Journal of the Society of Dix-Neuviémistes* 25, no. 3–4 (Winter), pp. 260–79. https://doi.org/10.1080/14787318.2021.2017557.

Lafond, Paul. 1918–19. *Degas*. 2 vols. Paris: H. Floury.

Leiris, Alain de. 1969. *The Drawings of Edouard Manet*. Berkeley: University of California Press.

Lemoisne, Paul-André. 1946–49. *Degas et son œuvre*. 4 vols. Paris: Paul Brame et C. M. de Hauke, aux Arts et Métiers Graphiques. Repr., New York: Garland, 1984.

Locke, Nancy. 2001. *Manet and the Family Romance*. Princeton, N.J.: Princeton University Press.

Loyrette, Henri. 1991. *Degas*. Paris: Fayard.

———. 1993. "Degas copiste." In *Copier créer: De Turner à Picasso; 300 œuvres inspirées par les maîtres du Louvre*, pp. 302–31. Exh. cat. Paris: Réunion des Musées Nationaux.

———. 1998. "Degas's Collection." *Burlington Magazine* 140, no. 1145 (August), pp. 551–58.

———. 2016. *Degas: A New Vision.* Exh. cat. Melbourne: Council of Trustees of the National Gallery of Victoria.

———. 2020. *Degas at the Opéra.* Exh. cat. London: Thames & Hudson.

Mallarmé, Stéphane. 1876. "The Impressionists and Édouard Manet." *Art Monthly Review and Photographic Portfolio* 1, no. 9 (September 30), pp. 117–22.

Manet: Portraying Life. 2012. Exh. cat. Toledo, Ohio: Toledo Museum of Art; London: Royal Academy of Arts.

Manet, Julie. 1979. *Journal (1893–1899): Sa jeunesse parmi les peintres impressionnistes et les hommes de lettres.* Paris: Librairie C. Klincksieck.

———. 1987. *Growing Up with the Impressionists: The Diary of Julie Manet.* Translated and edited by Rosalind de Boland Roberts and Jane Roberts. London: Sotheby's Publications.

Mathieu, Marianne, ed. 2021. *Julie Manet: An Impressionist Heritage.* Exh. cat. Paris: Hazan, Musée Marmottan Monet; New Haven: Yale University Press.

Meier-Graefe, Julius. 1912. *Edouard Manet.* Munich: R. Piper.

———. 1923. *Degas.* Translated by J. Holroyd-Reece. London: Ernest Benn.

Meyers, Jeffrey. 2005. "Degas and Manet: A Study in Friendship." *Apollo* 161, no. 516 (February), pp. 56–63.

———. 2005. *Impressionist Quartet: The Intimate Genius of Manet and Morisot, Degas and Cassatt.* Orlando, Fla.: Harcourt.

Le modèle noir: De Géricault à Matisse. 2019. Exh. cat. Paris: Musée d'Orsay; Flammarion.

Moore, George. 1889. *Confessions d'un jeune anglais.* Paris: Albert Savine.

Moore, George, and Walter Sickert. 2019. *Memories of Degas.* Los Angeles: J. Paul Getty Museum.

Moreau-Nélaton, Étienne. 1906. *Manet: Graveur et lithographe.* Paris: Éditions du "Peintre-Graveur Illustré," Loys Delteil.

———. 1926. *Manet: Raconté par lui-même.* 2 vols. Paris: H. Laurens.

———. 1931. "Deux heures avec Degas." *L'Amour de l'Art,* July, pp. 267–70.

Murrell, Denise. 2018. *Posing Modernity: The Black Model from Manet to Matisse to Today.* Exh. cat. New Haven: Yale University Press in association with the Miriam and Ira D. Wallach Art Gallery, Columbia University, New York.

Patry, Sylvie, ed. 2019. *Berthe Morisot.* Exh. cat. Paris: Flammarion; Musée d'Orsay.

Prat, Louis-Antoine. 2011. *Le dessin français au XIXᵉ siècle.* Paris: Musée du Louvre; Musée d'Orsay; Somogy.

Proust, Antonin. 1901. "L'art d'Édouard Manet." *Le Studio* 21, no. 94 (January 15), suppl., no. 28, pp. 71–77.

———. 1913. *Édouard Manet: Souvenirs.* Edited by Auguste Barthélemy. Paris: Henri Laurens.

Reed, Sue Welsh, and Barbara Stern Shapiro. 1984. *Edgar Degas: The Painter as Printmaker.* Exh. cat. Boston: Museum of Fine Arts.

Reff, Theodore. 1963. "Degas's Copies of Older Art." *Burlington Magazine* 105, no. 723 (June), pp. 241–51.

———. 1964. "The Meaning of Manet's Olympia." *Gazette des Beaux-Arts,* ser. 6, 63 (February), pp. 111–22.

———. 1964. "New Light on Degas's Copies." *Burlington Magazine* 106, no. 735 (June), pp. 250–59.

———. 1969. "Manet's Sources: A Critical Evaluation." *Artforum* 8, no. 1 (September), pp. 40–48.

———. 1976. *Degas: The Artist's Mind.* New York: The Metropolitan Museum of Art; Harper & Row.

———. 1977. "Degas: A Master among Masters." *The Metropolitan Museum of Art Bulletin* 34, no. 4 (Spring), pp. 2–48.

———, ed. 1985. *The Notebooks of Edgar Degas: A Catalogue of the Thirty-Eight Notebooks in the Bibliothèque Nationale and Other Collections.* Rev. ed. 2 vols. New York: Hacker Art Books.

———, ed. 2020. *The Letters of Edgar Degas.* New York: Wildenstein Plattner Institute.

Rodary, Samuel, ed. 2014. *Édouard Manet: Correspondance du siège de Paris et de la Commune, 1870–1871.* Paris: L'Échoppe.

Rouart, Denis, ed. 1986. *The Correspondence of Berthe Morisot, with Her Family and Friends: Manet, Puvis de Chavannes, Degas, Monet, Renoir and Mallarmé.* Translated by Betty W. Hubbard. London: Camden Press.

Rouart, Denis, and Daniel Wildenstein. 1975. *Édouard Manet: Catalogue raisonné.* 2 vols. Lausanne: Bibliothèque des Arts.

Sayre, Henry M. 2022. *Value in Art: Manet and the Slave Trade.* Chicago: University of Chicago Press.

Shackelford, George T. M., and Xavier Rey. 2011. *Degas and the Nude.* Exh. cat. Boston: Museum of Fine Arts.

Smee, Sebastian. 2016. *The Art of Rivalry: Four Friendships, Betrayals, and Breakthroughs in Modern Art.* New York: Random House.

Stevens, MaryAnne. 2014. "Degas–Manet: Eine facettenreiche und vitale Beziehung." In *Degas: Klassik und Experiment,* edited by Alexander Eiling, pp. 42–53. Exh. cat. Munich: Hirmer; Karlsruhe: Staatliche Kunsthalle Karlsruhe.

Tabarant, Adolphe. 1931. *Manet: Histoire catalographique.* Paris: Éditions Montaigne.

———. 1942. *La vie artistique au temps de Baudelaire.* Repr., Paris: Mercure de France, 1963.

———. 1947. *Manet et ses œuvres.* Paris: Gallimard.

Tinterow, Gary, and Geneviève Lacambre. 2003. *Manet/Velázquez: The French Taste for Spanish Painting.* Exh. cat. New York: The Metropolitan Museum of Art; New Haven: Yale University Press.

Tinterow, Gary, and Henri Loyrette. 1994. *Origins of Impressionism.* Exh. cat. New York: The Metropolitan Museum of Art.

Valéry, Paul. 1960. *Degas, Manet, Morisot.* Translated by David Paul. Bollingen series 45, vol. 12. New York: Pantheon Books.

Vollard, Ambroise. 1924. *Degas (1834–1917).* Paris: G. Crès et Cie.

———. 1937. *Souvenirs d'un marchand de tableaux.* Paris: Albin Michel. Translated by Violet M. MacDonald as *Recollections of a Picture Dealer* (Boston: Little, Brown, 1936).

———. 1938. *En écoutant Cézanne, Degas, Renoir.* Repr., Paris: Grasset, 1994.

White, Barbara Ehrlich. 1996. "Degas & Manet." In *Impressionists Side by Side: Their Friendships, Rivalries, and Artistic Exchanges,* pp. 23–55. New York: Alfred A. Knopf.

Wilson[-Bareau], Juliet, ed. 1978. *Manet: Dessins, aquarelles, eaux-fortes, lithographies, correspondance.* Exh. cat. Paris: Huguette Berès.

Wilson-Bareau, Juliet, ed. 1991. *Manet by Himself: Correspondence and Conversation; Paintings, Pastels, Prints and Drawings.* Boston: Little, Brown; Bulfinch Press.

———. 1992. *Manet, The Execution of Maximilian: Painting, Politics, and Censorship.* Exh. cat. London: National Gallery Publications.

———. 2012. "Édouard Manet dans ses ateliers." *Ironie* 161 (January/February). http://interrogationcritiqueludique.blogspot.com/2012/10/ironie-n161-janvierfevrier-2012.html.

Wilson-Bareau, Juliet, with David C. Degener. 2003. *Manet and the American Civil War: The Battle of U.S.S. Kearsarge and C.S.S. Alabama.* Exh. cat. New York: The Metropolitan Museum of Art; New Haven: Yale University Press.

Wilson-Bareau, Juliet, and David Degener. 2003. *Manet and the Sea.* Exh. cat. Philadelphia: Philadelphia Museum of Art.

INDEX

PHOTOGRAPH CREDITS

The Art Institute of Chicago / Art Resource, NY: fig. 57, pls. 31, 71, 77, 92, 101, 125; Photo by Jorge Bachman, courtesy Fine Arts Museums of San Francisco: pl. 126; Courtesy of Barnes Foundation: fig. 53; Courtesy of Bibliothèque littéraire Jacques Doucet (Sorbonne University). Photo by Pierre Auradon: fig. 27; Courtesy of Bibliothèque nationale de France: p. 18, figs. 6, 8, 14, 60, pls. 4, 148; © BnF, Dist. RMN-Grand Palais / Art Resource, NY: p. 1 top, fig. 1; bpk Bildagentur / Galerie Neue Meister / Staatliche Kunstsammlungen / Elke Estel / Hans-Peter Klut / Art Resource, NY: pl. 107; bpk Bildagentur / Hamburger Kunsthalle / Elke Walford / Art Resource, NY: pl. 128; bpk Bildagentur / Neue Pinakothek, Munich / Art Resource, NY: fig. 45; bpk Bildagentur / Neue Pinakothek / Bayerische Staatsgemaeldesammlungen / Art Resource, NY: pl. 20; Bridgeman Images: pl. 60; Courtesy of Brooklyn Museum: pl. 95; Photo by Dominic Büttner: fig. 33; Courtesy of Calouste Gulbenkian Foundation, Lisbon–Calouste Gulbenkian Museum. Photo by Catarina Gomes Ferreira: pl. 130; Photo © Christie's Images / Bridgeman Images: fig. 42; Chronicle / Alamy Stock Photo: fig. 17; Photo © The Courtauld / Bridgeman Images: pp. 112–13, fig. 59, pl. 35; © CSG CIC Glasgow Museums Collection: fig. 56, pl. 149; © DeA Picture Library / Art Resource, NY: pl. 23; © Detroit Institute of Arts / Bridgeman Images: pl. 78; © Detroit Institute of Arts / Gift of Mr. and Mrs. Edward E. Rothman / Bridgeman Images: pl. 13; © Detroit Institute of Arts / Bequest of Robert H. Tannahill / Bridgeman Images: pl. 41; Gordon, Robert, and Andrew Forge, *Degas* (New York: Harry N. Abrams, 1988), p. 39. Image © The Metropolitan Museum of Art, photo by Teri Aderman: fig. 31; History and Art Collection / Alamy Stock Photo: fig. 10; Institut national d'histoire de l'art: pl. 17; Courtesy Isabella Stewart Gardner Museum: fig. 46; Courtesy of Robert Flynn Johnson: pl. 25; Courtesy of Kitakyushu Municipal Museum: p. 71, pl. 3; Courtesy of Koons Collection: pls. 134, 137; Kunsthalle Bremen–Die Kulturgutscanner–ARTOTHEK: fig. 18; Kunsthalle Bremen–Marcus Meyer–ARTOTHEK: fig. 19; Photo by Kunsthalle Mannheim / Kathrin Schwab: fig. 13; Courtesy of Kunsthaus Zürich: pl. 16; Courtesy of LACMA: fig. 43; © P. Lorette, coll. Comédie-Française: fig. 20; Courtesy of Louisiana State Museum: figs. 23, 24; Image © Lyon MBA–Photo by Alain Basset: fig. 54, pl. 21; Photo by Isabella Matheus: pl. 61; Mathieu, Marianne, ed., *Julie Manet: An Impressionist Heritage* (New Haven: Yale University Press, 2021), pp. 68, 71. Image © The Metropolitan Museum of Art, photo by Teri Aderman: figs. 28, 29; Image © The Metropolitan Museum of Art: front cover bottom, front endpaper 1, front endpaper 2, pp. 4, 68–69, back endpaper 1, figs. 3, 4, 9, 12, 15, pl. 6, 7, 8, 11, 12, 19, 27, 29, 30, 42, 44, 50, 51, 54, 57–59, 61, 62, 67, 70, 73, 75, 79, 93, 94, 96, 102, 106, 123, 131, 133, 135, 136, 142, 144–46, 150, 153, 155; Image © The Metropolitan Museum of Art, photo by Anna-Marie Kellen: pls. 46–48; Image © The Metropolitan Museum of Art, photo by Juan Trujillo: back cover top, pp. 6, 89, 182–83, 218–19, fig. 52, pls. 15, 28, 33, 53, 65, 66, 84, 87, 89, 90, 112–14, 122, 139; © Ministère de la Culture / Médiathèque du Patrimoine, Dist.

RMN-Grand Palais / Art Resource, NY: fig. 36; © Musée d'Orsay Dist. RMN-Grand Palais / Patrice Schmidt: pp. 10, 50, 78–79, 115, 132–33, 157, 168–69, 197, 206–7, figs. 50, 64, pls. 2, 5, 9, 24, 36, 38, 39, 45, 49, 56, 62–64, 81, 83, 88, 97, 98, 105, 118, 120, 147; Musée Marmottan Monet, Paris, France / Bridgeman Images: fig. 11; Photo © 2023 Museum of Fine Arts, Boston: fig. 47, pls. 40, 43, 72; Courtesy of Nationalmuseum, Stockholm: pls. 18, 37, 151, 152, 154; Courtesy of the National Gallery, London: figs. 26, 41, pls. 111, 160; Courtesy National Gallery of Art, Washington: front cover top, figs. 39, 49, 58, pls. 14, 85, 86, 119; Courtesy of National Gallery of Scotland: pl. 68; Courtesy of National Museum of Western Art: fig. 32; Photo courtesy Nelson-Atkins Media Services, Gabe Hopkins: fig. 55; Photo by Ny Carlsberg Glyptotek, Copenhagen: fig. 40; Courtesy of Roberta J. M. Olson and Alexander B. V. Johnson. Image © The Metropolitan Museum of Art, photo by Mark Morosse: back endpaper 2, pl. 156; Ordrupgaard, Copenhagen. Photo by Anders Sune Berg: pl. 117; Courtesy of Oskar Reinhart Collection 'Am Römerholz', Winterthur: fig. 34; Courtesy Philadelphia Museum of Art: p. 26, pls. 127, 138; Photo © President and Fellows of Harvard College: pls. 34, 99, 140; Image courtesy Princeton University Art Museum. Photo by Bruce M. White: p. 58, pl. 159; Private Collection, NY. Image © The Metropolitan Museum of Art, photo by Heather Johnson: fig. 44; Courtesy of the Reading Public Museum, Reading, Pennsylvania: pl. 124; Courtesy of the RISD Museum, Providence, RI: pls. 55, 116; © RMN-Grand Palais / Art Resource, NY: fig. 7; © RMN-Grand Palais / Art Resource, NY. Photo by Michèle Bellot: fig. 16, pl. 10; © RMN-Grand Palais / Art Resource, NY. Photo by Jean-Gilles Berizzi: fig. 22; © RMN-Grand Palais / Art Resource, NY. Photo by Gérard Blot: fig. 5; © RMN-Grand Palais / Art Resource, NY. Photo by Adrien Didierjean: pl. 80; © RMN-Grand Palais / Art Resource, NY. Photo by Thierry Le Mage: pls. 26, 76; © RMN-Grand Palais / Art Resource, NY. Photo by Hervé Lewandowski: back cover bottom, p. 1 bottom, figs. 2, 37, 63, 65, pls. 74, 100; © RMN-Grand Palais / Art Resource, NY. Photo by Thierry Ollivier: pp. 252–53, pl. 141; © RMN-Grand Palais / Art Resource, NY. Photo by Rachel Prat: pl. 108; © RMN-Grand Palais / Art Resource, NY. Photo by Franck Raux: fig. 35, pls. 22, 82; © RMN-Grand Palais / Art Resource, NY. Photo by Michel Urtado: pl. 52; Photo by Peter Schälchli, Zurich: pl. 1; © Shelburne Museum / Gift of the Electra Havemeyer Webb Fund, Inc. / Bridgeman Images: pl. 115; Photo Courtesy of Sotheby's, Inc. © 2023: pls. 104, 129; © Dr. Georg Steinmetzer, Munich: pl. 109; Studio Tromp: fig. 48; Courtesy of Szépművészeti Múzeum / Museum of Fine Arts, Budapest, 2022: pp. 38, 247, pls. 91, 143 (left and right); Photo by Tate: p. 261, fig. 25, pl. 158; Courtesy of Toledo Museum of Art: pl. 69; Photo © O. Vaering / Bridgeman Images: fig. 30; Vidimages / Alamy Stock Photo: fig. 38; Courtesy of Villers Cotterets Musée A Dumas: fig. 21; © Virginia Museum of Fine Arts. Photo by Katherine Wetzel: pl. 110; The Walters Art Museum, Baltimore: pl. 121; Yale University Art Gallery: pl. 103

This catalogue is published in conjunction with *Manet/Degas*, on view at the Musée d'Orsay, Paris, from March 27 through July 23, 2023, and at The Metropolitan Museum of Art, New York, from September 24, 2023, through January 7, 2024.

The exhibition is made possible by Alice Cary Brown and W. L. Lyons Brown, the Sherman Fairchild Foundation, and Harry and Linda Fath.

Additional support is provided by the Janice H. Levin Fund, the Gail and Parker Gilbert Fund, The Sam and Janet Salz Trust, and Rosalind and Kenneth Landis.

It is organized by The Metropolitan Museum of Art, New York, and the Musées d'Orsay et de l'Orangerie, Paris.

The catalogue is made possible by Gregory Annenberg Weingarten, GRoW @ Annenberg.

Additional support is provided by Anonymous, Robert M. Buxton, Elizabeth Marsteller Gordon, and Claude Wasserstein.

Published by The Metropolitan Museum of Art, New York

Mark Polizzotti, Publisher and Editor in Chief
Peter Antony, Associate Publisher for Production
Michael Sittenfeld, Associate Publisher for Editorial

Edited by Elisa Urbanelli
Production by Christopher Zichello
Designed by McCall Associates, New York
Bibliographic editing by Margaret Aspinwall
Image acquisitions and permissions by Jenn Sherman
Translations from French by John Goodman

Photographs of works in The Met collection are by the Imaging Department, The Metropolitan Museum of Art, unless otherwise noted. Additional photography credits appear on page 315.

Typeset in Malleable Grotesque, Muller, and Arno
Printed on 150 gsm Magno Volume
Printed and bound by Verona Libri, Verona, Italy

MIX
Paper | Supporting responsible forestry
FSC® C119614
www.fsc.org

Front cover: top, Édouard Manet, *The Dead Toreador* (detail), probably 1864 (pl. 85); bottom, Edgar Degas, *The Dancing Class* (detail), ca. 1870 (pl. 112)

Back cover: top, Manet, *The Monet Family in Their Garden at Argenteuil* (detail), 1874 (pl. 113); bottom, Degas, *Racehorses before the Stands* (detail), 1866–68 (pl. 100)

Front endpapers: Manet, *The Races* (detail), 1865–72 (pl. 102); Degas, *Édouard Manet, Seated, Holding His Hat* (detail), ca. 1868 (pl. 6)

Back endpapers: Degas, *Mary Cassatt at the Louvre: The Etruscan Gallery* (detail), 1879–80 (pl. 70); Manet, *At the Theater* (detail), ca. 1878–80 (pl. 156)

Frontispieces: p. 4, Manet, *Young Lady in 1866* (detail), 1866 (pl. 93); p. 6, Degas, *A Woman Seated beside a Vase of Flowers (Madame Paul Valpinçon?)* (detail), 1865 (pl. 84); p. 10, Degas, *The Orchestra of the Opera* (detail), ca. 1870 (pl. 120); p. 18, Degas, *The Infanta Margarita, after Velázquez* (detail), 1861–62 (fig. 6); p. 26, Manet, *The Battle of the USS "Kearsarge" and the CSS "Alabama"* (detail), 1864 (pl. 138); p. 38, Manet, *Woman with a Fan (Jeanne Duval)* (detail), 1862 (pl. 91); p. 50, Manet, *Stéphane Mallarmé* (detail), 1876 (pl. 63); p. 58, Manet, *Woman with a Cigarette* (detail), ca. 1878–80 (pl. 159); pp. 68–69, Degas, *Mademoiselle Bécat at the Café des Ambassadeurs, Paris* (detail), 1877–78 (pl. 123); p. 71, Degas, *Monsieur and Madame Édouard Manet* (detail), 1868–69 (pl. 3); p. 89, Manet, *Fishing* (detail), ca. 1862–63 (pl. 33); p. 115, Degas, *Lorenzo Pagans and Auguste De Gas* (detail), 1871–72 (pl. 39); p. 157, Manet, *Lola de Valence* (detail), 1862 (pl. 97); p. 197, Degas, *In a Café (The Absinthe Drinker)* (detail), 1875–76 (pl. 118); p. 247, Manet, *The Barricade* (detail), ca. 1871 (pl. 143r); p. 261, Manet, *Woman with a Cat* (detail), ca. 1880 (pl. 158)

The Metropolitan Museum of Art
1000 Fifth Avenue
New York, New York 10028
metmuseum.org

Distributed by
Yale University Press, New Haven and London
yalebooks.com/art
yalebooks.co.uk

Cataloguing-in-Publication Data is available from the Library of Congress.

ISBN 978-1-58839-763-8

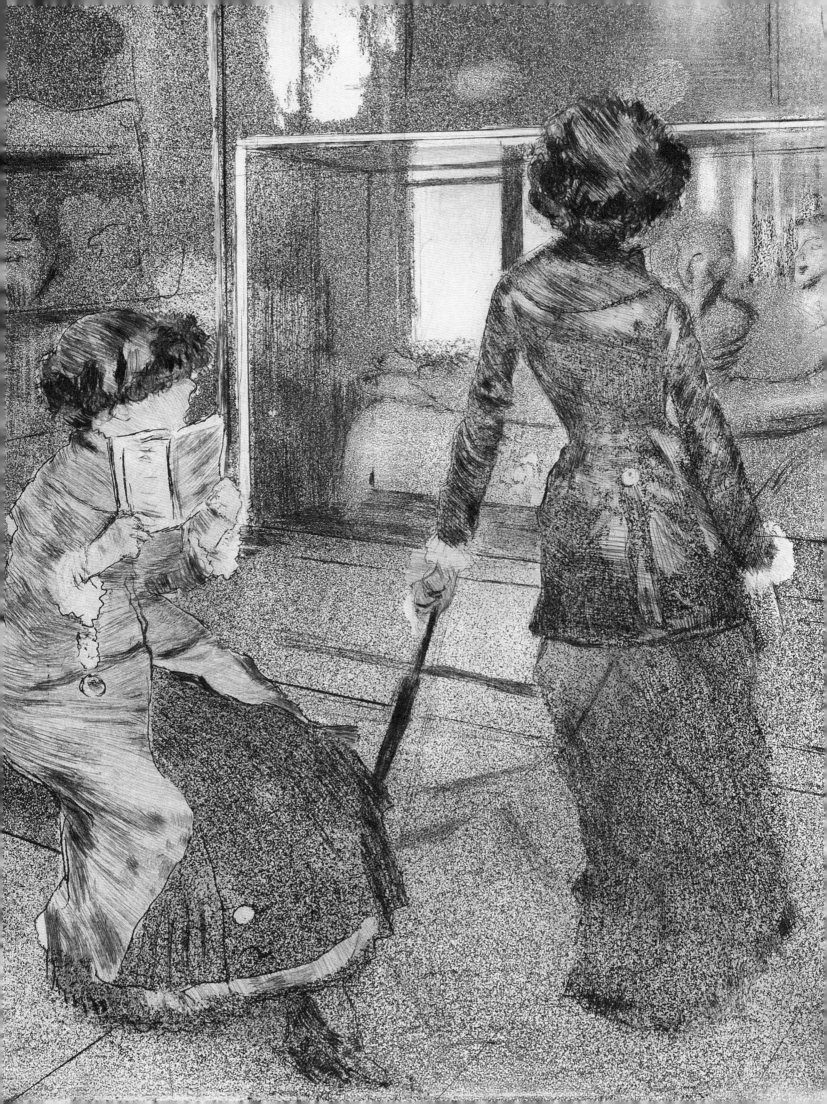